IN THE FOOTSTEPS OF ABRAHAM

THE HOLY LAND IN HAND-PAINTED PHOTOGRAPHS

IN THE FOOTSTEPS OF ABRAHAM

THE HOLY LAND IN HAND-PAINTED PHOTOGRAPHS

Richard Hardiman and Helen Speelman

Foreword by Joël J. Cahen

OVERLOOK DUCKWORTH
New York • Woodstock • London

First published in 2008 by
Overlook Duckworth, Peter Mayer Publishers, Inc.
New York, Woodstock, and London

NEW YORK:
141 Wooster Street
New York, NY 10012

WOODSTOCK:
One Overlook Drive
Woodstock, NY 12498
www.overlookpress.com
[for individual orders, bulk and special sales, contact our Woodstock office]

LONDON:
90-93 Cowcross Street
London EC1M 6BF
inquiries@duckworth-publishers.co.uk
www.ducknet.co.uk

Cataloging-in-Publication Data is available from the Library of Congress

Book design and type formatting by Bernard Schleifer
Manufactured in Singapore
ISBN 978-1-59020-107-7 US
ISBN 978-0-71563-817-0 UK
10 9 8 7 6 5 4 3 2 1

CONTENTS

IN THE FOOTSTEPS OF ABRAHAM

THE HOLY LAND IN HAND-PAINTED PHOTOGRAPHS

FOREWORD

Joël J. Cahen, JEWISH HISTORICAL MUSEUM, AMSTERDAM

The photographs in this volume illustrate the landscapes, cities, villages, and peoples of the Holy Land from a largely Biblical point of interest. The photos were in fact made to be sold to the rising number of tourists visiting the Holy Land, of whom a great number came primarily to see Biblical sites. Arie Speelman commissioned this hand-colored collection of glass lantern slides, now at the Joods Historisch Museum Amsterdam, from The Matson Photo Agency (formerly the American Colony Photo Department) in the 1920s. It is one of the few fully hand-colored sets in existence, and certainly one of the largest.

It seems to me important to note that *In the Footsteps of Abraham*—published out of a collection that has been in Dutch hands for years but remained in its origins American—may be the first book of such scale since Frank Scholten's *Palestine Illustrated / Palestina de toegangspoort* was published in several editions, languages, and versions by A.W. Sijthofs uitgeversmaatschappij in Leiden and distributed worldwide in the years after 1930.

The collection of hand-colored glass slides from which the images in this book are derived came to the Joods Historisch Museum, Amsterdam, in 1991 and although the historical meaning of the collection was recognized and a write-up in the museum's newsletter of March 1991 appeared immediately upon its acquisition, extensive use or discussion about a possible exhibition didn't occur until Peter Mayer of The Overlook Press acquired the rights to publish this book from Helen Speelman, the granddaughter of Arie Speelman, the original owner and extensive user of the collection, and Richard Hardiman.

The publication of *In the Footsteps of Abraham* marks an achievement both for the Joods Historisch Museum, Amsterdam, and for the authors, Richard Hardiman and Helen Speelman. I thank them first of all for their drive and work. I owe thanks to Peter Mayer and Tracy Carns of The Overlook Press for realiz-ing this project, and to which end Anton Kras of our Library and Photo Service took every effort to keep the line to Peter Mayer open, and along with Andreas Landshoff in Amsterdam, Jeroen Proost at Roto Smeets, Utrecht, and George Davidson at Overlook, took care that the scans were made to the highest possible standard.

We are very pleased with this book and the attendant show because they will give rightful attention to these wonderful photographs and present a lasting image of the Holy Land.

Amsterdam June 2008

INTRODUCTION:
ARIE SPEELMAN AND THE HAND-PAINTED LANTERN SLIDES

Helen Speelman

MY GRANDFATHER, Arie Speelman, traveled to the Middle East with his wife in 1926 and 1931. He traveled in style with a good car, driver, and a guide throughout Palestine, Jordan, Lebanon, and Syria. In David Street, just inside the Jaffa Gate of the City of Jerusalem, my grandfather met the American Colony's Eric Matson in his photographic studio. Well-pursed tourists would come to this studio to choose lantern slides and pictures from an album for reproduction.

The American Colony photographic studio came into being as the result of a social need and grew rapidly to satisfy the increasing demands of elite tourism and the established mixed foreign community living in Palestine at the time. The photographs were taken and collected by the staff operating the studio: Elijah Meyers, Frederick Vester and their associates, Eric Matson, and Lewis Larsson. One of its new employees was Edith Yantiss. Edith emigrated to Palestine from a Kansas farm with her family in 1896. Eric and Edith, who later married, learned quickly, by trial and error, all the complex techniques of professional photography.

At the time the photographs in this volume were taken, only black and white photography was commercially available. Eric and Edith were particularly successful in using oil-paints for hand coloring photographs, producing colored enlargements and sets of color slides that became an important feature of their business. Coloring individual lantern slides or photographs was a time-consuming activity requiring much concentration, cost, and indeed skill, sometimes using a brush of a single hair. The attention to detail employed in painting these lantern slides is such that, in many instances, the image can hardly be differentiated from modern color photography. The photographs presented in this volume are a result of this fine work.

In the studio inside the Jaffa Gate, my grandfather selected about 1200 lantern slides to be reproduced and added them to the collection that he had taken with his own camera during his travels through the region. In order to enhance the reality of Palestine and to portray the true colors of the land and the people, my grandfather commissioned the Matson studio to hand-color each lantern slide with oil paints—a skill developed within the photographic studio. This was an incredibly unusual undertaking on such a large group of photos; hand-coloring was more commonly carried out on single photographs of family portraits, or of a favored grandchild, but rarely in this number, and of views, scenes, and people. The collection was carefully packed in wooden boxes and sent to my grandparents' home in Holland.

During those days my grandfather would use the hand-colored slides to give "Palestina Evenings" throughout Holland, to share his love of the country. With these lantern slides he would give a visual tour through the Holy Land, its people, customs, and religions, to an audience who rarely had a chance to leave the shores of Holland. He projected the slides onto a screen of white linen 3 meters x 3 meters. The projector was a Leitz product with a mirrored lamp of at least 1000 watts. These presentations came to an end during the Second World War. When I was a child, he used to tell me about his travels and show me the lantern slides, which left an indelible imprint on my mind.

Eric Matson spent the latter years of his life at the Episcopal Home in Alhambra, California, where he died in 1977 and to which he endowed his entire collection of photographs; the slides were later given by the Home to the Library of Congress. Eric Matson and the other members of the American Colony had a vision of peace in the Middle East, and he hoped that his photography could somehow contribute to that dream. After my grandfather died, my father donated the entire collection of hand-painted lantern slides to the Jewish Historical Museum in Amsterdam. The photographs in this volume were selected from that collection. Although the American Colony/Matson Collection of photos, in black and white, have been available to specialists in the Arno Press's four-volume *The Middle East in Pictures*, this Overlook Press publication marks the first time the hand-colored images have been reproduced in a work for the general public and with the photos in a large format.

As was the wish of Eric Matson, so I too wish this publication be dedicated to a lasting peace in the Middle East, in the name of my grandfather, Arie Speelman and my father, Arie Speelman.

HELEN SPEELMAN'S GRANDFATHER, ARIE SPEELMAN, WITH GUIDES, TOURING THE HOLY LAND

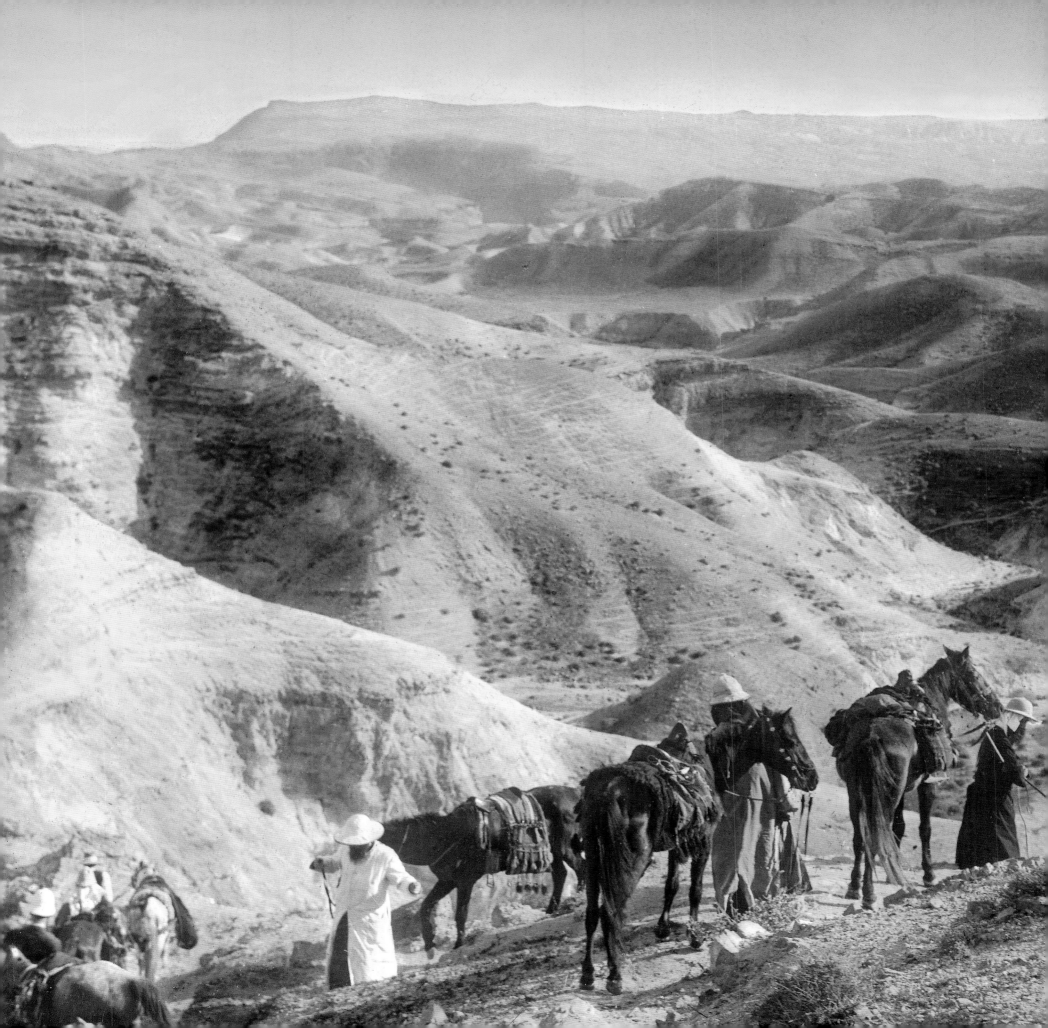

THE MATSON COLLECTION:
A HALF CENTURY OF PHOTOGRAPHY IN THE MIDDLE EAST

George S. Hobart, LIBRARY OF CONGRESS

IN THE FALL OF 1971 a young octogenarian with silvery hair and sparkling blue eyes could be seen in the Library of Congress, walking between Annex deck 4 south and the cafeteria two or three times each day. His name was G. Eric Matson ("G" for Gästgifvar, a Swedish family name), and for five weeks Library staff members came to know him well, for he worked six days a week, from seven to seven.

His work was really pleasure, for he was busy cleaning, identifying, and organizing his beloved group of photographic negatives that had been "lost" in East Jerusalem since 1946. These negatives are a part of the Matson Photo Service Collection, twenty thousand negatives providing a half-century's pictorial documentation of persons, places, and events in the Middle East, which was given to the Library of Congress by Mr. and Mrs Matson in 1966.

Eric Matson was born in Nås parish in Dalarna, Sweden, on June 16, 1888. Eight years later his family, along with several other farming families, joined a small community of Americans in Palestine, founded in 1881 by Horatio Gates Spafford, a Chicago lawyer. These Americans and Swedes shared "a deeply felt need to dedicate their lives to simple Christian service to God and humanity. They pooled their resources, lived a communal life similar to that of the early church, and bent their efforts toward helping the people of the land."[1] The American Colony, as it came to be known, flourished through hard work and simple living, and in ministering to the sick and needy of Jerusalem. The colonists came to be loved by Arabs, Jews, and Christians alike. Yet the group was not with out its detractors. Suspicions were aroused by the colony's "liberal policy," and malicious rumors circulated not only in Jerusalem but reaching other part of the world as well.

It was to probe these reports that Selma Lageröf came to Jerusalem in 1899. The result was her novel *Jerusalem*, in which she portrays the Swedish emigration and life in the colony. Some twenty years later she was able to cite evidence of the settlement's accomplishments: "The colony now owned a great palace, situated not far from the Damascus Gate, as well as six smaller buildings. It owned dromedaries and horses, cows and goats, buildings and land, olive and fig trees, shops and workrooms. Photographs of Palestine from its studio were sold all over the world, and it fitted out caravans which transported travellers far and wide."[2]

The American Colony Photo Department came into being as a result of a social need, as did many of the communal economic enterprises. Initially organized to meet the demand for photographic mementos of the state visit of Wilhelm II of Germany in 1898,[3] it grew rapidly to satisfy the increasing needs of tourism. Two of its new employees were Eric Matson and another teenager, Edith Yantiss, whose family came to Jerusalem from a Kansas farm in 1896. Eric and Edith leaned quickly, by trial and error, all the complex techniques that separated professional photography from that of amateurs and experimented with new ones. They were particularly successful in using oil paints for hand colored photographs, producing colored enlargements and sets of colored slides that became an important feature of their business. (PUBLISHER'S NOTE: It is these hand-colored slides which are the focus of this book.) Eric and Edith were married in 1924, took over the photo department in 1934 as the Matson Photo Service, and worked together until her death in 1966.

Reviewing the techniques of his craft, Eric Matson said:

In looking for the right composition I rely on feelings and intuition. In general, particularly with black and white photography, I avoid taking outdoor pictures near the noon hour, when the sun is overhead. I prefer the lighting and the shadows provided earlier or later in the day. . . . In the early days, our picture-taking and processing were somewhat primitive and often improvised. We had to sensitize our own albuminized printing paper and used sunlight as our light source. Our earliest enlargements were made by placing a box camera through the window of a darkened room, putting the glass negative of the picture to be enlarged into the camera, and then projecting its image, by means of the daylight behind the camera, onto bromide paper that was placed on an easel inside the room at a distance determined by the desired size of the enlargement. . . . For a number of years, we used a "cabinet size" camera for 13 x 18 cm glass plates. The camera had a division fixture and was used for taking stereoscopic views with a double lens. For a full-plate picture, the division was removed and a single lens used.

We also used a large plate camera with which our 24 x 30 cm . . . negatives were taken. In later years, after glass plates were generally replaced by films, I used 9 x 12 cm films . . . and, to a lesser extent, the smaller, 6 x 9 cm film packs. . . . In the later years, our cameras included the German Plaubel Machina for press work, the German 9 x 12 cm Voigtlander, Eastman's Graflex, and, for 35-mm the Contax and Leica."[4]

The Matson Collection shows the dramatic changes that swept over Palestine and the Middle East during World War I and the following mandate period, as well as the previous two decades of Turkish rule when the sites, customs, and dress were very like those of Biblical times. (Publisher's note: it is this during this latter period that most of the photographs in the present volume were taken.) The titles of some of the Matson series of hand-colored slides are indicative of the importance accorded Biblical documentation: "The 23rd Psalm, portrayed in the land if its inception"; "Blue Galilee: life of its fishermen and scenes on its shores"; "Ruth, the Moabites"; "Bethlehem Juda: scenes of the first Christmas"; "Sites and scenes in Palestine bearing on Biblical prophecies"; "Petra, caravan stronghold of the Nabateans"; The life of Jesus of Nazareth"; "Babylon, land of exile. (. . .)

Although the Matsons saw both world wars and many Arab-Jewish riots through the camera lens, the terrorist activities of 1946, aimed at forcing withdrawal of the British Mandate, finally compelled them to leave Palestine. They fled to the United States with their three children, leaving their life work behind them to be collected and forwarded by trusted employees [5]

NOTES:
1. Selma Lagerlöf, *Jerusalem* (London, 1903). See her address "Christian Love," in *The Stockholm Conference 1925, the Official Report of the Universal Christian Conference on Life and Work Held in Stockholm, 19-30 August 1925* (London 1926), p. 556.
2. Lagerlöf, "Christian Love," p. 559.
3. Bertha Spafford Vester, *Our Jerusalem* (Garden City, NY, 1950) p. 183.
4. Letter of Eric Matson to Jerald C. Maddox, Prints and Photographs Division, Library of Congress, December 1969.

PUBLISHER'S NOTE:
5. "A number of boxes containing about 7,000 negatives had been left behind on the YMCA premises in East Jerusalem, however. When the city was divided they ended up in the Arab-controlled part. Not until after the Six-day War in 1967 could the boxes be recovered and shipped to the United States. This material was also handed over to the Library of Congress. Unfortunately in the intervening years a considerable number of the plates had been damaged by damp and heat, while others were broken.

"With unusual energy for a man well into his eighties, Matson devoted the last years of his life to assisting the Library of Congress in cataloguing the collection of pictures. He looked forward with interest to an exhibition in Sweden, which unfortunately did not happen during his lifetime. Eric Matson died in California in 1977, at the age of 89.

"Some years after Matson's death, the Arno Press in the United States published four large volumes, *The Middle East in Pictures*, comprising a facsimile reproduction of about 5,000 photographs from the eleven photo albums which could at one time be browsed through at the Matson Photo Service in Jerusalem. On more than 900 pages in flat offset printing, with six same-sized pictures on each page, superb reportage photos are mixed with mediocre ones in a photographic publication which might not be the taste of those who are advocates of artistic photography but which will be of value to historians and sociologists."

—Rune Hassner, Curator, Hasselblad Center, Gothenberg, Sweden, from "Eric Matson: Half a Century as a Photographer in Jerusalem," catalog to the 1990 exhibition of Matson's work.

THE AMERICAN COLONY:
A FAMILY, A COLONY, A LIFE OF GOOD WORKS IN THE HOLY CITY

Jonathan Broder

IT WAS DECEMBER 9, 1917, the height of the First World War, and in Palestine, four centuries of Ottoman rule were hurtling to an end. While the British general Sir Edmund Allenby massed men and artillery in the Judean hills for the conquest of Jerusalem, an American woman named Anna Spafford secured the Holy City with a bed sheet.

The seventy-five-year-old Anna presided over the American Colony, a community of expatriates who lived on a sprawling estate outside the Old City walls. Shortly after dawn on that clear winter day, Jerusalem's Ottoman mayor arrived at the Colony's villa with the news that he was going to surrender the city. The Turkish Army had fled, he explained, and he wanted to reach the British encampment in time to avert Allenby's onslaught.

As the mayor and his aides turned to leave, Anna noticed that they dutifully carried Jerusalem's ancient iron keys, but no white flag of surrender. Without such a flag, she knew, snipers would cut them down as they approached the British lines, and Allenby would launch his attack on the city after all. So Anna quickly tore off a large square from a bed sheet, attached it to a stick, and advised the mayor to hold it high, for his own sake and that of Jerusalem.

Her prudence paid off. Waving Anna's bed sheet as he made his way out of the city, the mayor and his retinue formally surrendered to two British sergeants. Two days later, after an official surrender had been made to one of his generals, Allenby strode triumphantly through the Jaffa Gate. In a letter home later that week, Col. T. E. Lawrence ("of Arabia")—who had accompanied Allenby into Jerusalem—marvelled that never before in Jerusalem's long and violent history had the city "fallen so tamely."

Today, Anna's makeshift flag is on display at London's Imperial War Museum, a reminder of that historic day. But for the American Colony, the story of the flag represents just one chapter in the remarkable saga of an expatriate American family who devoted their lives to the peace and people of the Holy City.

It has been 112 years since Anna Spafford founded what became the American Colony to help Jerusalem's sick, wounded, and needy. Since then, with faith, courage, and the force of their personalities, three generations of Spafford women have maintained the colony and its humanitarian tradition through wars, political upheaval, and the ebb and flow of empires.

Their mission of mercy was handed down from mother to daughter to granddaughter. Anna Spafford, and later her daughter Bertha Spafford Vester, established medical clinics, orphanages, social welfare programs, soup kitchens, and schools, administering what was, in essence, America's first foreign aid program in the Holy Land. For a time, their colony flourished as one of Palestine's first successful communes, predating the first Jewish kibbutz by more than 25 years. Eventually, to help fund the Colony's charitable works, Bertha's daughter, Anna Grace Lind, transformed their villa into the American Colony Hotel, creating one of the most storied landmarks in the modern Middle East.

Secluded behind a garden wall in the eastern, Arab sector of the city, the American Colony Hotel still evokes the exotic backdrop against which the Spaffords played out their lives. The elegant nineteenth century structure, with its large, airy rooms, vaulted ceilings, and arched windows, once served as the residence of a wealthy Ottoman pasha. The walls of the entry hall are inlaid with intricate tile mosaics, and the upstairs parlour, or "Pasha's Room," has a blue-painted wooden ceiling with a gilded Damascene dome. The rooms surround a stone courtyard with a fountain and earthen pots filled with red geraniums, shaded by an old cypress tree. Vines of bougainvillea bristle purple against the Colony's ochre stone walls.

"The hotel has the feel of not being in this century at all," Sir Peter Ustinov, the actor and longtime Spafford family friend, told me a few years before he died in 2004. "It's more like some old colonial outpost, where you can sit languorously in the shade, sipping a gin and tonic, and occasionally whacking at a wasp with your newspaper."

Two stately palms once towered over the Colony's courtyard, presented as gifts in 1904 by Ustinov's grandfather, Baron Plato von Ustinov, another expatriate in Palestine at the turn of the century. During British Mandate days, person-

alities such as Allenby, Lawrence, the Arabist Gertrude Bell, and Colonial Minister Winston Churchill sought respite in the courtyard's cool shadows.

The hotel has hosted not only generals and statesmen, but also artists, scholars, writers, and celebrities. While filming *Lawrence of Arabia*, actor Peter O'Toole dropped in to hear the Spaffords' personal recollections of the legendary British soldier. Over the years, foreign correspondents have made themselves at home at the American Colony, finding its East Jerusalem location a convenient spot from which to report on both sides of the Israeli-Palestinian conflict.

Remarkably, despite the tensions between Jerusalem's Jewish and Palestinian communities, the Spaffords have managed to keep their hotel above the political fray. It is no accident that the secret negotiations between Israel and the Palestine Liberation Organization that culminated in their 1993 peace accord began with a meeting at the American Colony.

Despite the collapse of Israel-Palestinian peace talks in 2000 and the communal violence that have now become a way of life in Jerusalem, the Colony somehow has remained neutral, a place where Israelis and Palestinians can address their most difficult issues, including the future of Jerusalem itself. Just like Rick's Café Americain, the fictional expatriate watering hole of the film *Casablanca*, it seems everyone with a stake in the Middle East peace process—journalists, aid workers, diplomats and visiting dignitaries—now stays at the Colony or drops by the bar for a drink. Amid the haze of cigarette smoke and the tinkle of a piano, the talk is of international politics, business deals, the constant threat of Arab-Israeli violence.

In addition to the hotel, the American Colony runs the eighty-year-old Spafford Children's Center, a pediatric clinic just outside the Old City walls. Each year some 20,000 poor Palestinian mothers come with their children to the hilltop clinic for free medical care, prenatal, and nutritional advice, and special education. Its staff includes both Palestinian and Israeli doctors in another effort by the Spaffords to foster goodwill in the disputed city.

Shortly before she died in 1994, I visited with Anna Grace Lind at the Children's Center, where she served, like her mother before her, as its director. We walked through the whitewashed, high-domed wards, past the nurses' station to the small apartment where she lived.

On the walls of her living room, framed citation and medals from the Ottoman, British, Jordanian, and Israeli governments testified not only to the fam-

ily's good works but also to its stamina. The crenellated parapet of the Old City wall, built in the sixteenth century by Suleiman the Magnificent, formed one side of the small courtyard where we sat.

Anna Grace pulled out several old family albums, and as she turned the pages she guided me through a century of life at the American Colony. Then she turned to a photograph of her grandmother, the family matriarch and the founder of the American Colony. Anna Spafford's portrait showed a face with a firm mouth and pale eyes. She had begun her chartable work in Chicago after the great fire of 1871. The twenty-nine-year-old Anna and her husband, Horatio, a successful lawyer and Presbyterian deacon, opened the doors of their lakefront home to scores of displaced citizens. Then, two years later, while sailing to Europe for a well-earned rest, Anna barely survived a shipwreck in which her four young daughters drowned. In 1880, tragedy struck again when a young son died of scarlet fever.

The Spaffords turned to their church but instead of finding solace, they found themselves ostracized, victims of the prevailing church doctrine that judged their aguish as divine retribution for their "sins." Determined to lead a simple religious life of humanitarian service, the Spaffords left Chicago in 1881 and set sail for the Holy Land with two young daughters, both born after the family's tragic loss at sea, and an entourage of friends and family. Arriving after a month-long voyage, they settled into the house that the clinic now occupies, a large stone manor perched on a hilltop, high above the squalor of Jerusalem's ancient, unwashed alleyways.

This was American frontiersmanship at its most extreme. In the nineteenth century, Jerusalem was a forgotten outpost of the Ottoman Empire. There were few hospitals or schools, no telephones, sewers, or electricity. At dusk, Turkish guards closed the heavy wooden gates of the city wall to keep out marauding bands of Bedouin. Soon after the Spaffords' arrival, a sceptical American diplomat warned Washington that the colonists' efforts would "result in disappointment and disaster."

Within a few years, Horatio was dead from malaria. But amazingly, Anna prevailed. Against all expectations, she and her small extended clan struck roots in Jerusalem, working as nurses and educators. A charismatic woman, Anna eventually attracted a group of Midwesterners to the American Colony. In 1896 needing more space, Anna and her followers moved into the pasha's palatial villa.

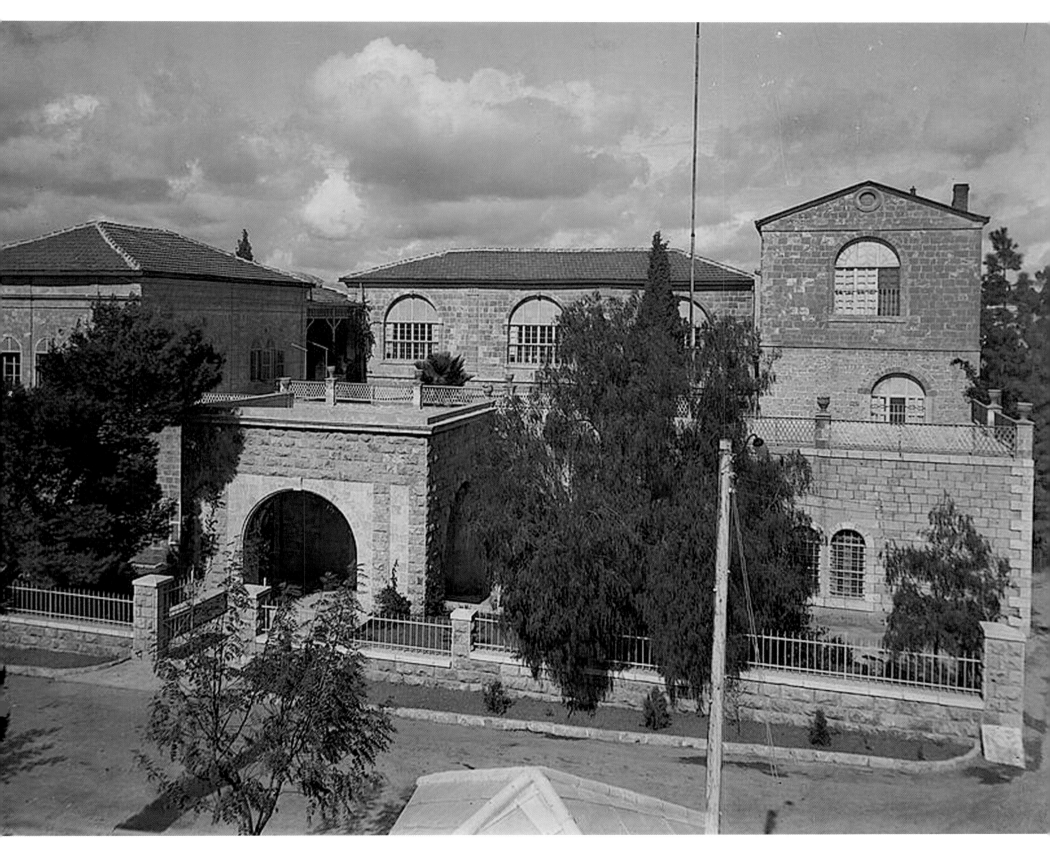

AMERICAN COLONY, MAIN BUILDING

Within months, a group of Swedes joined the Colony, bringing the number of members to 130.

Anna directed the Colony's charitable services from the building in the Old City, while the other members labored to make the Colony self-sufficient in their new home outside the city walls. Organizing themselves into a commune, they raised their own crops and livestock, wove their own cloth and made their own clothes. Soon, in addition to their reputation as healers and educators, the colonists became known as the artisans of Jerusalem, operating a carpentry business, a bakery, a forge, a photography service—the genesis of the photographs in this book—and a store that sold souvenirs to tourists. For their amusement the colonists organized their own literary society, an art club a bad and a choir. To earn additional money, the Colony began calling itself the American Colony Hostel, opening its doors to American and European pilgrims seeking a clean, comfortable place to stay in the Holy Land.

With the outbreak of World War I on 1914, the Colony's pastoral existence ended, and its tradition of wartime relief began. Fighting between the British and the Turks in the eastern Mediterranean severed supplies of food and fuel to Palestine, a situation that deteriorated into a full-blown famine after a plague of locusts in 1915. While many American and British diplomats and missionaries pulled out of Palestine, the American colonists remained. With the food from their farm, they opened a soup kitchen, sometimes feeding more than a thousand people a day. At night, they worked by the dim glow of lamps improvised from discarded sardine tins filled with sesame oil.

But in the spring of 1917, a German officer attached to the Turkish Army dismissed the Colony's relief work as "American propaganda" and shut it down completely. The Colony found itself helpless in the face of the closure. In the face of so much suffering, the Spaffords decided to offer the Colony's services to the Turkish governor of the region, Jamal Pasha. One of the "Young Turks" who had overthrown the Ottoman sultan before the war, Jamal Pasha was ruthless and unpredictable, and Bertha's Arab friends warned her to stay away from him. Not surprisingly, Bertha ignored them. When the Turkish governor received her at his Jerusalem residence on April 6, 1917, Bertha found him "cold and distant" but soon learned the reason why. The United States had just declared war on Germany, Turkey's ally in the war. When Jamal Pasha asked if she was still will-

ing to nurse his wounded, Bertha did not flinch. "We are not offering our services to Turkey or Germany or any other country. We are offering our services to humanity," she recalled in her 1950 memoir, *Our Jerusalem*. Taken aback by this bold American, he accepted her offer.

Eventually the colonists took over four Ottoman hospitals and a government soup kitchen in Jerusalem, keeping thousands of people alive. The wartime conditions under which they worked were not only harsh but intimidating as well. Every day, it seemed, Jerusalem residents suspected as pro-British were hanged, their bodies left dangling from the ramparts of the Old City's Jaffa and Damascus gates as a warning to others. On that December day in 1917 when the mayor surrendered, the Colony was directing all of the city's relief operations.

* * *

After Anna Spafford died in 1923, Bertha took over the Colony's leadership and expanded its charitable work. One of her most beloved accomplishments occurred on Christmas Eve in 1925. As Bertha prepared to join her family in Bethlehem to sing carols, she encountered a poor Bedouin leading his ailing wife and their infant on a donkey, in search of medical treatment. Bertha admitted the wife into one of the colony's hospitals, where she died the next morning. At the Bedouin's insistence, Bertha took in the child. Soon more children followed, and a wing of the Old City building became the Anna Spafford Baby Home.

Bertha had another side as well—appearing to some as vain and imperious. She hosted parties in the main villa for the British colonial elite and illustrious visitors such as Lady Astor and John D. Rockefeller, but often excluded other members of the Colony. In 1929, believing that Bertha had become too powerful, some of the members pulled out, nearly breaking up the commune. But once again the Spaffords remained in Jerusalem, continuing the Colony's various enterprises and its charitable works.

With the outbreak of World War II, Jerusalem turned into a furlough town for the British Eighth Army, which was fighting the Germans in North Africa. Bertha entertained her friends and turned the Colony's villa into a Red Cross station, preparing medical supplies for the frontline troops. Though Arab-Jewish hostilities had escalated during the British Mandate period, during the war, "Jewish

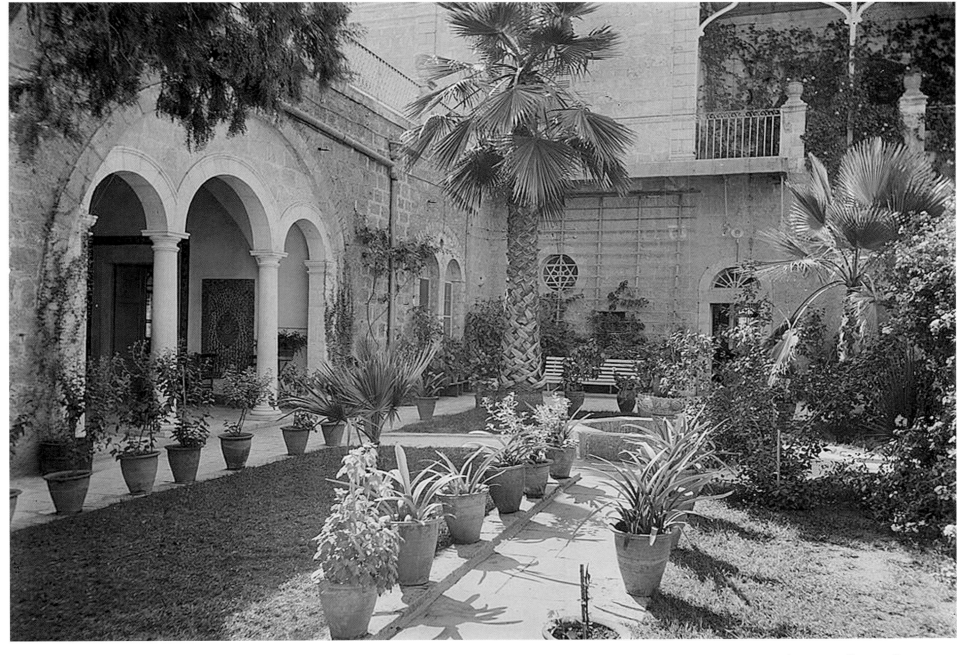

AMERICAN COLONY COURTYARD

and Arab ladies sat at the same table, making surgical dressings . . . and talking," Bertha later wrote. "For the time being, controversy was buried." But as soon as the war ended, communal violence between Arabs and Jews flared anew, with terrorist attacks by both sides against the British.

In July 1946, in response to Britain's repeated refusal to grant entry permits to Jewish refugees, a group of Jewish terrorists bombed British military headquarters at the King David Hotel. In 1948, when Israel declared its independence and the first Arab-Israeli war erupted, the Colony found itself only yards away from the battlefront that divided the western, Jewish side of the city from its eastern, Arab sector. To ensure the Colony's neutrality, Bertha again placed the villa under the Red Cross flag. Still, the property took at least 30 direct hits, shattering windows and destroying one of Baron von Ustinov's palms.

The 1949 armistice left Jerusalem a divided city, with the American Colony in the eastern sector, then officially part of Jordan. Pressing ahead with the Colony's charitable mission, Bertha, by then in her 70s, returned to the United States to raise funds for the expansion of the Old City clinic into a full-fledged pediatric hospital. Armed with introductions from friends like Lowell Thomas, Bertha met with potential donors around the country. But after living for so many years outside the United States, she had become hopelessly disconnected from its cultural currents. At one such gathering in Los Angeles, she was introduced to Marilyn Monroe, who was then at the height of her fame. Bertha politely shook her hand and moved on to the other guests, The name meant nothing to Bertha, who had no idea of the actress's celebrity.

Returning to Jerusalem with donations and grants, Bertha began construction in 1954 of the Spafford Children's Hospital, beside the original clinic in the Old City. In recognition of her work, a young King Hussein awarded Bertha the Jordan Star, making her the first woman to be awarded the prestigious medal.

Meanwhile, to help keep the hospital running, the Spaffords decided to turn the American Colony villa into a fully functioning, modern hotel, Starting in 1952, Anna Grace Lind began overseeing the transformation, installing a swimming pool and modern utilities, but carefully preserving the building's nineteenth century character. By the early 1960s, the renamed American Colony Hotel had become known as the finest hotel in East Jerusalem.

* * *

It wasn't long before the Spaffords found themselves once again on the front lines of the Arab-Israeli conflict. One June 5, 1967, Anna Grace and her sister, Frieda, were working at the hospital when they heard sirens wailing on the Israeli side of town. Alerted by a British diplomat that war had erupted, they quickly moved their patients away from the windows. Leaving Anna Grace to look after the hospital, Frieda dashed back to the hotel, only to find a Jordanian tank in the driveway and Arab legionnaires hastily erecting gun positions across the street. Just before noon, the Jordanians opened fire, prompting a retaliatory Israeli barrage. Despite the fighting that raged around the Colony compound, the eighty-nine-year-old Bertha, nearly deaf and hobbled with a broken hip, refused to budge.

By dawn, the fighting had moved farther east, and Frieda emerged to inspect the damage. A neighbor's house was in flames, and a dead Jordanian soldier lay in the driveway. Inside the hotel, Frieda could trace the course of combat from floor to floor by following the blood stains and empty shell casings on the stairway. Upstairs, the antique Damascene ceiling had somehow escaped unscathed, but the courtyard lay in shambles. Flowerpots had been shattered, the fountain smashed, and the remaining Ustinov palm killed.

Bertha appeared from a back room, unhurt but disoriented. "Who is on the desk this morning? she asked. Peering into the smashed reception hall, Frieda replied, "The desk isn't there."

The Colony soon repaired its damage and settled in under Israeli rule. In 1968, at the age of 90, Bertha died. Anna Grace, also a trained nurse, took over the hospital and the hotel, with the help of her brother, Horatio Spafford Vester, and his wife Valentine, whose aunt was Gertrude Bell, the renowned British archaeologist who helped draw the borders of the modern Middle East after World War I.

The next two decades were the hotel's heyday, as its reputation spread to the United States and Europe, attracting a steady stream of visiting celebrities, including Henry Kissinger, the actor Richard Dreyfus, Bob Dylan, and Saul Bellow. More importantly, after 1967, the imposing stone portals of the American Colony became the gateway through which many Israelis came to know Palestinians personally. Every Saturday, the hotel hosted a sumptuous brunch in the courtyard. Enchanted by the Colony's discreet and gracious ambience, Israelis and Palestinians mingled, often dispelling their mutual fears. While some disapproved of these contacts, over the years the Colony became one of Jerusalem's most important neutral corners.

One evening in March 1996, as part of the Colony's centennial celebrations, some 300 guests joined the Spafford descendants at the hotel to pay tribute to the extraordinary institution they had created. There were Israelis, Palestinians, European and American diplomats, United Nations officials, rabbis, Muslim sheiks, and members of the clergy—a throng speaking at least a dozen different languages, representing a microcosm of Jerusalem's timeless human mosaic. And as they gathered in the storied courtyard, with candlelight dancing off Ottoman-era stones, Sir Peter Ustinov planted a palm tree to replace the pair given by his grandfather at the beginning of the century. The American Colony, he said, had survived as long as it had because it offered "an ecumenical oasis of peace where people can hold all kinds of discussions. . . . It is an object lesson to the people and the city around it."

Valentine Vester, until her death at the age of 96 in 2008, lived at the hotel, which remains in the hands of six Spafford family members, including Valentine's two sons. Though her hearing and eyesight were failing, Valentine oversaw the operations of the hotel and the clinic until her death and could be seen most days issuing orders to her staff in her clipped British accent. In the years before her death she made a generous donation to the Library of Congress of American Colony archival material, including photographs, documents, and artifacts; the American Colony-Vester Collection joins the Matson Photo Service Collection to provide a unique record of the history of Jerusalem in the early twentieth century.

But after a lifetime in Jerusalem dealing with both sides of the Middle East conflict Valentine had few illusions about the prospects for peace, noting she sometimes felt guilty sitting in the Colony's lovely courtyard. She consoled herself with the knowledge that she, like three generations of Spafford women before her, successfully kept the Colony's doors open to Israelis and Palestinians, even in the midst of their latest round of communal warfare. "We've tried very hard to be neutral," Valentine told a reporter.

In a city like Jerusalem, that is no small accomplishment.

THE PHOTOGRAPHS

1

JAFFA AND THE COAST

JAFFA (IN THE BIBLE, JOPPA) IS ONE of the most ancient port cities in the world. Called Jaffa because of its great beauty (*yofi* in Hebrew), it existed as a port some 4,000 years ago, serving Egyptian and Phoenician sailors. Under Egyptian rule until about 800 BC, Jaffa was conquered by King David and his son King Solomon, who used its port to bring cedars for the construction of the first temple from Tyre (2 Chronicles 2:16) and was also the port of entry for the cedars used for the second temple (Ezra 3:7). It is the setting of the Old Testament book of Jonah. In the New Testament, Jaffa is the home of Simon the Tanner and of Tabitha (also called Dorcas) who was raised from the dead by Peter.

It has been said that scarcely any other town has been so often overthrown, sacked, pillaged, burned, and rebuilt. In the Roman suppression of the Jewish Revolt, Alexander the Great took Jaffa in late fourth century BC. Jaffa was captured and burned by Cestius Gallus; first century Jewish historian Flavius Josephus writes that eight thousand inhabitants were massacred. Pirates operating from the rebuilt port incurred the wrath of Vespasian, sent next by Nero into Judea to quash the revolt, and he destroyed the city in 68 AD. Moving ahead several centuries, in 636 the rebuilt city of Jaffa was conquered by Arabs; during the Crusades it was captured and became one of the vassals of the Kingdom of Jerusalem. Saladin took it in 1187; it surrendered to Richard the Lionheart in 1191. Egyptian Mamelukes conquered the city in 1268 and destroyed it completely in 1345. In the sixteenth century, Jaffa fell under Ottoman rule, and it was sacked by Napoleon in 1799.

In the early twentieth century, Jaffa had the most advanced commercial, banking, fishing, and agriculture industries in Palestine. It had many factories specializing in, among other things, cigarette making, cement making, tile and roof tile production, and iron casting. The majority of books and newspapers were published in Jaffa. And it is of course known for its splendid orange groves, the source of the famous Jaffa orange, exported around the world.

ROUGH SEA AT JAFFA.

There was a mighty tempest in the sea so that the ship was likely to be broke.
Jonah 1:4

The squalls at Jaffa consumed many men trying to reach the Holy Land. There was no harbor at Jaffa; often ships had to wait days until the sea was calm enough for landing vessels to provide safe passage to shore. It was from this port that Jonah "took ship to flee from the presence of the Lord" (Jonah 1:3). These treacherous waters are also the home of Andromeda's Rock, to which, according to Greek mythology, the virgin Andromeda was chained to appease the god of the sea, Poseidon.

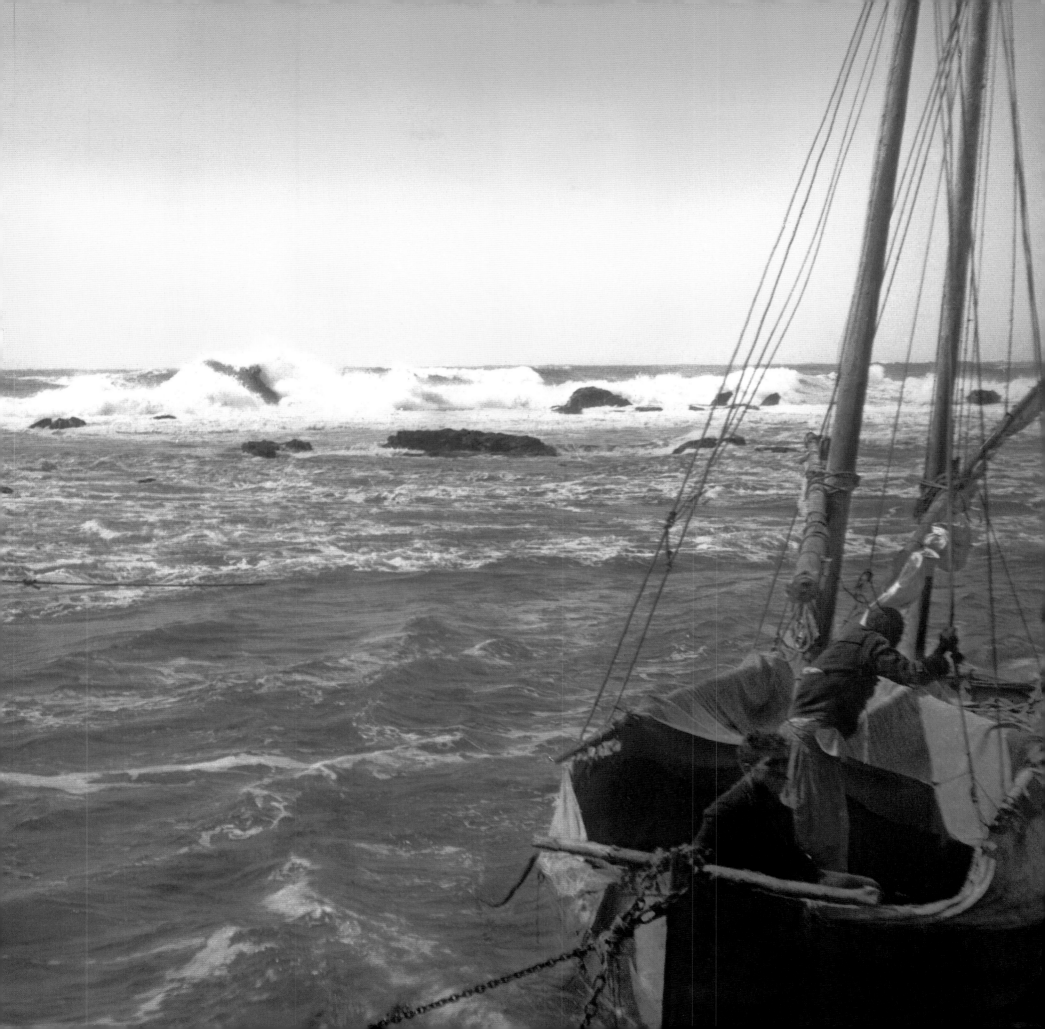

JAFFA FROM THE SEA.

Thirty miles northwest of Jerusalem lies the ancient town of Jaffa, the modern name for Joppa, one of the oldest towns in Asia and the primary port of Judea. Jaffa, rising out of the flattened coastline like a huge fortress, existed as a port city some 4,000 years ago, serving Egyptian and Phoenician sailors in their sea voyages.

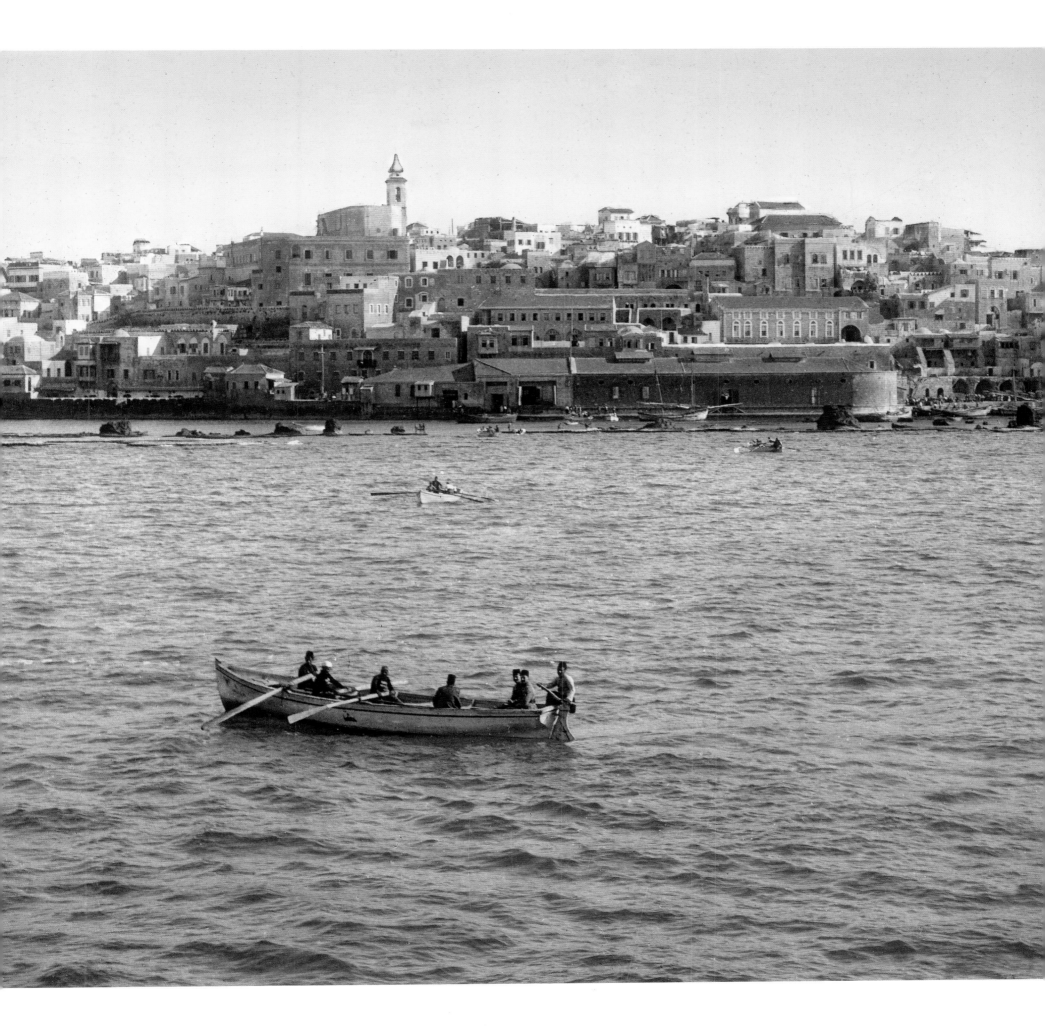

BOYS WITH BASKETS OF ORANGES.

In the Autumn, groups of boys could be seen collecting the thick-skinned Jaffa oranges—the prize product of Judea—ready for export to foreign lands.

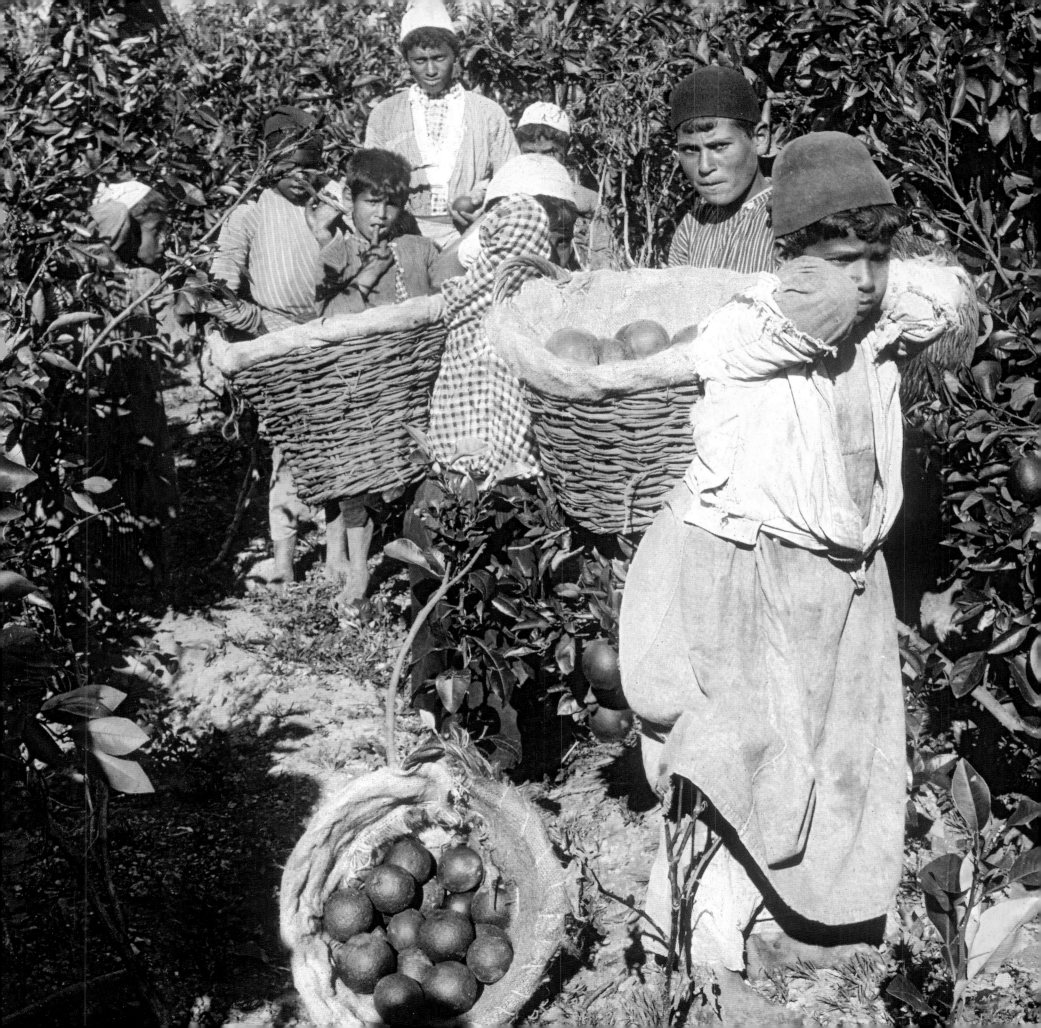

MAN IN ORANGE GROVE.

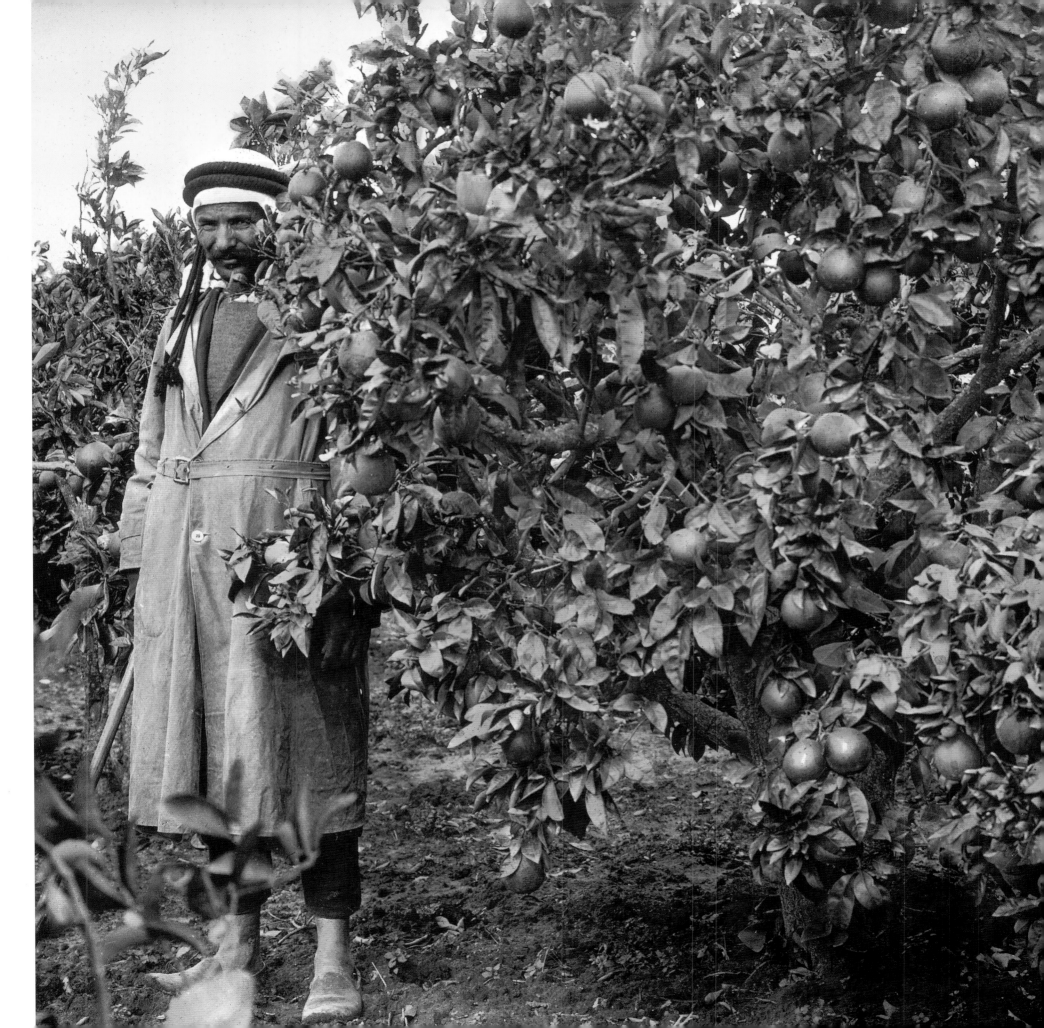

JAFFA MARKET.
Oranges, pomegranates, lemons, mulberries, peaches, apricots, and prickly pear would be among the offerings at the bustling fruit and vegetable market.

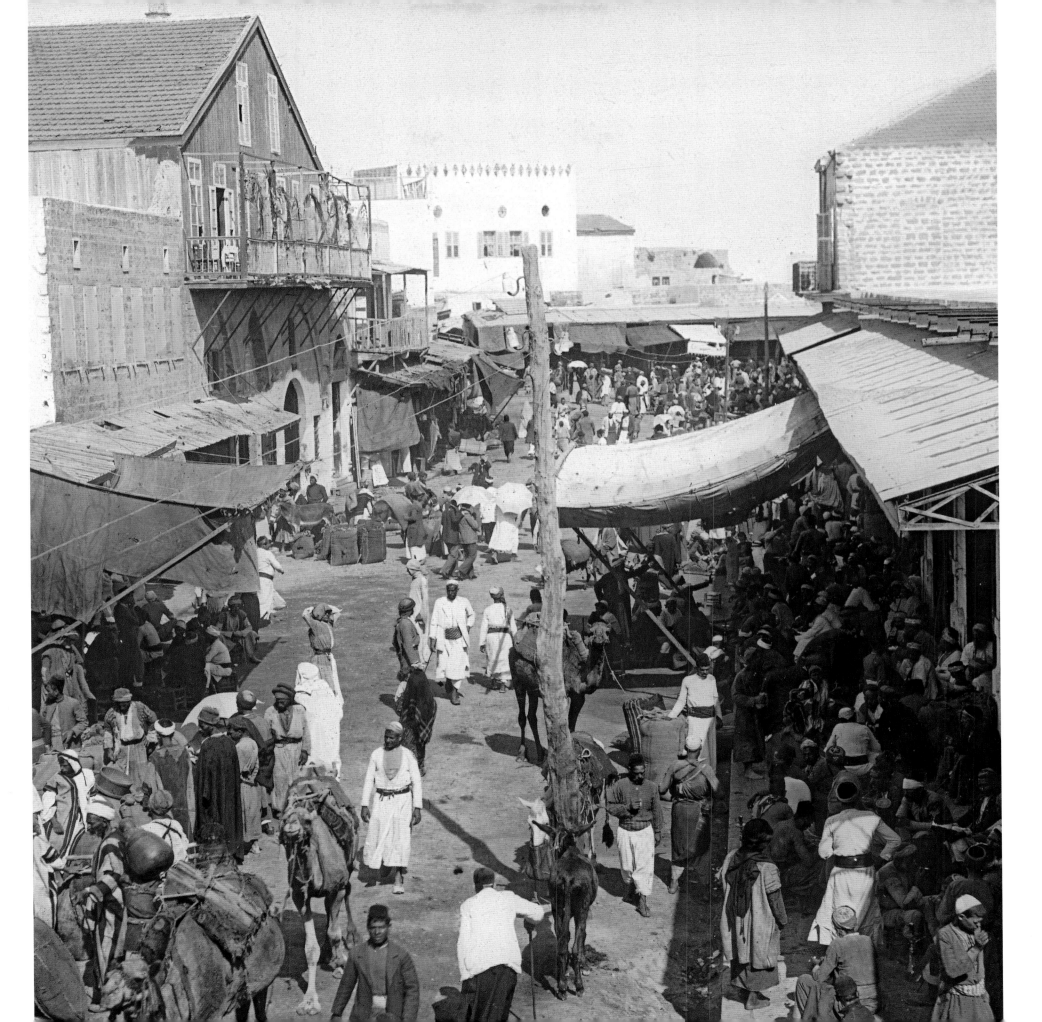

THE FRUIT VENDOR.
Vendors with their baskets of fruit could be found in the long arcades of the bazaar, which was shaded with cloth and matting. In other parts of the bazaar would be displays of silk from Aleppo and Damascus, cottons from Manchester, and veils from Constantinople.

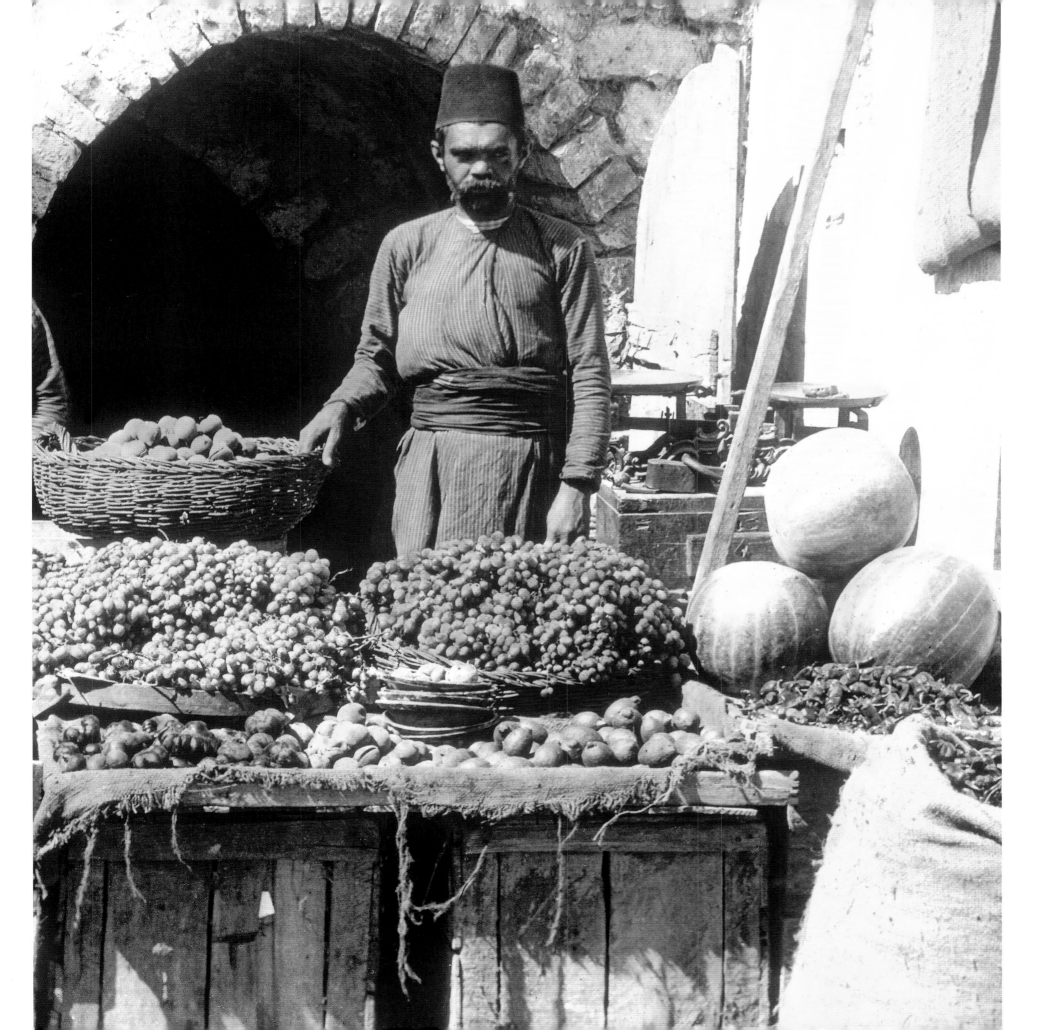

WOMAN AND BOY ON SEA CLIFF, ASHKELON.

South of Jaffa, Ashkelon was the largest seaport in ancient Canaan and one of the "five cities" of the Philistines (along with Gath, Gaza, Ekron and Ashdod; I Samuel 6:17). In biblical history, Ashkelon is where Delilah cut Samson's hair to sap his strength (Judges 14-16). It is believed to be the birthplace of Herod (in 37 BC), who rebuilt and enlarged it, constructing a summer house, palaces, and an aqueduct. It flourished in the Roman and Byzantine periods. It was much in play during the Crusades, and during the Third Crusade, Saladin demolished the city because of its potential strategic importance to the Christians. King Richard I (the Lionheart) of England, constructed a citadel upon the ruins.

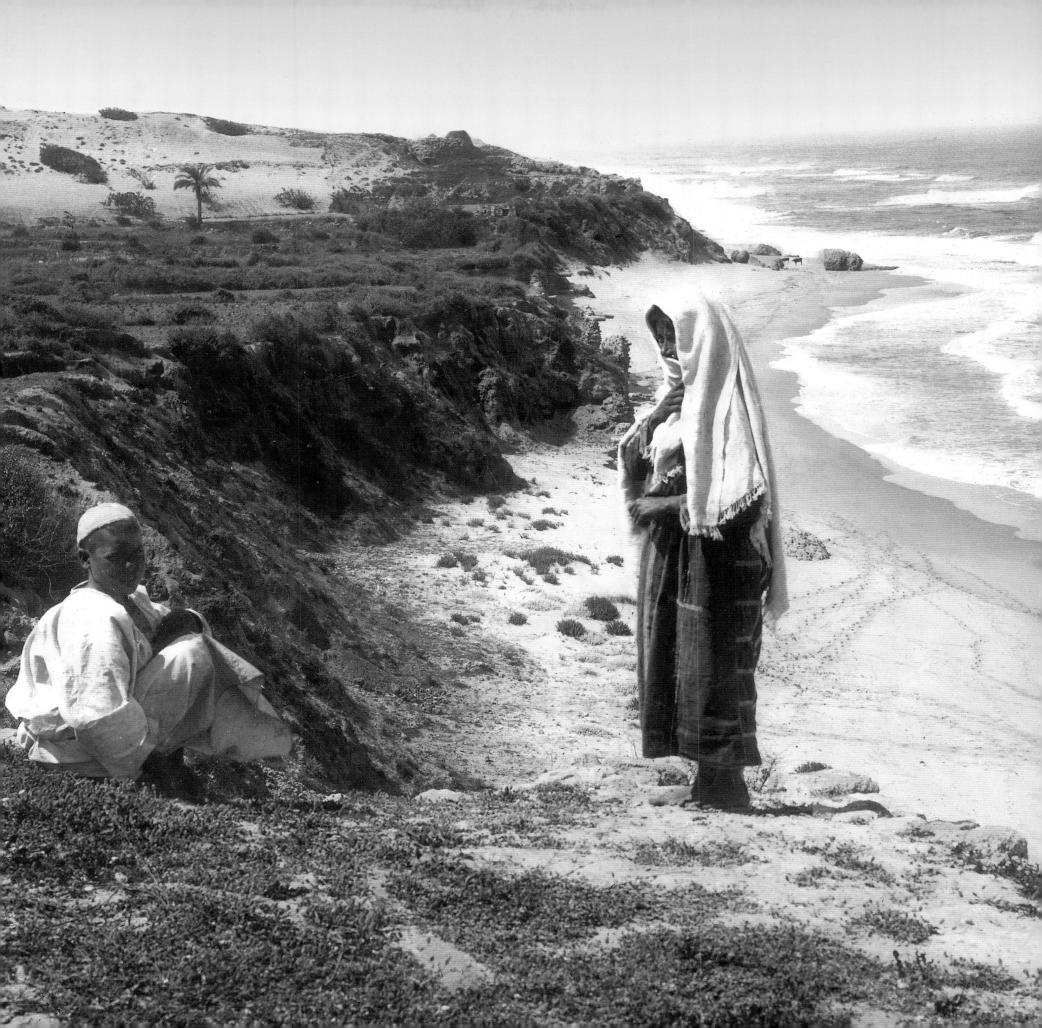

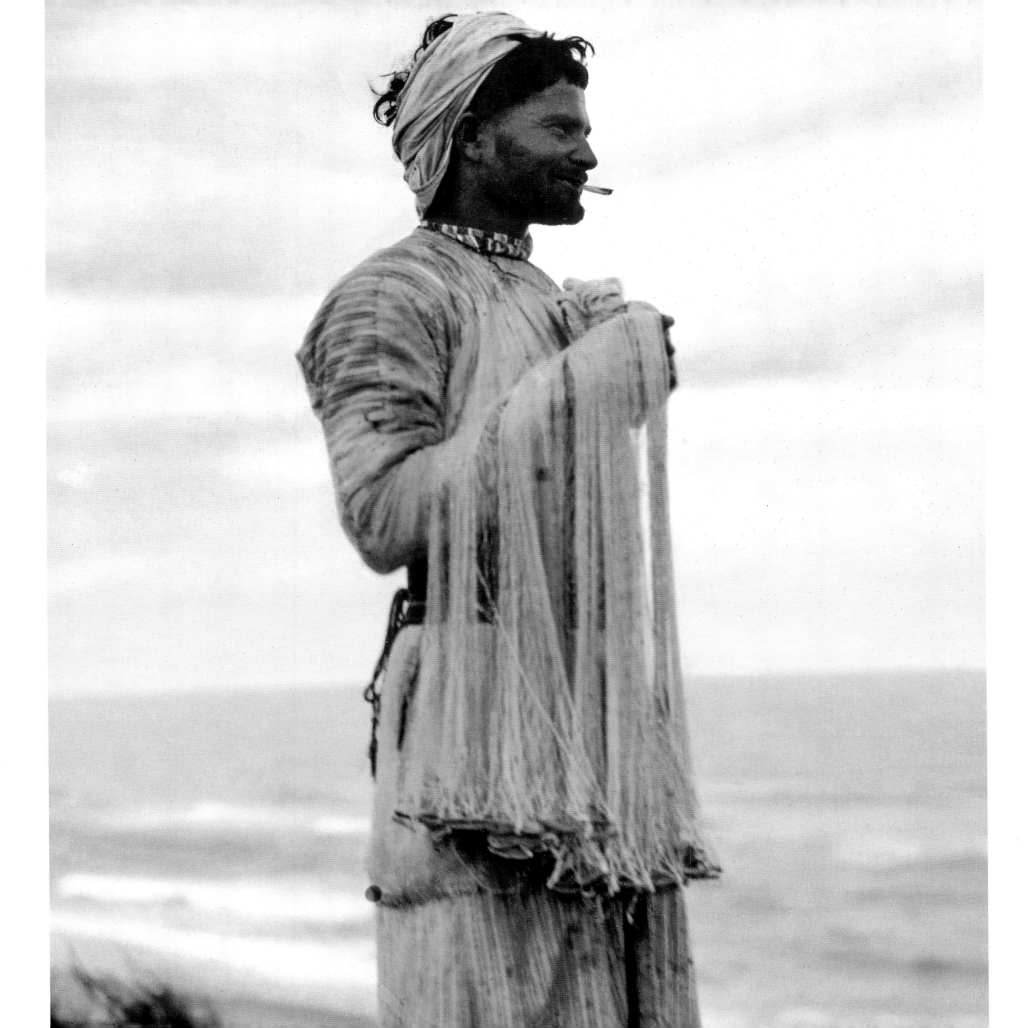

VIEW OF ASHDOD.
After capturing the Ark of the Covenant from the Israelites, the Philistines took it to Ashdod, where it was placed in the temple of Dagon. The next morning the image of Dagon was found prostrate before it; on being restored to its place, it was on the following morning again found prostrate and broken (I Samuel 5).

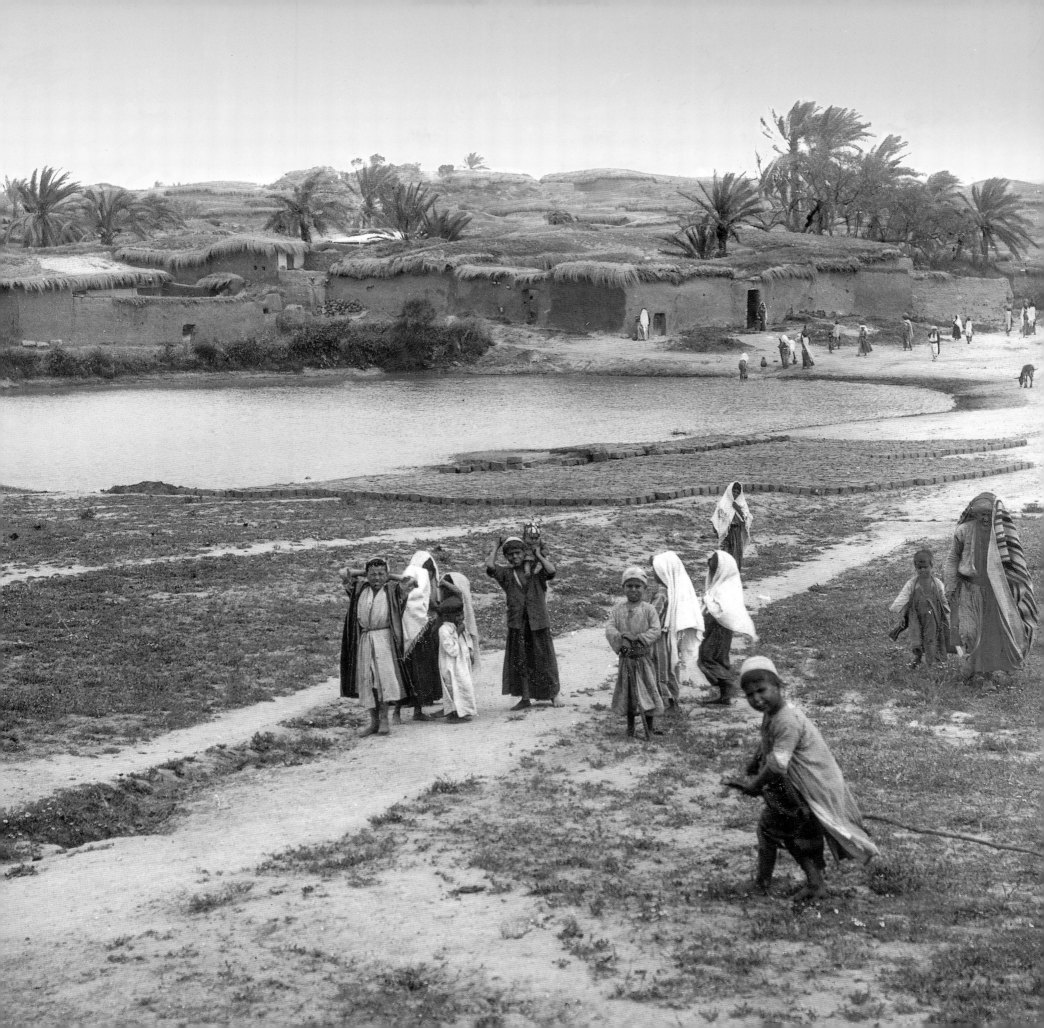

PALM TREES ON BEACH AT HAIFA.

Haifa is a seaport city on the northern coast with a history dating back to Biblical times. Built on the slopes of Mt. Carmel, in the background, it is home to many caves, including the Cave of Elijah, believed by many to be the home of the prophet Elijah and his student, Elisha.

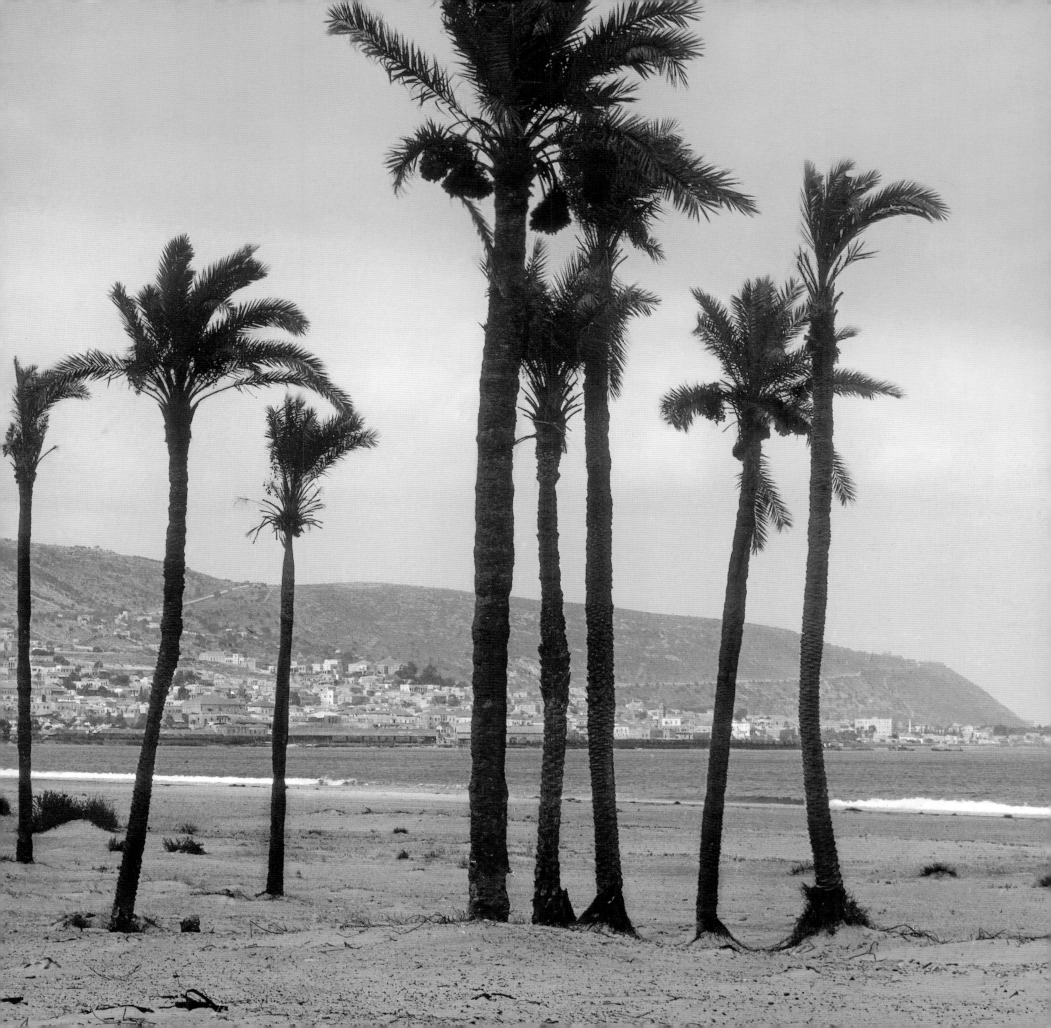

PALM TREES AND COLONNADED BUILDING AT ACRE.
The Crusaders conquered the coastal town of Acre in 1104, who for a time made it their chief port in the Holy Land.

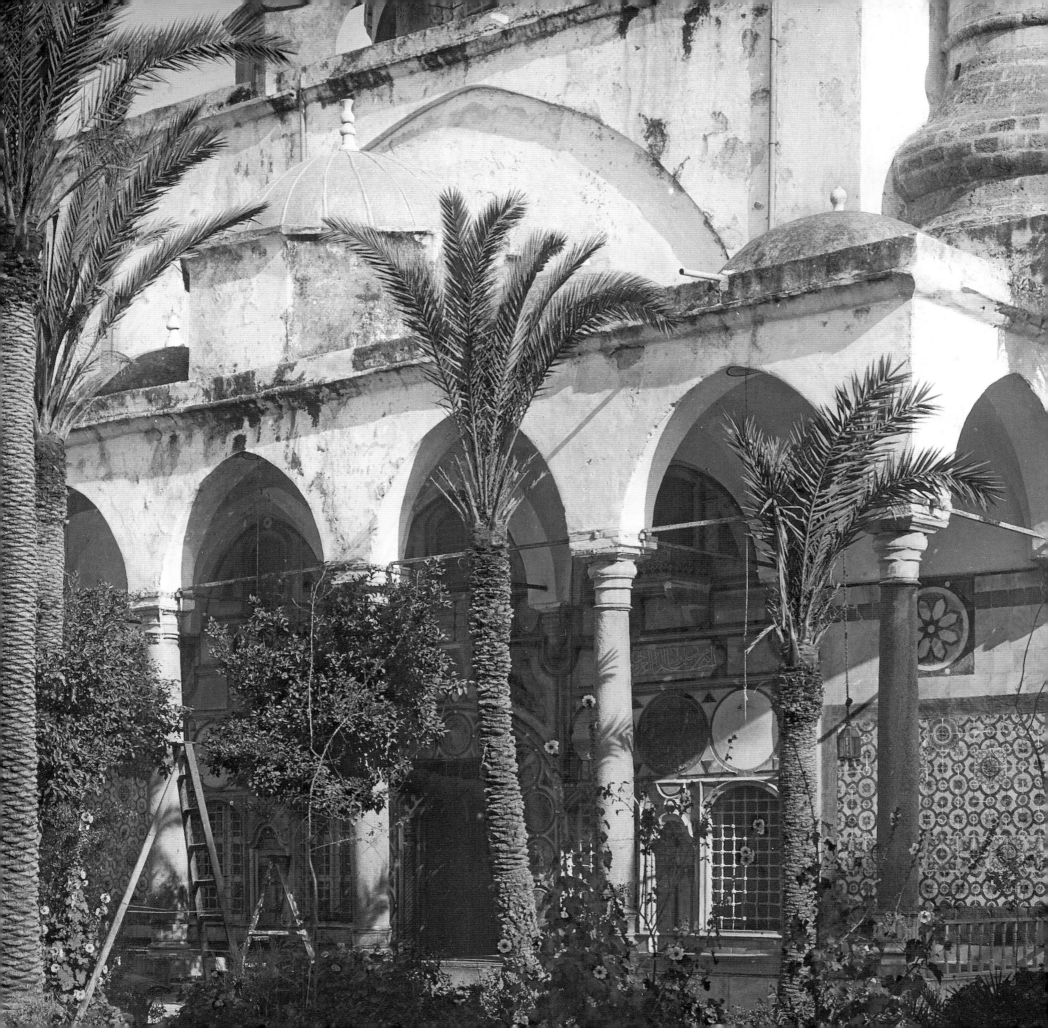

2 JERUSALEM

ITH A HISTORY THAT EXTENDS back to the fourth millennium BC, Jerusalem is one of the oldest cities in the world and certainly one of the most storied. The Old City, with its imposing gated walls, is an architectural palimsest, built and rebuilt over the centuries as it was conquered and reconquered, by men whose names sound with loud and sustained historical and religious resonance, including David, Solomon, Alexander, Herod, Vespasian, Hadrian, Constantine, Saladin, Richard the Lionheart, and Suleyman the Magnificent. It is the holiest city in Judaism, containing the Temple Mount and Western Wall. It holds a number of key sites for Christianity, including the Via Dolorosa and The Church of the Holy Sepulchre; and for and Islam, notably the El-Aqsa Mosque and the Dome of the Rock. Beyond the Old City walls are the Kidron Valley, the Mount of Olives, the Garden of Gethsemane, and the Gihon Spring.

In one of the most famous Psalms, number 137, the Israelites are exhorted to remember Jerusalem in their captivity following the Babylonian conquest of the city:

> By the rivers of Babylon, there we sat down, yea, we wept, when we remembered Zion. We hanged our harps upon the willows in the midst thereof. For there they that carried us away captive required of us a song; and they that wasted us required of us mirth, saying, Sing us one of the songs of Zion. How shall we sing the LORD's song in a strange land? If I forget thee, O Jerusalem, let my right hand forget her cunning. If I do not remember thee, let my tongue cleave to the roof of my mouth; if I prefer not Jerusalem above my chief joy. Remember, O LORD, the children of Edom in the day of Jerusalem; who said, Rase it, rase it, even to the foundation thereof. O daughter of Babylon, who art to be destroyed; happy shall he be, that rewardeth thee as thou hast served us. Happy shall he be, that taketh and dasheth thy little ones against the stones.

THE OLD CITY OF JERUSALEM FROM GOVERNMENT HOUSE.
Travelers never forget their first sight of the Holy City, with the low line of battlement wall surrounding the city, the domes and minarets, the churches and spires. In the distance one could make out the high mountains of Moab.

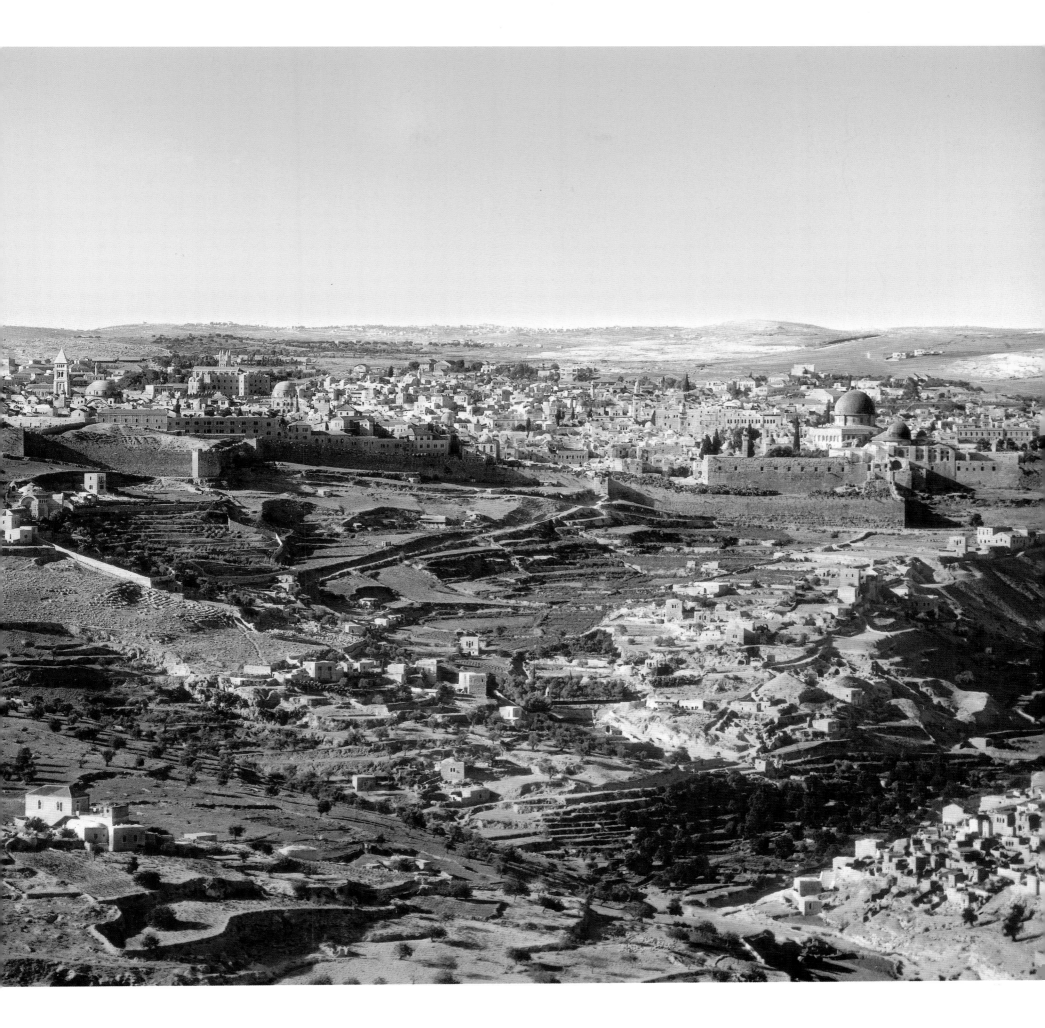

TOWER OF DAVID FROM BETHLEHEM ROAD.

The Tower of David is located on the western side of the Old City of Jerusalem, south of the Jaffa Gate, the main entrance to the city. This tower, named after the city's founder, the Biblical King David, is from the sixteenth century Ottoman period. Its base is one of three towers built by Herod as part of an improvement to the series of fortifications built on this vulnerable spot, with no natural defenses, over twenty centuries to protect the city from attacks from the west. It was the original Jebusite fortress captured by David.

So David dwelt in the fort, and called it the city of David. And David built round about from Millo and inward. II Samuel 5:9

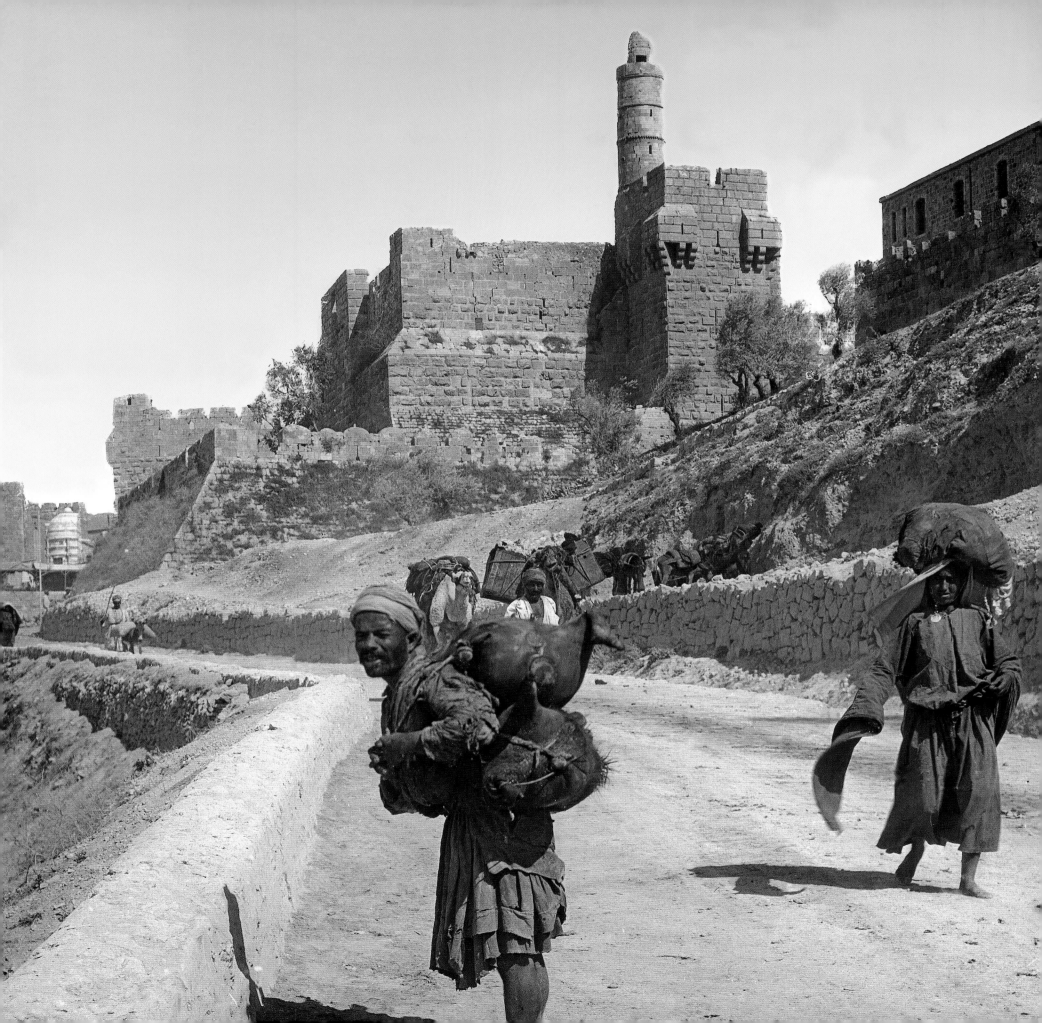

NORTH WALL OF JERUSALEM.

The walls of Jerusalem exude history, built and rebuilt over time to protect the city. The current walls were built in the sixteenth century by the Ottoman emperor Suleyman the Magnificent. There are around 2.8 miles of walls, with eleven gates, some now closed. The original gates were angled at a sharp 90 degrees to prevent marauders on horseback from charging full speed into the city.

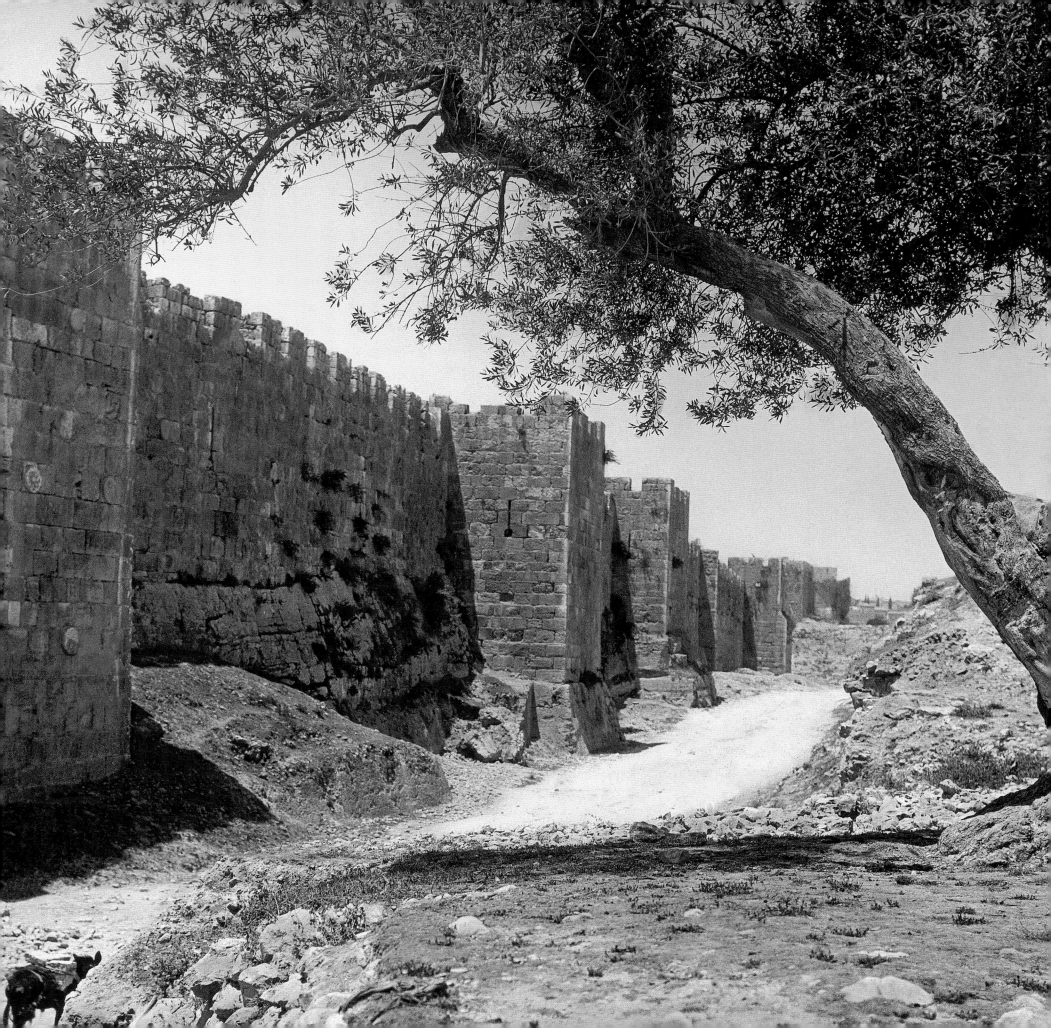

VIEW OF OLD CITY AND EL-AQSA, FROM THE MOUNT OF OLIVES.
The El-Aqsa (or "most distant") Mosque is the congregational mosque to the south of the Dome of the Rock. It was to the "most distant mosque" (el-masjid el-aqsa) that Muhammad is carried, from Mecca, on his Night Journey, before ascending to Heaven. The name once referred to the entire Temple Mount (or Haram esh-Sharif, "Noble Sanctuary" to the Muslims) area, before being restricted to refer to the mosque only.

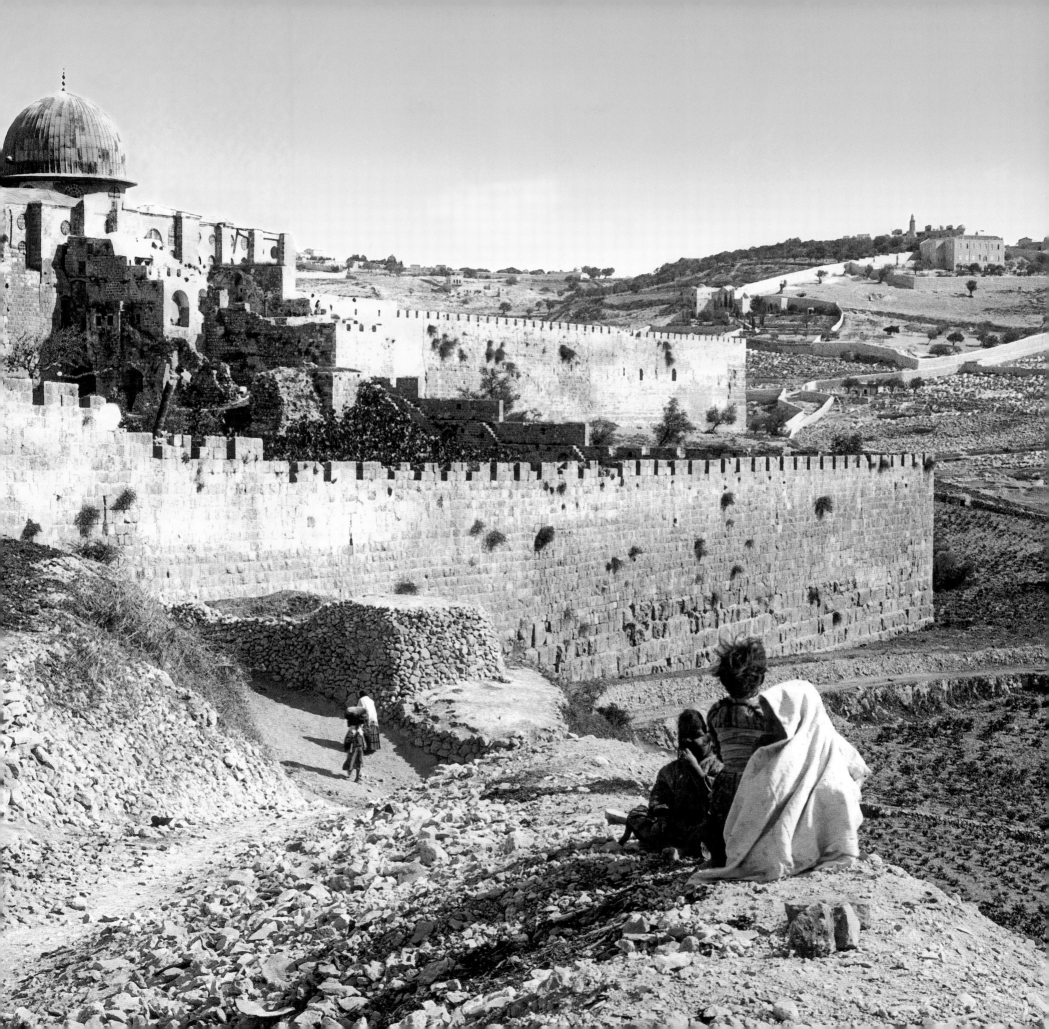

LION'S GATE.

Lion's Gate, located in the east wall of the Old City, leads to the Via Dolorosa. Near the gate's crest are four figures of lions, two on the left and two on the right. The gate was rebuilt in 1538 by Suleyman the Magnificent, who, according to legend, placed the figures there in response to a recurring dream about lions tearing him apart, a dream he believed to be a sign that he should protect the city or face God's wrath. The name St. Stephen's Gate was given to it in the Middle Ages in honor of the Christian martyr; however, prior to this it had been generally believed that St. Stephen had been stoned to death outside Damascus Gate.

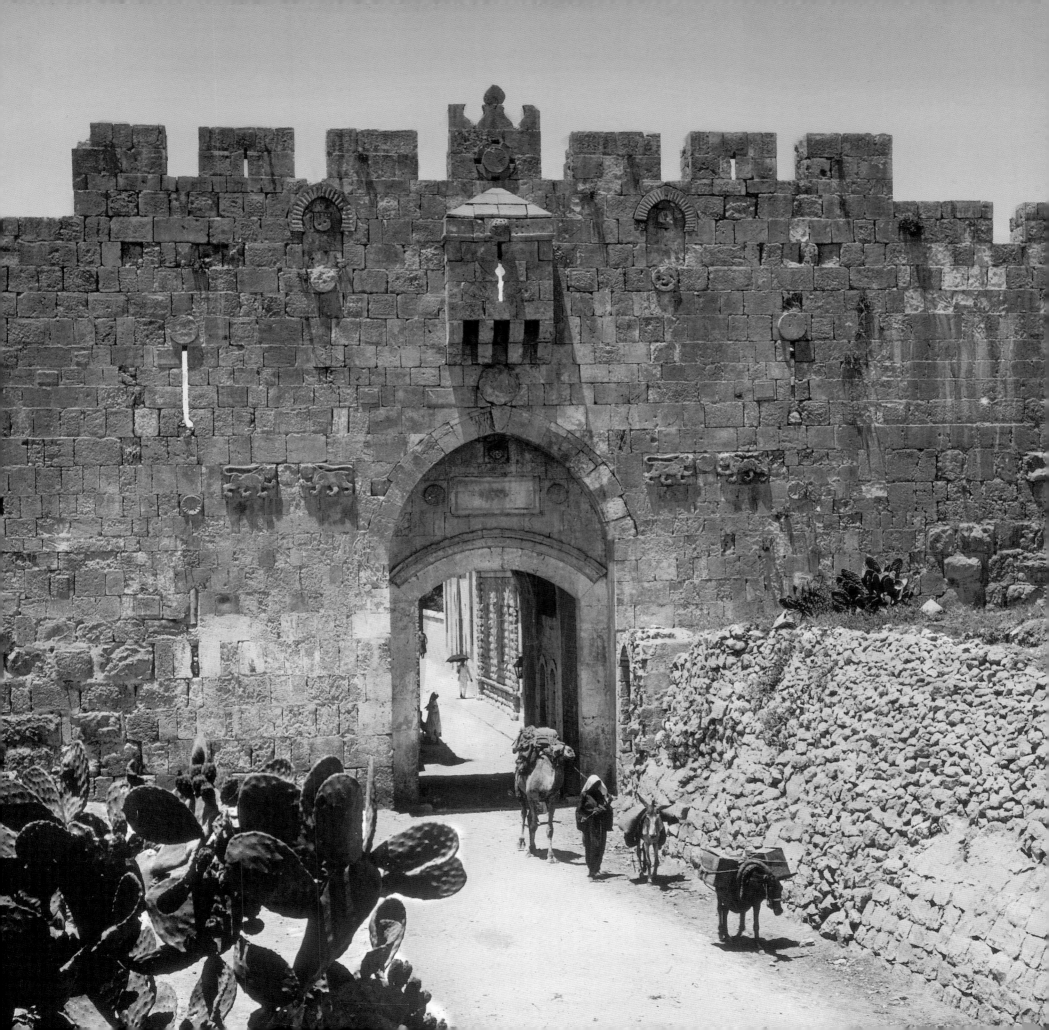

REMAINS OF OLD CITY WALL NEAR LION'S GATE.

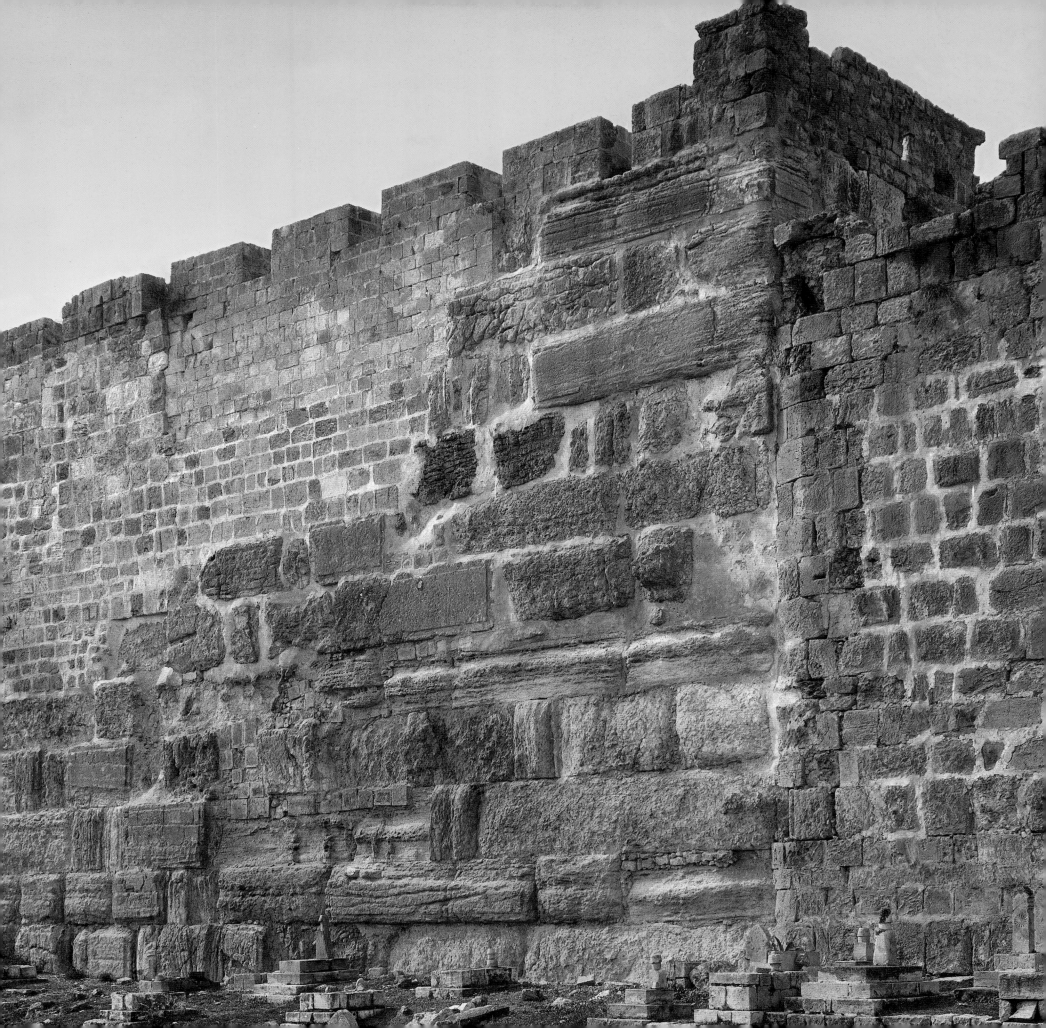

ZION GATE.

Zion Gate, facing Mount Zion, is located in the southwestern wall of the Old City and, like many of the other gates, was built by Suleyman the Magnificent. It leads into the Jewish and Armenian quarters. It is also known as David's Gate, as Mount Zion, according to tradition, is believed to be the burial place of King David.

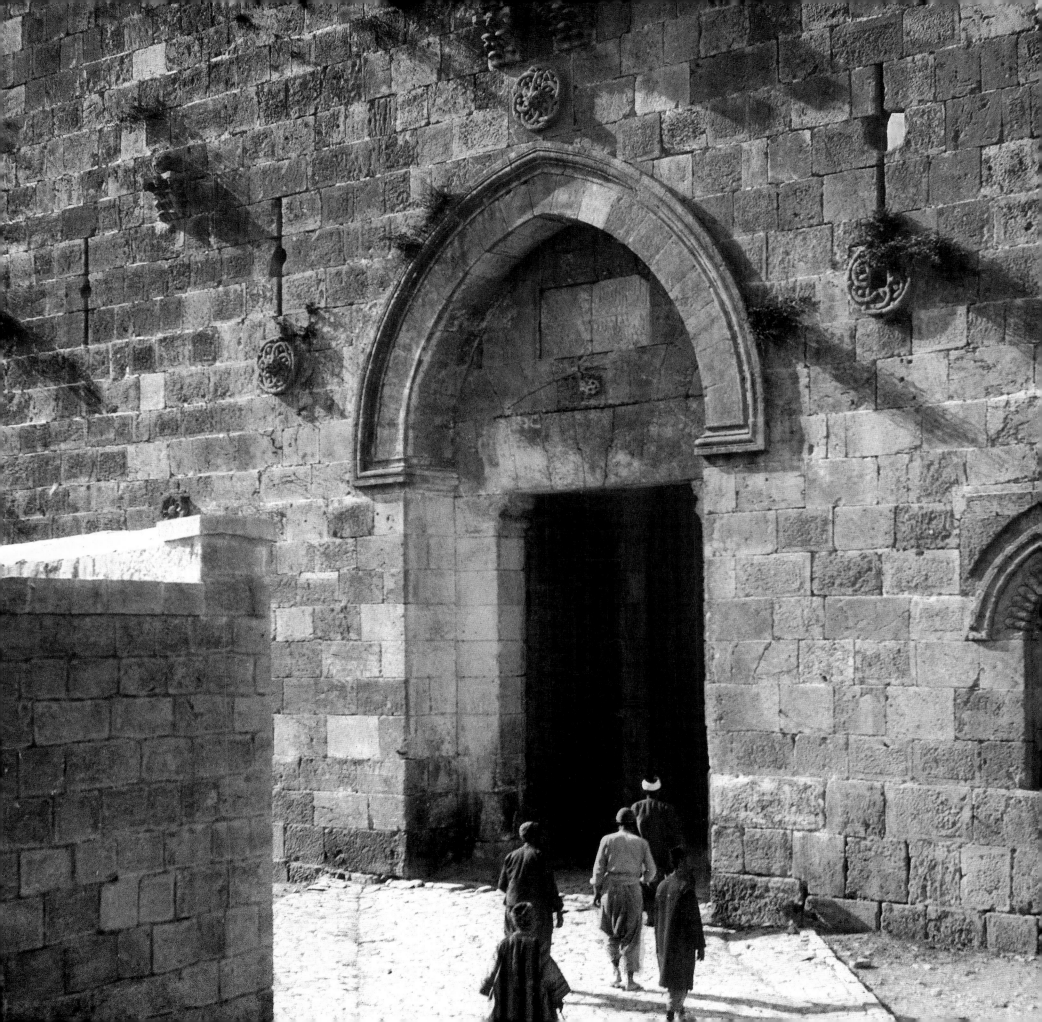

BEDOUIN WITH CAMELS IN FRONT OF DAMASCUS GATE.
Damascus Gate, the largest and most magnificent of the Old City gates, was built by Suleyman the Magnificent in 1542. On the northern wall, the road from the gate leads to Damascus and also Nablus, and is thus called the Sha'ar Shechem, *or Nablus Gate, in Hebrew.*

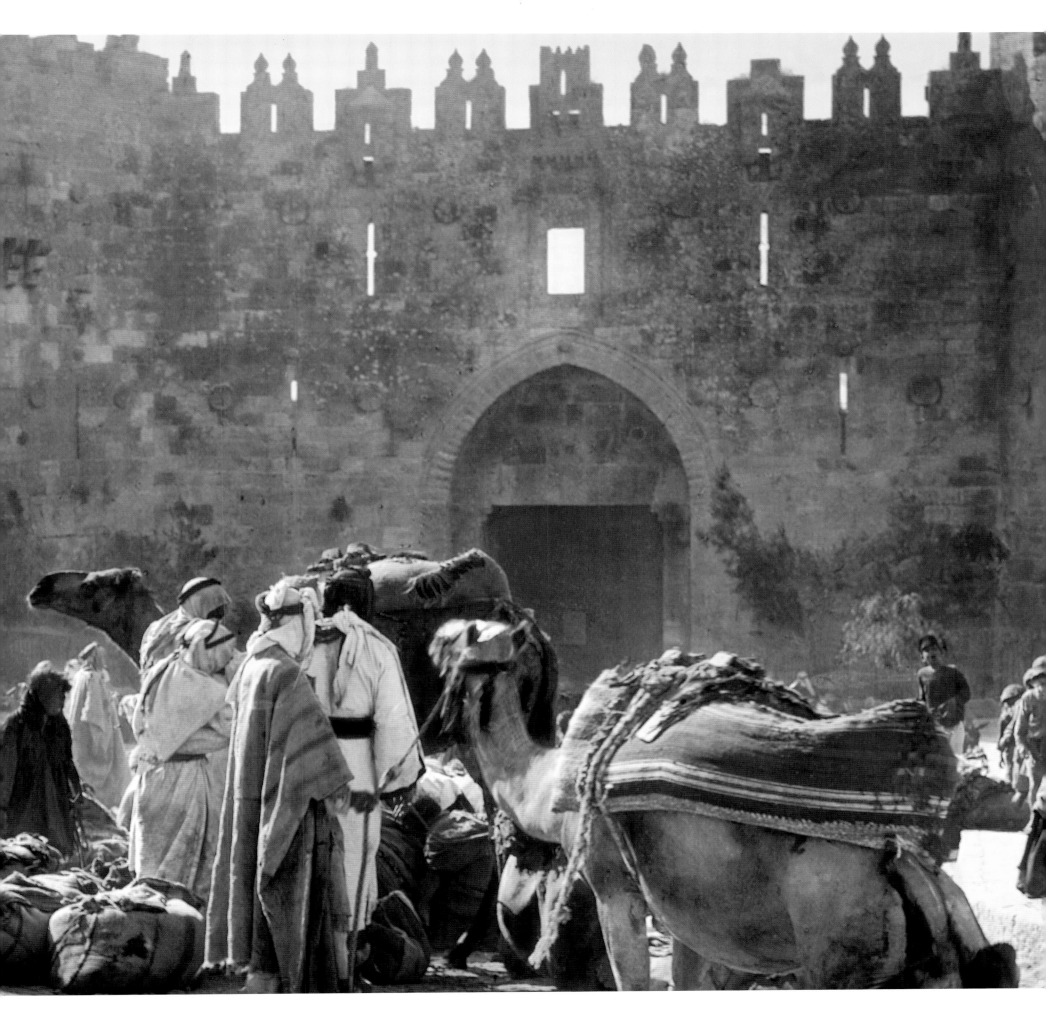

DOME OF THE ROCK, FRAMED BY CYPRESS TREES, FROM THE SOUTH.
When approaching the Old City from the south, the first impression one gets is the glittering gold dome of the Dome of the Rock, located at the center of the Temple Mount (Haram esh-Sharif or "Noble Sanctuary" to the Muslims), a site which is sacred to the three major Abrahamic faiths, Christianity, Judaism, and Islam. It is the spot where Abraham took Isaac to be sacrificed on its stone platform and the site of Solomon's Temple; it features in the story of the Prophet Mohammed's Night Journey and ascent to Heaven; and it is the location of many of the key events in the life of Jesus. The platform, greatly enlarged under the rule of King Herod, was the former site of the Second Jewish Temple which was destroyed during the Roman Siege of Jerusalem in 70 AD. In 637 AD Jerusalem was conquered by the Rashidun Caliphate army during the Islamic invasion of the Byzantine Empire. The Dome of the Rock was erected between 685 and 691 AD.

Fourteenth century traveler Ibn Batuta wrote "This is one of the most fantastic of all buildings. Its queerness and perfection lie in its shape . . . It is so amazing it captivates the eye . . . Both the inside and the outside are covered with many kinds of tiles of such beautiful make that the whole defies description. Any viewer's tongue will grow shorter trying to describe it."

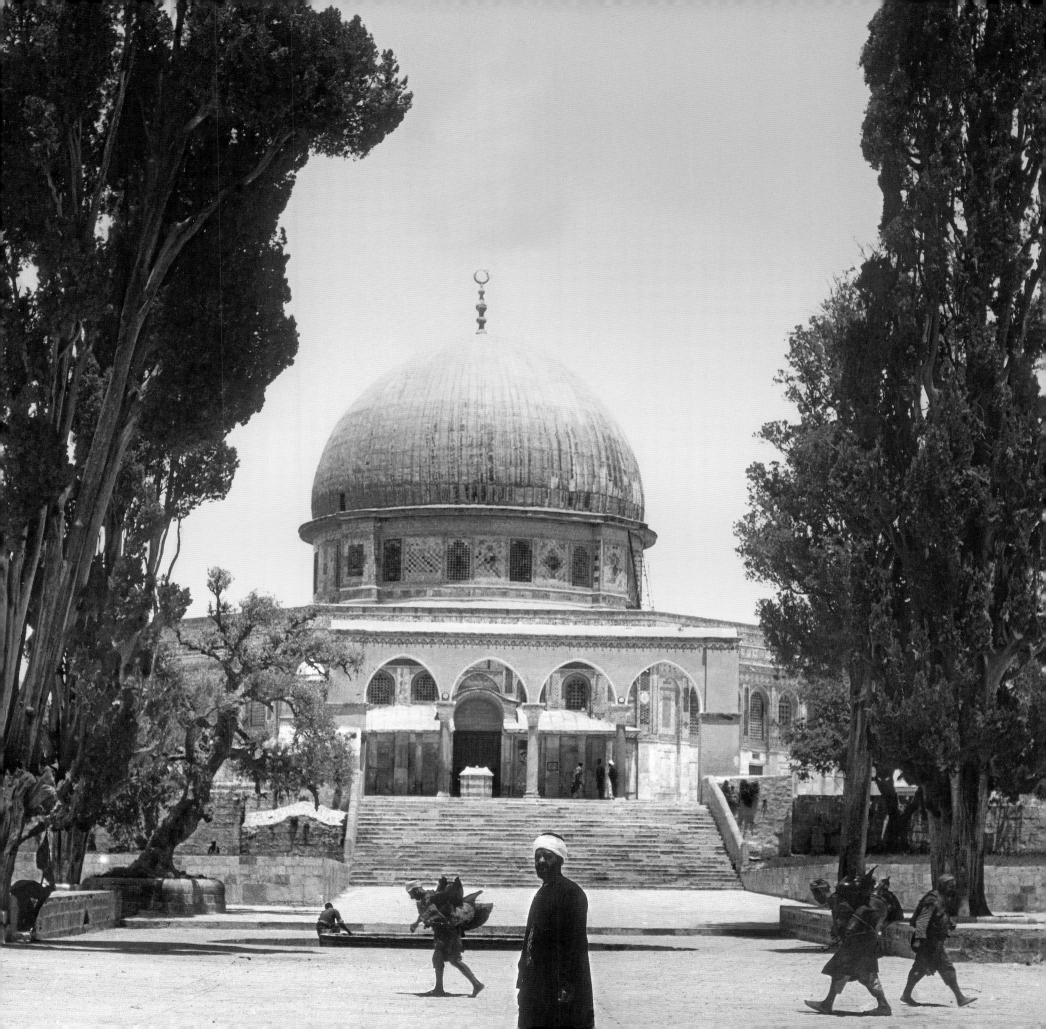

COTTON MERCHANTS GATE.
This monumental gate, Bab al-Qattanin, *leads to* Suq al-Qattanin, *market of the cotton merchants. This distinctive entrance portal with its colorful decorative stone inlays is typical of the Mameluke period.*

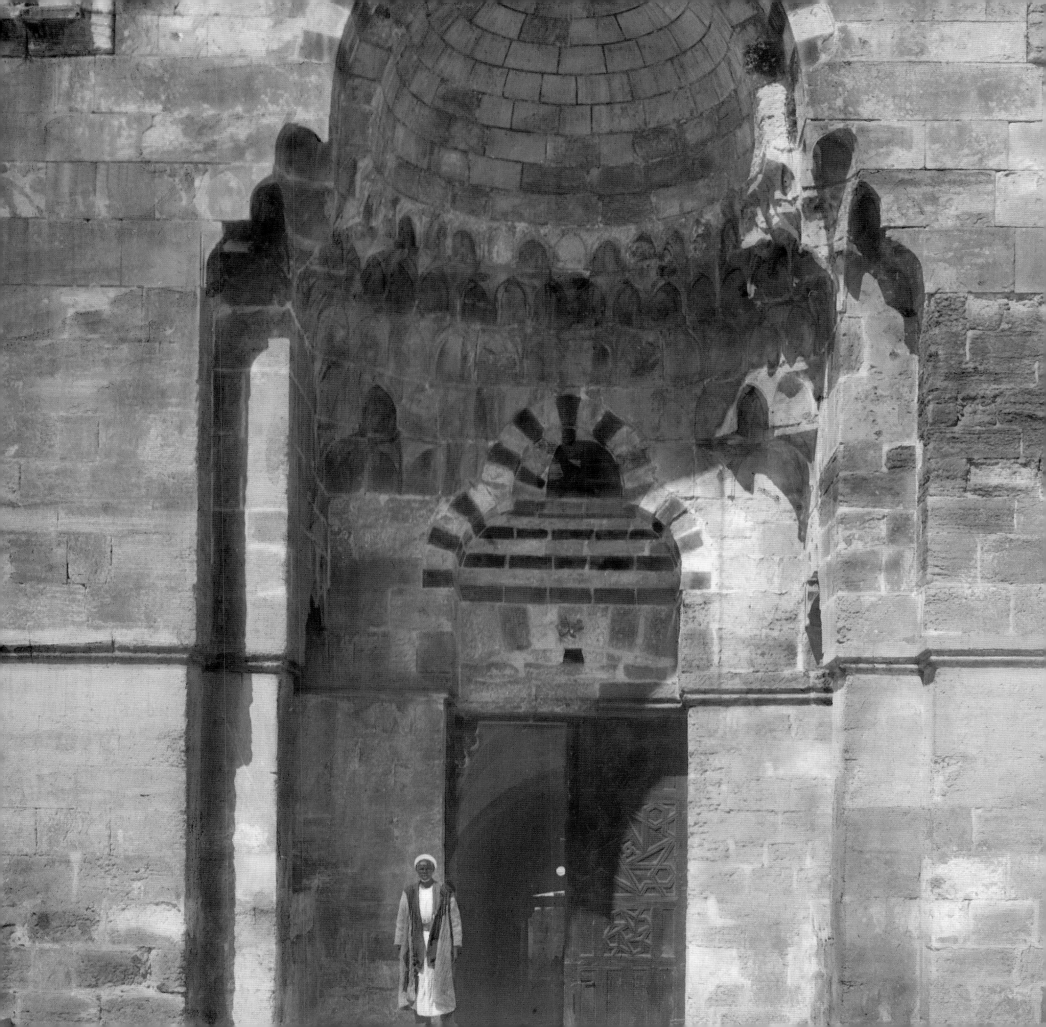

TOWER OF ANTONIA, SEEN THROUGH A COLONNADE.

The Tower of Antonia was built on the site of an existing ancient citadel and is part of Antonia fortress, built near the Temple by King Herod around 6 AD and named for his friend, the Roman emperor Mark Antony. During the life of Christ it served as an official residence for the Roman procurator; historian Flavius Josephus described its palatial courtyards and splendid baths. The location is considered to be the first of the fourteen Stations of the Cross on the Via Dolorosa.

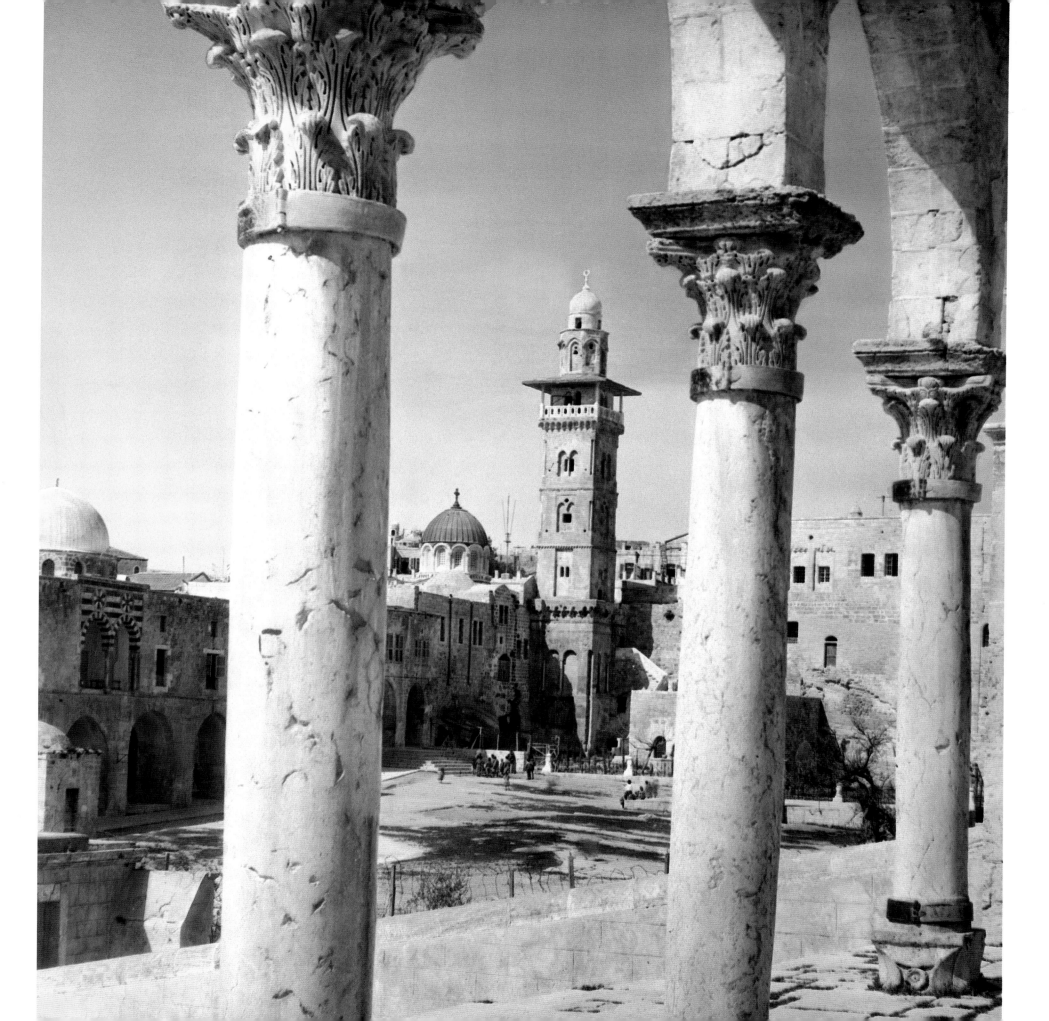

SOLOMON'S STABLES.

Throughout Jerusalem, vaulted subterranean rooms were built to support the structures above them. Solomon's Stables, believed to date from the time of King Herod, are a series of such rooms, built under the Temple Mount and consisting of twelve rows of pillars and arches.

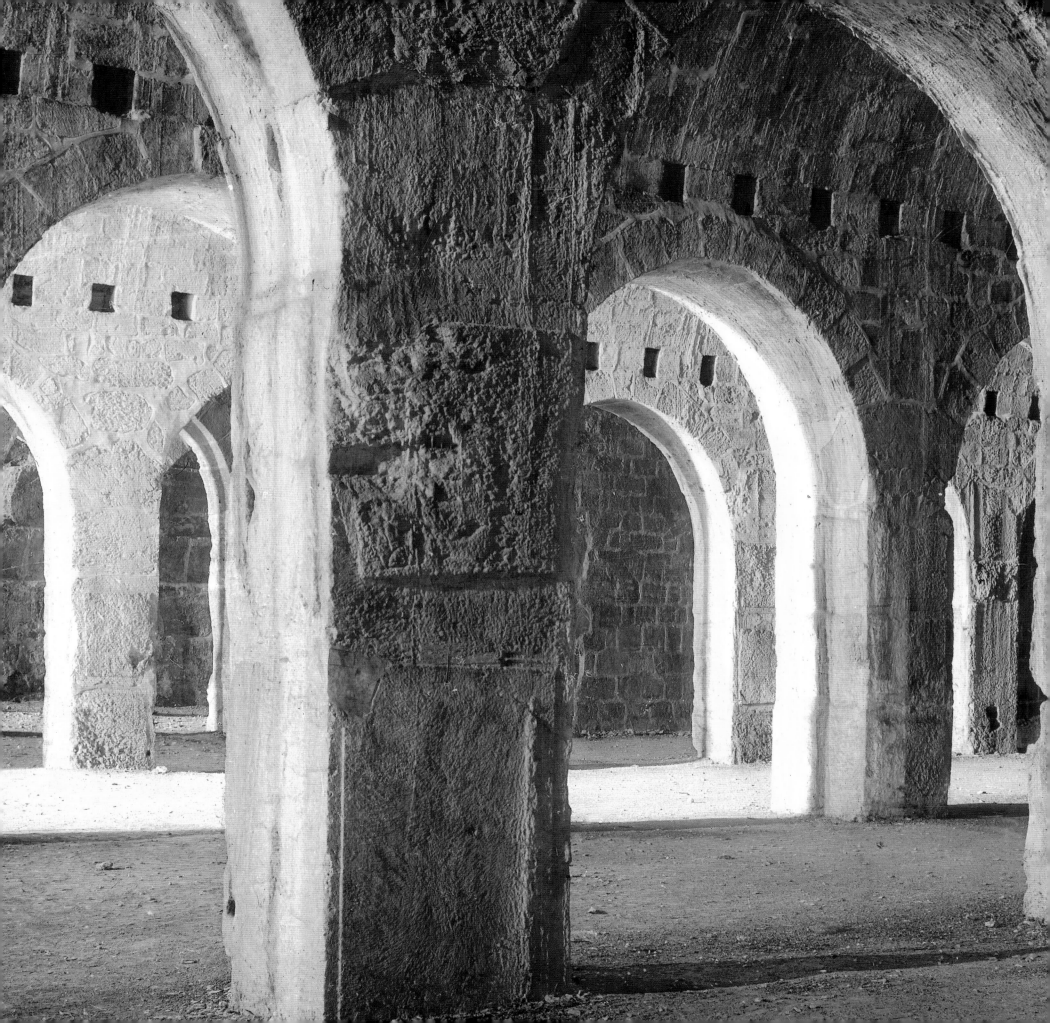

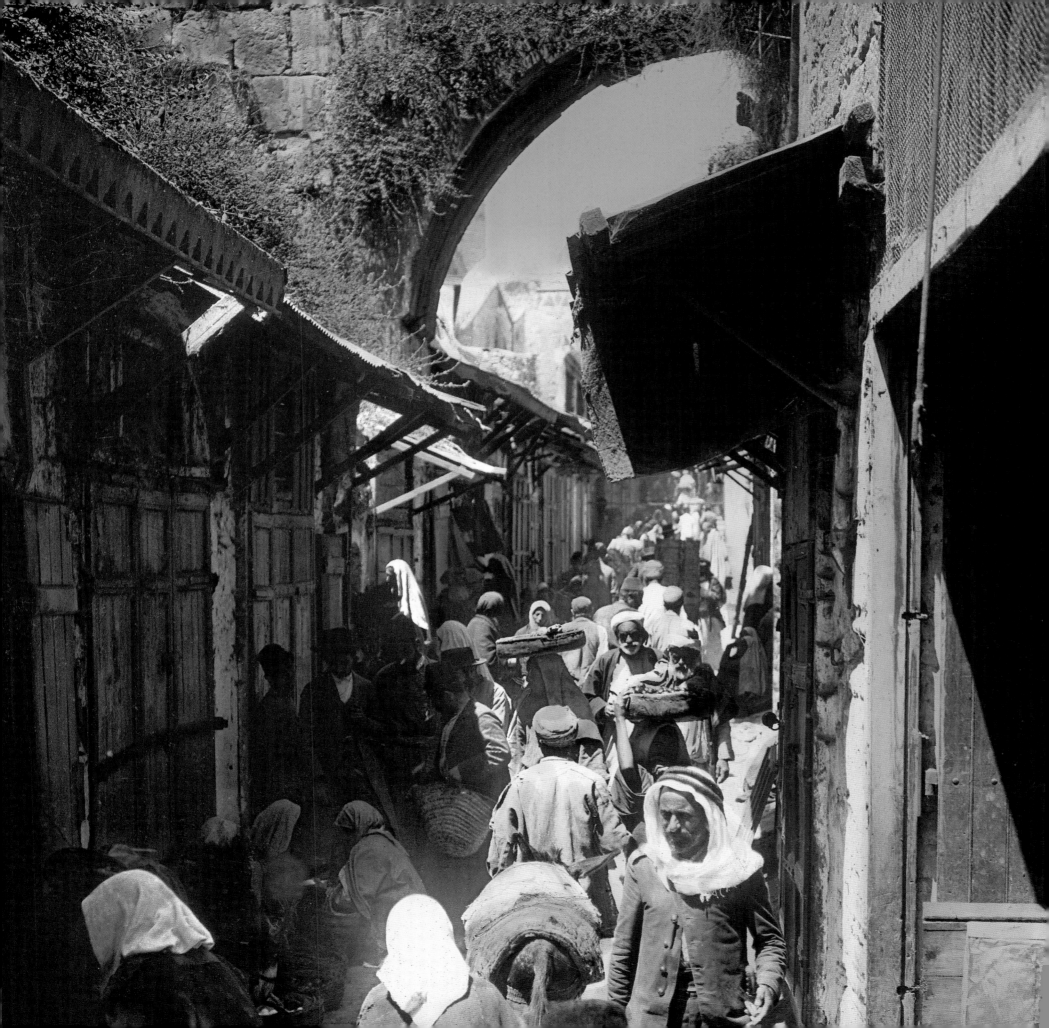

An Alleyway in the Old City after a Rare Snowstorm.

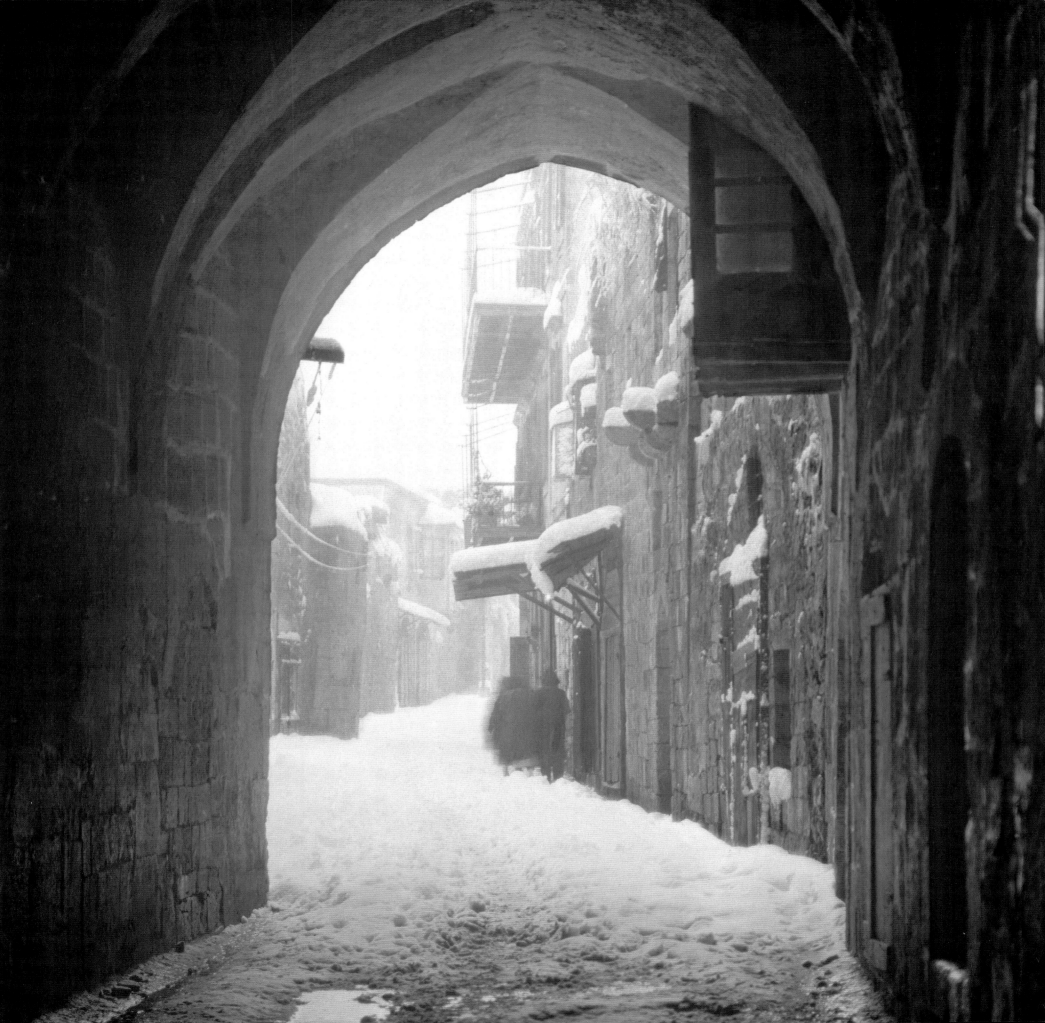

GROUP OF LEPERS.

Most pitiable would be have been the lepers, huddled together outside the gate, outcasts of society, even the society of beggars. They were forbidden to beg inside the city. According to Leviticus, they were unclean and had to live apart from others; the four lepers of Samaria (II Kings 7:3) had been excluded from the city and were outside the gate.

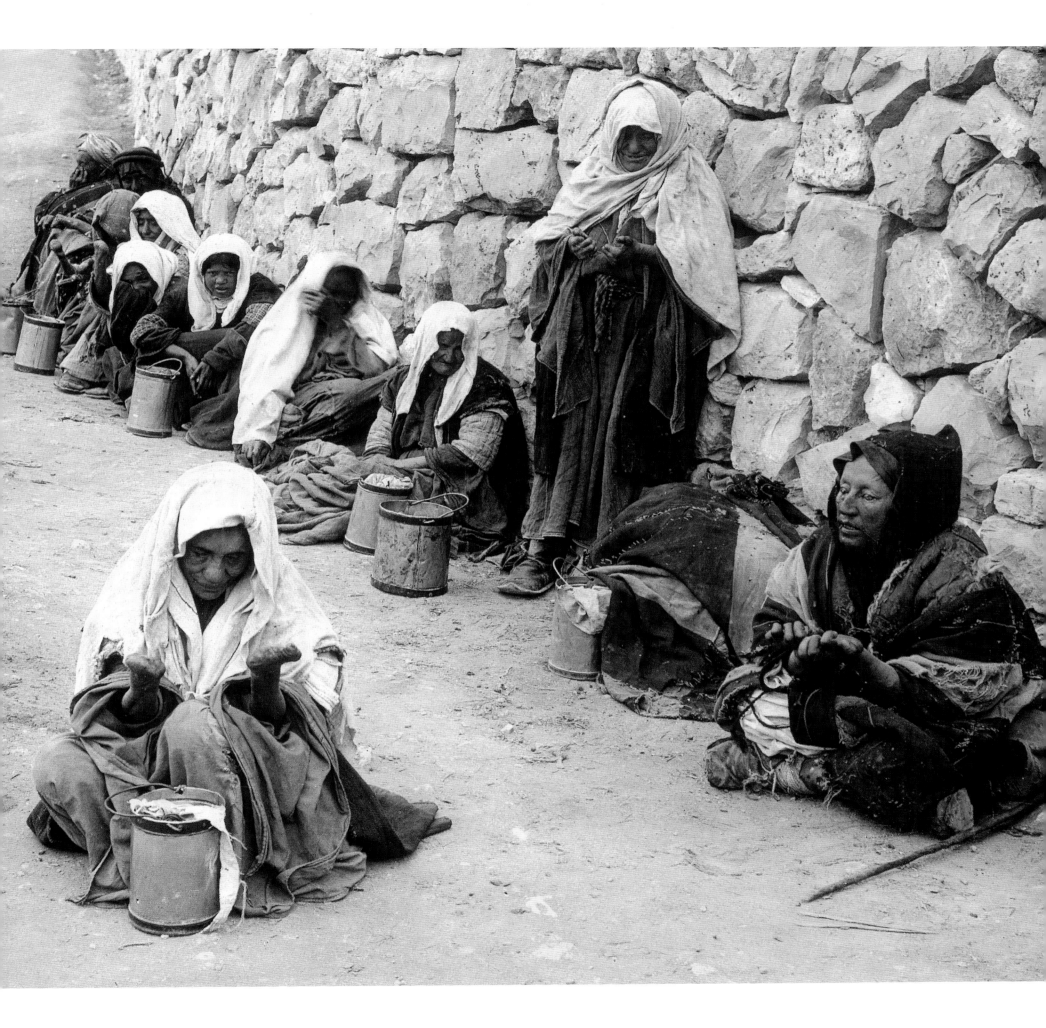

LEPER WOMAN.

Leviticus 13 and 14 relates elaborate instructions for priests to recognize leprosy; ceremonial methods of cleansing are detailed but nowhere in the Bible is there mention of remedy or treatment; the implication being that the only cure was a miracle.

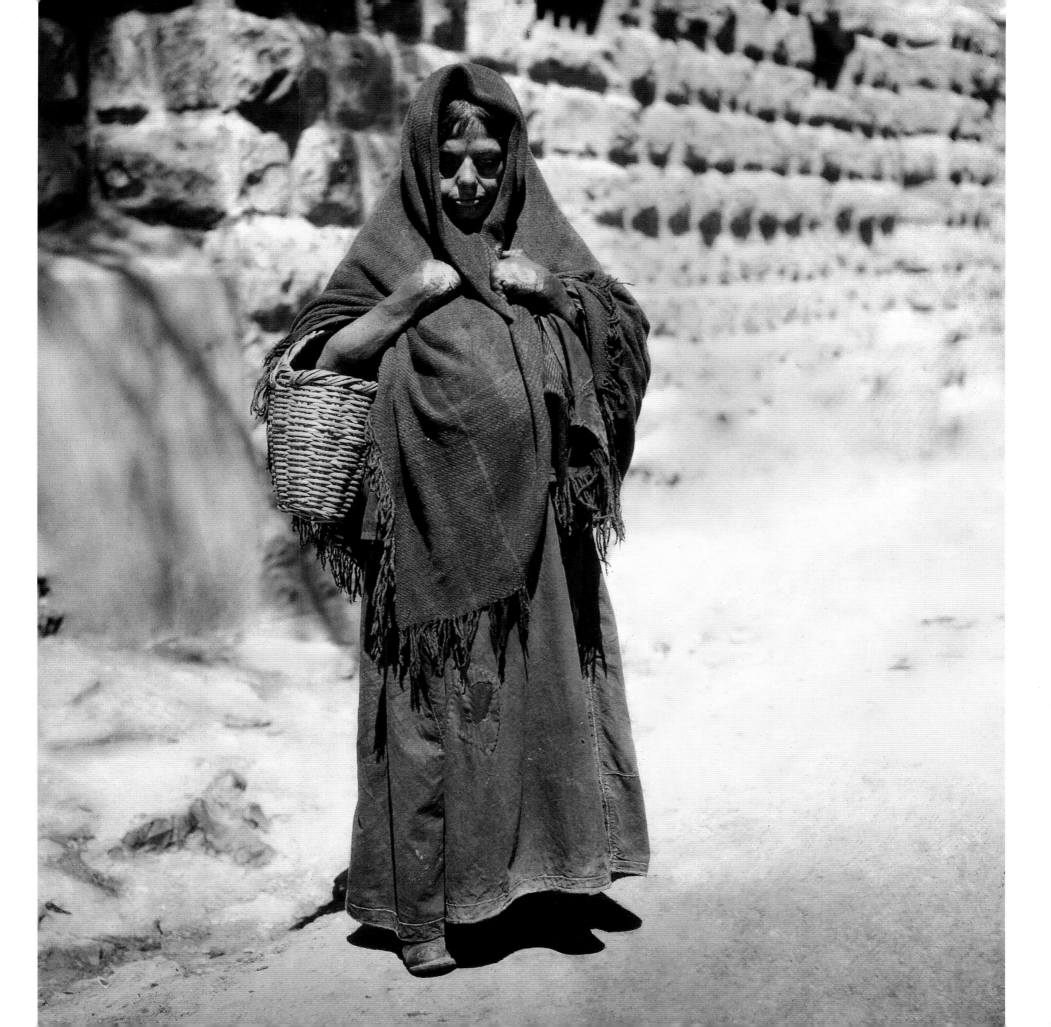

GROUP OF BEGGARS.

Beggars would hold out their tin cans and metal buckets to catch whatever was thrown to them. That the poor existed among the ancient Hebrews there is ample Biblical evidence but there is no mention of "beggars" per se in the Old Testament. The poor were provided for by Mosaic law: "And thou shalt not glean thy vineyard, neither shalt thou gather every grape of thy vineyard; thou shalt leave them for the poor and stranger: I am the LORD your God" (Leviticus 19:10).

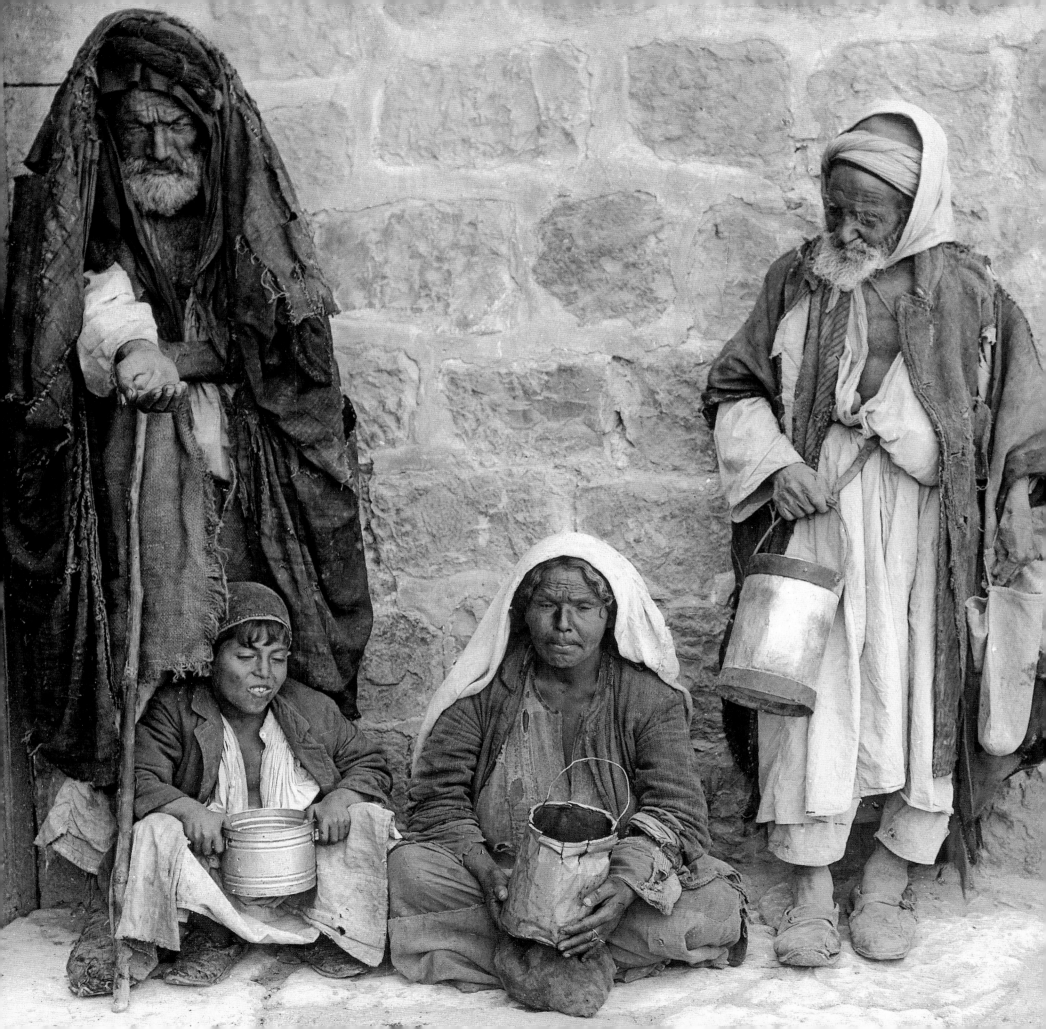

PORTER WITH TWO TRUNKS.
A laborer carting luggage in the Old City.

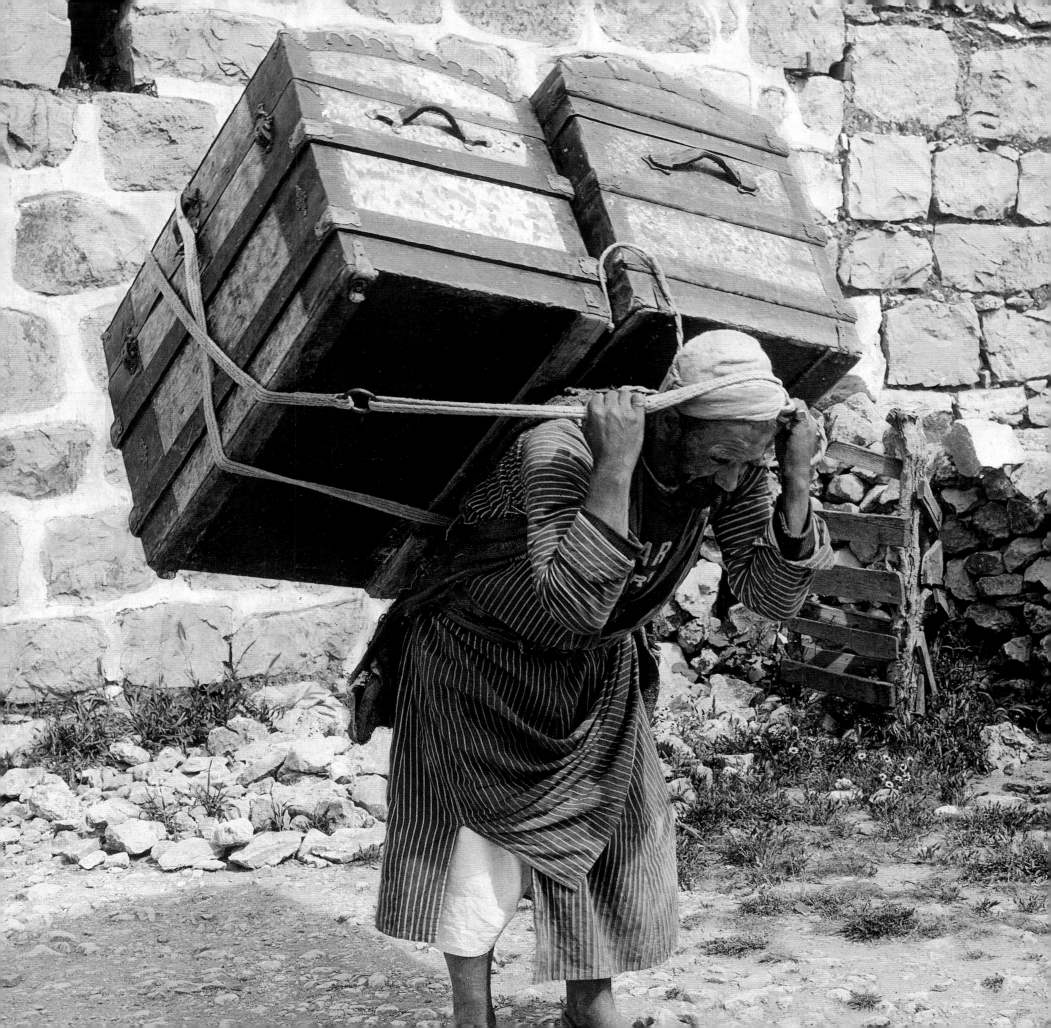

THE WESTERN, OR WAILING, WALL.

The Western Wall is an exposed section of ancient wall on the western side of the Temple Mount in Jerusalem's Old City. It is part of the retaining wall built by King Herod as part of his expansion of the Temple in 20 BC. The holiest site in Judaism and a place of pilgrimage and prayer, it is traditionally thought to be the sole remnant of Solomon's Temple. It became a place of mourning over the destruction of the Temple; hence the common name, the Wailing Wall. The Western Wall has remained intact since the destruction of the Second Temple in 70 AD.

Women and men have separate sections at the wall; here are women and children praying on the women's side.

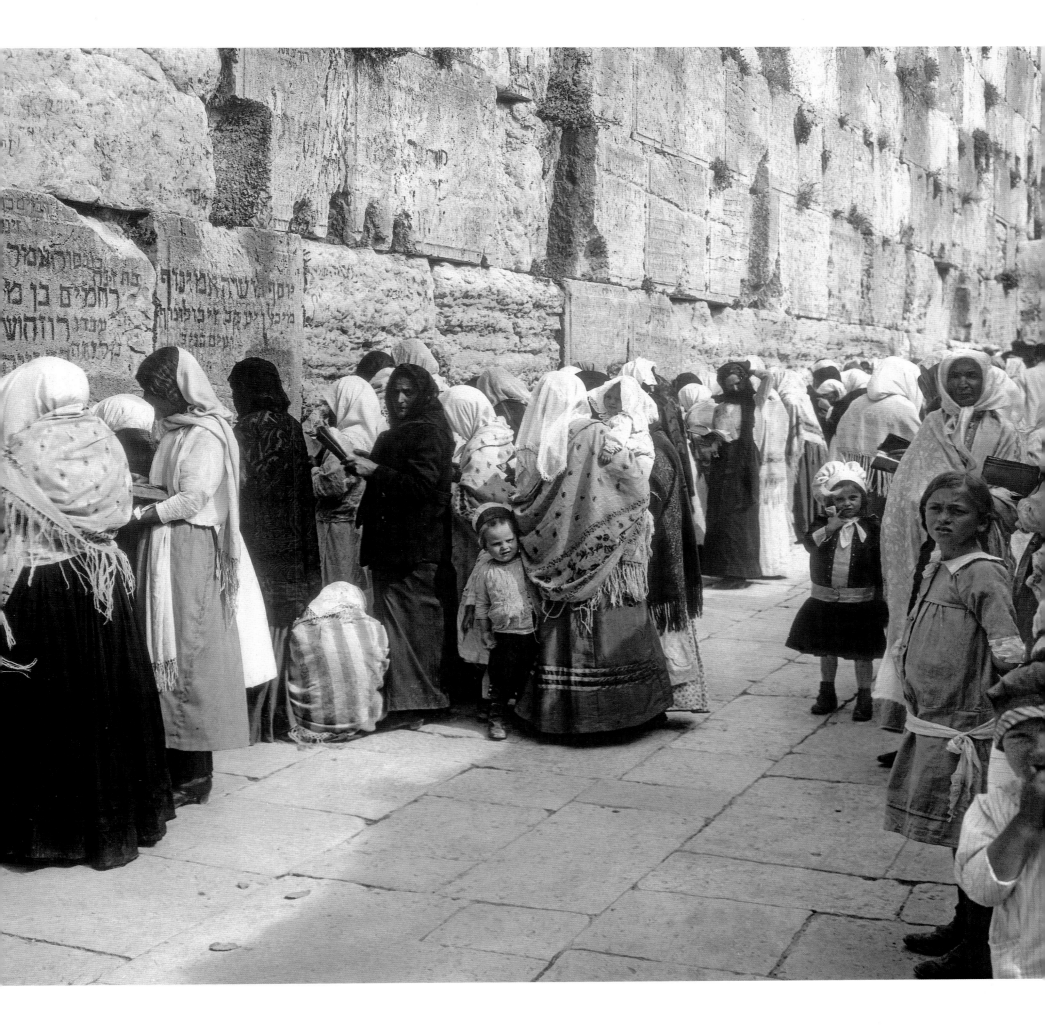

OLD MAN READING AT THE WESTERN, OR WAILING, WALL.
Some worshippers visit the wall daily to recite from Book of Psalms or the Book of Lamentations. Others insert scrolls or slips of paper with prayers on them between the stones.

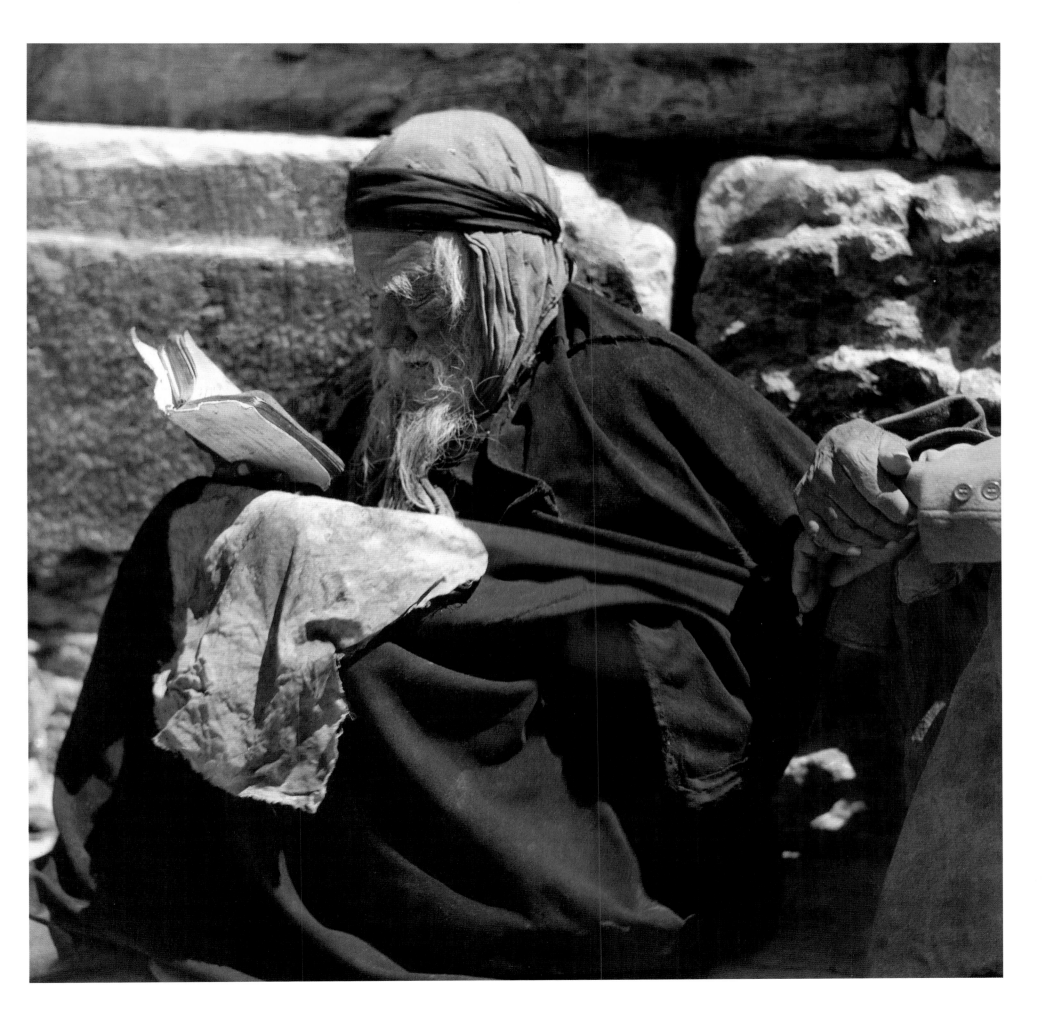

OUTSIDE A COFFEE SHOP ON A JERUSALEM STREET.
Coffee shops would be found on many street corners, under awnings and vaulted passageways. Nargilahs, large water pipes, were lined up along the walls and a supply of charcoal was kept burning on a stove to fuel them. Some men would sit on thin rugs, others on stone benches, some well-dressed, some half naked, or in sandals and sackcloth, sitting and chatting, or listening to a storyteller, cross-legged on the floor, spinning his tales.

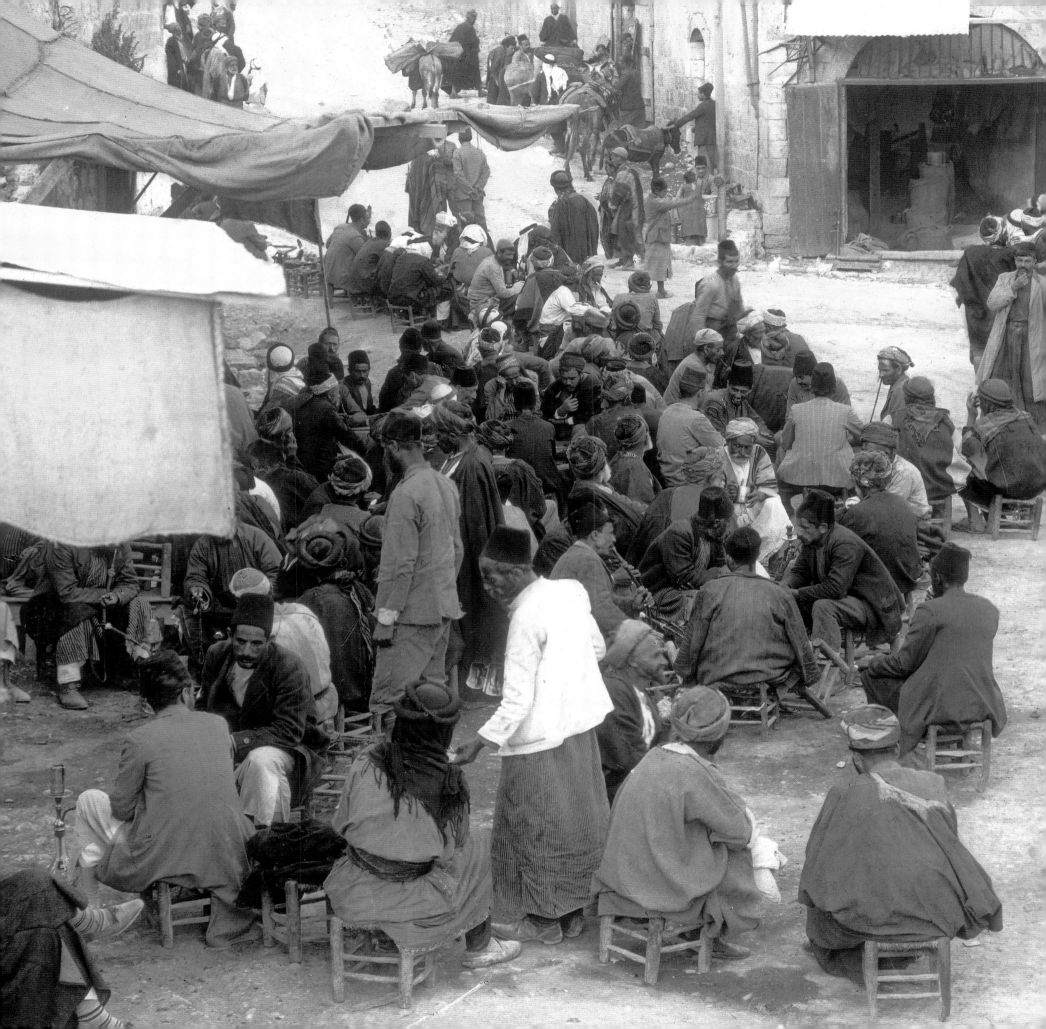

TWO MEN SMOKING NARGILAHS.

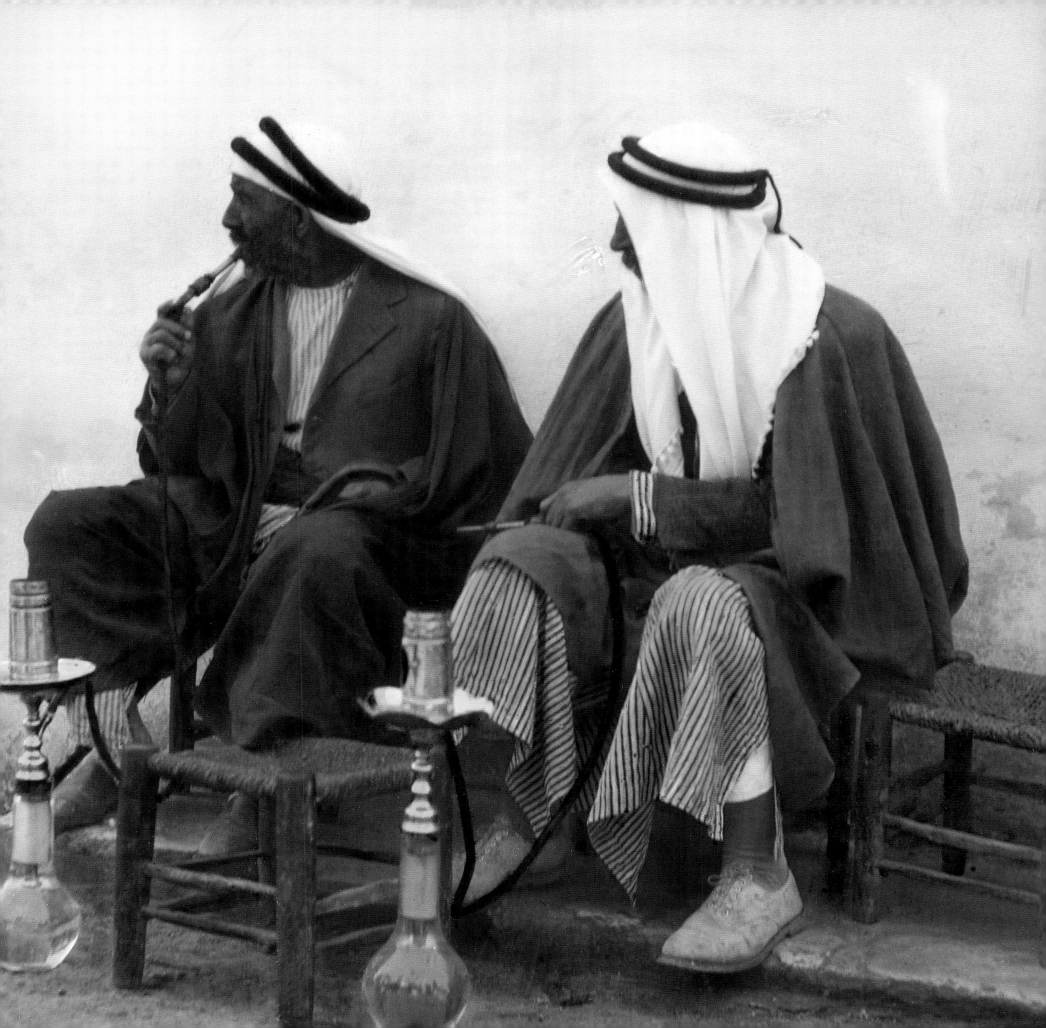

FIVE MOSLEM GIRLS IN ALLEY.
Groups of girls, chattering and laughing, could be seen in their traditional garb—indigo linen dresses, white cotton veils, and red shawls.

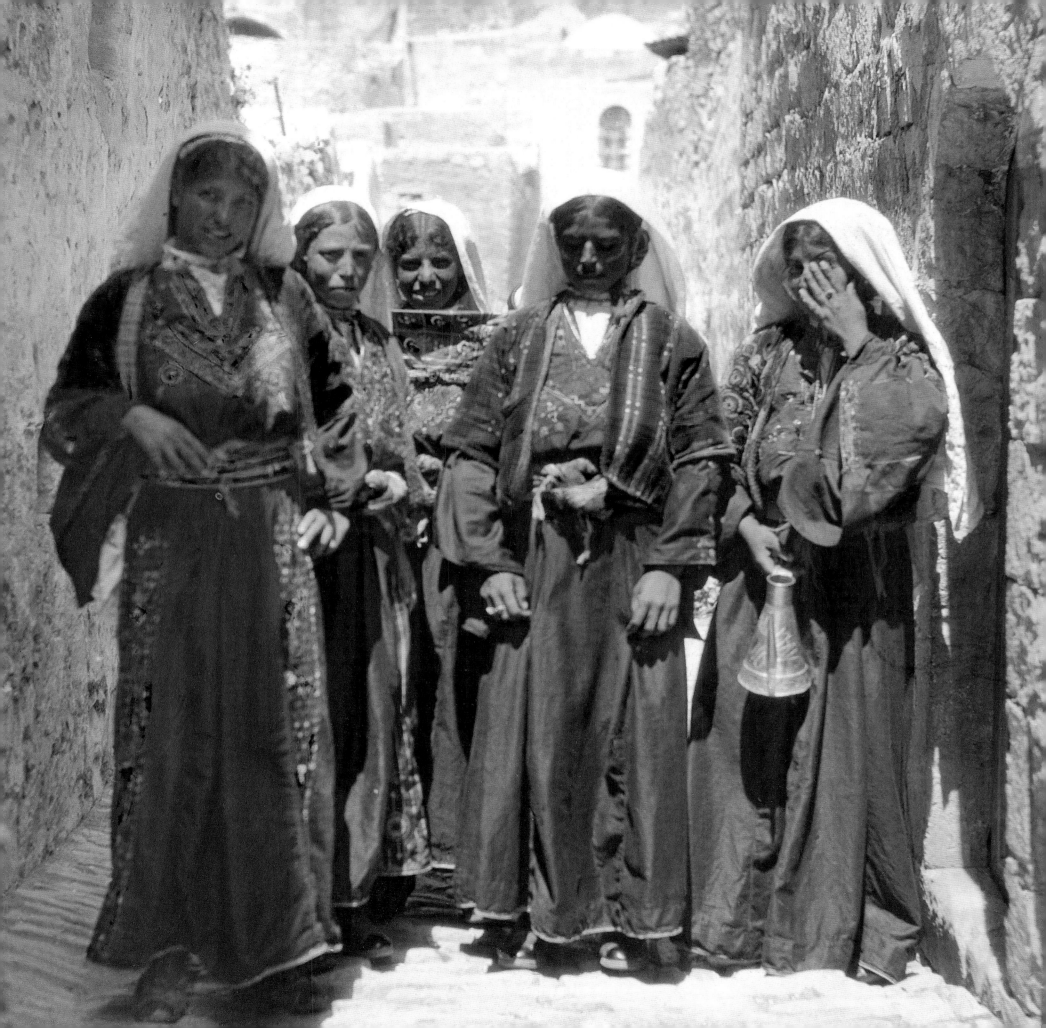

EGYPTIAN WATER CARRIERS.

Water has been a problem in Jerusalem since the city was founded. Citizens would be largely dependent upon private and public cisterns constructed to collect rainwater from domed roofs and along gutters and pavements. Special prayers for rain could be heard throughout the city, both in mosques and at the Wailing Wall.

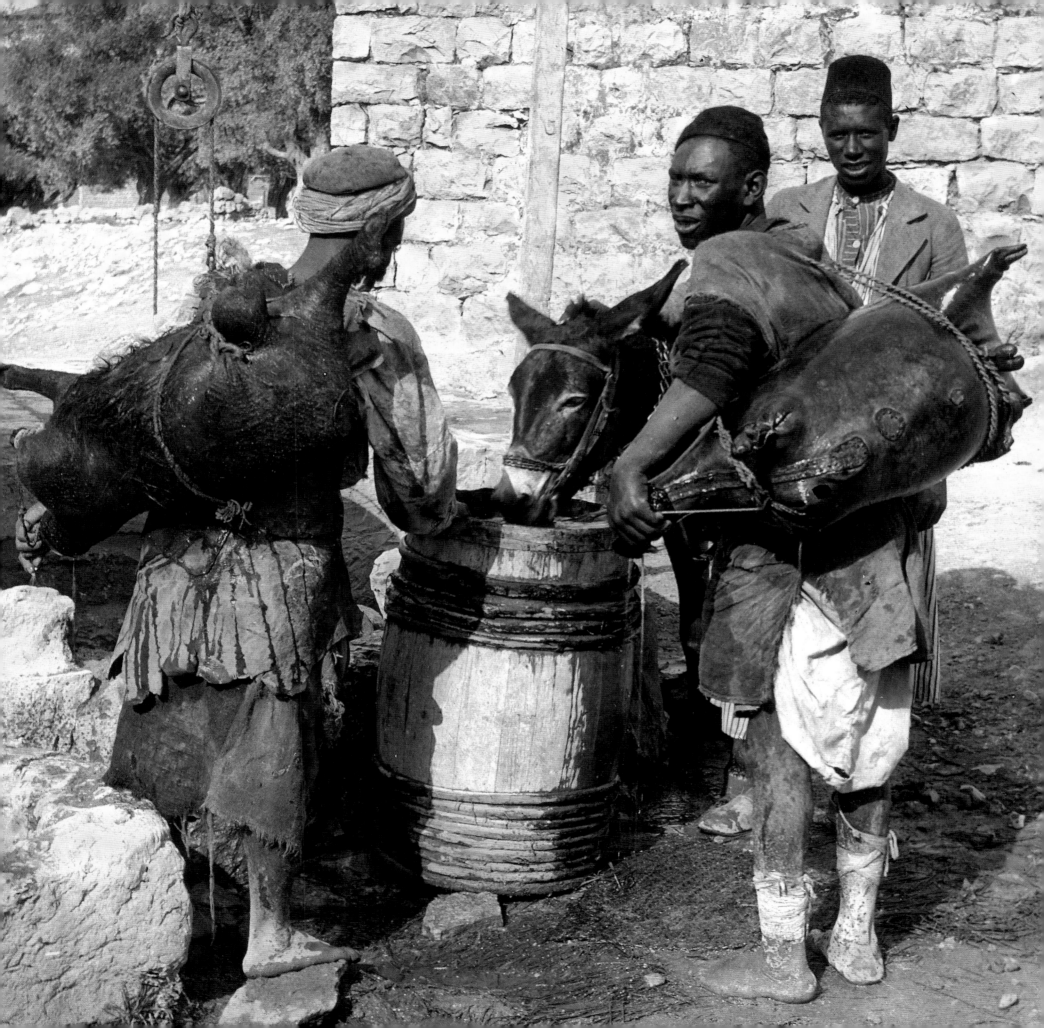

WATER CARRIER WITH GIRBEH.
A large girbeh *(water container made from a cured animal hide, usually goatskin) could hold seven gallons of water.*

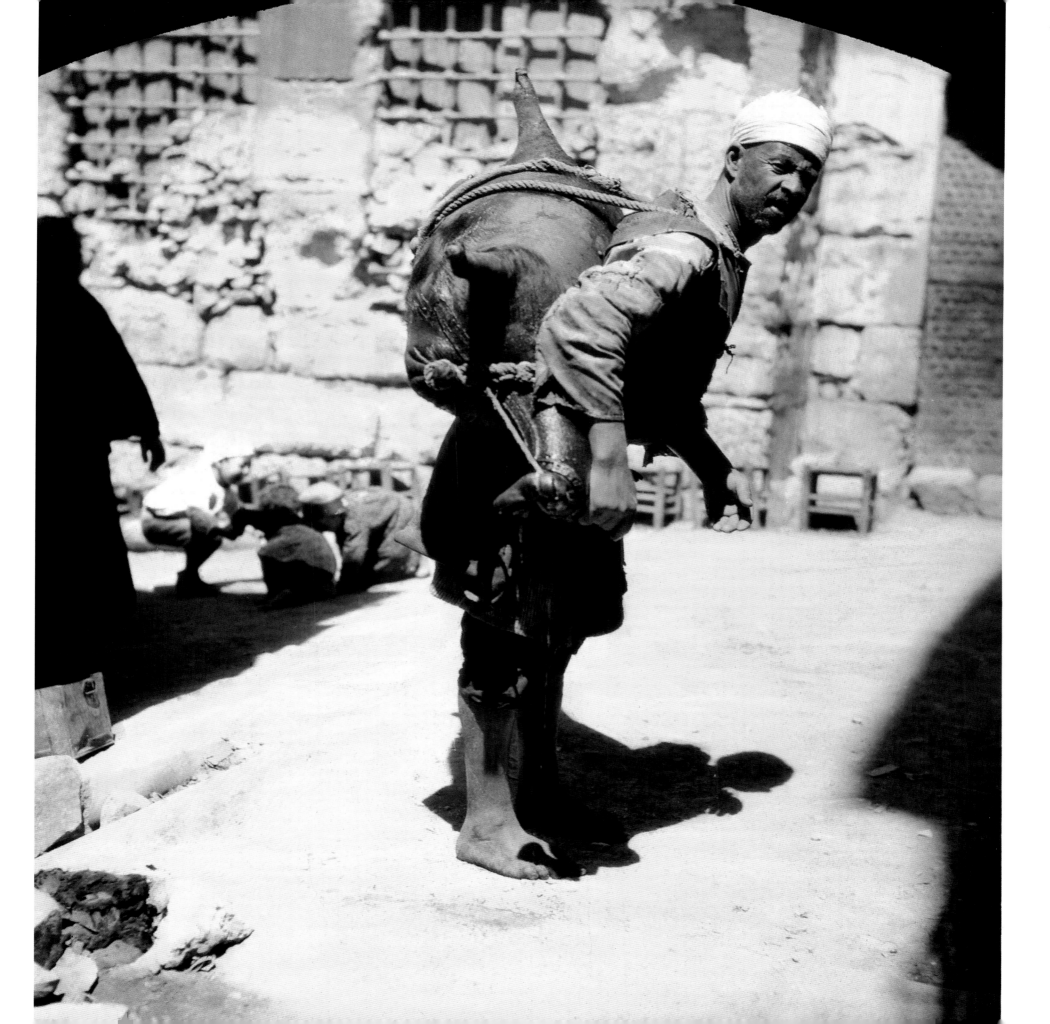

GIRL AT THE VIRGIN'S FOUNTAIN.
In the village of Siloam, in the Kidron Valley and behind the Garden of Gethsemane, throngs of water carriers would gather around the Gihon (Hebrew for "gushing") Spring, also called the Fountain of the Virgin, the primary fresh water spring within the vicinity of the city of Jerusalem. Water from the Gihon Spring anointed King Solomon and served as the only water source for ancient Jerusalem. In the eighth century BC, King Hezekiah built an aqueduct to bring water from the spring into the besieged city.

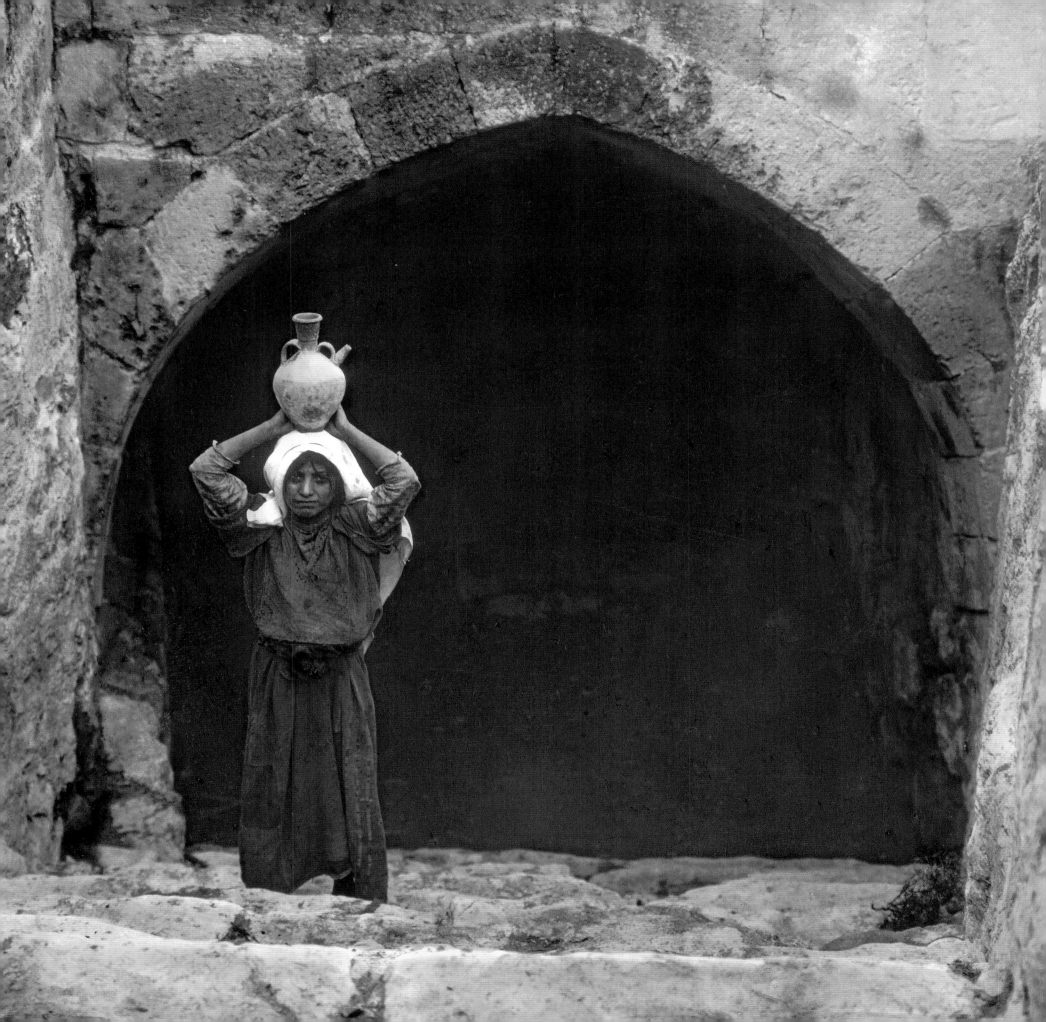

POOL OF SILOAM.

The Pool of Siloam is a rock-cut pool that served as storage for the water brought to Jerusalem from the Gihon Spring via Hezekiah's Tunnel.

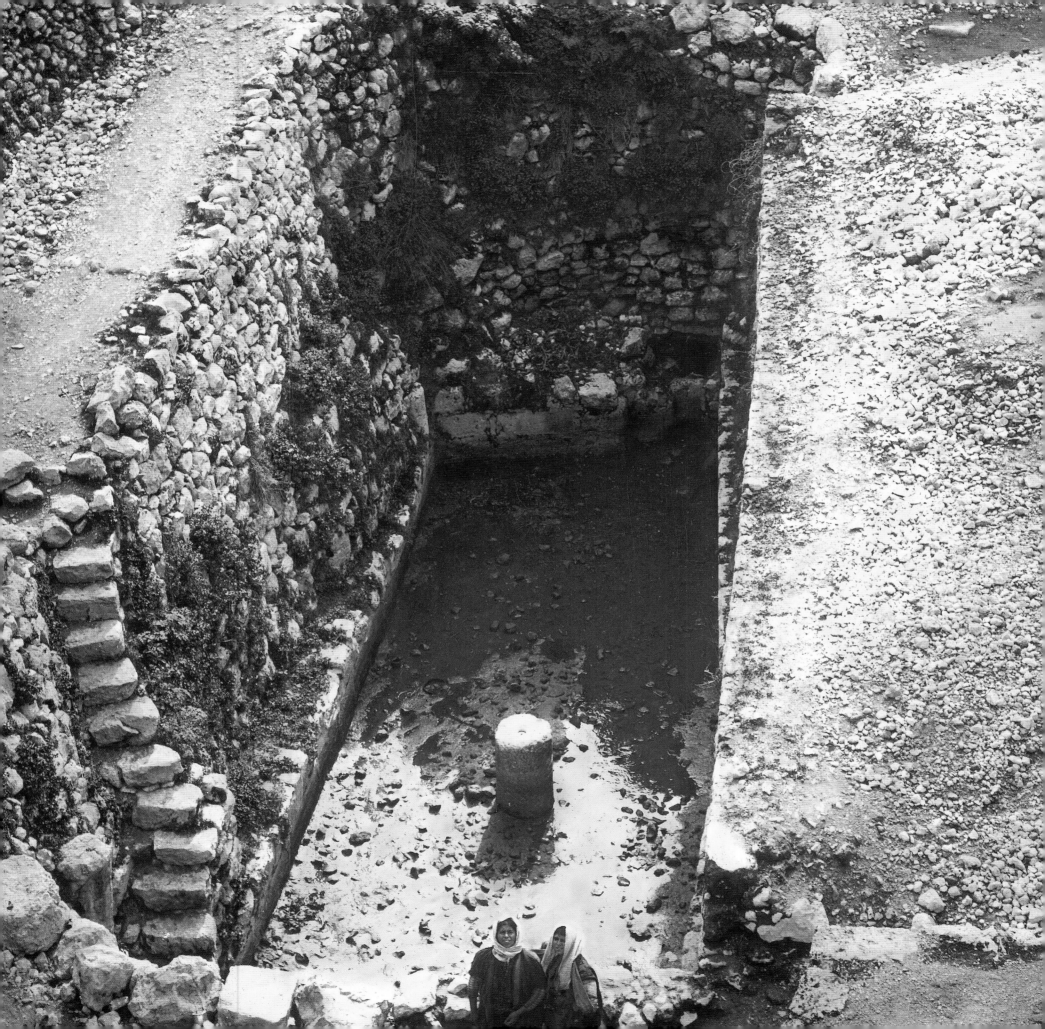

EIN ROGEL.
Ein Rogel, or Jacob's Well, is located where the Kidron and Hinnon Valleys meet.

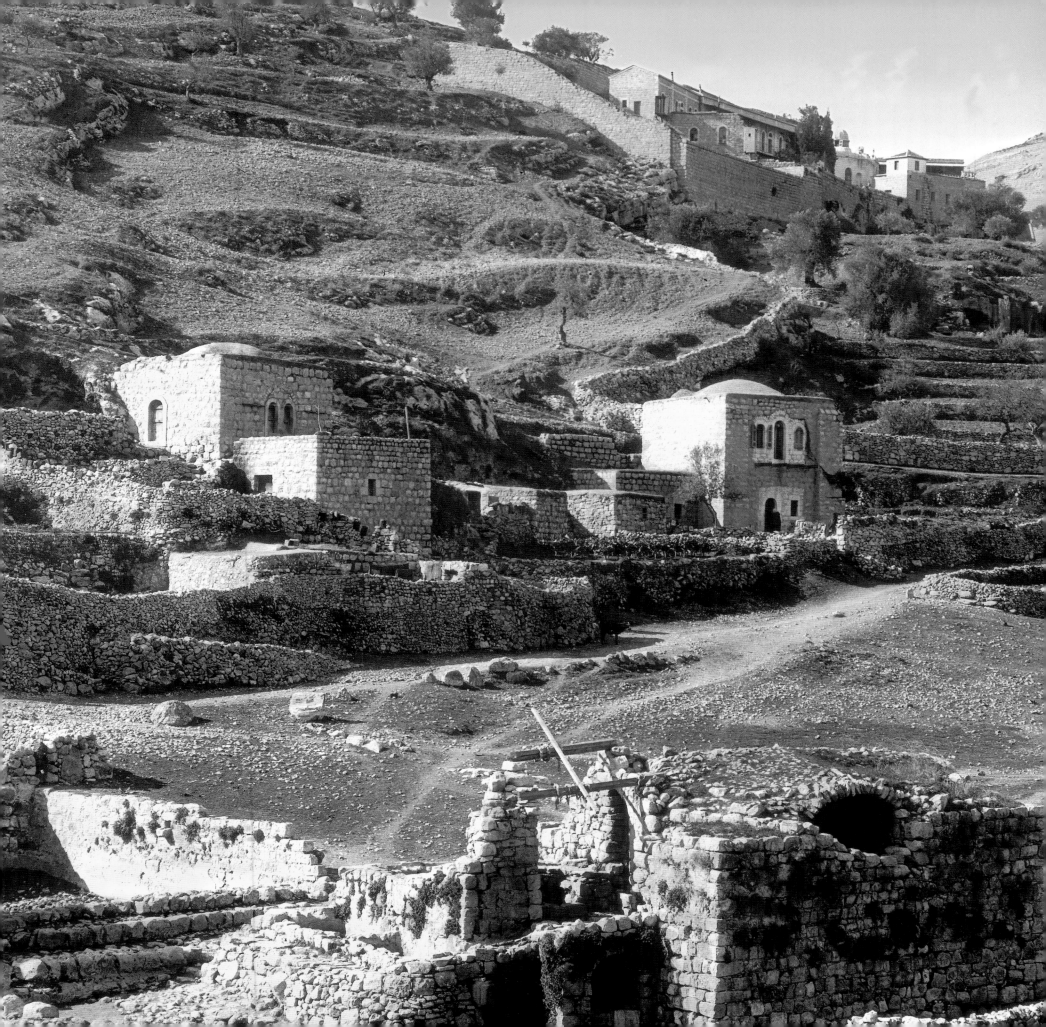

KIDRON VALLEY.

Kidron Valley is a deep ravine between the Mount of Olives and the Temple Mount. The Gihon Spring ran through it before King Hezekiah diverted it into the city. There are two tombs here: Absalom's Tomb and the Tomb of Zechariah.

The Bible calls Kidron Valley the Valley of Jehoshaphat. In Old Testament prophecy, it is to be the site of the Last Judgment. The New Testament has Jesus crossing the valley many times, including on his trip to heal Lazarus and after the Last Supper, when he went with his disciples to Gethsemane.

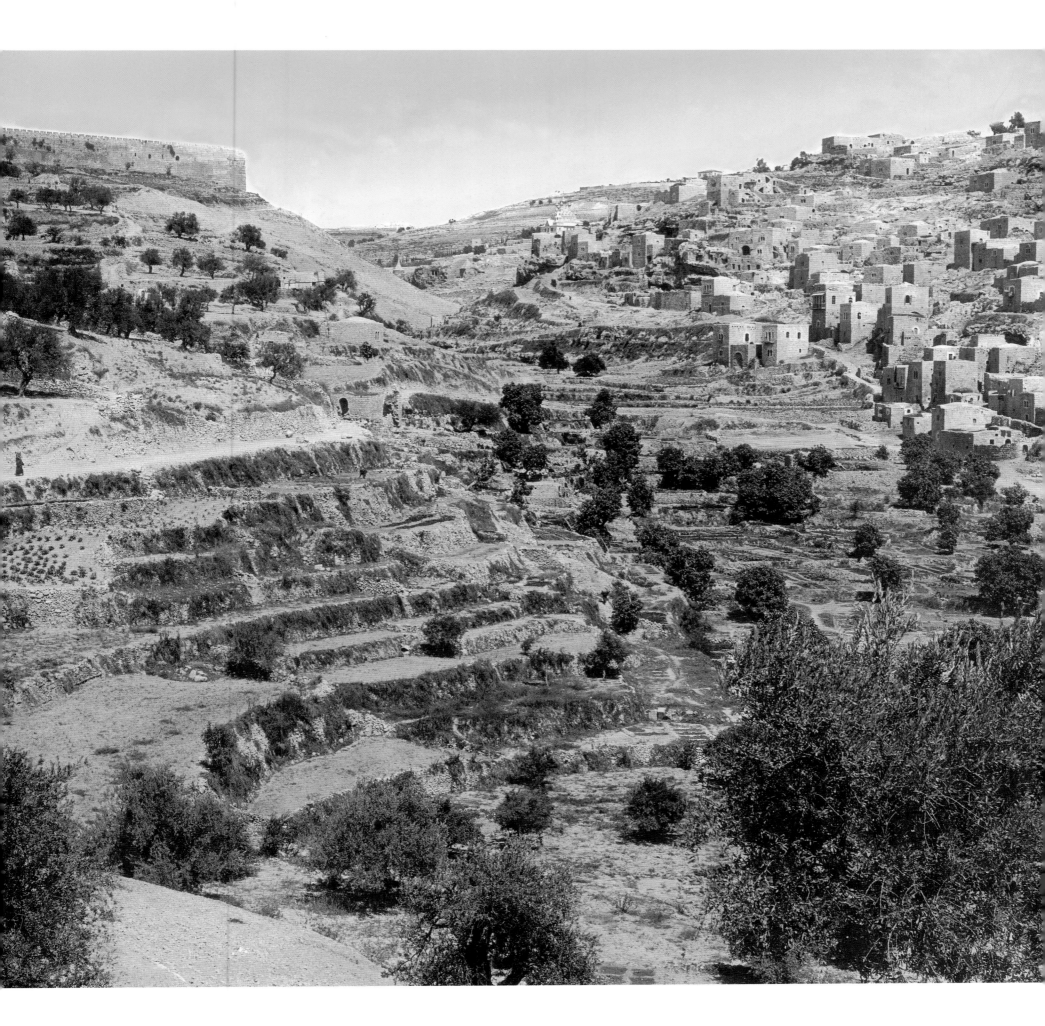

ABSALOM'S TOMB.

This imposing rock-hewn monument, located in the Kidron Valley, is traditionally known as Absalom's Tomb, after the rebellious son of King David.

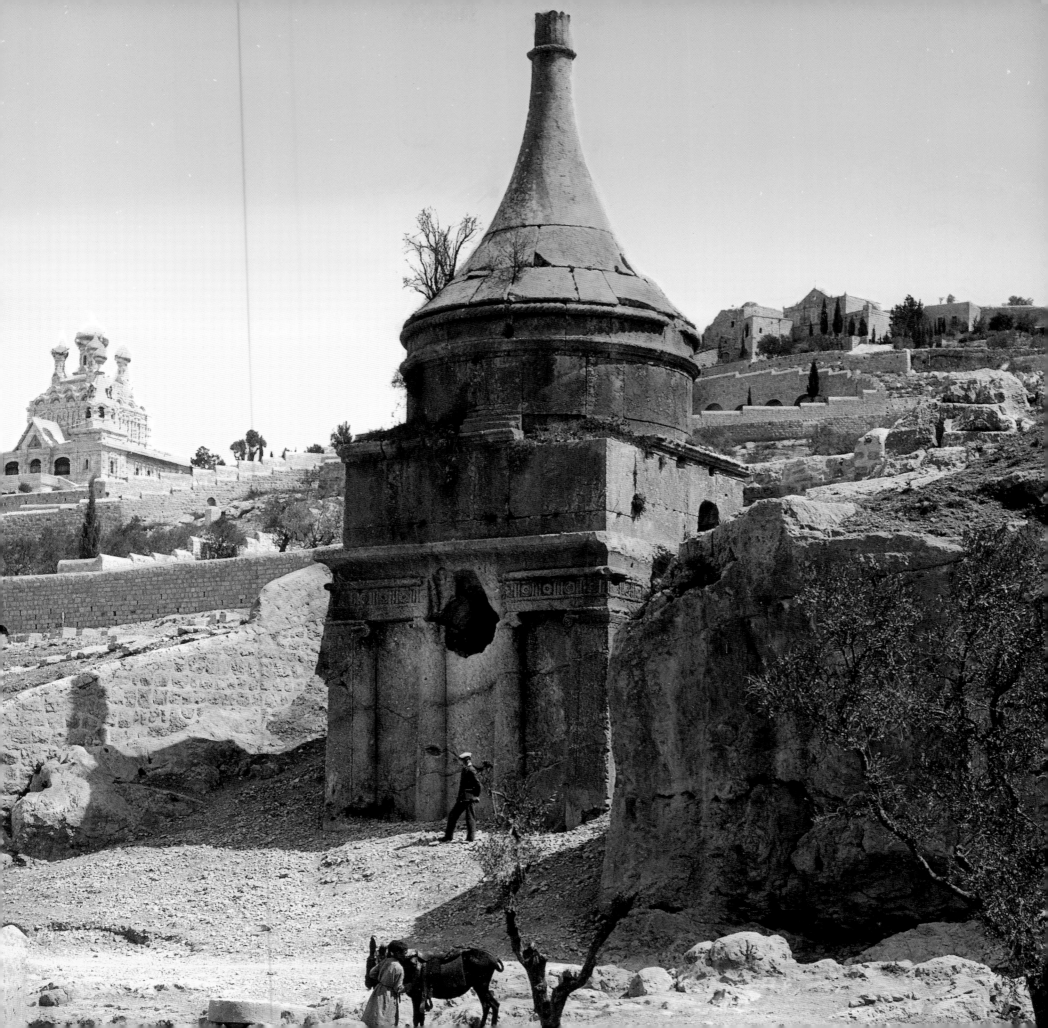

VILLAGE OF EIN KEREM.
Ein Kerem, traditional birthplace of John the Baptist, is a village southwest of the Old City of Jerusalem and the location of Mary's Spring.

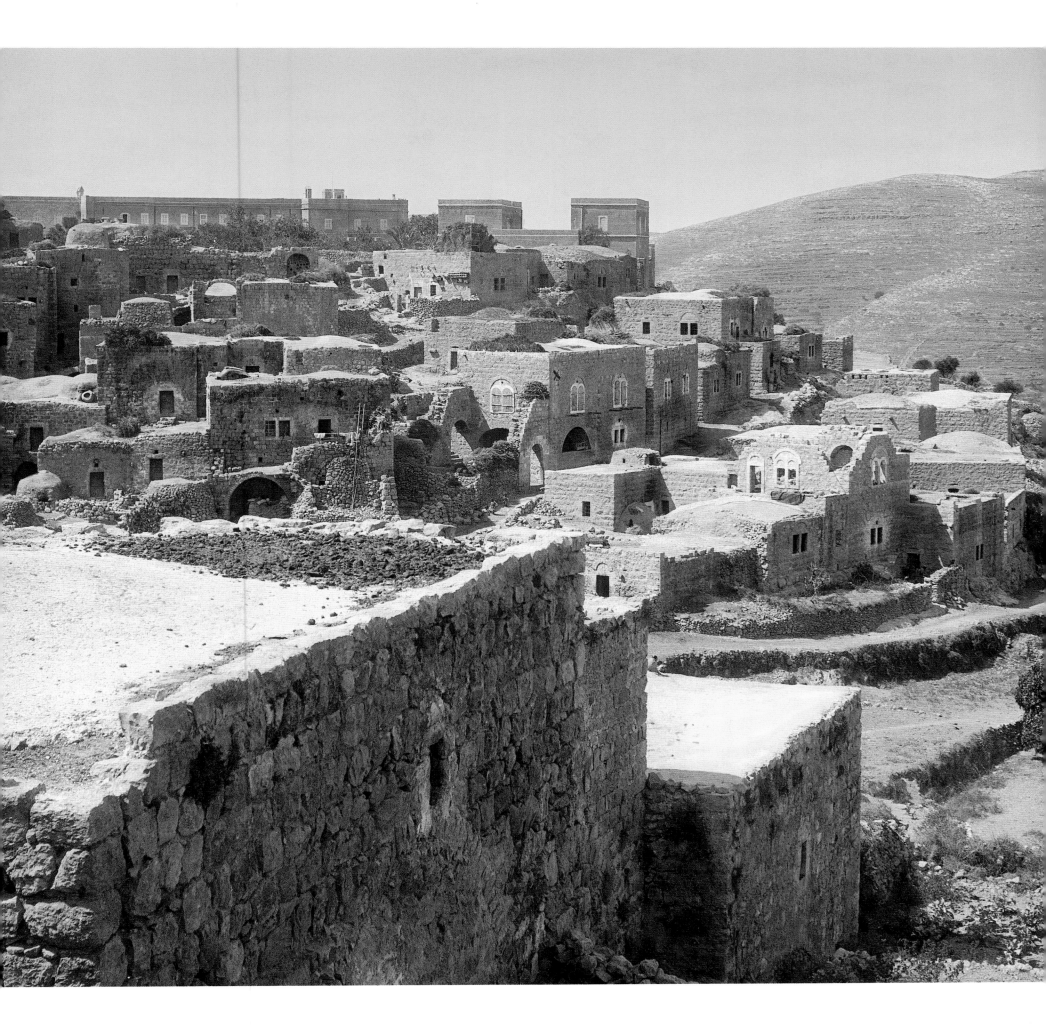

VIEW FROM GETHSEMANE.
The Garden of Gethsemane, where Christ prayed the night before his crucifixion, lies at the foot of the Mount of Olives.

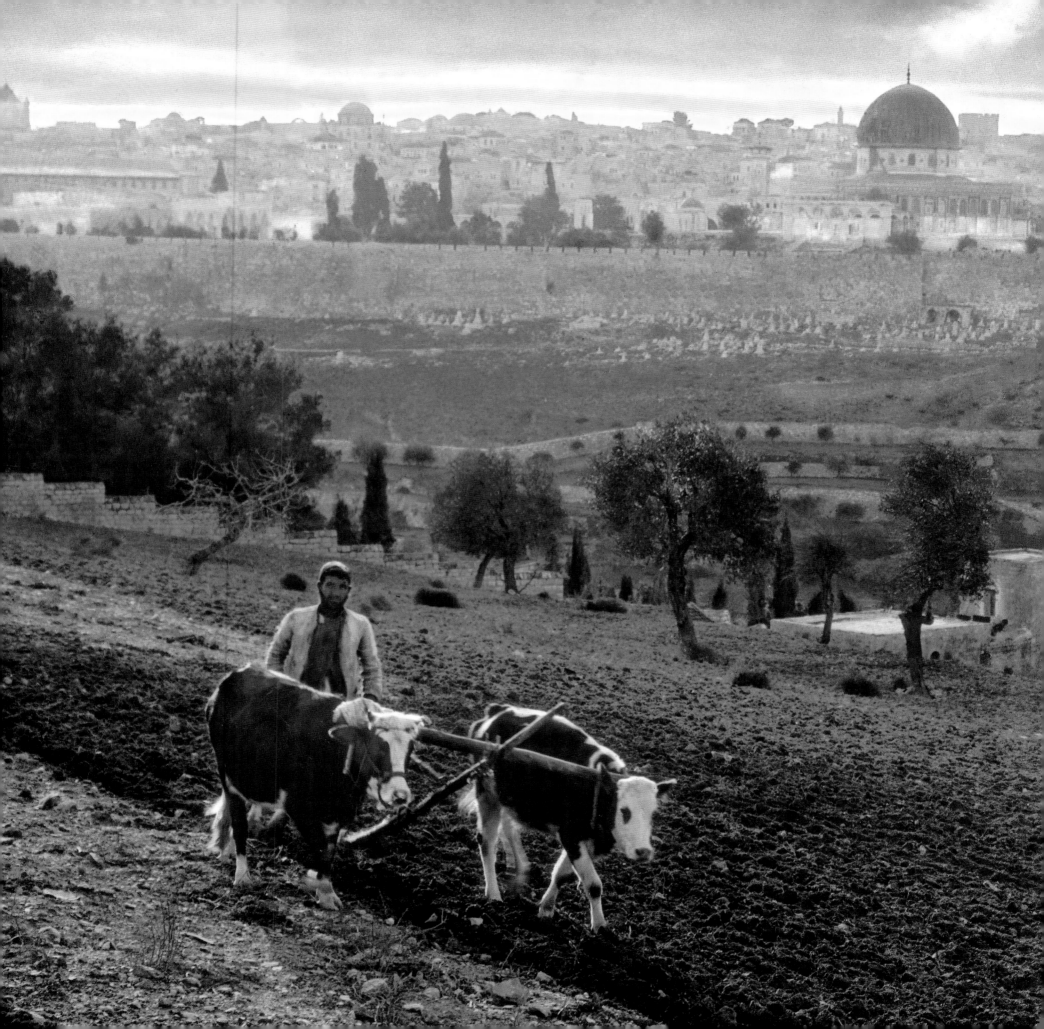

3 VILLAGE LIFE

THE BASIC FEATURES OF VILLAGE LIFE in the Holy Land as depicted in these photographs would have been familiar to Jesus from his Nazareth upbringing. His mother and the other women would have gone to the well for water, baked bread, prepared meals and performed other housekeeping chores. His father would have plied his trade as a carpenter while their neighbors planted and plowed their fields of wheat, barley, lentils, and chickpeas, harvested olives, tended vineyards and orchards, or herded sheep and goats for their livelihoods. In some regards, these ancient ways of life have changed little since Old Testament times, with many generations following the professions of the sons of Adam and Eve—Cain a farmer and Abel a shepherd.

The shops and marketplace were the hub of village life, where potters, metalworkers, stonecutters, weavers, oil vendors and others sold their wares. Village houses, situated on narrow, winding streets, usually centered on a courtyard shared by several families and consisted of one to two rooms with flat roofs and narrow doorways. Houses were made of mud bricks or sometimes stone and were dark and often smoky due to poor ventilation; mostly people spent their time outdoors.

MAN PLOWING.
On a rocky slope, a Fellah (an agricultural laborer, as distinct from a nomadic Bedouin) is plowing a field with an ox and an ass held together by a sturdy wooden yoke, with one hand on a primitive plow and the other holding a goad to urge the animals forward.

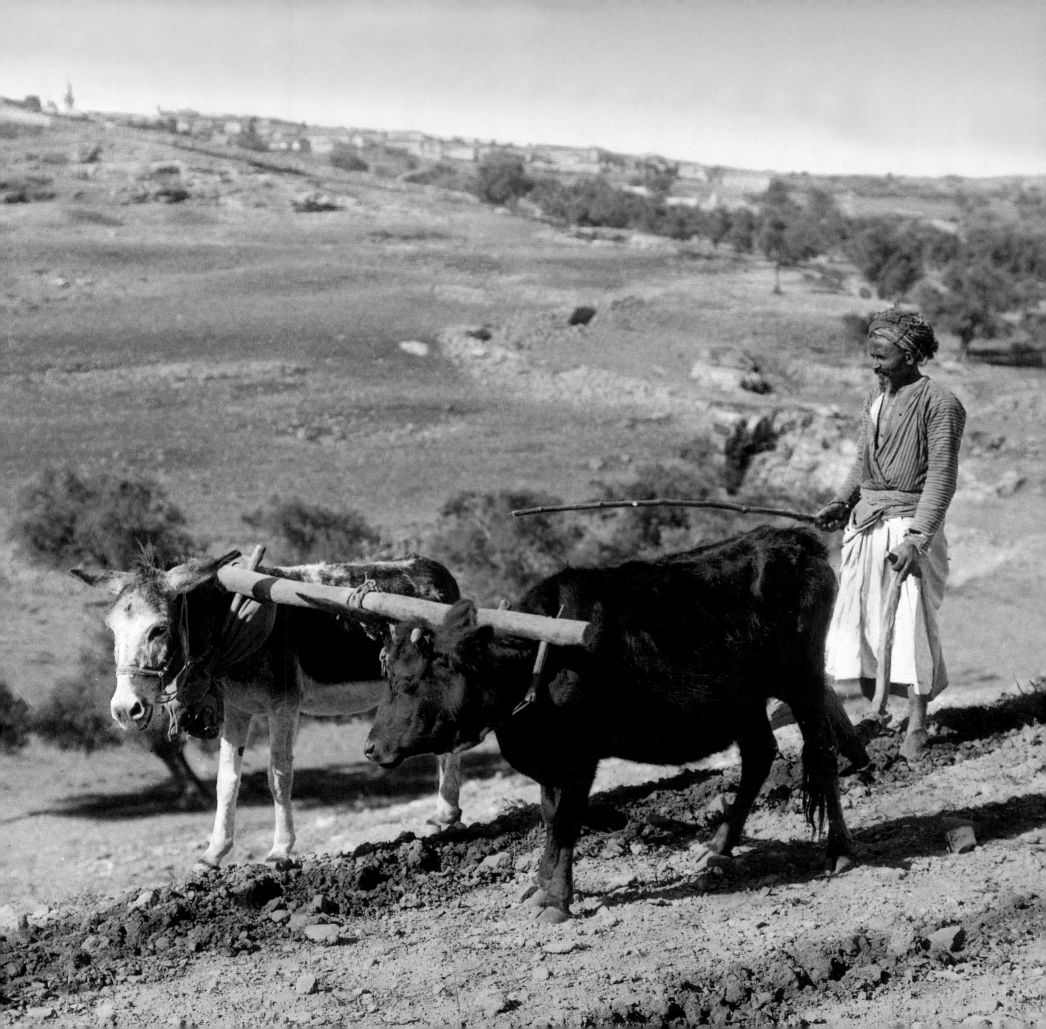

MOSLEM MEN PRAYING.
The daily cycle of prayers is one of the Five Pillars of Islam and consists of prayers said five times a day. The muezzin *sounds the call to prayer to the faithful, and although they are encouraged to pray with others in local mosques, it is acceptable to pray almost anywhere.*

WOMEN CARRYING THEIR WATER JARS.
Women and girls would traverse one by one on a narrow footpath heading for a nearby village. All would be barefoot and one arm would be raised to steady the jar.

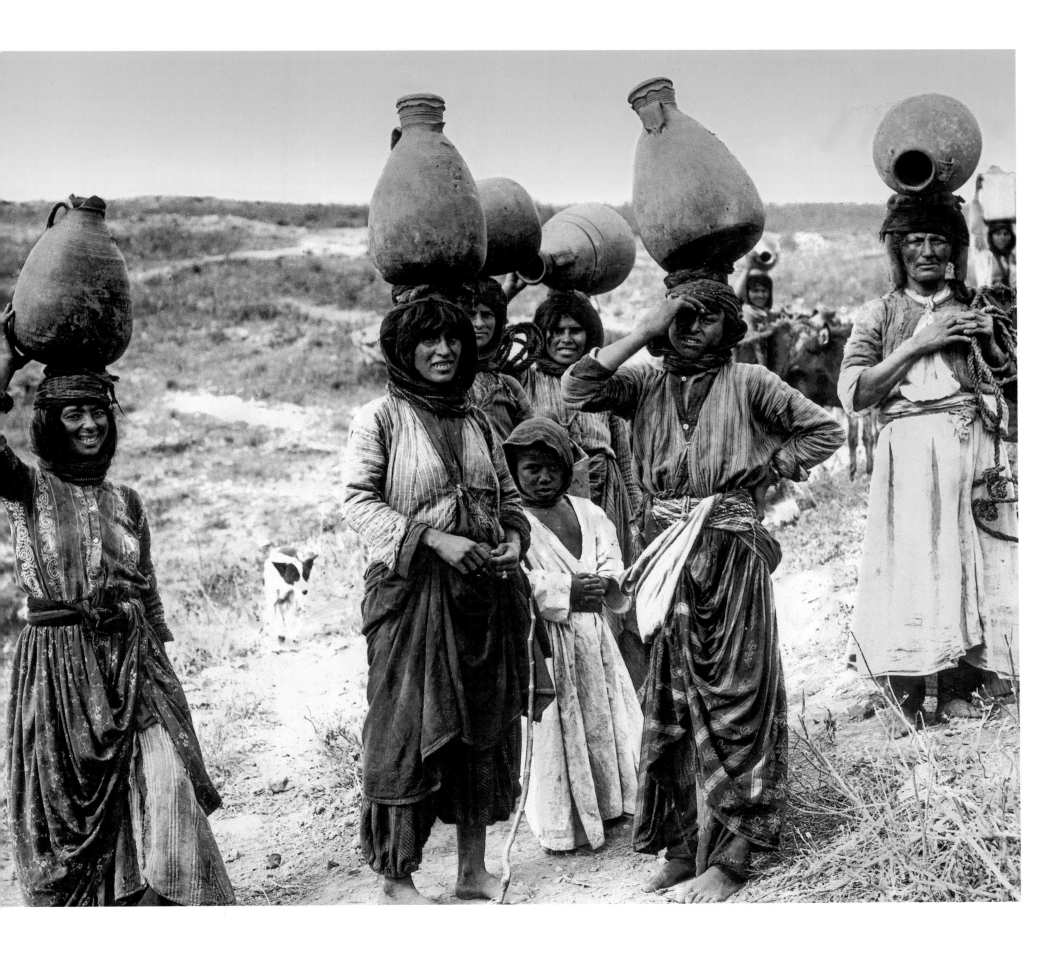

FILLING WATER JARS AT THE WELL.

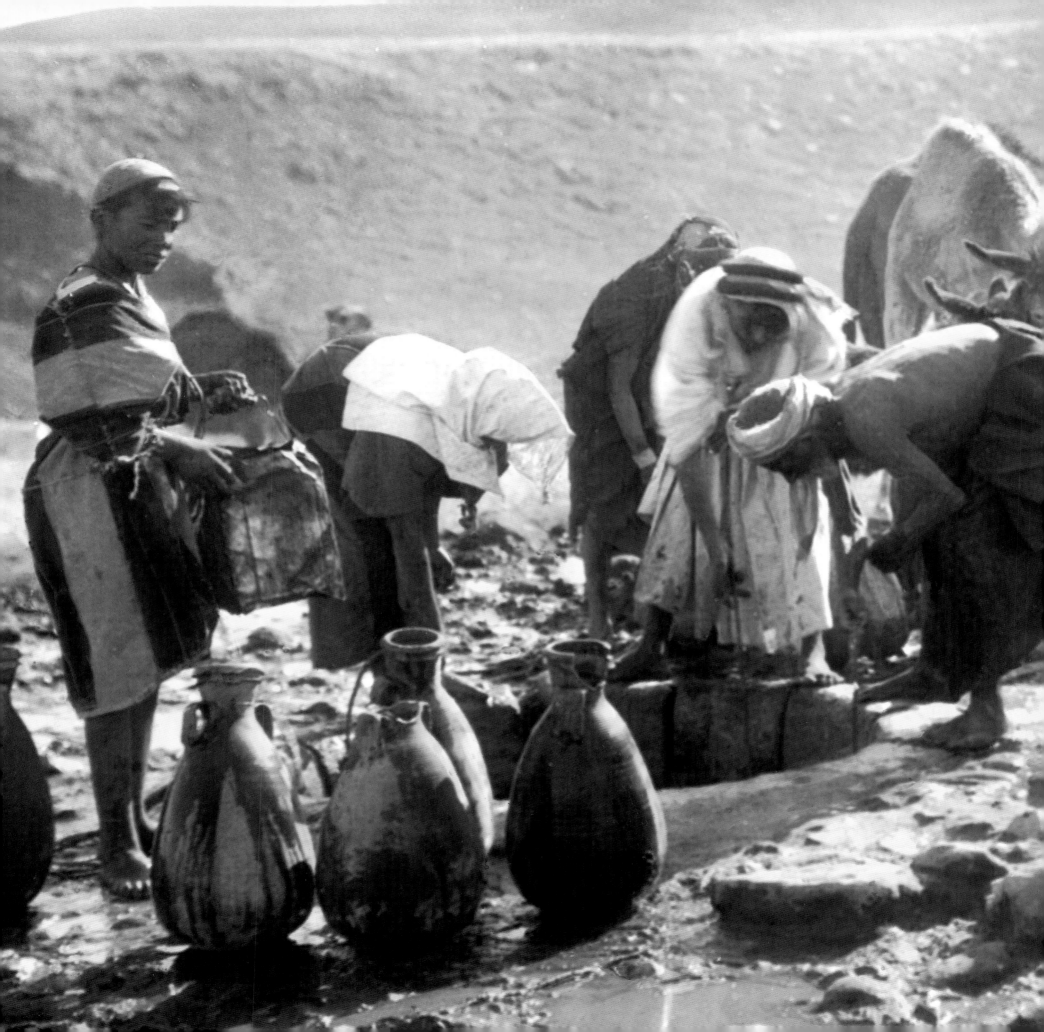

REAPERS IN THE FIELD OF BOAZ DURING THE WHEAT HARVEST.
This is the setting of the Book of Ruth, where Ruth went to glean in the fields the leavings of the harvesters. The Hill of Bethlehem is in the background.

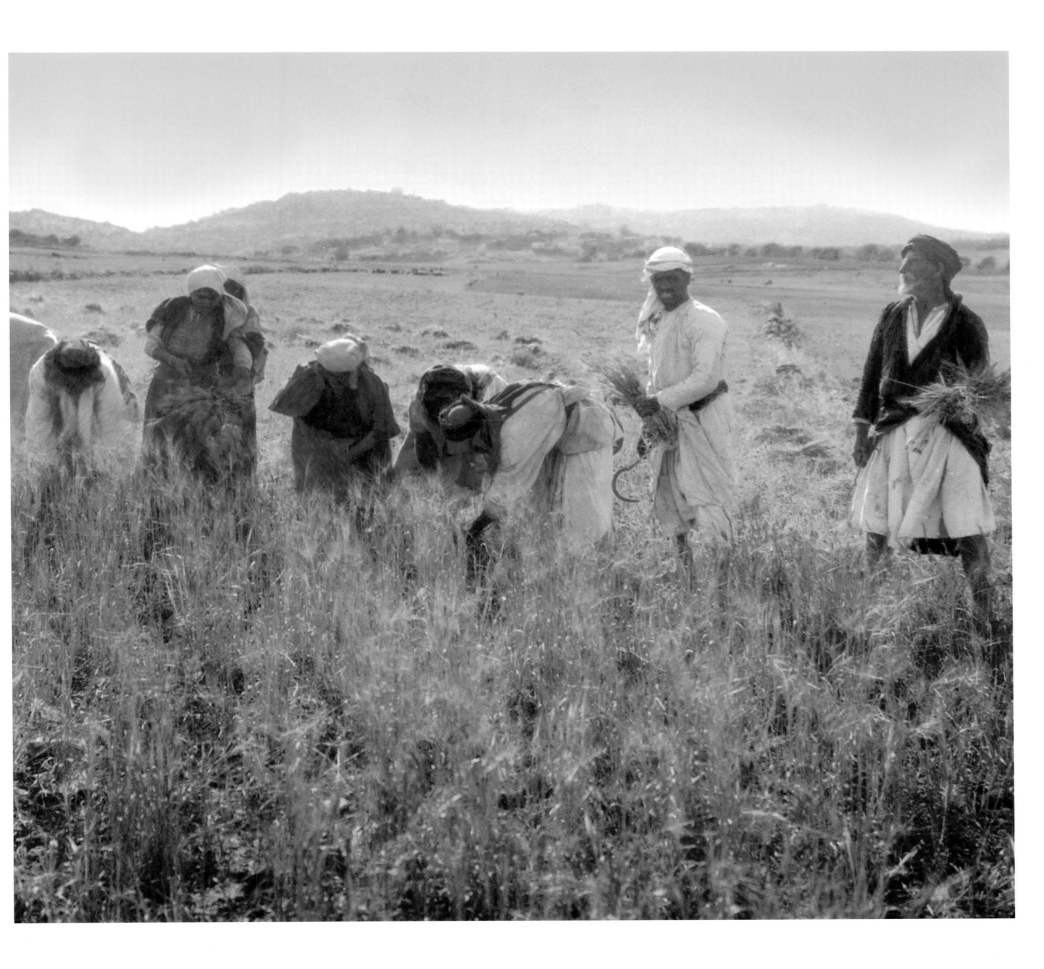

MAN IN WHEAT FIELD.

Usually the men were in the field before dawn and the women would bring a meal of flatbread, olives, and lebaneh, *a yogurt dish seasoned with thyme and dried mint, and dressed with olive oil.*

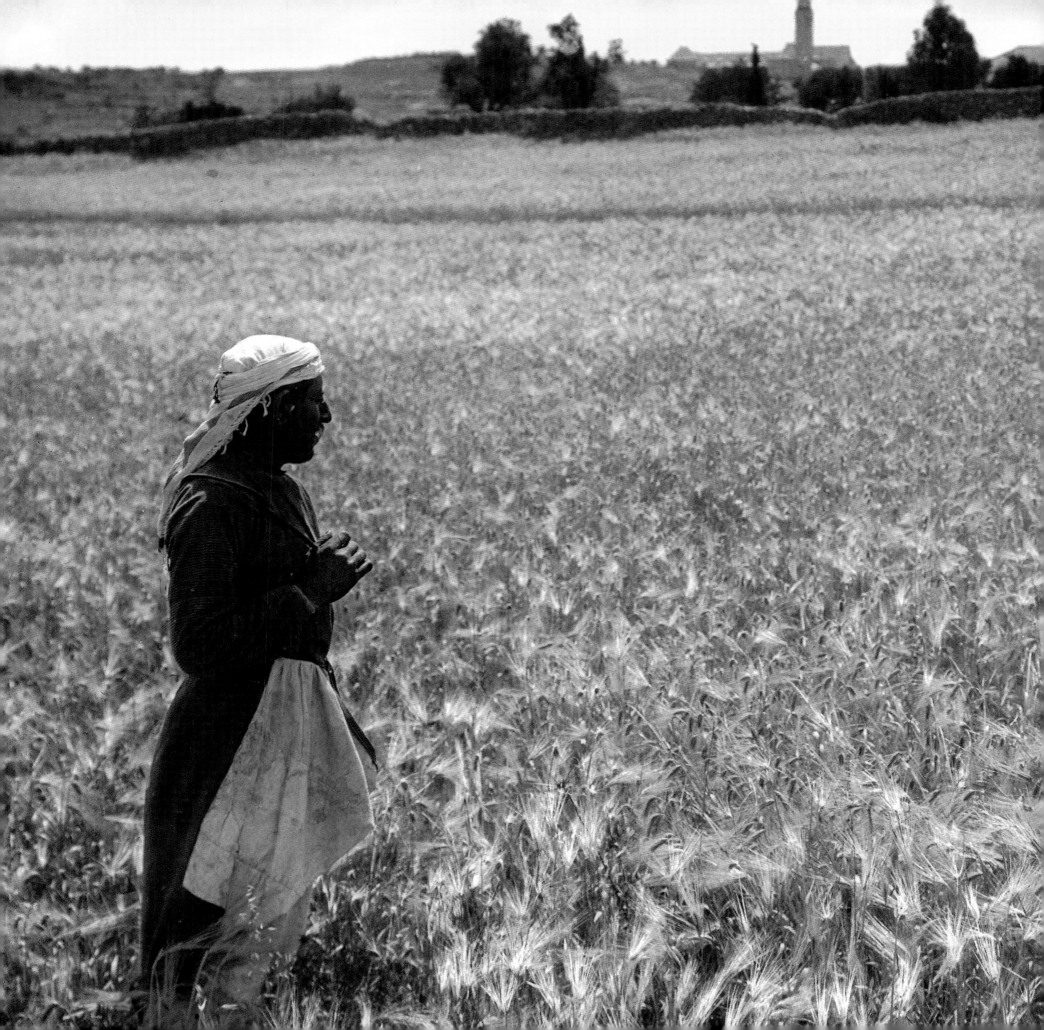

MAN WITH SHEAF OF WHEAT.

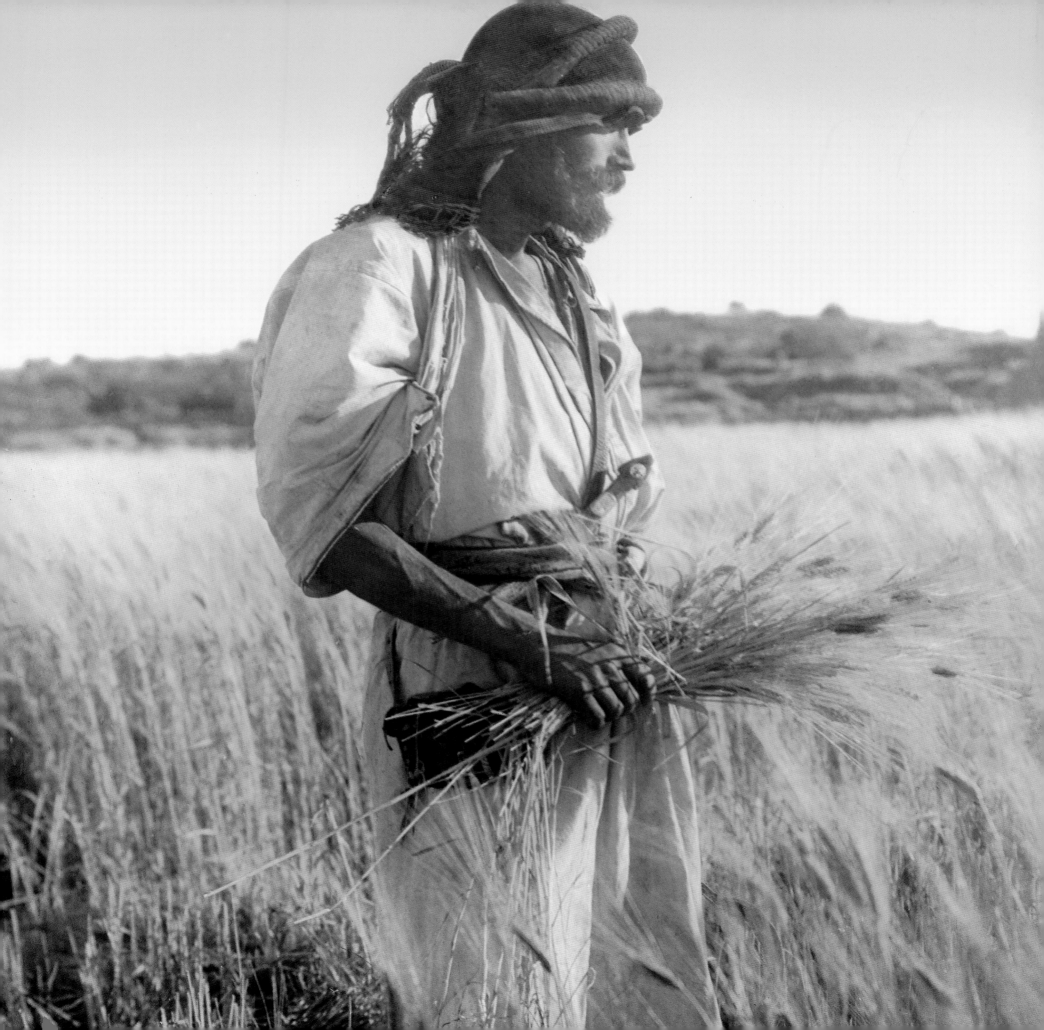

WORKERS IN A FIELD OUTSIDE BEITIN.
*Beitin, widely believed to be the Biblical town of Bethel, is about 10 miles
north of Jerusalem.*

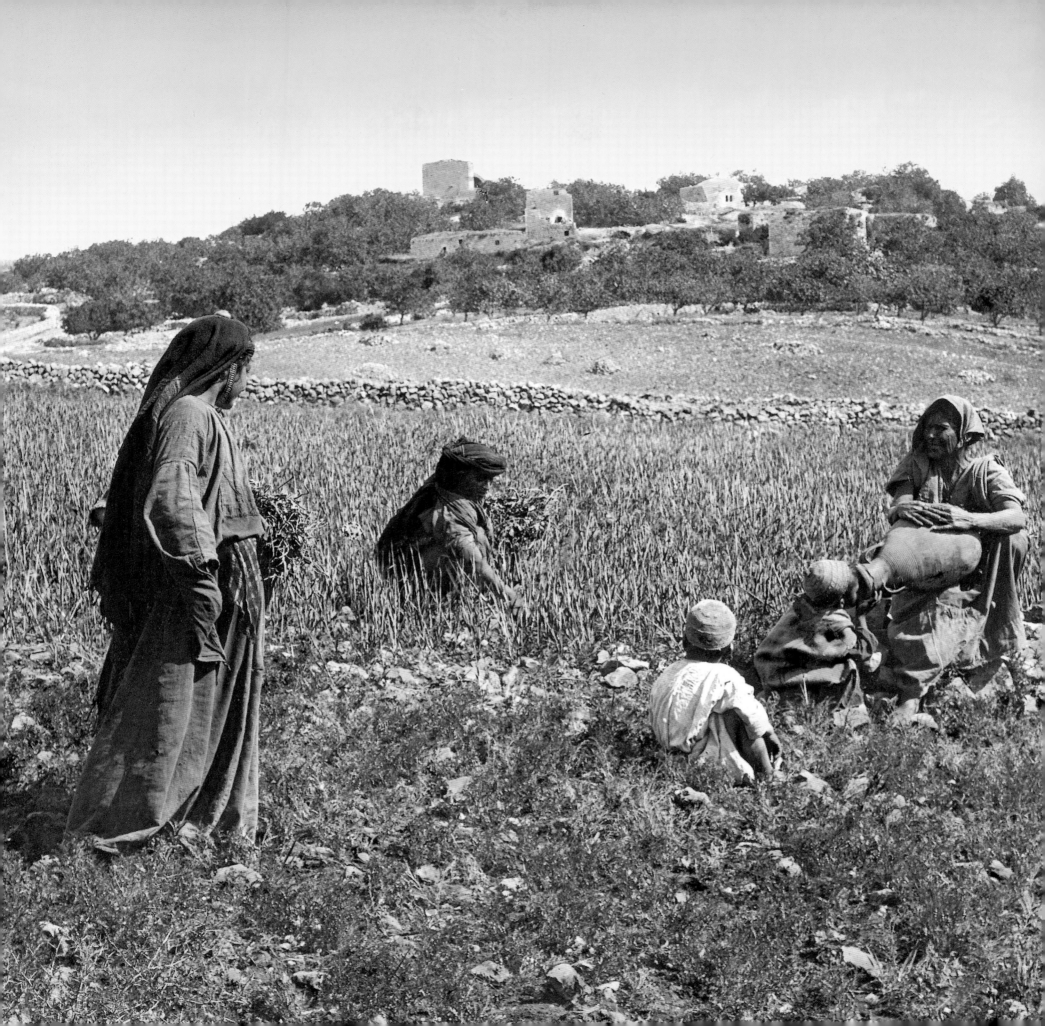

GATHERING TARES.

But he said, Nay; lest while ye gather up the tares, ye root up also the wheat with them. Let both grow together until the harvest: and in the time of harvest I will say to the reapers, Gather ye together first the tares, and bind them in bundles to burn them: but gather the wheat into my barn. Matthew 13: 29-30

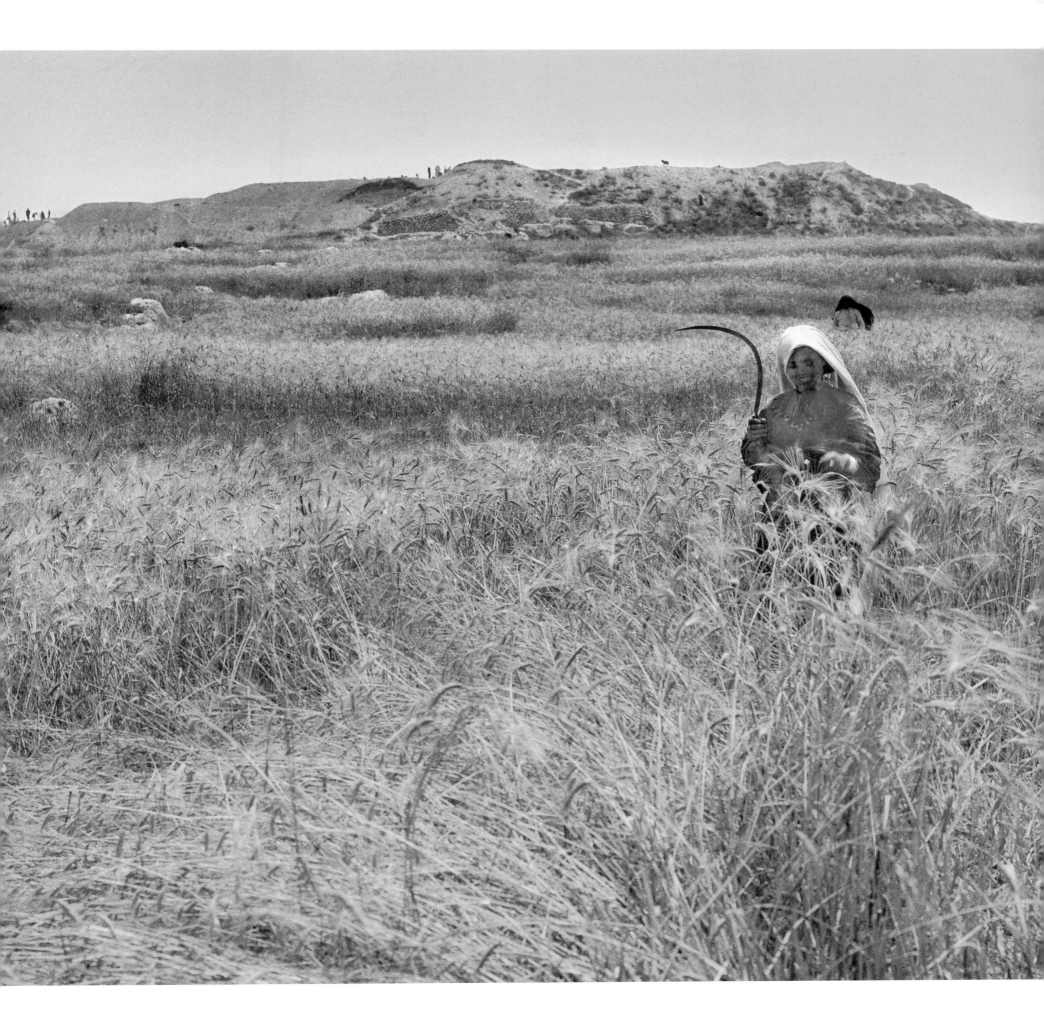

SHEEP GRAZING ON THE LEAVINGS IN HARVESTED FIELDS.
And ye my flock, the flock of my pasture, are men, and I am your
God, saith the Lord GOD. Ezekiel 34:31

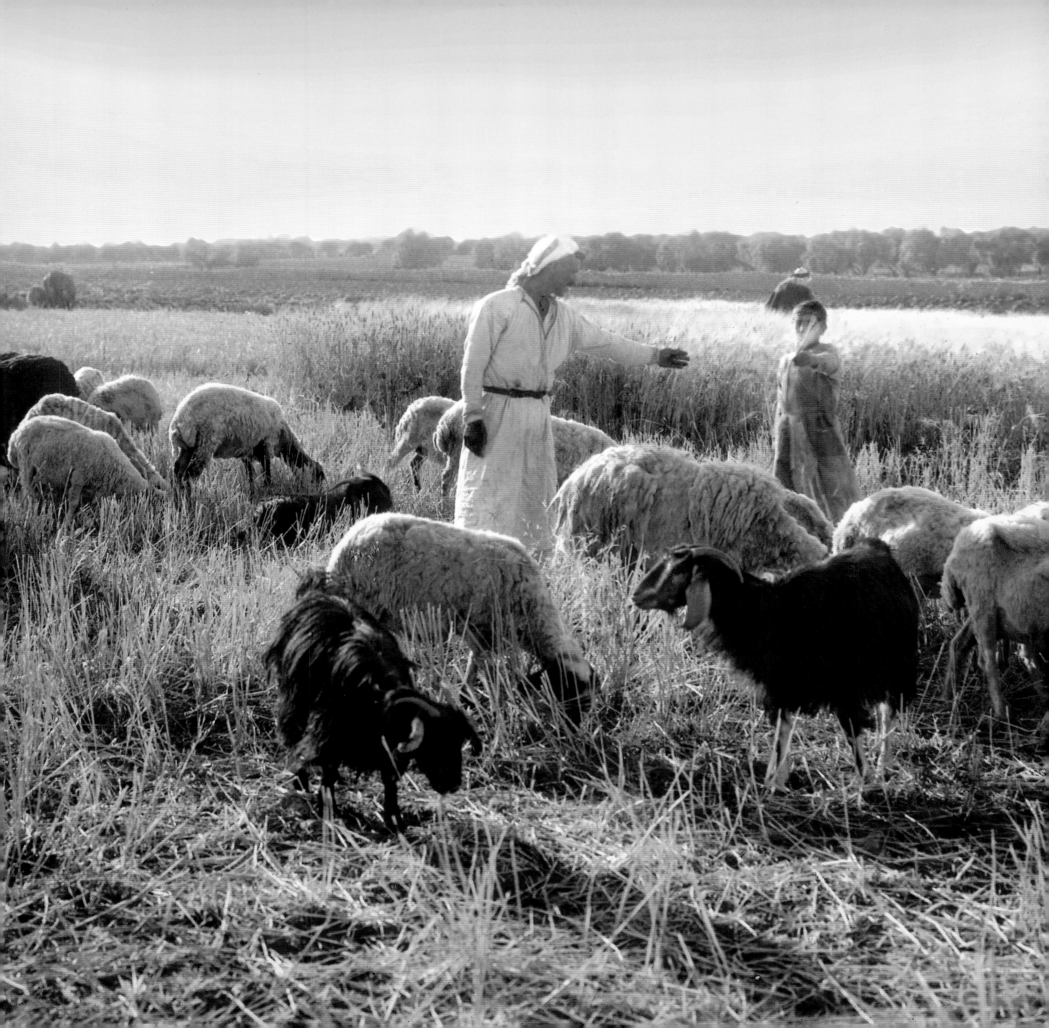

SHEPHERD BOY PLAYING HIS FLUTE.
A reed flute would have been standard equipment for a shepherd, along with his rod, staff, and slingshot.

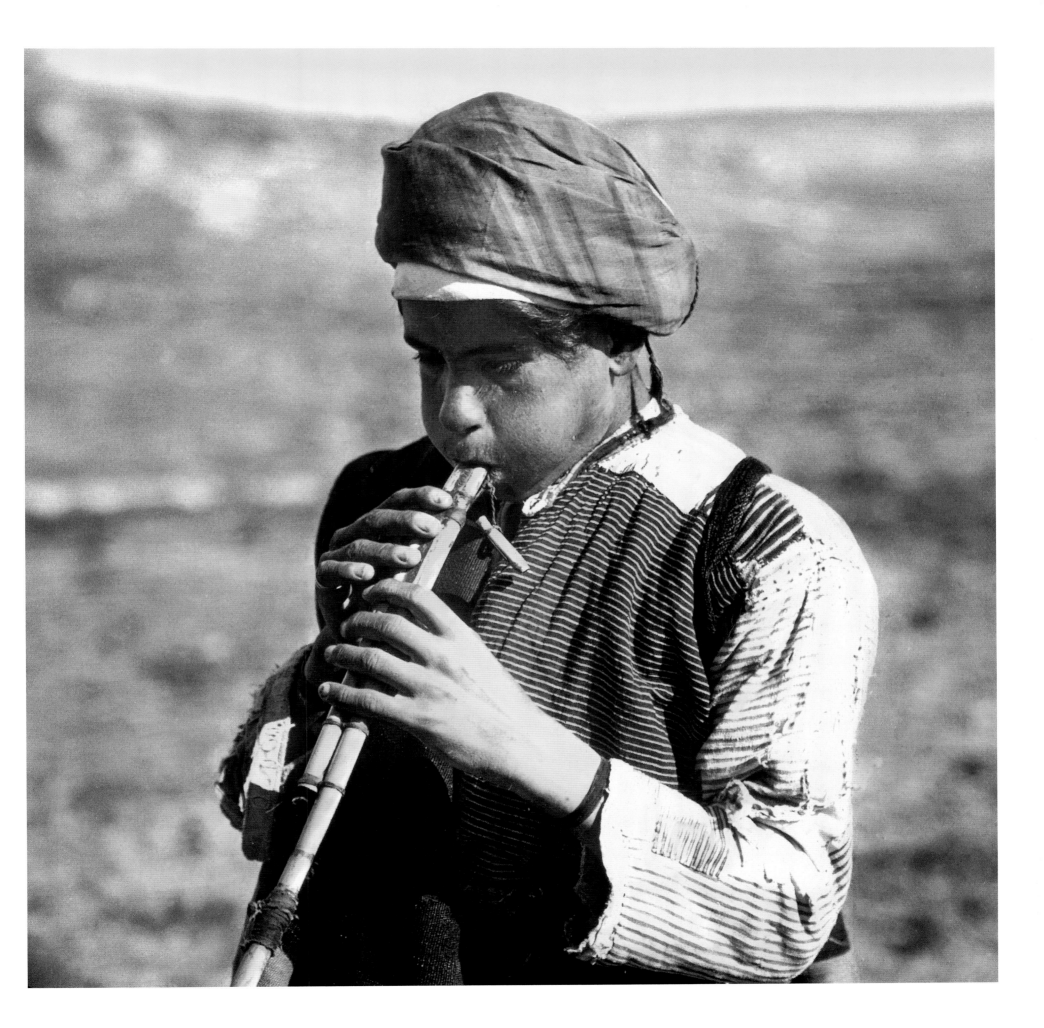

MAN AND WOMAN WITH HOES DIGGING THORNS FROM A CHICKPEA FIELD.

The chickpea is a staple of the region's diet, eaten most often in the form of hummus or falafel. Much to the consternation of those making a living by working the land, whether growing chickpeas or other crops, brambles, nettles, and thorns grow easily and abundantly in the Holy Land.

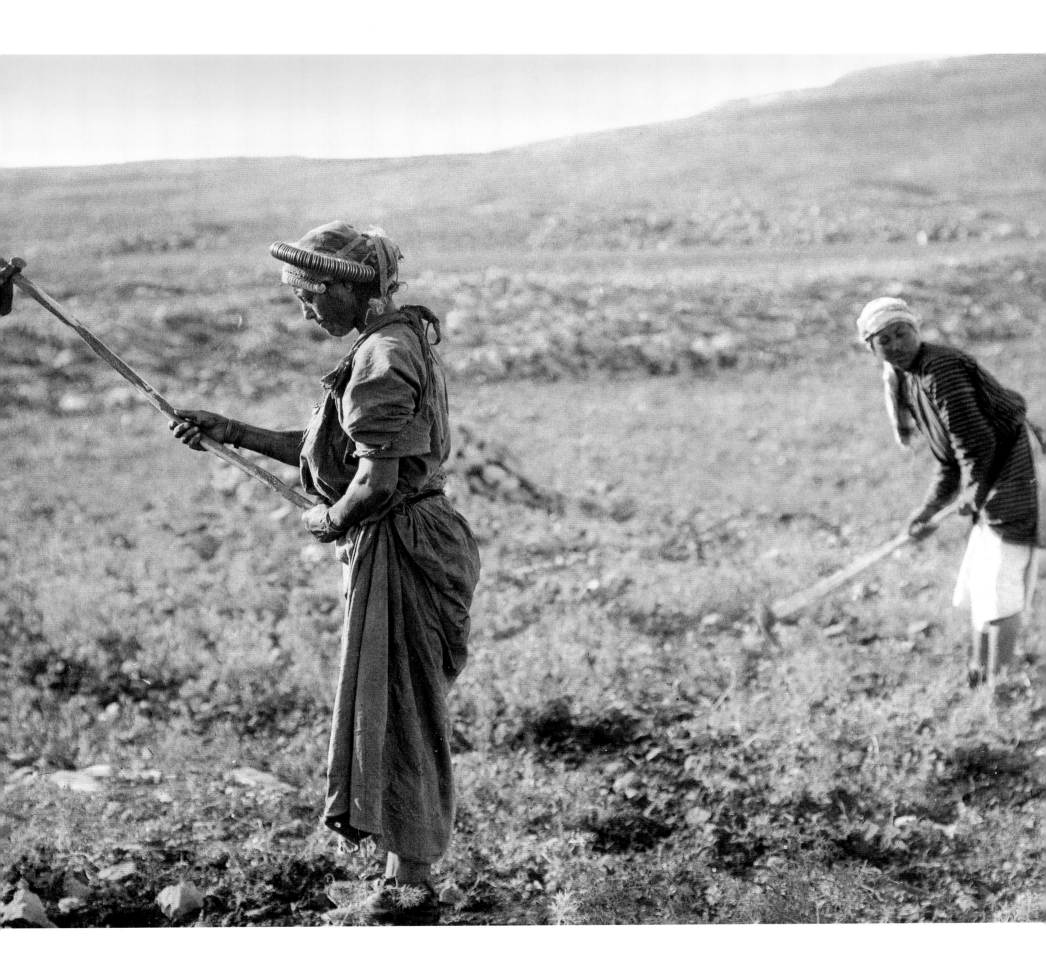

MAN CARRYING A BUNDLE OF RAPESEED.
Rapeseed, with its distinctive brilliant yellow flowers, is grown primarily for processing into edible vegetable oil and as animal feed.

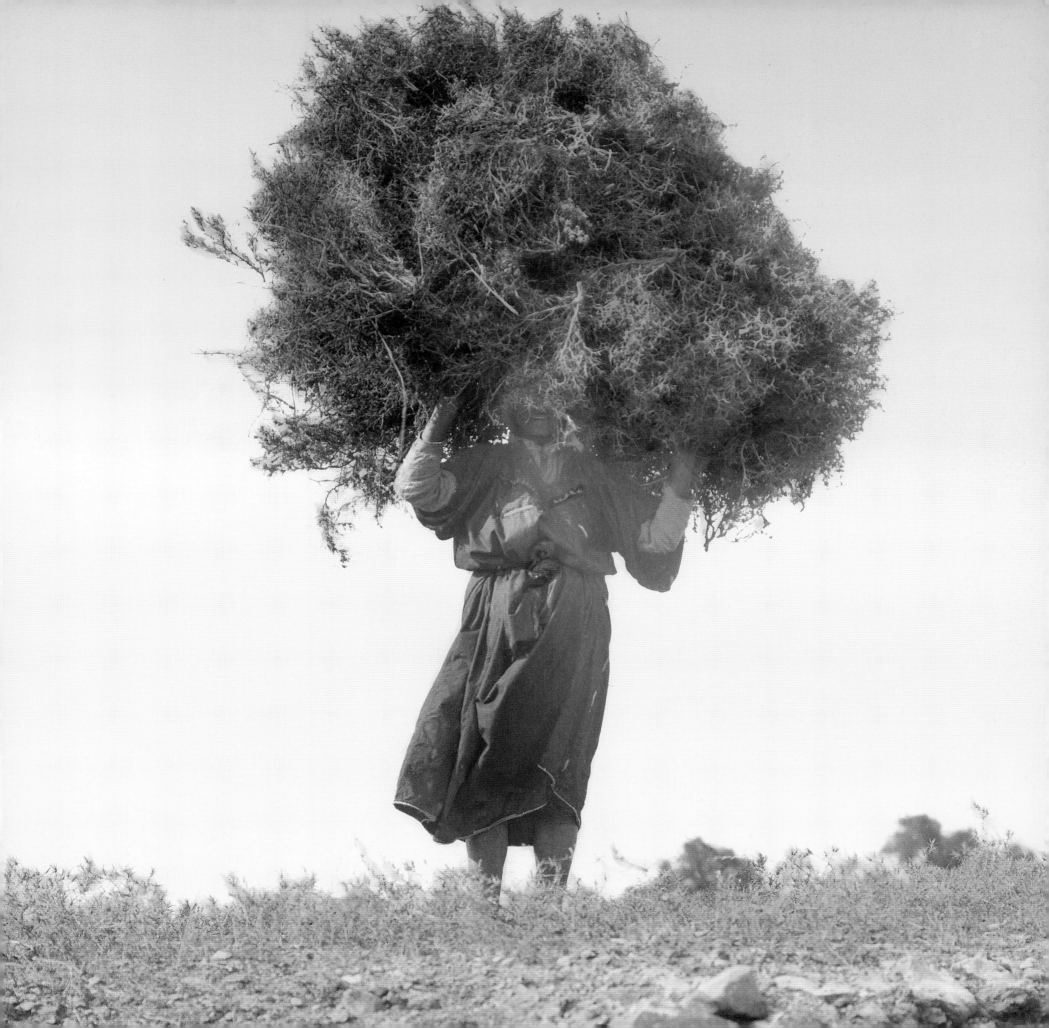

Man Overlooking the Village of Shafat.
Shafat is thought by some to be the site of the ancient Nob, city of the priests.

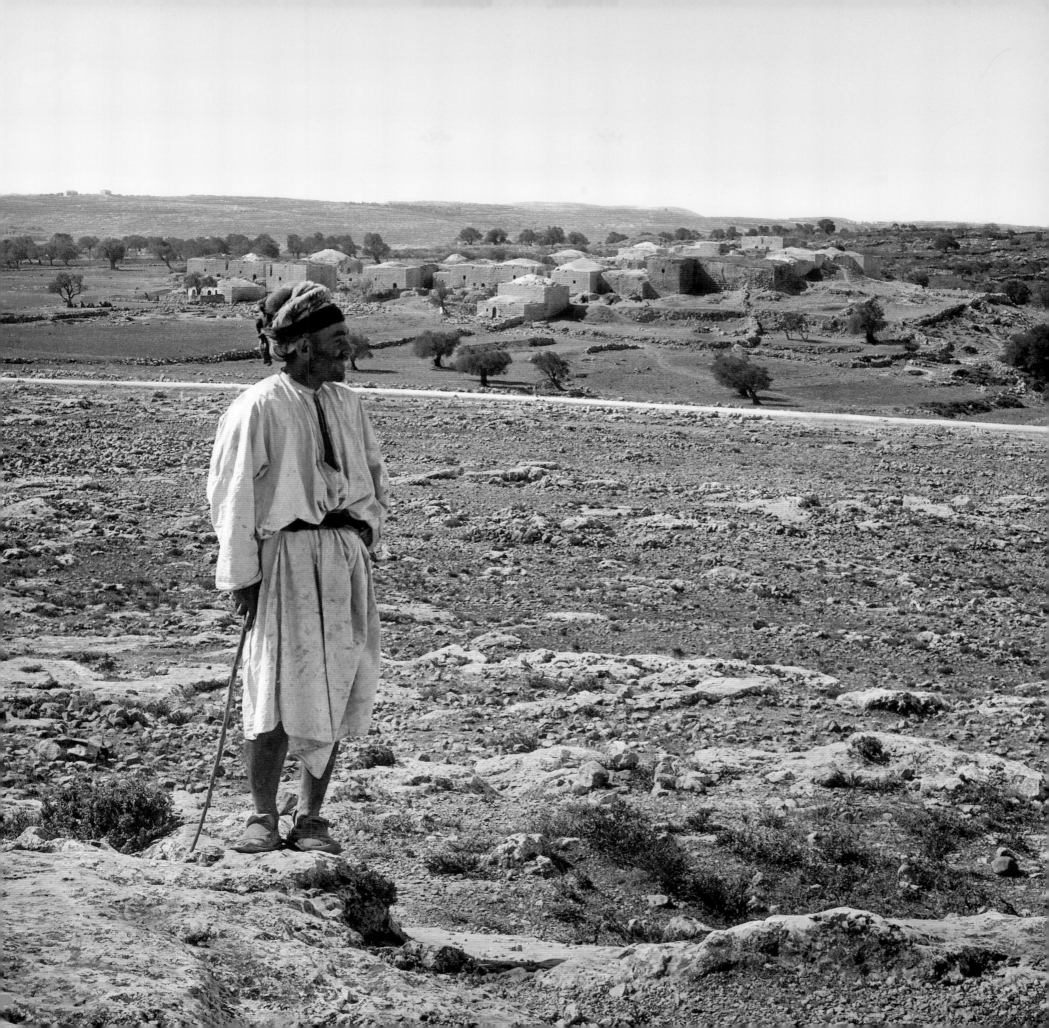

VILLAGE MEN IN AN UPPER ROOM.

This room would have been reserved for male guests, for the partaking of a meal and smoking a nargilah. *The meal would have consisted of flatbread, a relish made from vegetables and onions, and some homemade cheese and olives. The men would have eaten from a common plate set in the middle, tearing off pieces of bread with which to pick up the food.*

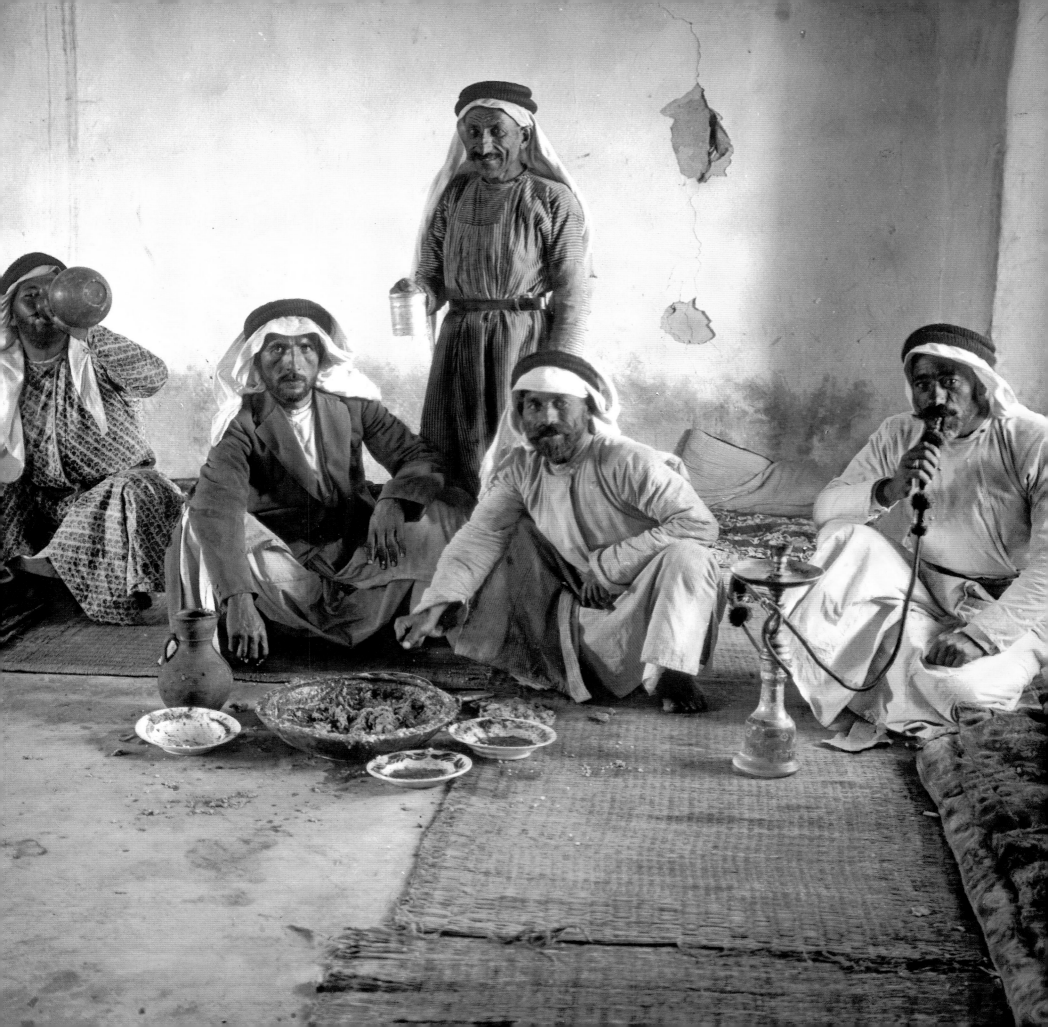

Village Women Inside a Home, Sifting Grain.

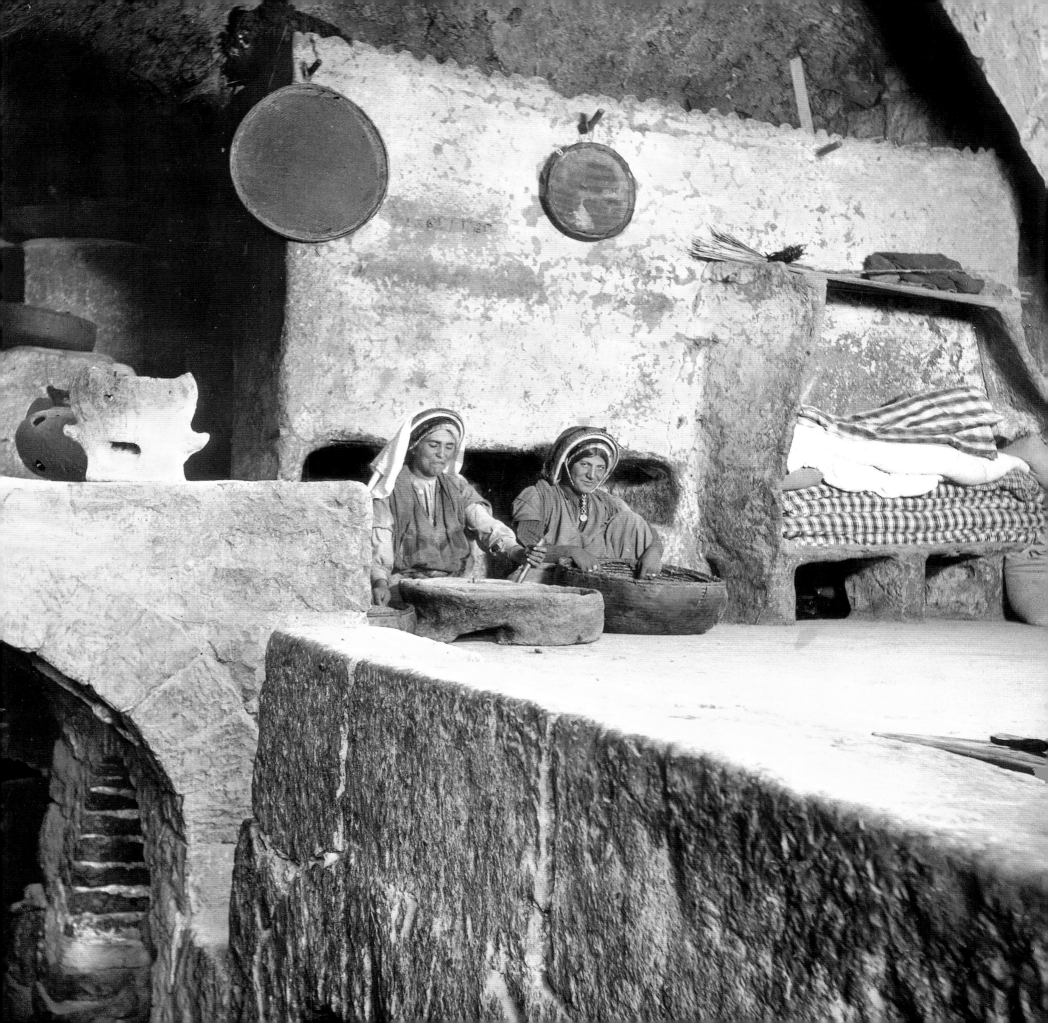

THREE YOUNG WOMEN, MAKING FLOUR.
The first chore of the day would be to grind the wheat. Two women would slowly turn the mill, with a third occasionally feeding it with fresh grain through a hole in the center. This was always the work of the women.

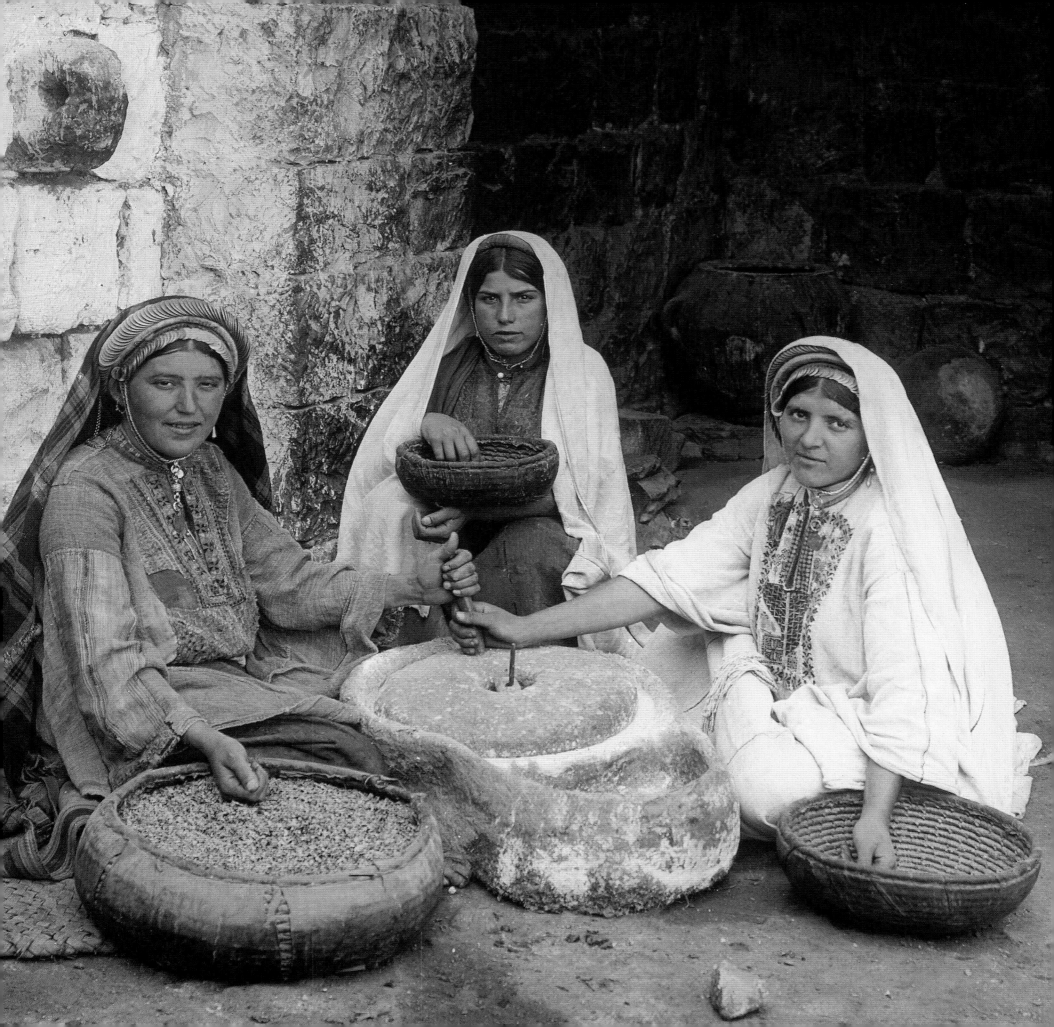

GIRL WITH HER ORNAMENTS.

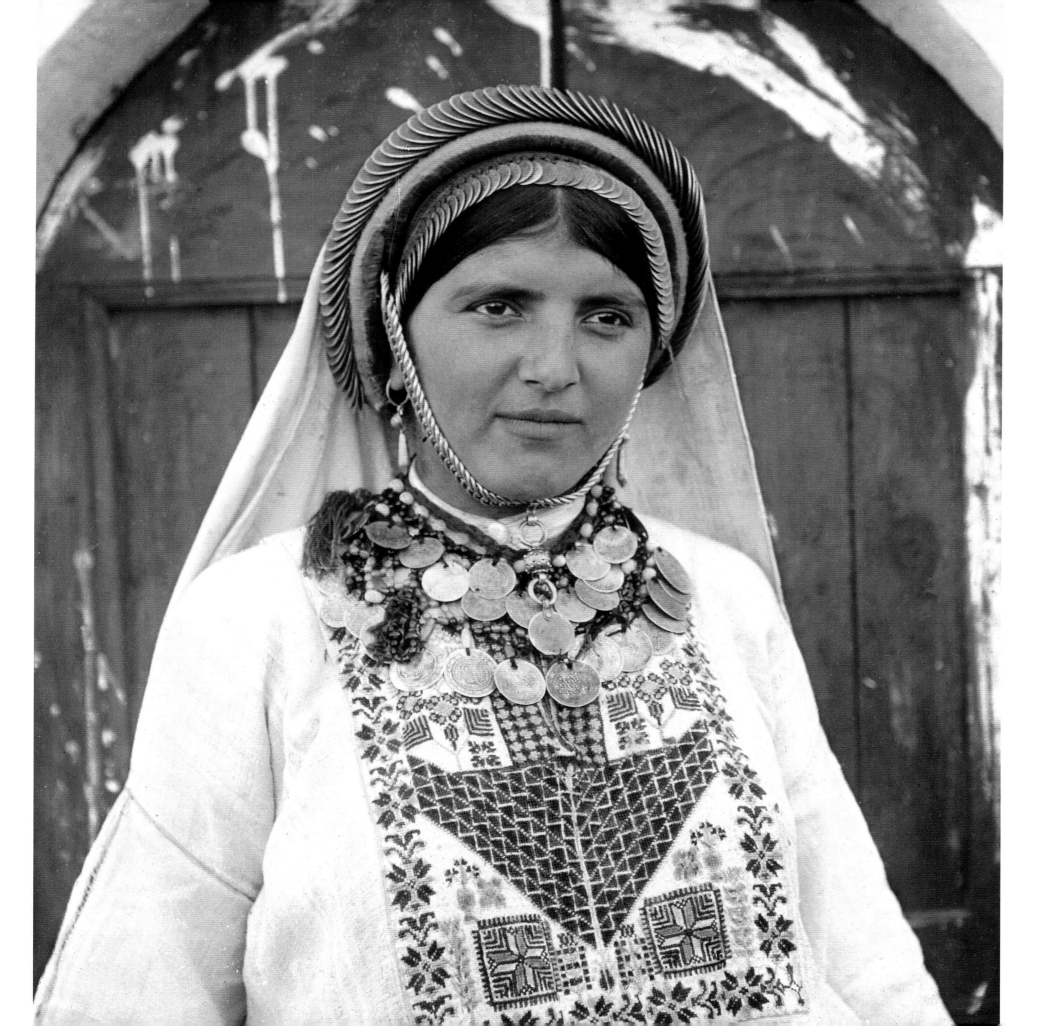

Making Bread on an Inverted Metal Bowl.

This technique has been used for generations as an outdoor oven—a large metal bowl held up by stones and a wood fire underneath.

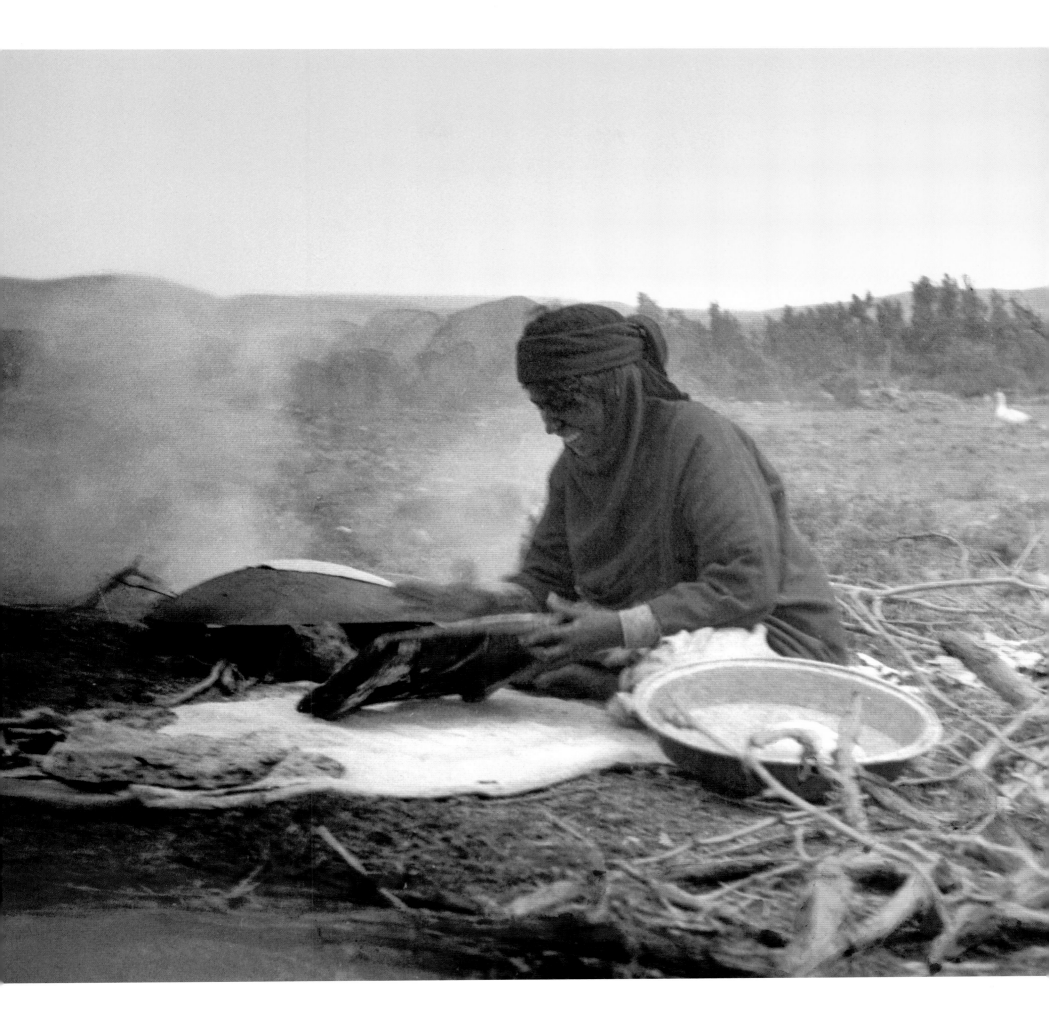

BOY WITH DISKS OF FLATBREAD.

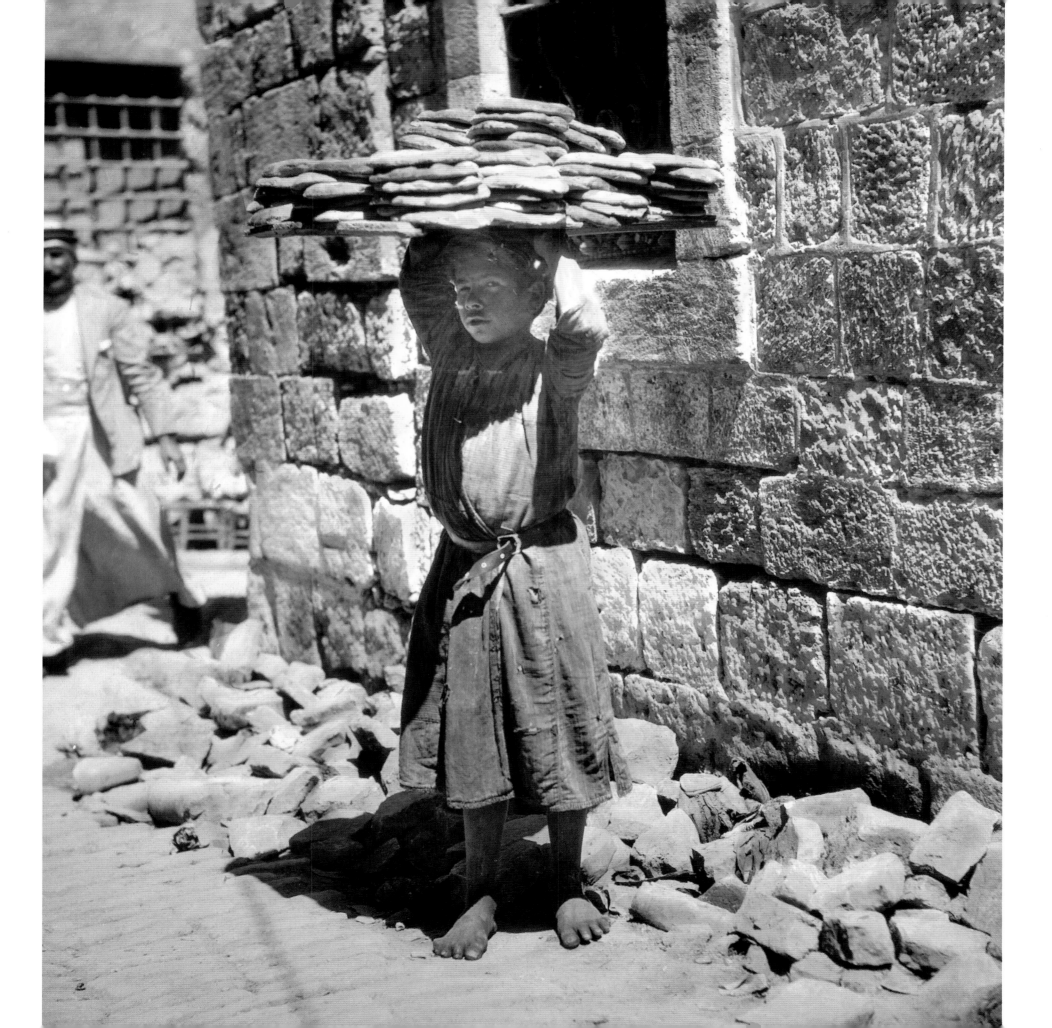

GIRLS WASHING CLOTHES AND WATCHING THE CHILDREN.

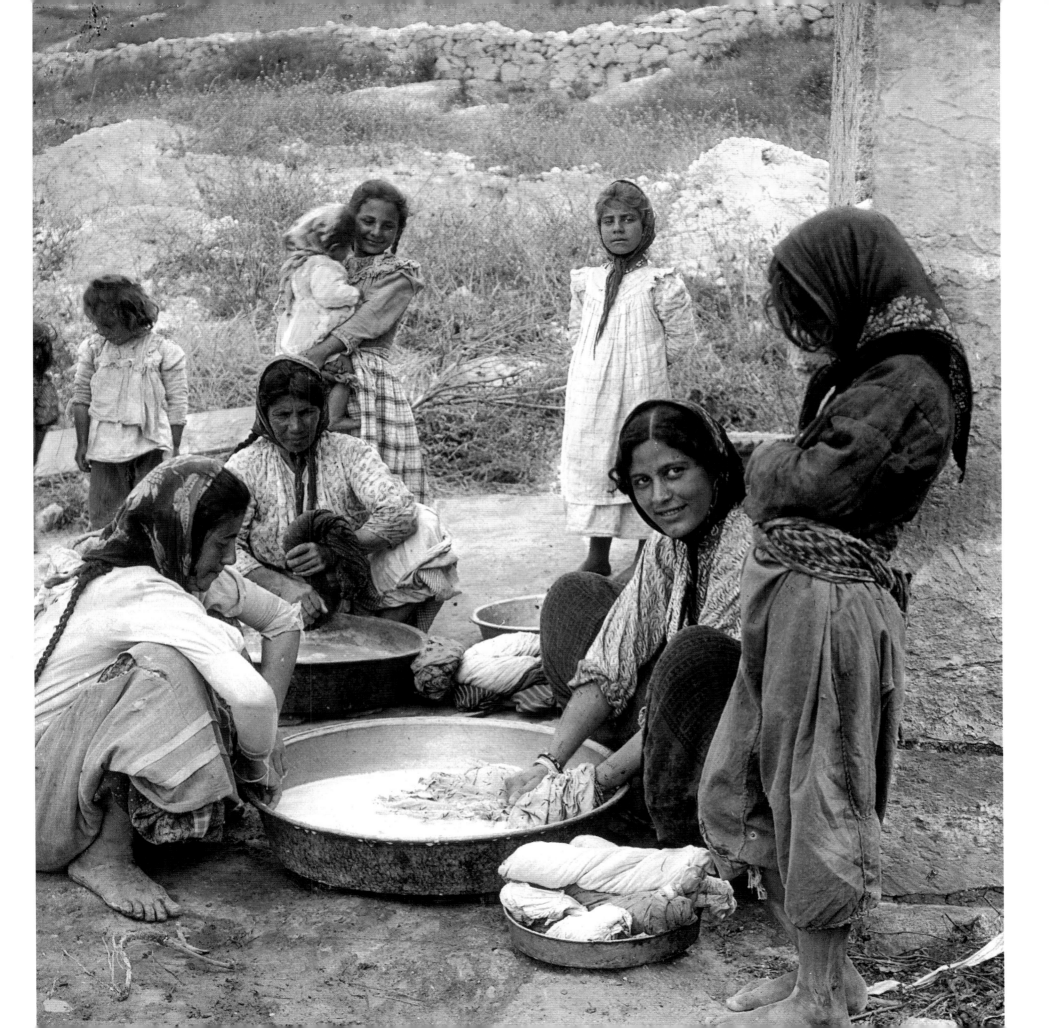

Doing Chores in Front of a Doorway.

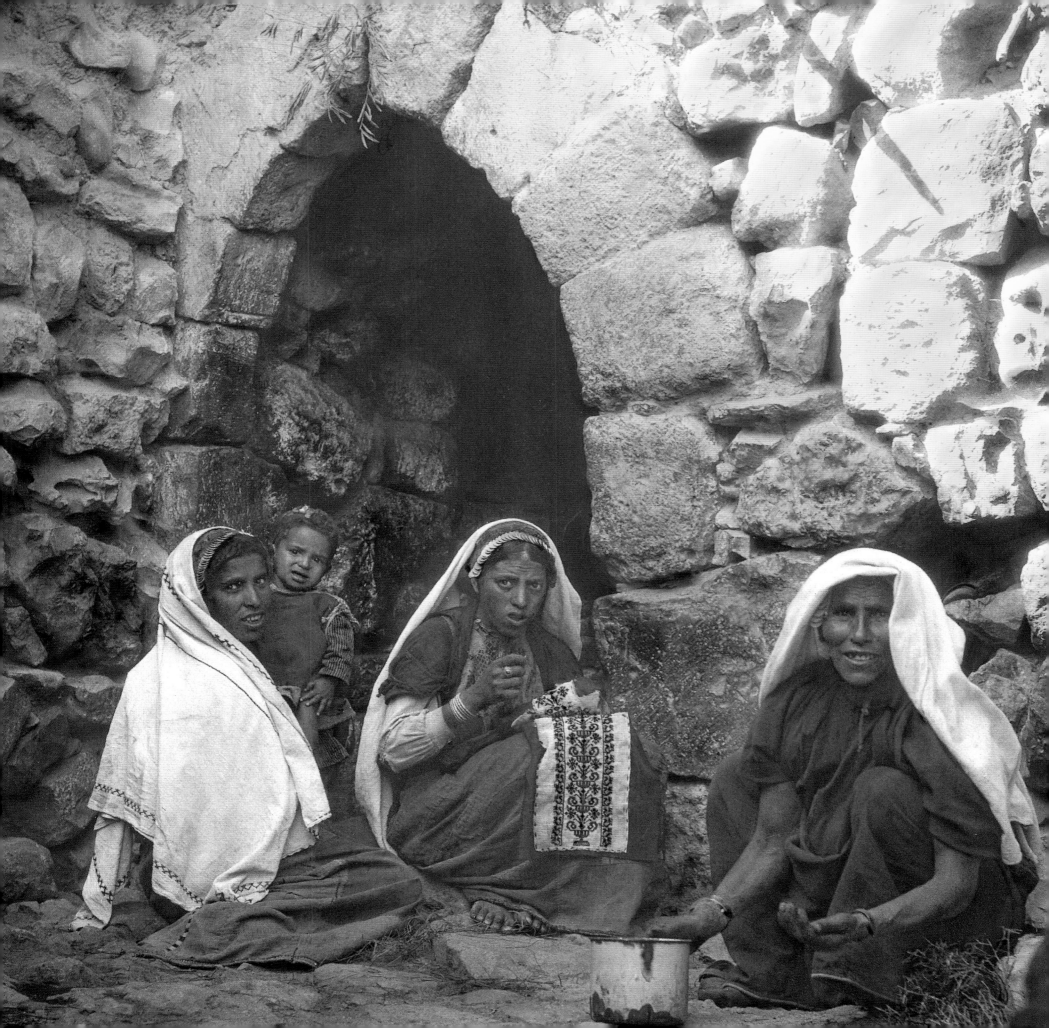

Girl Doing Embroidery.
Moslem women would often have elaborately embroidered breastplates on their dresses.

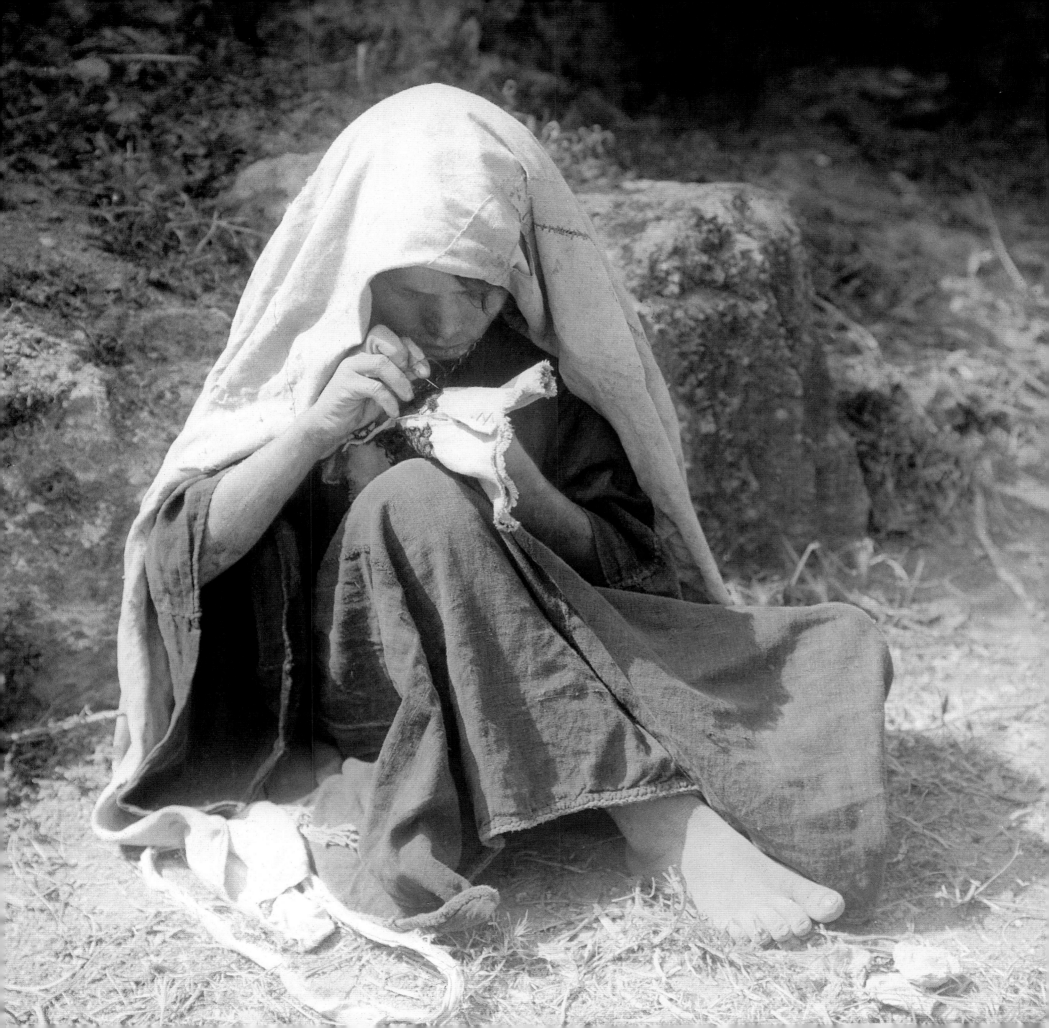

MAN PLOWING WITH CAMEL.

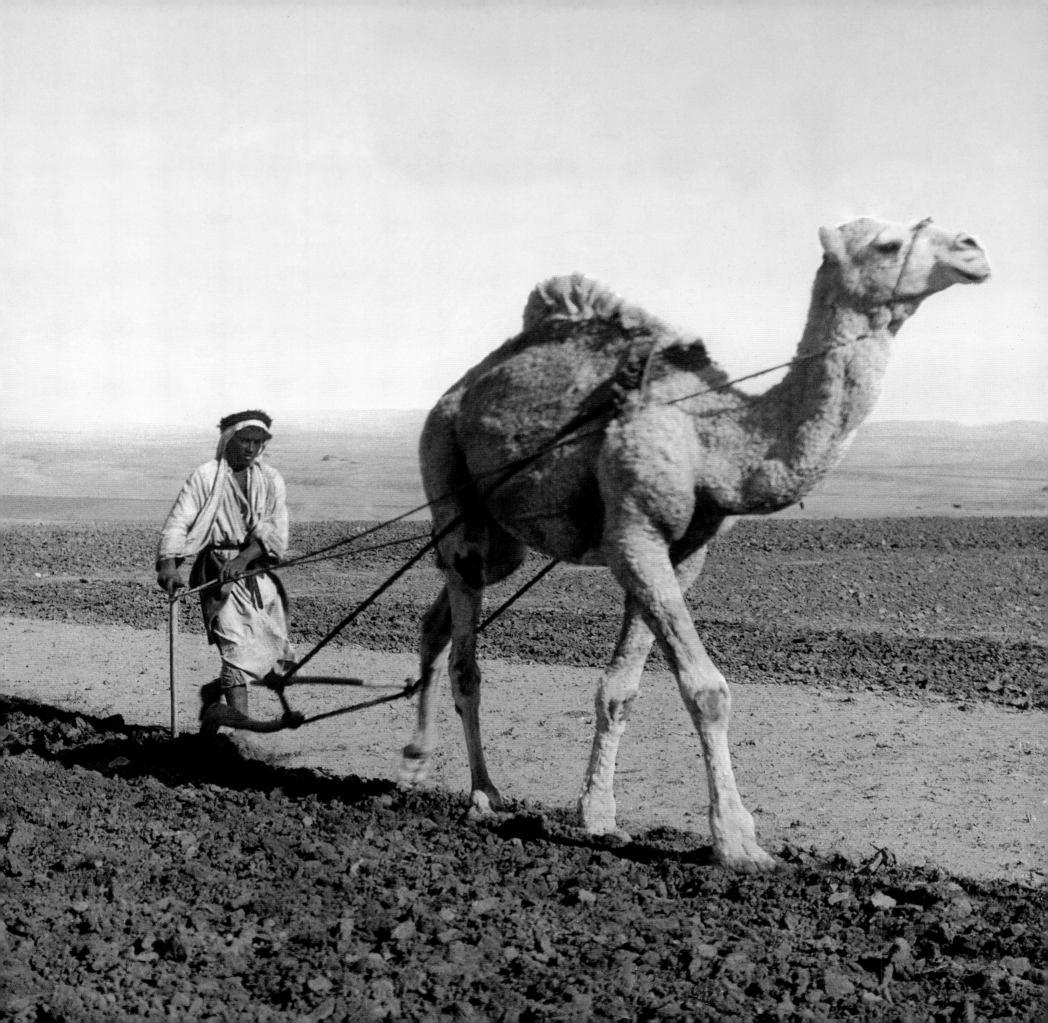

MEN SOWING.

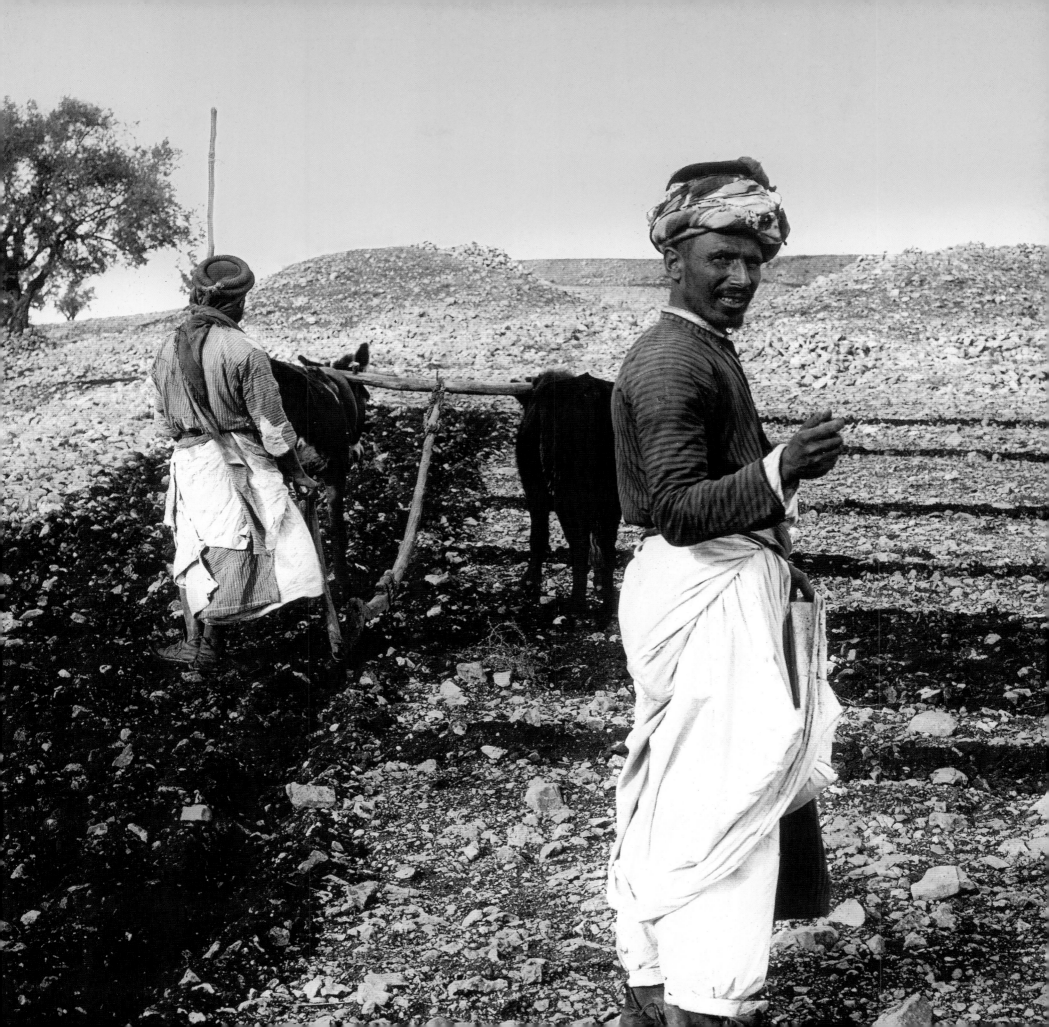

A Potter with his Pots.

A potter at work inside a clay hut. His wheel would be made to spin through the nimble action of his foot while his equally dexterous hands would shape a lump of wet clay to become a vessel for water.

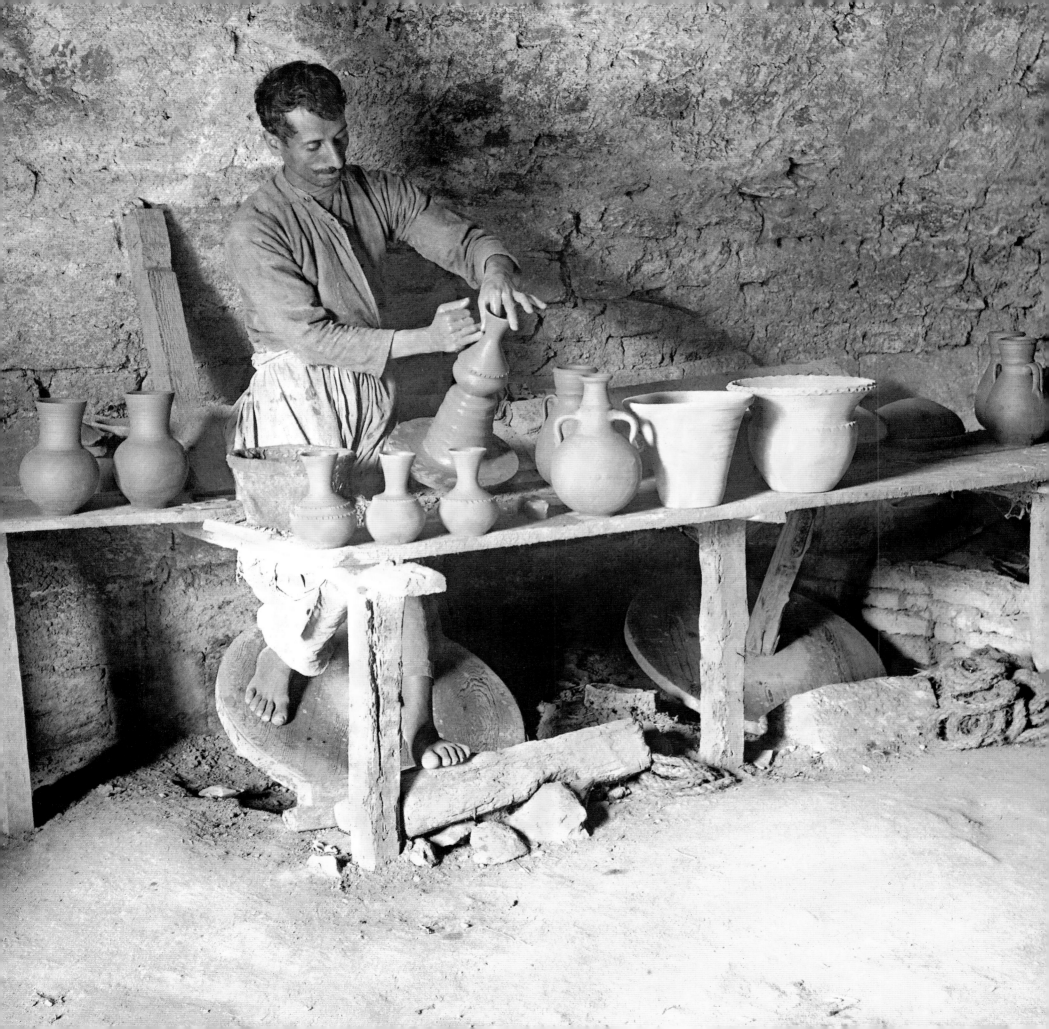

MAKING *ZIRS*, LARGE CLAY JARS USED TO HOLD WATER.

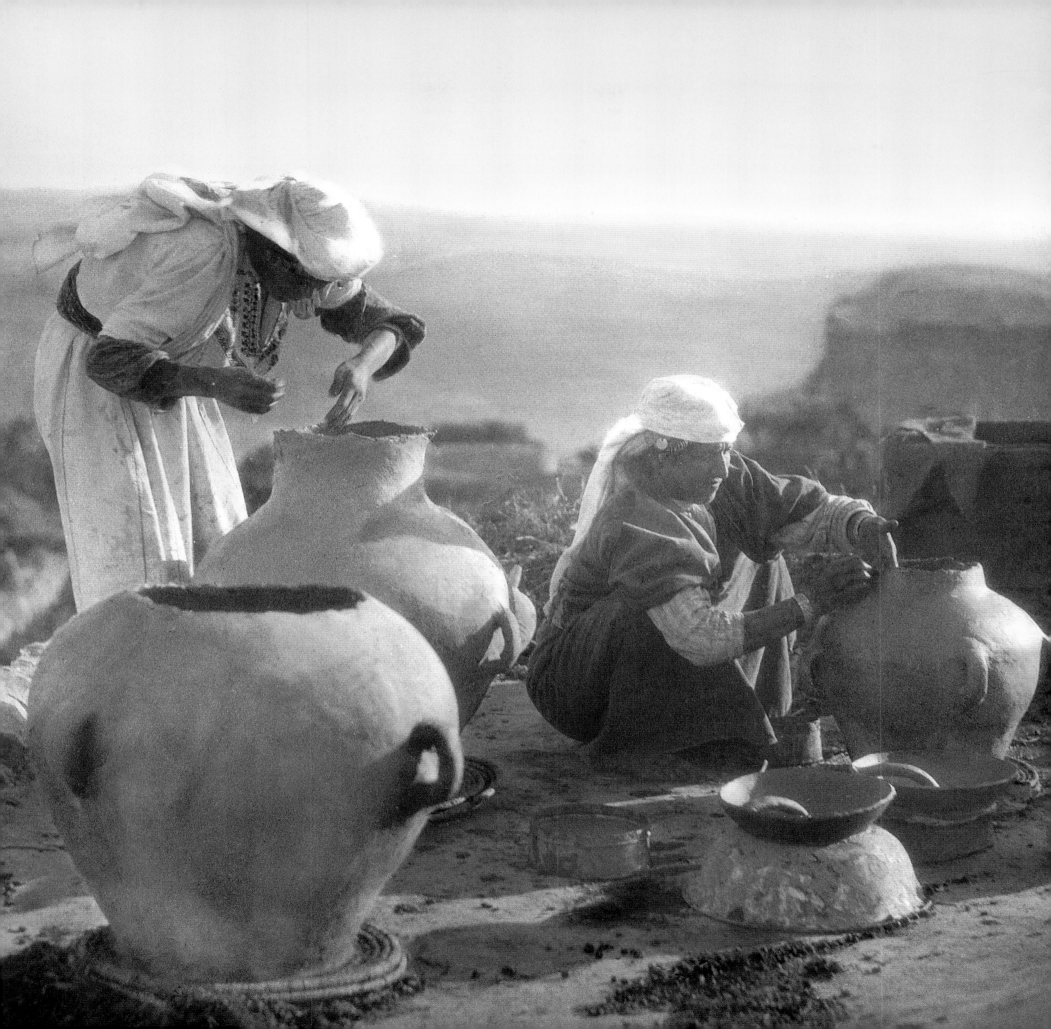

A Village Carpenter Drilling a Hole.

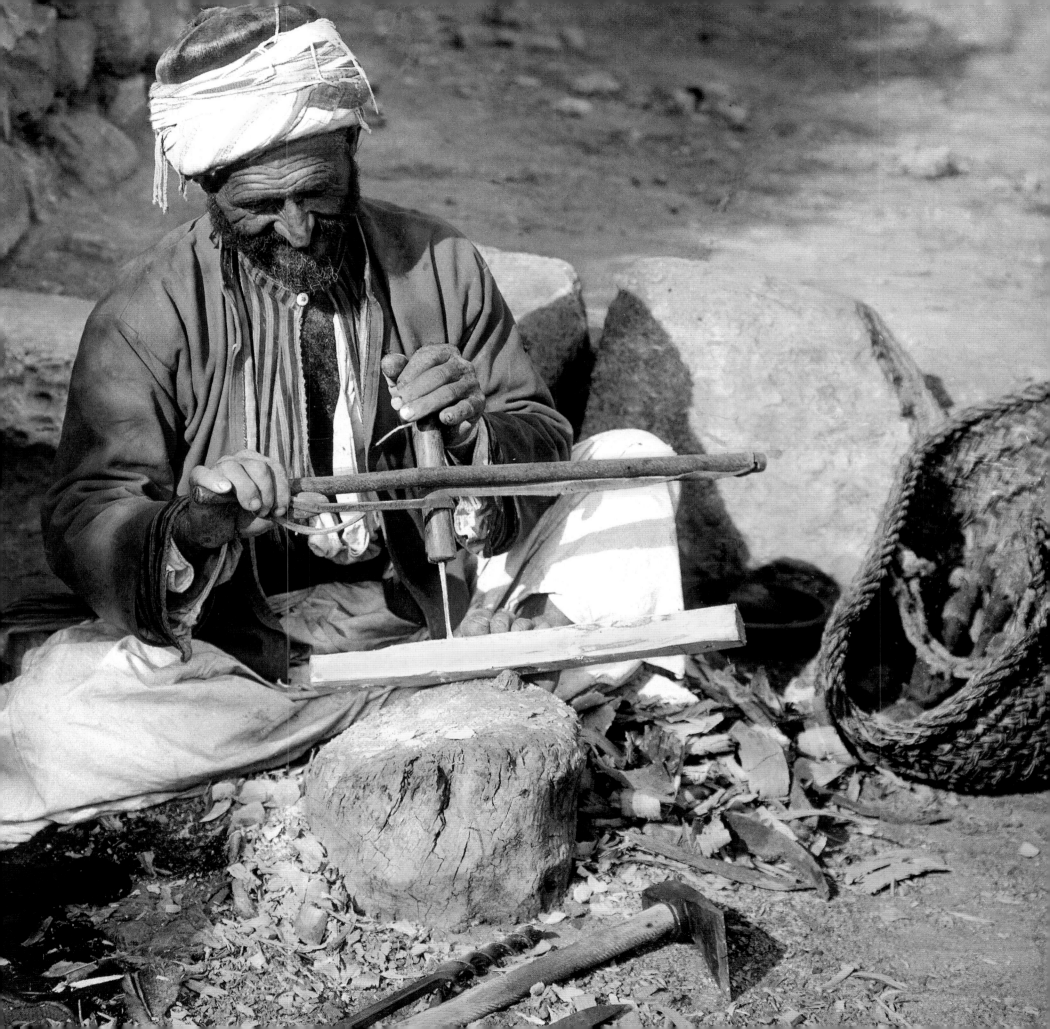

CRUSHING OLIVES.

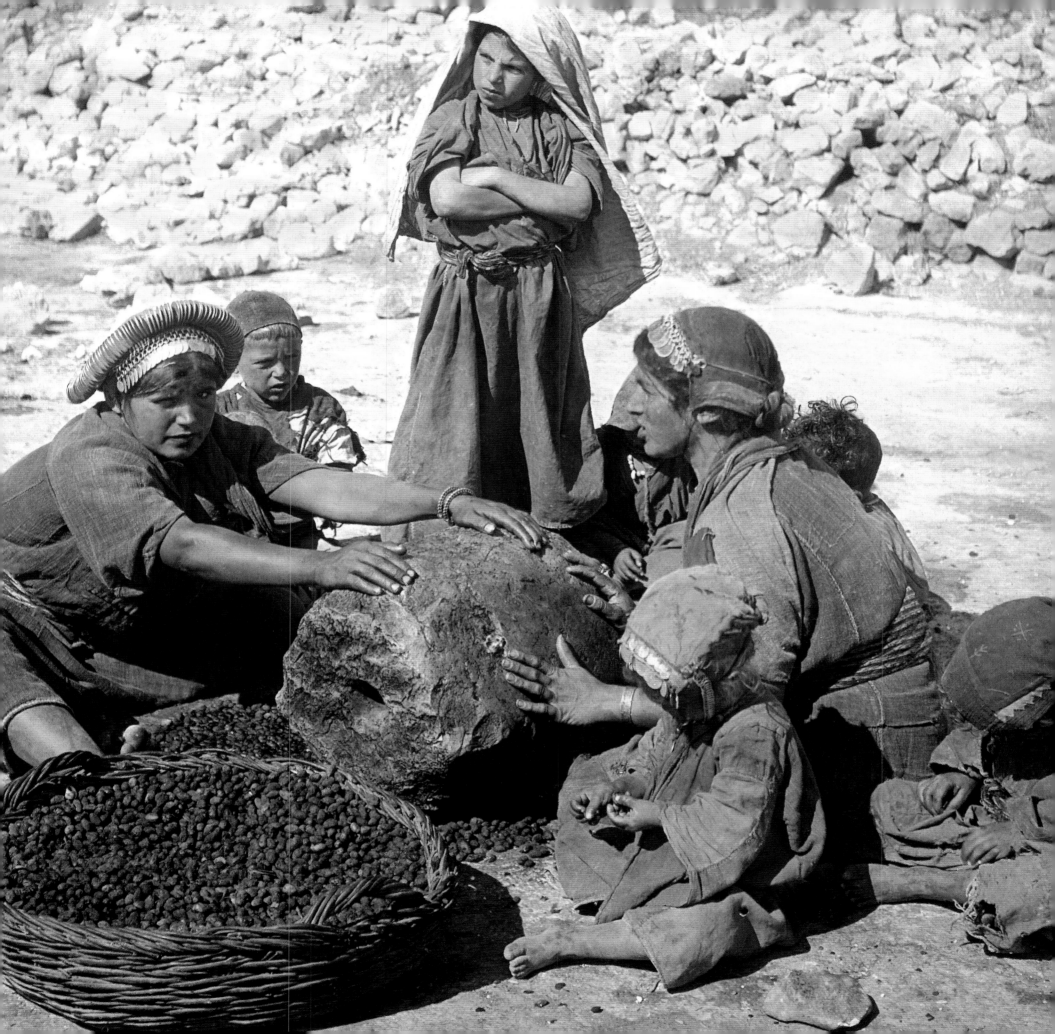

MAN AT OLIVE PRESS.
This press would be used to crush olives to release their green, fragrant oil. This type of mill press dates back more than 2000 years. It is impossible to overstate the importance of the olive to the region, as a food source, fuel for lamps, a base for cosmetics, soap, perfumes, and medicines, and for ritualistic use.

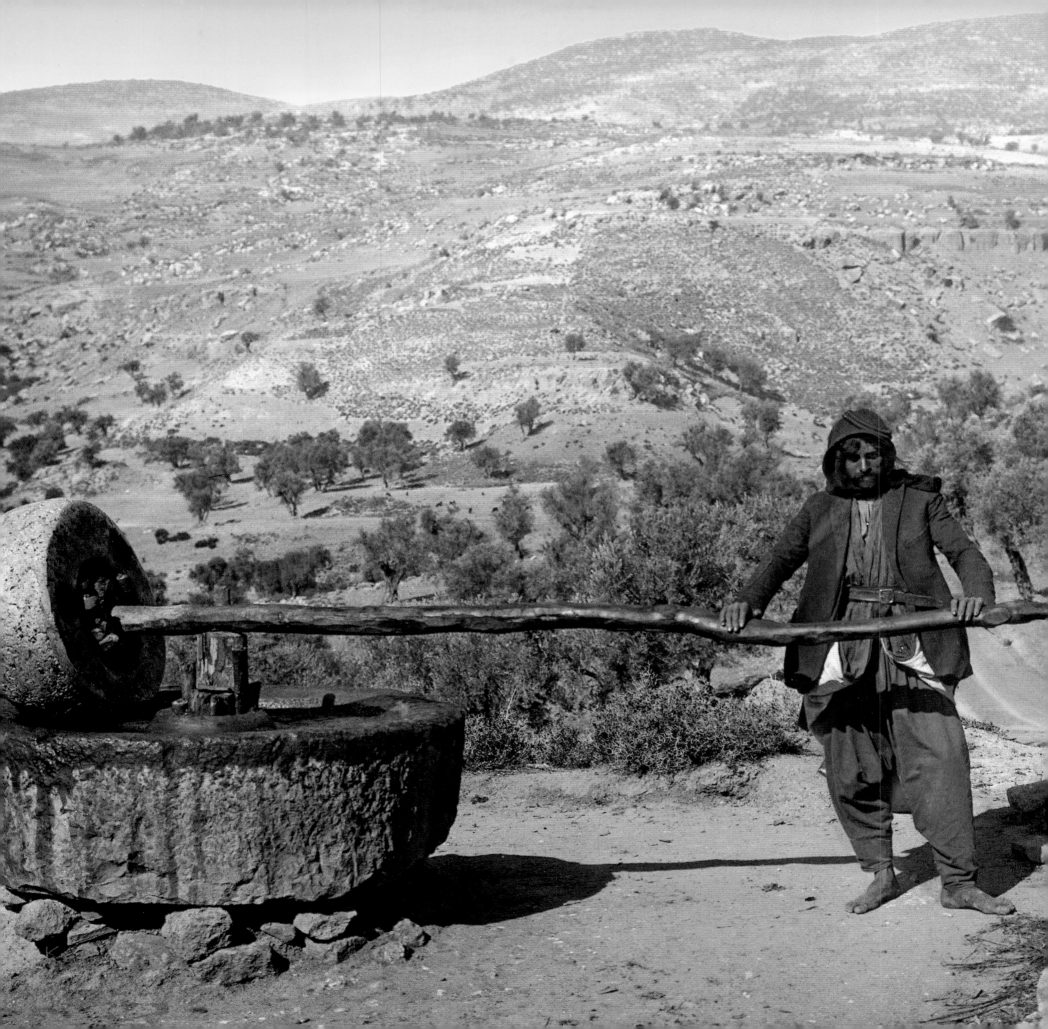

VILLAGE MEN CONSTRUCTING A DOME HOUSE.
Stones would be carried up a ladder to be mixed with mortar and carefully placed on the domed roof.

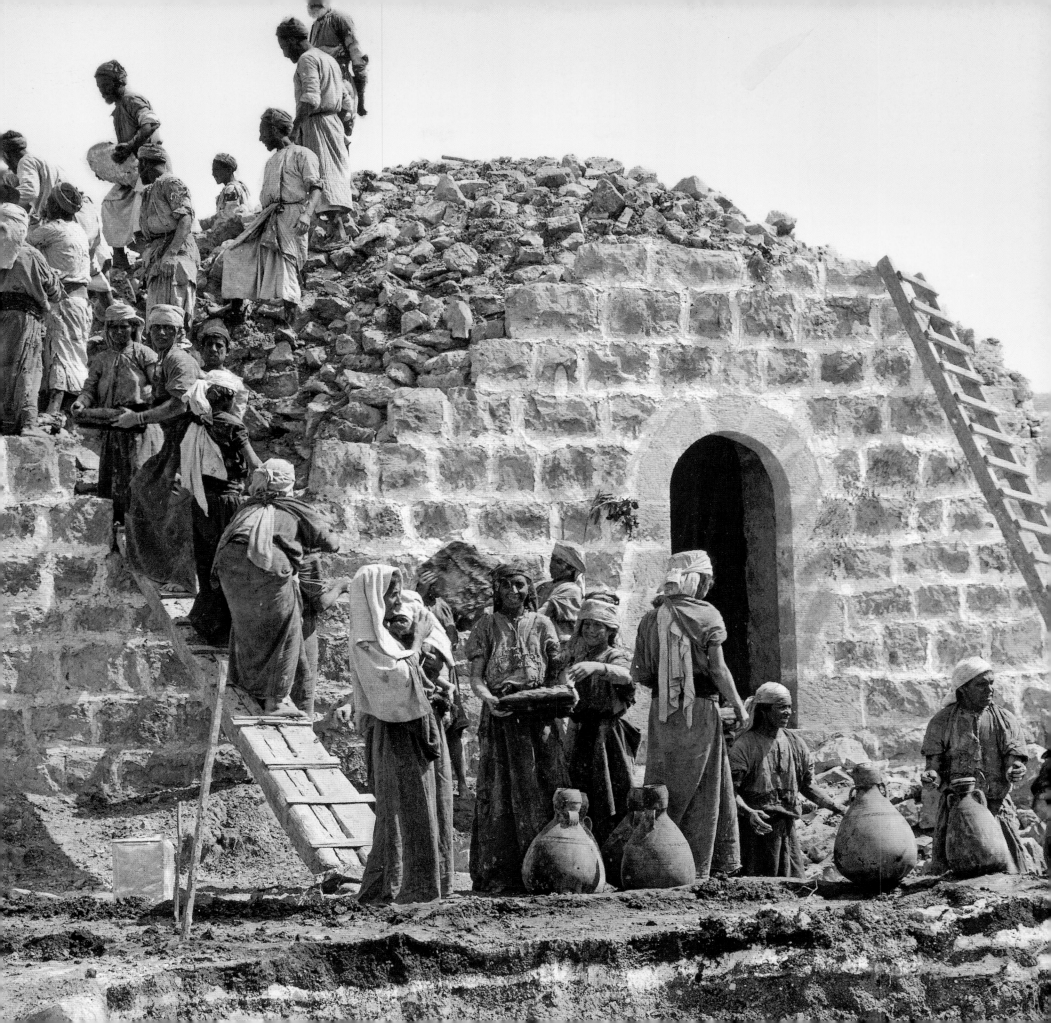

IRRIGATION WHEEL.
As the camel-powered wheel turned, earthenware jars would dip into a large well where they would collect water and then empty into a stone viaduct that carried the water through a series of channels to the gardens below and their chickpeas, lentils, beans, corn, and millet.

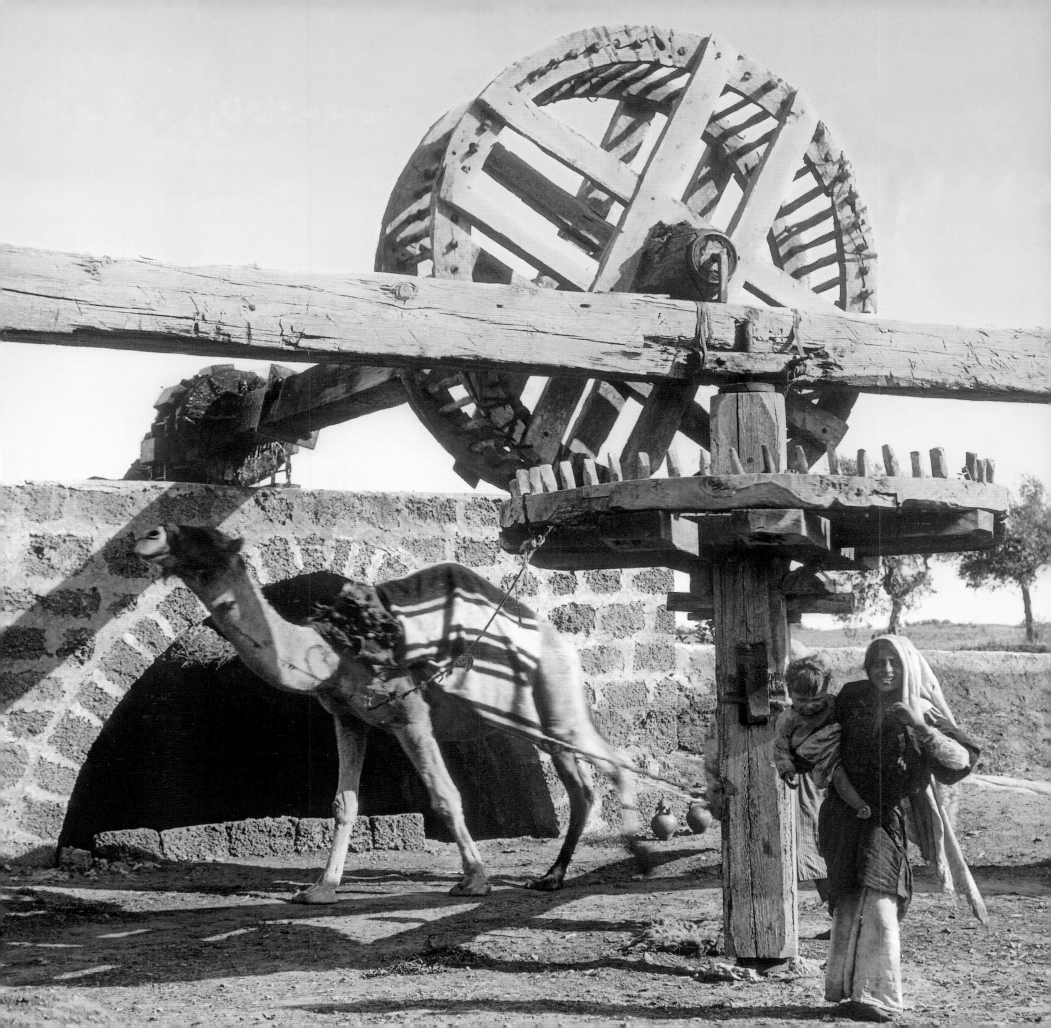

OLD MAN AND CHILDREN AT LAZARUS'S TOMB IN BETHANY.
Like most Jewish tombs of the time, this, the traditional site of Lazarus's Tomb, consists of a vestibule and a burial chamber. Jesus raising Lazarus from the dead, from the Gospel of John, is one of the best-known New Testament episodes.

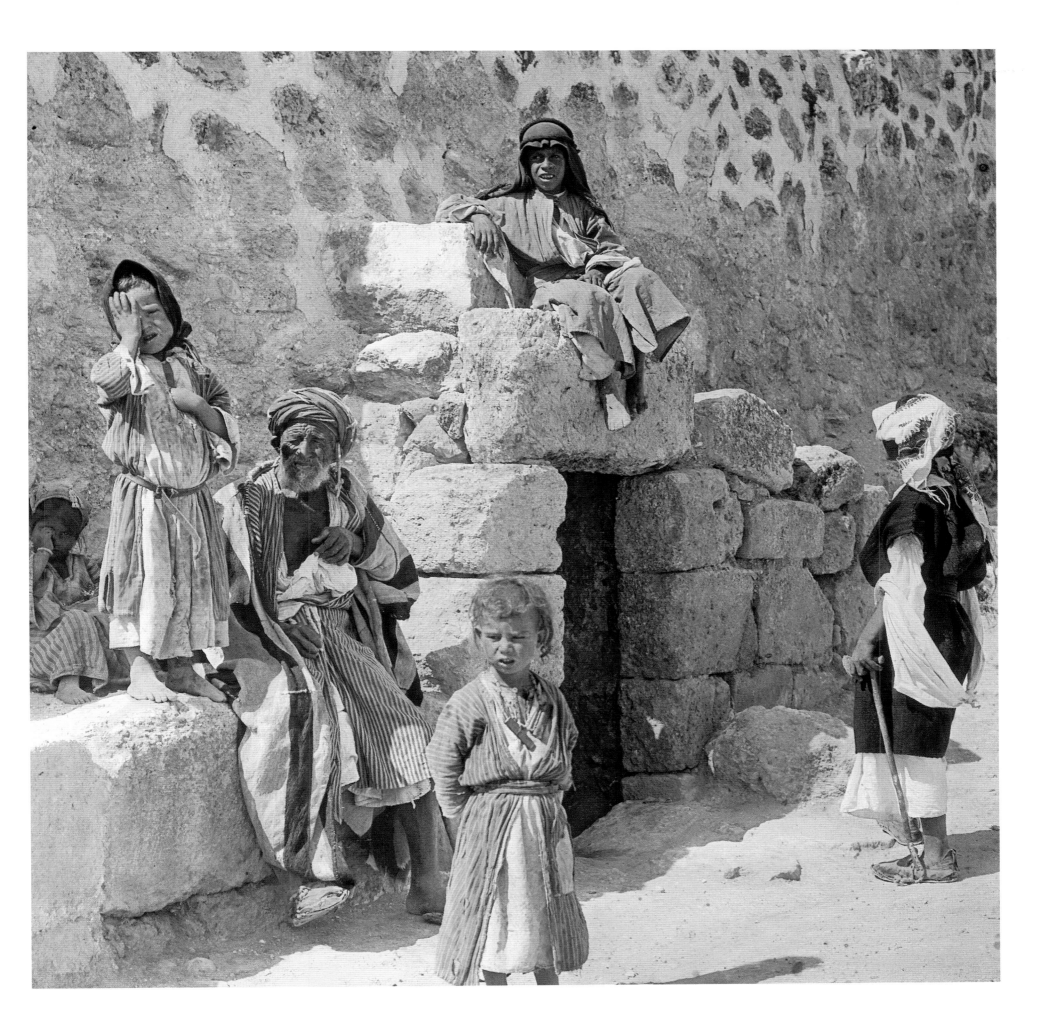

AJALON VALLEY AND BETH-HORON.

The lower end of the Beth-Horon pass, part of the vital road from Jerusalem to the sea, widens out into the Valley of Ajalon.

Then spake Joshua to the LORD in the day when the LORD delivered up the Amorites before the children of Israel, and he said in the sight of Israel, Sun, stand thou still upon Gibeon; and thou, Moon, in the valley of Ajalon. And the sun stood still, and the moon stayed, until the people had avenged themselves upon their enemies. Is not this written in the book of Jasher? So the sun stood still in the midst of heaven, and hasted not to go down about a whole day.

Joshua 10: 12-13

CHILDREN ON ROAD TO ENTRANCE OF 'ANATA.
The Old Testament town of Anathoth was the home of the prophet Jeremiah. Now the village of 'Anata, it lies three miles north of Jerusalem.

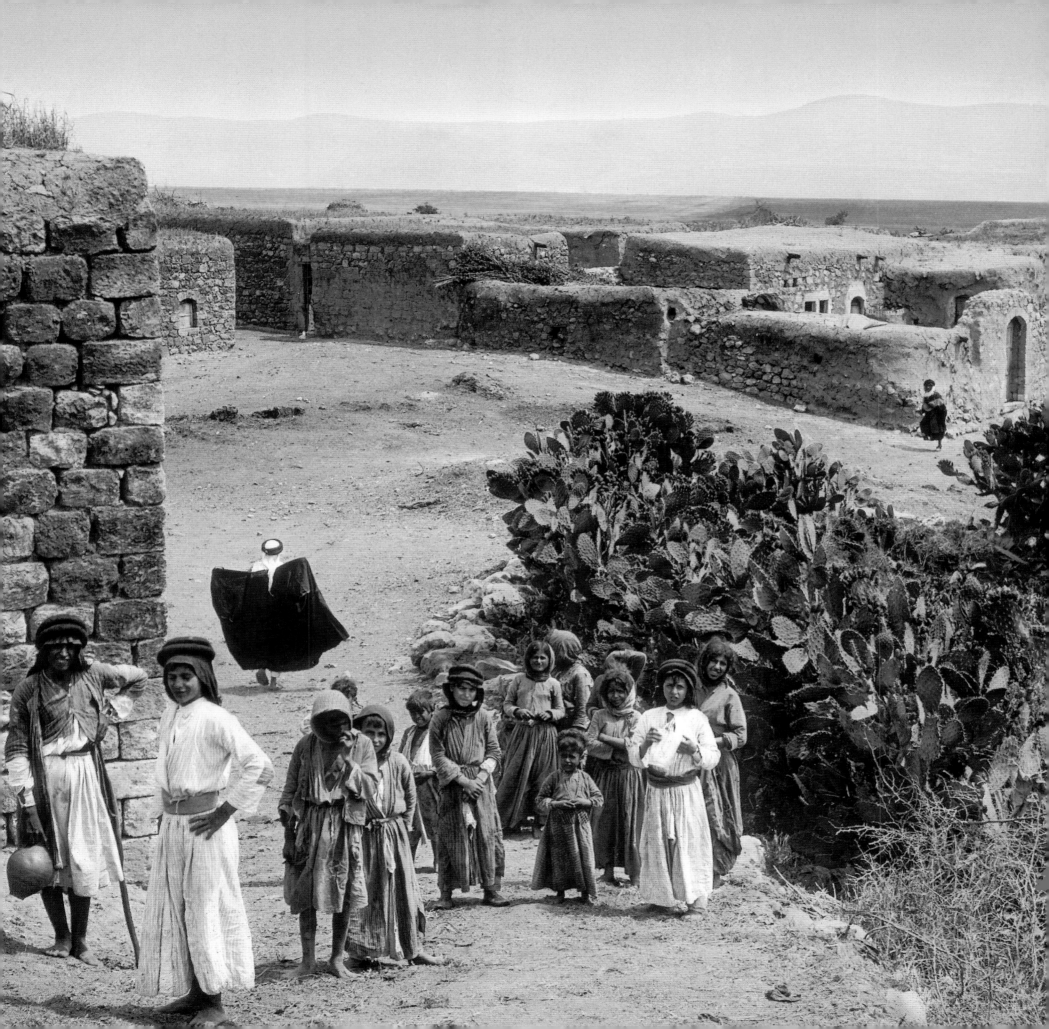

MAN WITH WITNESS STONES.
And Joshua said unto all the people, Behold, this stone shall be a witness unto us; for it hath heard all the words of the LORD which he spake unto us: it shall be therefore a witness unto you, lest ye deny your God. Joshua 24:27

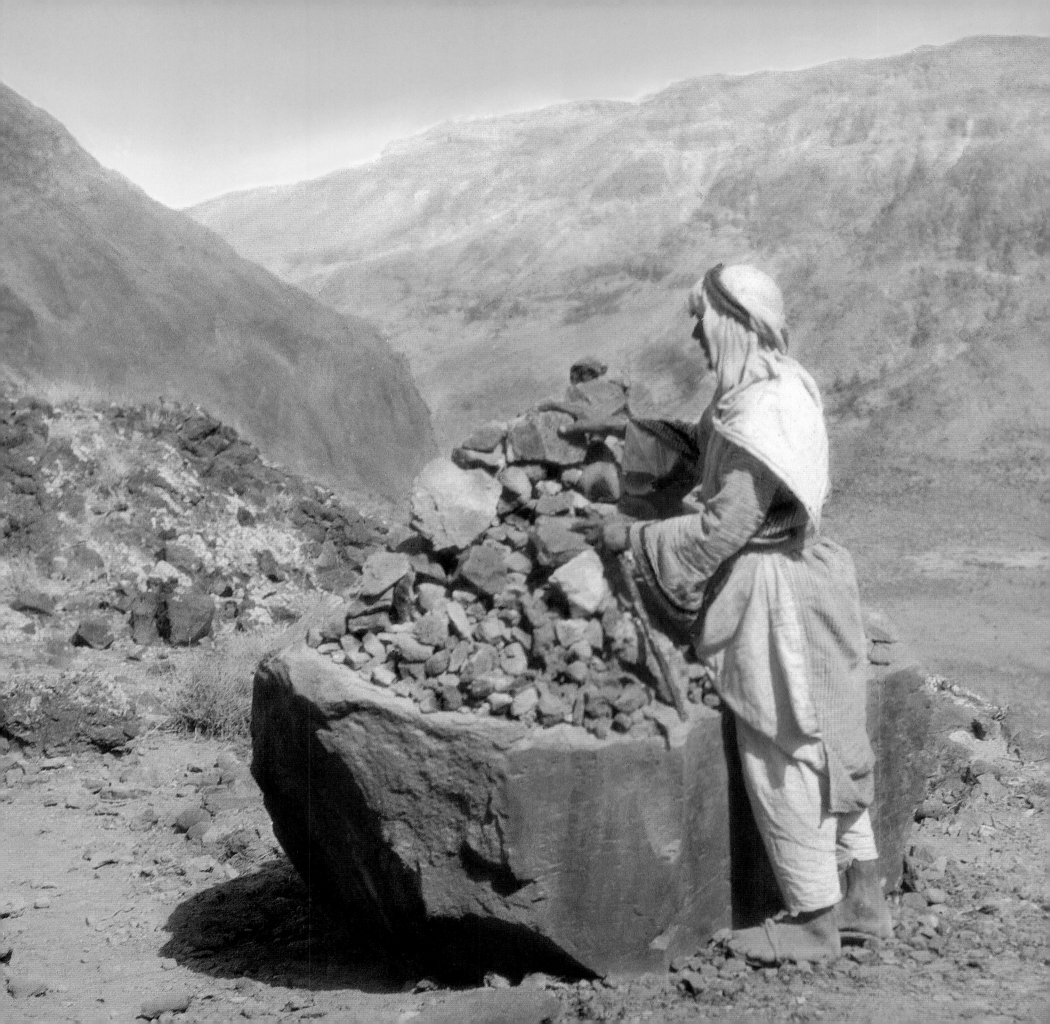

OLD SAMARITAN MAN.

The Samaritans are an ancient sect that split with Judaism in the eighth century BC. Their holy spot is Mount Gerizim, near Nablus. The parable of the Good Samaritan in Luke 10: 25-37 was told by Jesus to illustrate his message that men should show compassion to all.

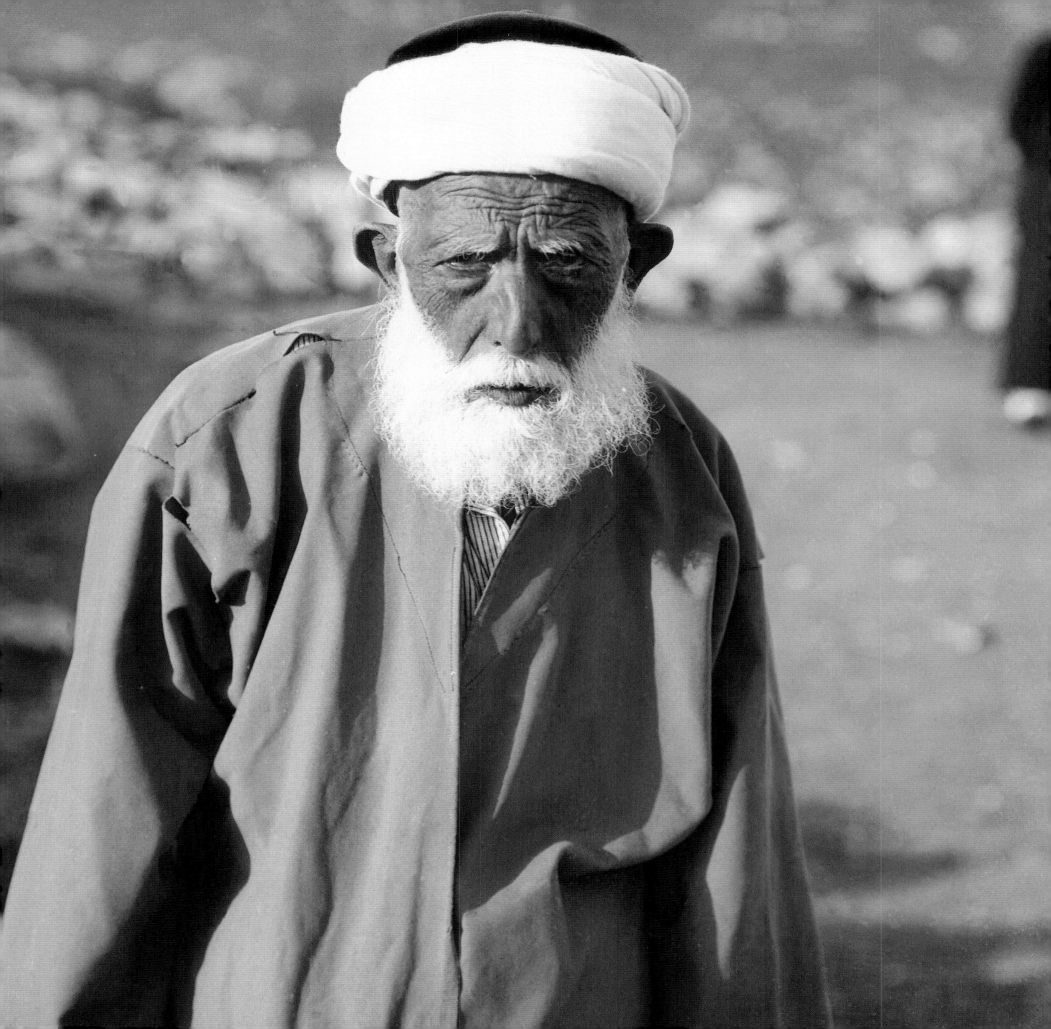

SAMARITANS EATING THE SACRIFICE IN HASTE.
The Samaritan Passover, with meat from lambs slaughtered at sunset, is eaten at midnight and in accordance with the Old Testament injunction of the first Passover: And thus shall ye eat it; with your loins girded, your shoes on your feet, and your staff in your hand; and ye shall eat it in haste: it is the LORD's passover (Exodus 12:11).

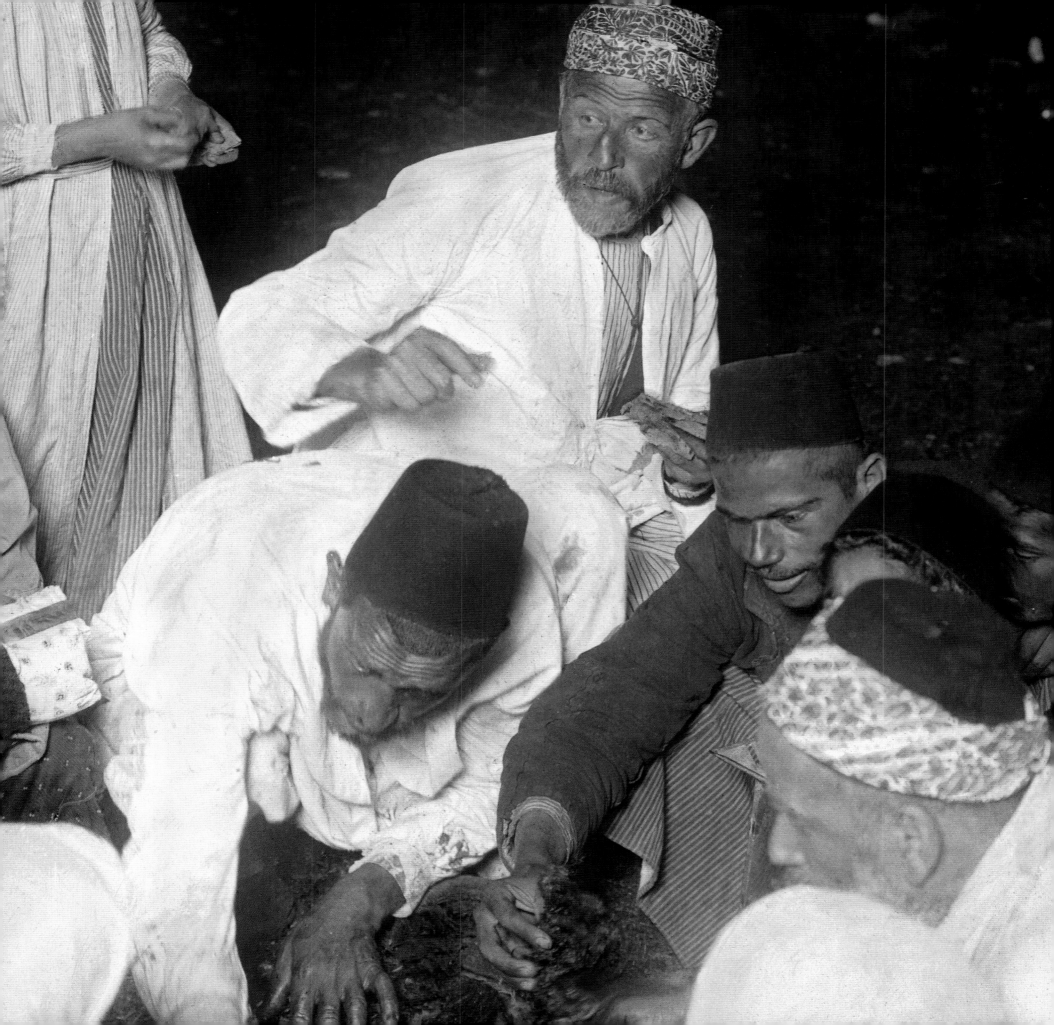

SAMARITAN HIGH PRIEST WITH TORAH SCROLLS.
The Samaritans' scriptures include a Samaritan version of the Torah.

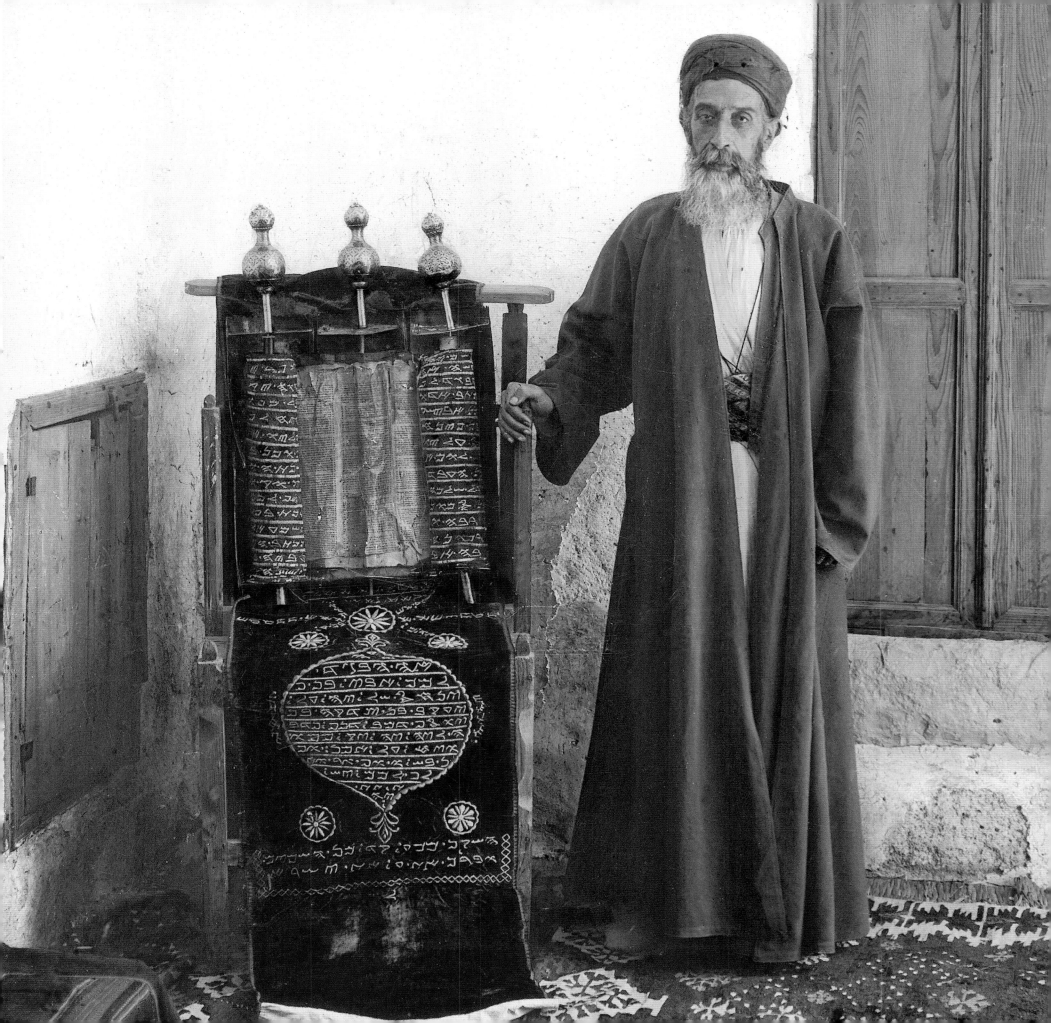

4 BETHLEHEM

SITUATED ABOUT 6 MILES SOUTH OF Jerusalem, Bethlehem is a small town in the Judean hills first mentioned in Genesis as the site where the Biblical matriarch Rachel is buried; Rachel's Tomb is to this day a holy landmark for Christians, Jews, and Moslems. Bethlehem is also the traditional birthplace of David, the shepherd-turned-king, warrior and psalmist.

For Christians the world over, Bethlehem evokes the vivid, iconic New Testament tableau of the birth of Jesus: the rough manger, the bright star marking the birth of the Messiah, the wise men bearing gifts, the simple shepherds, and Mary and Joseph finding no room at the inn. The most venerated Bethlehem site for Christian pilgrims, the Church of the Nativity, had its beginnings when St. Helena, the mother of Emperor Constantine I, ordered the building of the first basilica in the fourth century AD. The present basilica was built in the sixth century by Emperor Justinian. Through the years it has been rebuilt and expanded; it is the oldest operating church in the Holy Land.

The narrow streets, ancient buildings, and even more ancient olive trees of Bethlehem seem little changed since the birth of Christ, belying the fact that the town has seen regular attacks and looting by different empires throughout its history. One visible reminder of this part of its history is the Door of Humility, the very low main entrance to the Church of the Nativity, which requires visitors to stoop to enter. It was reduced to its present tiny size during the Ottoman period to prevent to prevent horsemen from charging in.

TRAVELING A TRADITIONAL CARAVAN ROUTE TO BETHLEHEM.
Camels with packsaddles and their driver heading towards Bethlehem.

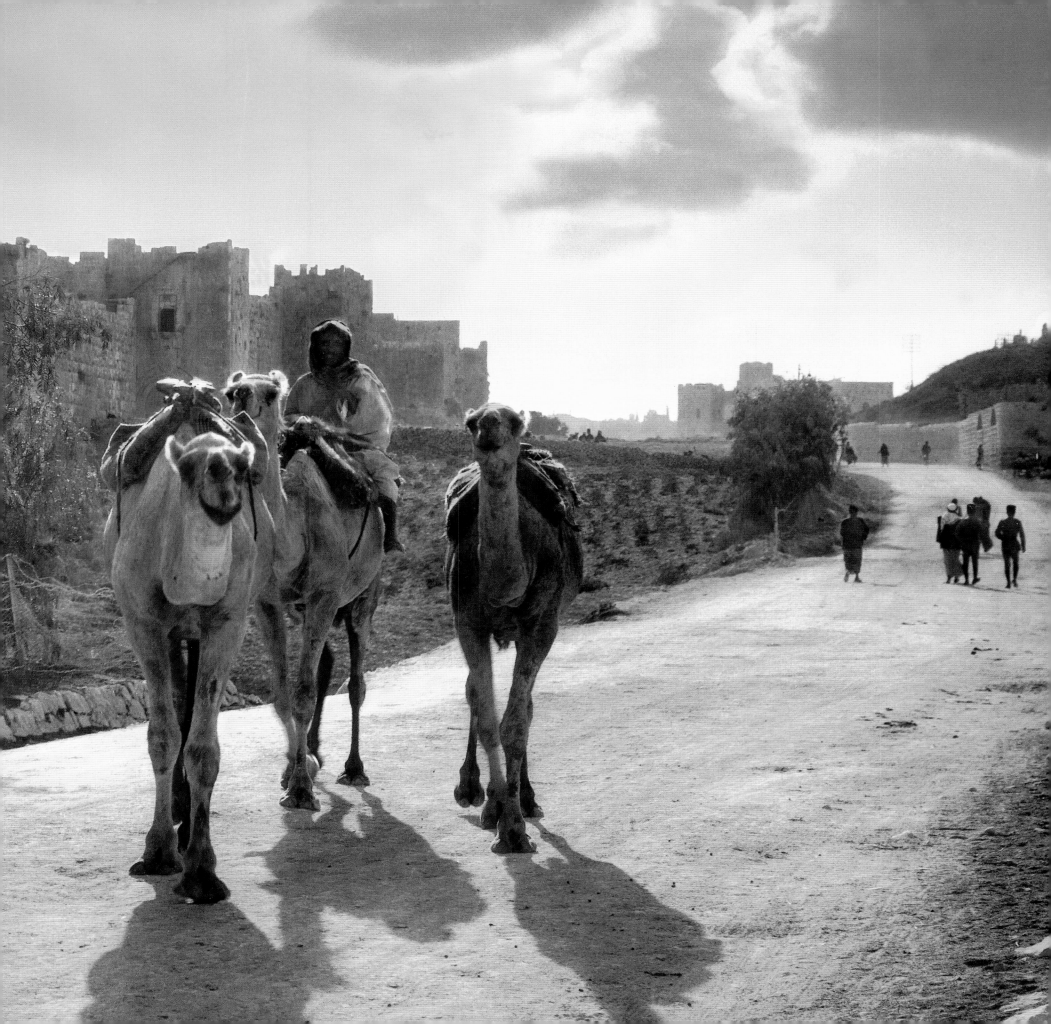

MAN WITH CAMEL ON BETHLEHEM ROAD, OVERLOOKING AN OLIVE GROVE.

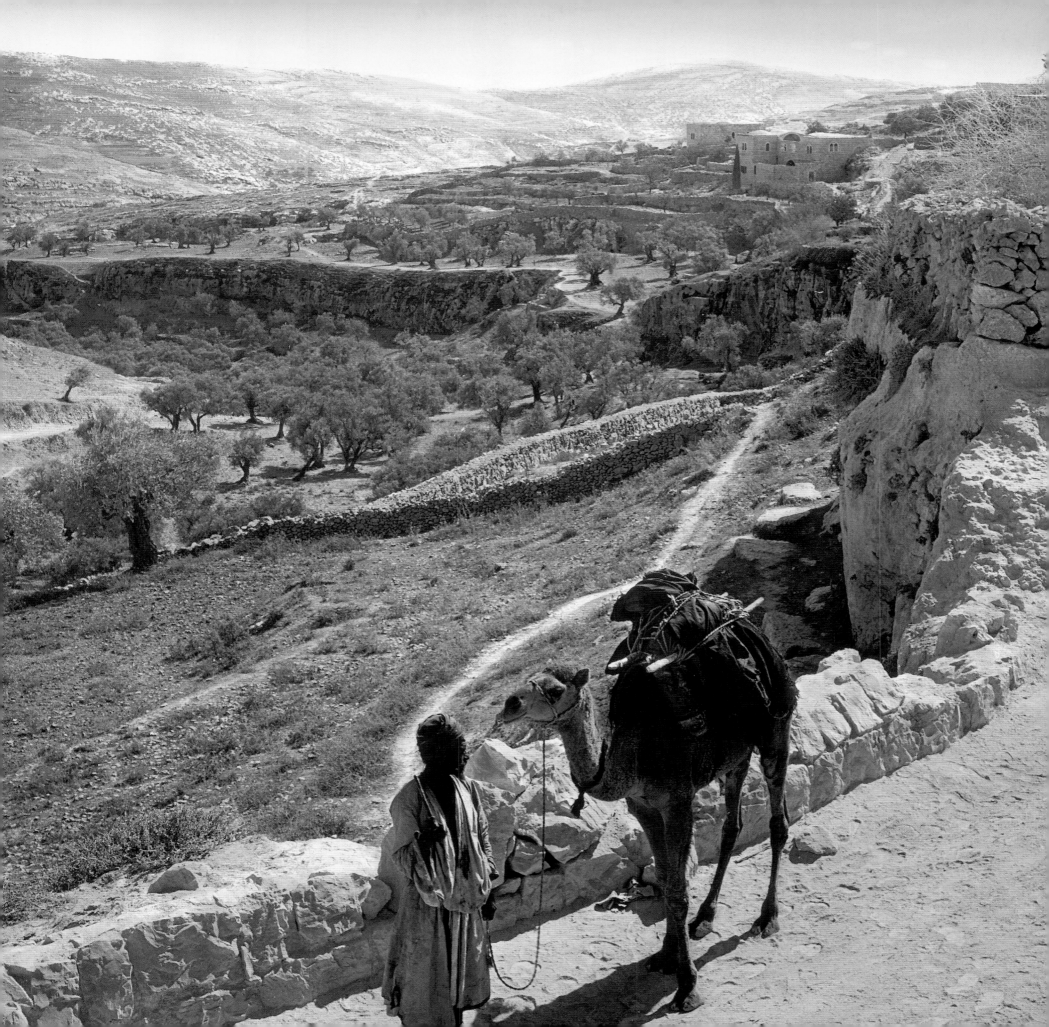

WOMEN WITH WATER JUGS, ON A MOUNTAIN PATH TO BETHLEHEM.
These women are wearing traditional indigo robes and white head scarves.

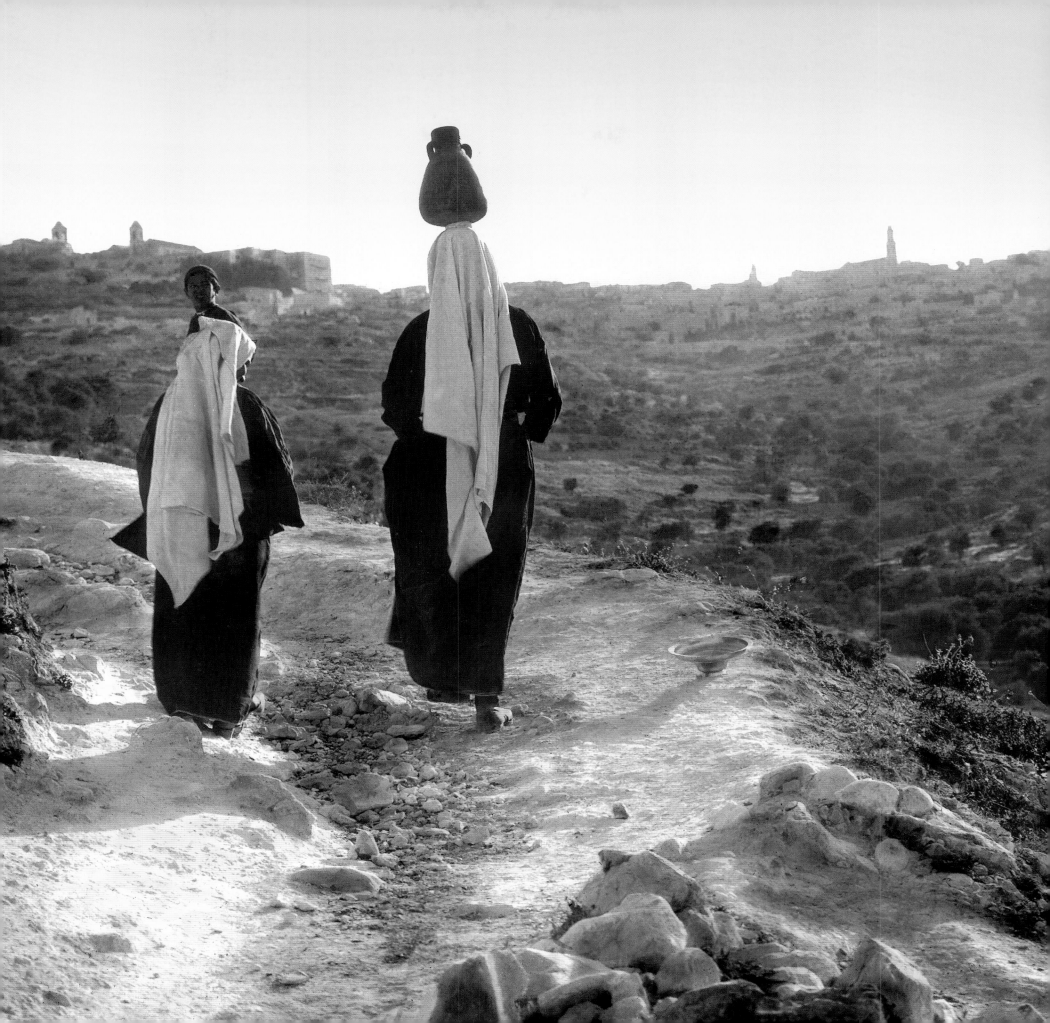

MEN AND WOMEN THRESHING, NEAR BETHLEHEM.
The cultivation of wheat and barley in the Holy Land goes back to ancient times.

And the LORD spake unto Moses, saying, Speak unto the children of Israel, and say unto them, When ye be come into the land which I give unto you, and shall reap the harvest thereof, then ye shall bring a sheaf of the firstfruits of your harvest unto the priest: And he shall wave the sheaf before the LORD, to be accepted for you: on the morrow after the Sabbath the priest shall wave it. Leviticus 23:9-11

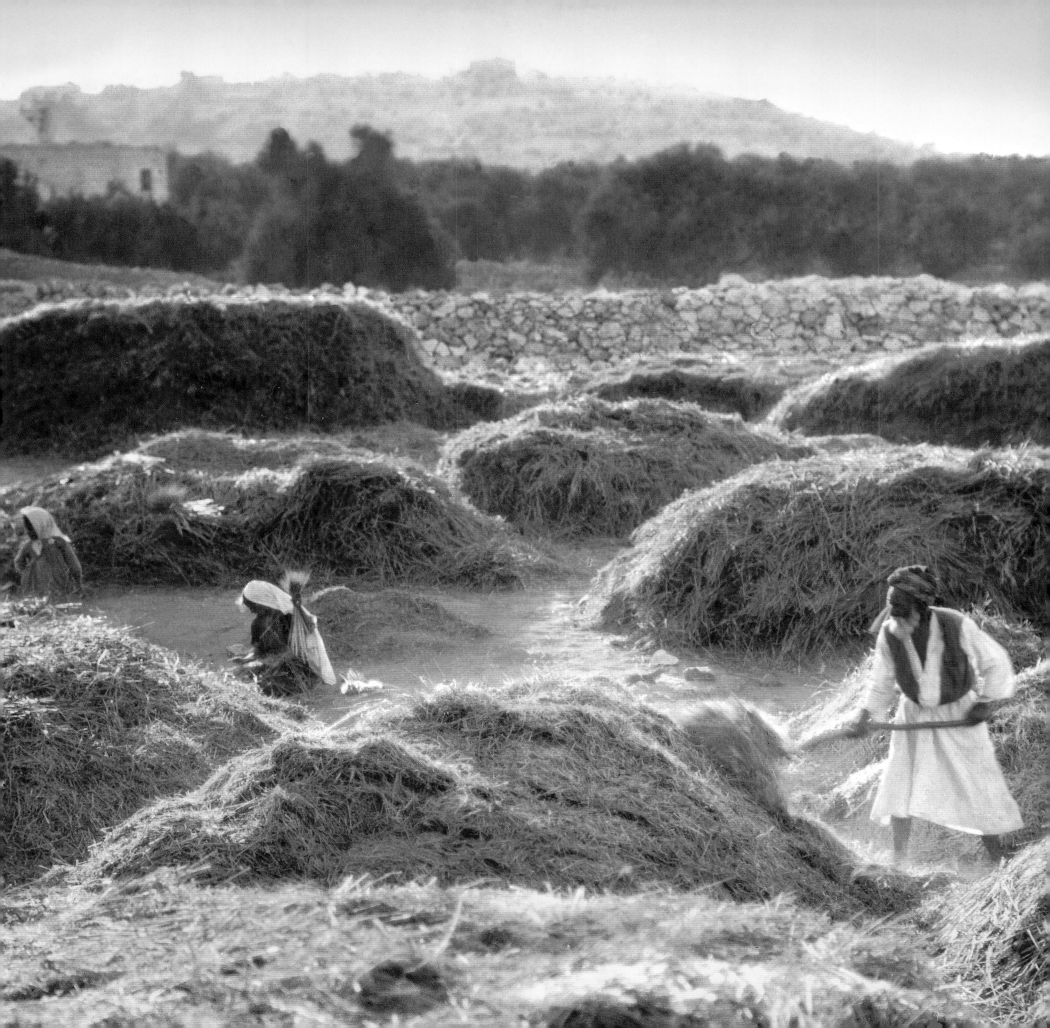

BETHLEHEM ALLEYWAY.
Old Holy Land villages such as Bethlehem are a maze of narrow streets and alleyways.

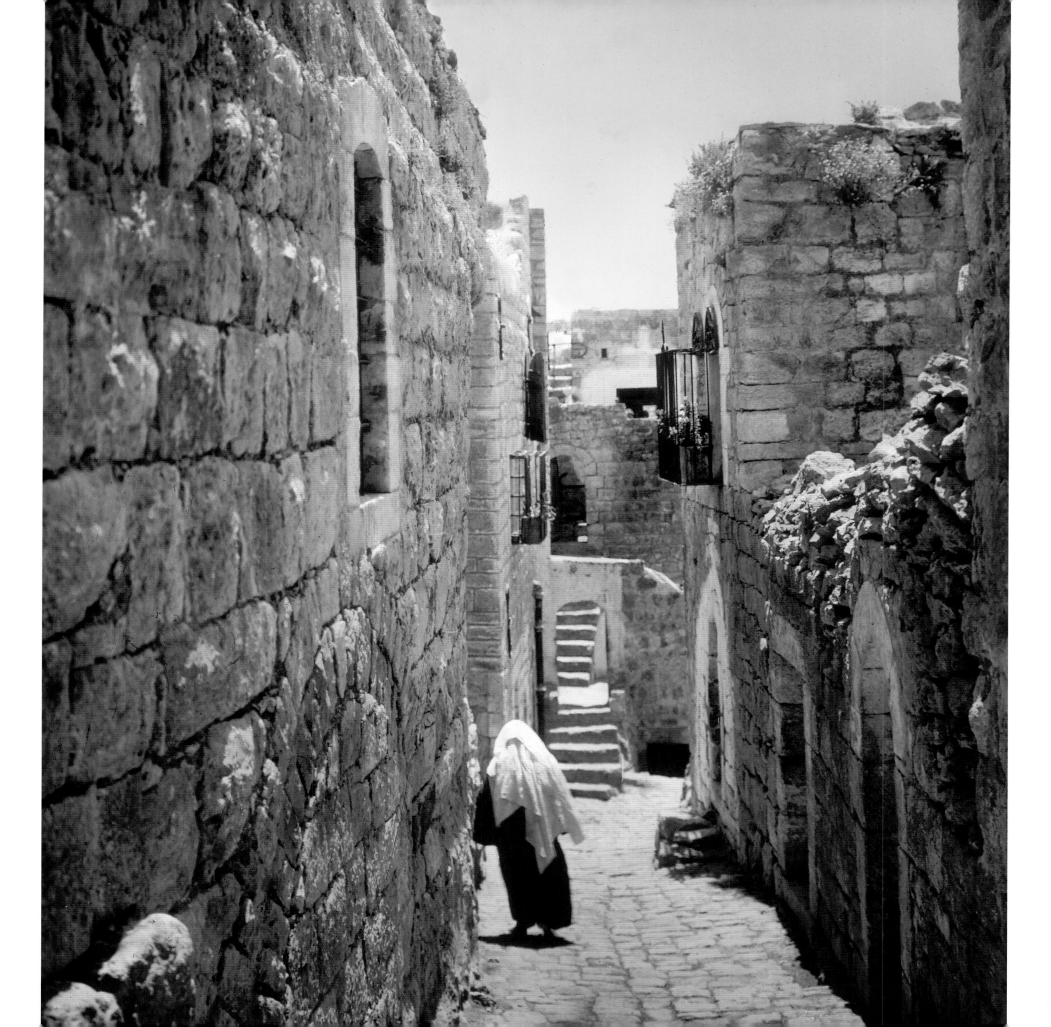

BUSY STREET IN BETHLEHEM.

In an open café men would be smoking their nargilahs, *while next door a butcher would cut the sinews from a lamb carcass. A merchant and customer would haggle over the price of a piece of cloth while at the next stall another a transaction, for oranges or potatoes, might be taking place.*

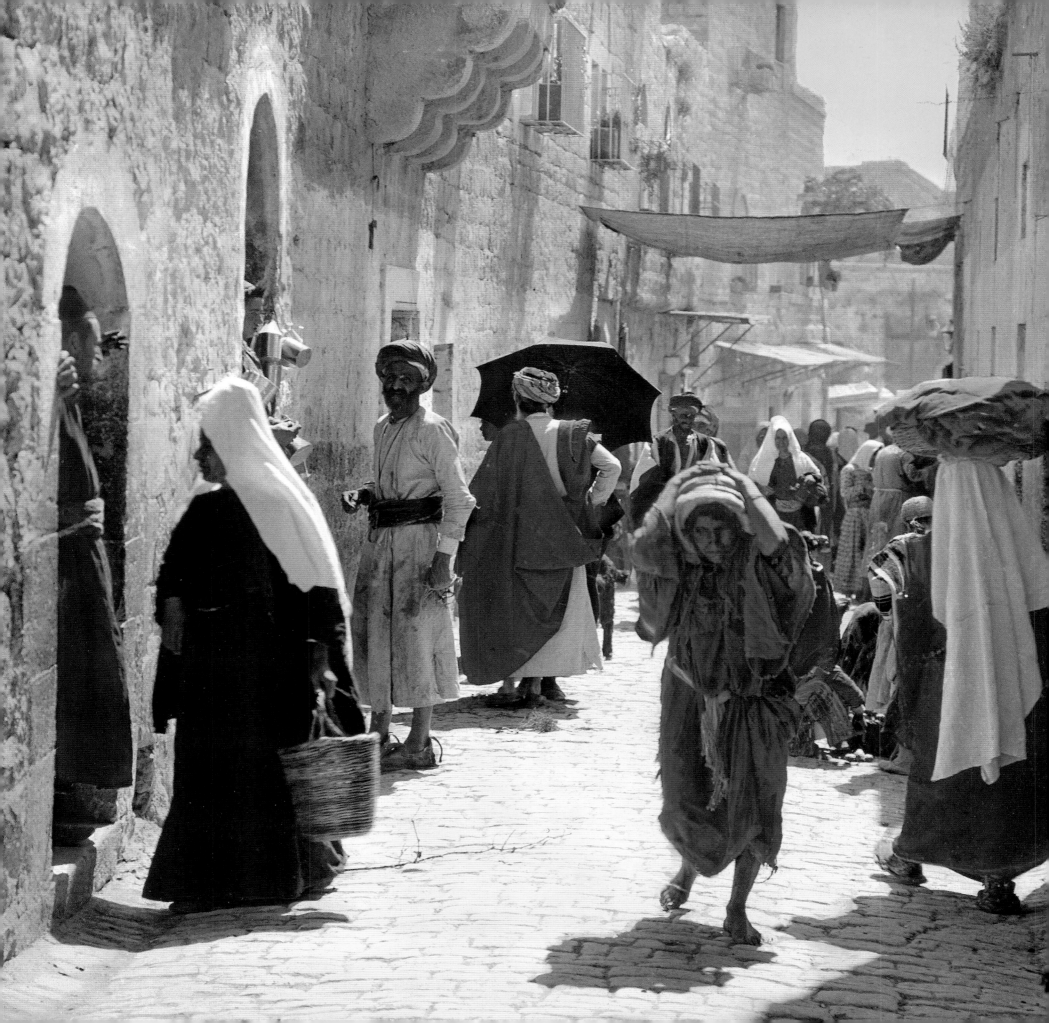

SELLING APPLES IN A STREET IN BETHLEHEM.

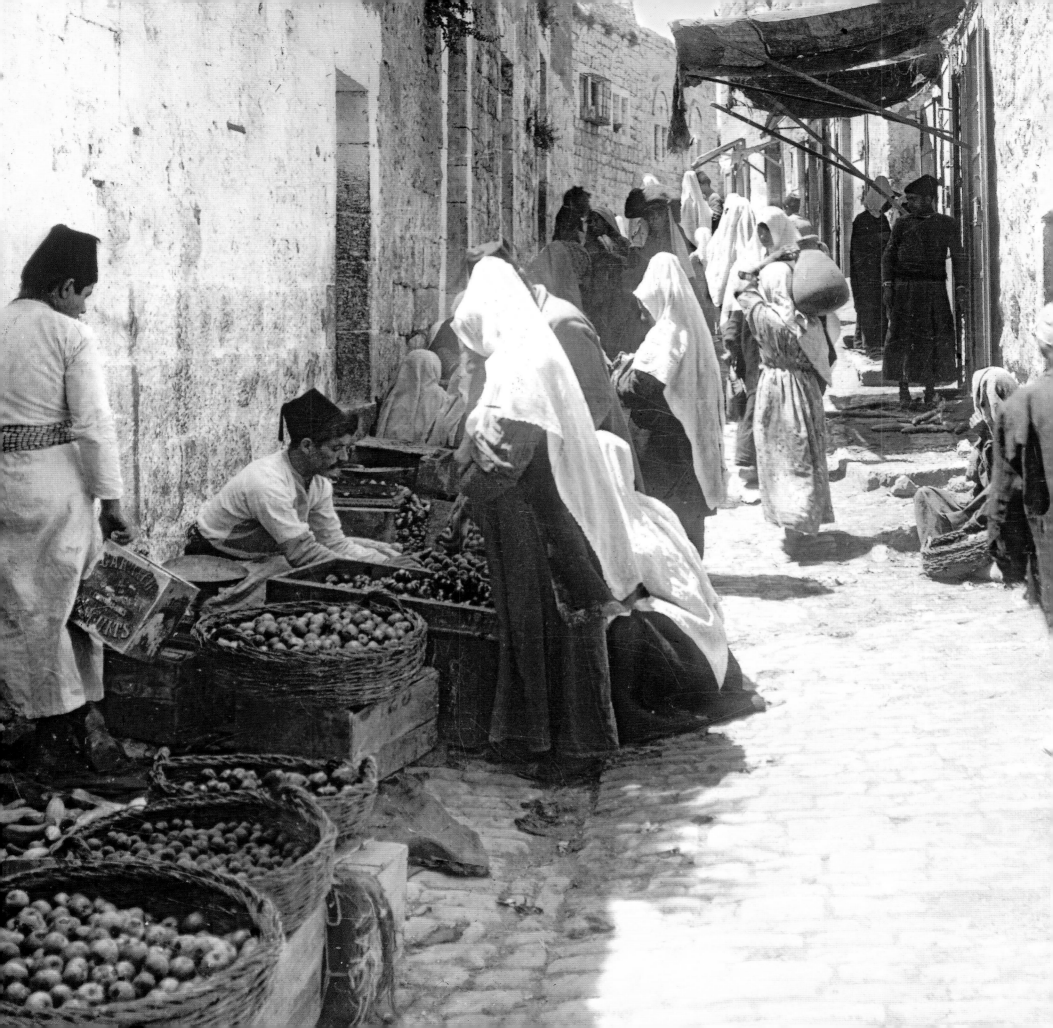

TWO WOMEN AND A BOY IN A BETHLEHEM HOME BUILT INTO A CAVE.

It is thought by some that Christ's birth took place in a cave that served as an animal shelter. The Church of the Nativity is built over the cave, or grotto, believed to be the traditional birth site.

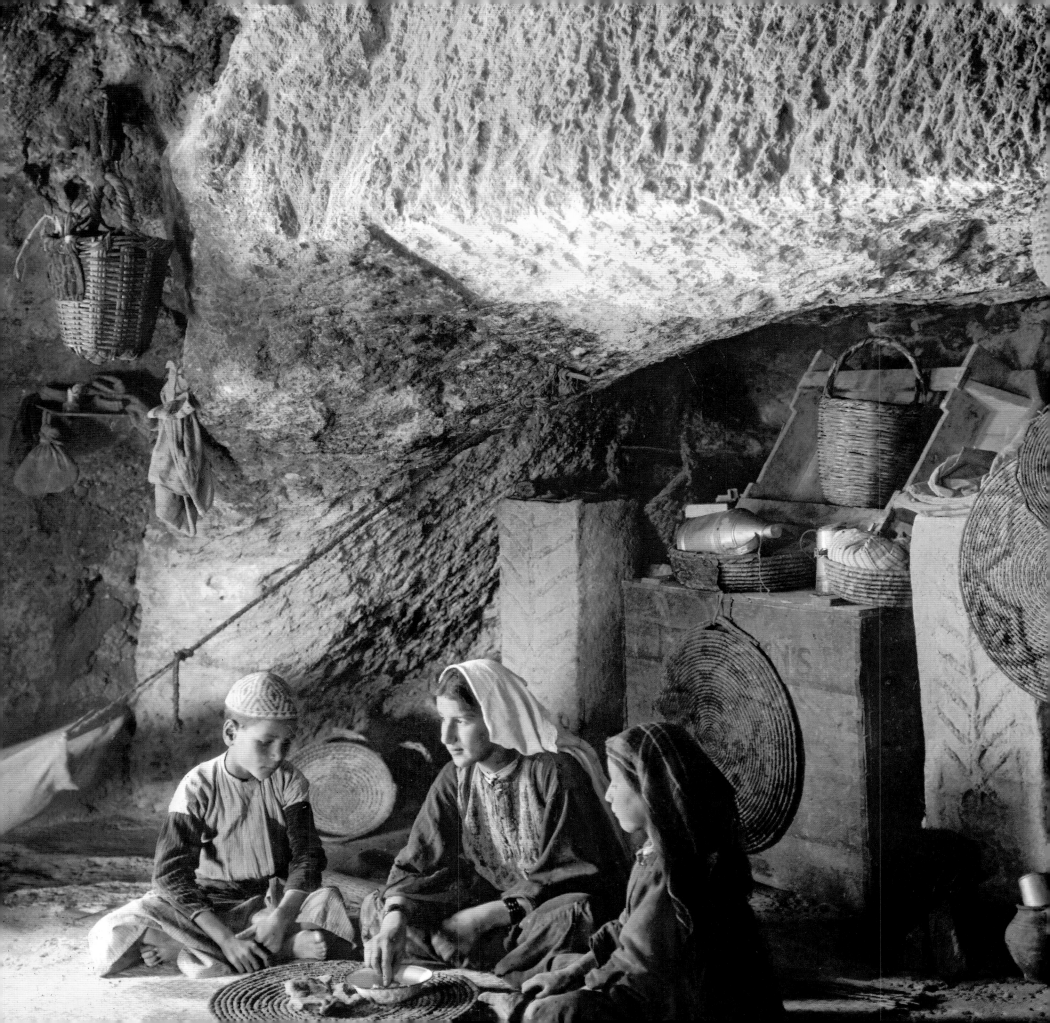

MOTHER AND CHILD IN COURTYARD.
Several families would share a courtyard, like this one in the oldest part of Bethlehem, near the Church of the Nativity.

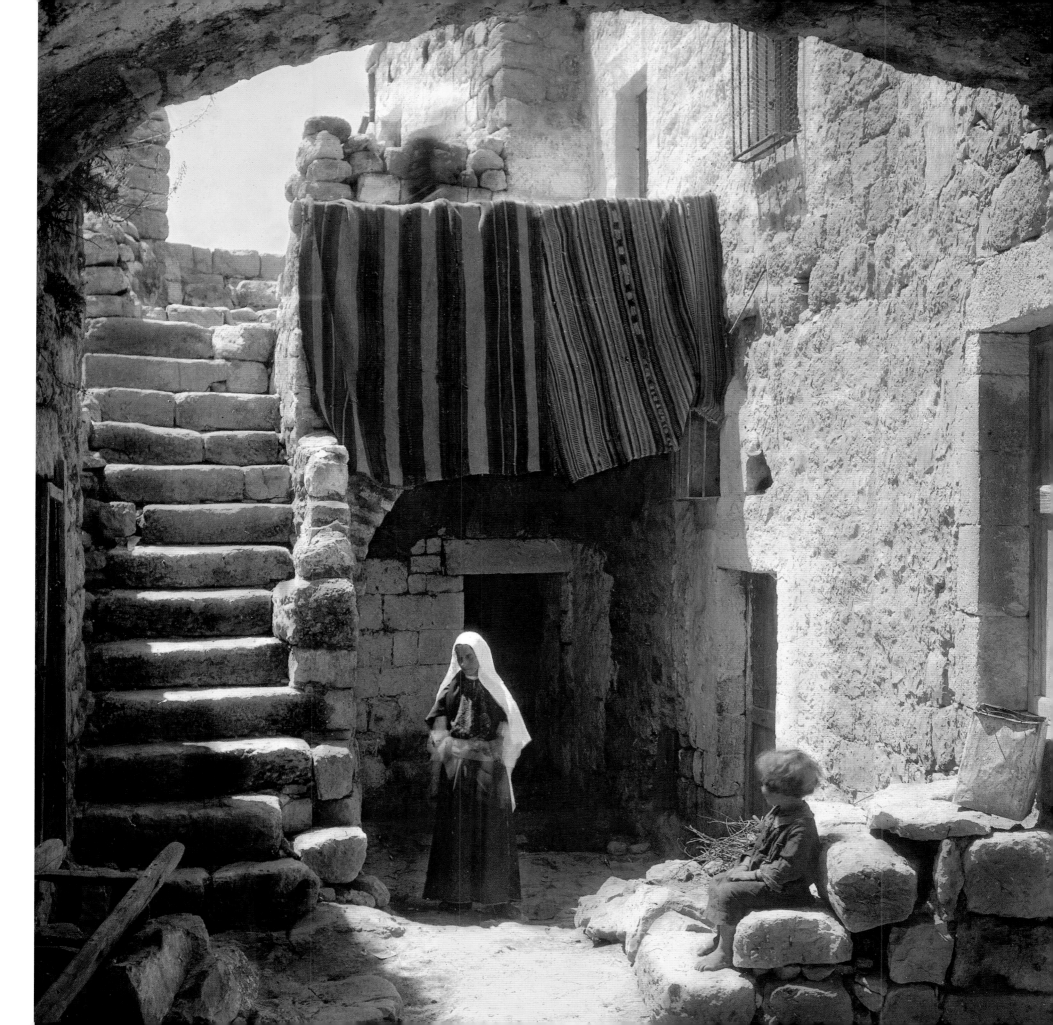

WOMEN AND GIRLS DOING EMBROIDERY AND SEWING IN AN OLD
BETHLEHEM HOME

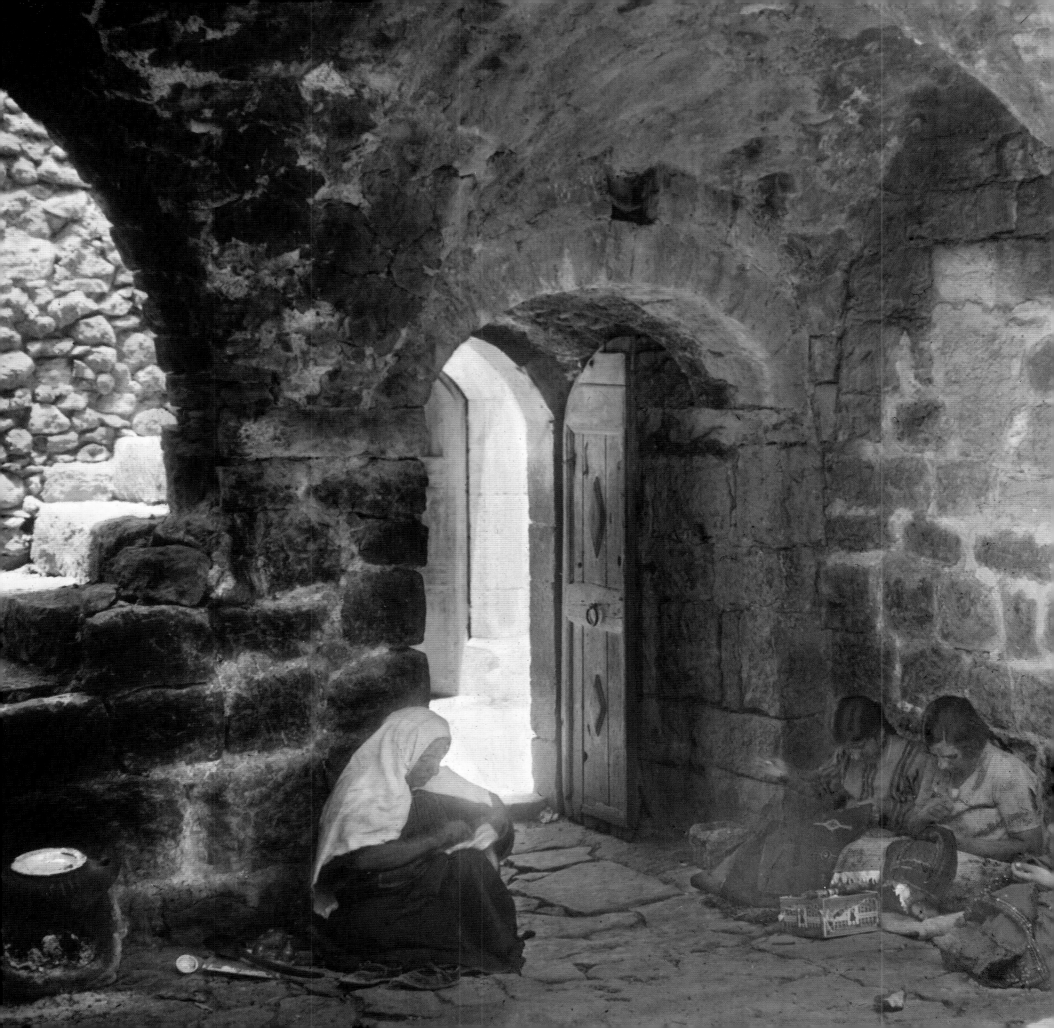

A Shaded Gate in Bethlehem.

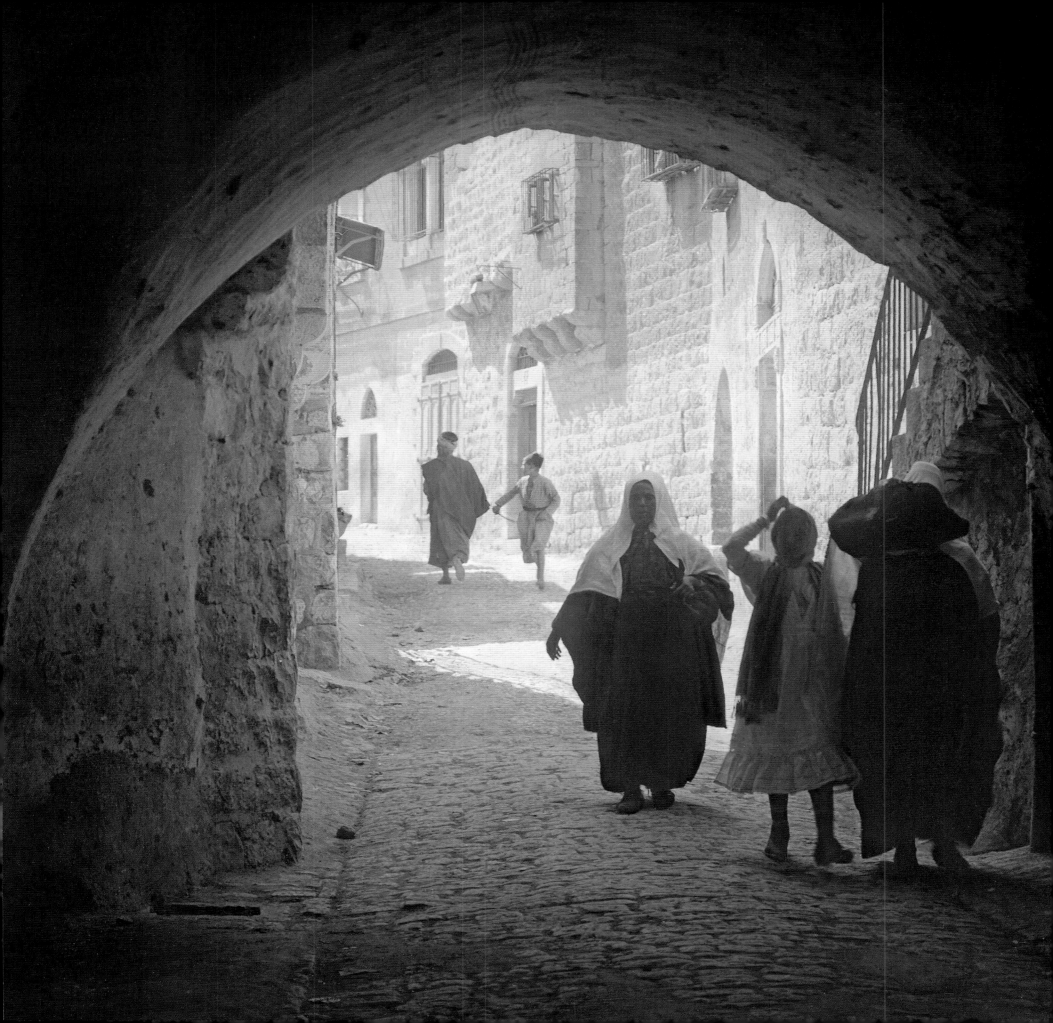

THE WELL OF THE MAGI, NEAR BETHLEHEM.
This cistern is known as the Well of the Magi, believed by some to be the spot where the Three Wise Men, in search of the Messiah, regained sight of the Star of Bethlehem.

When they saw the star, they rejoiced with exceedingly great joy.
Matthew 20:10

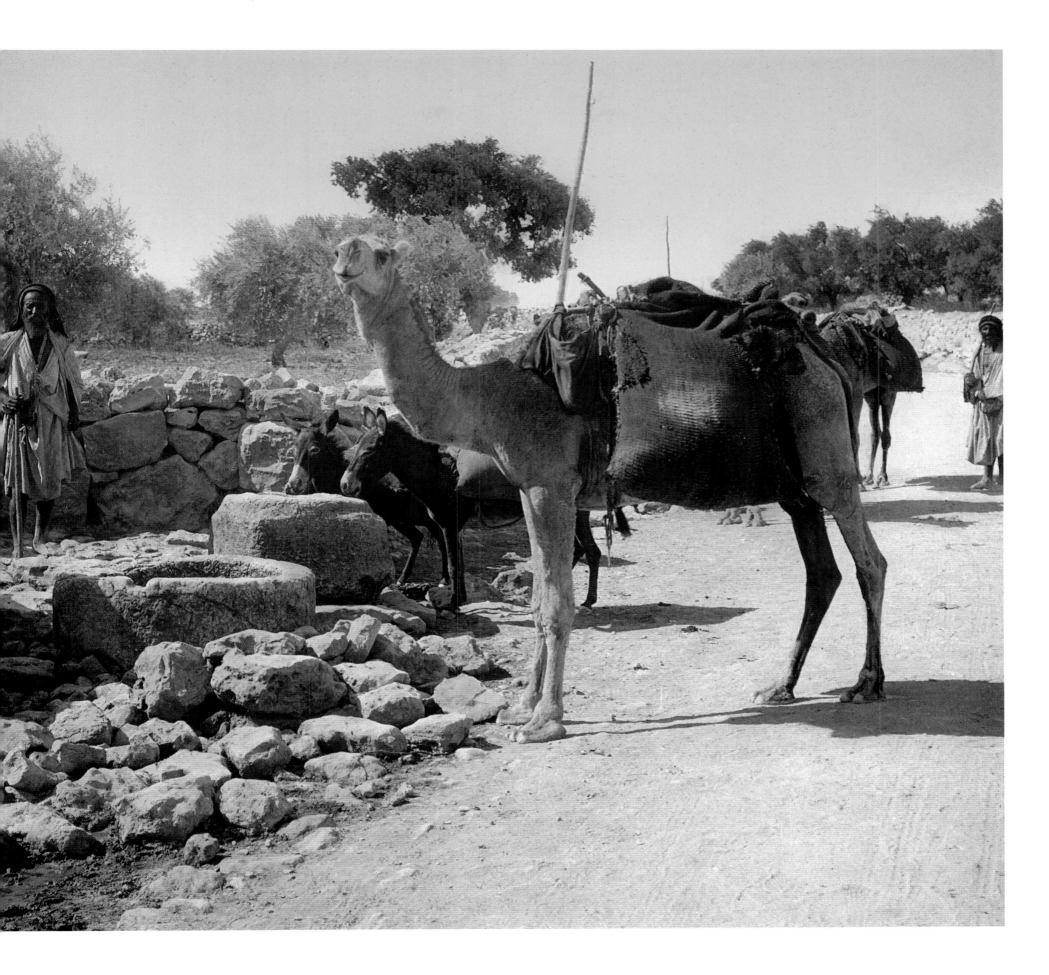

SHEPHERDS WITH THEIR FLOCK IN FIELD.

And there were in the same country shepherds abiding in the field, keeping watch over their flock by night. And, lo, the angel of the Lord came upon them, and the glory of the Lord shone round about them: and they were sore afraid. And the angel said unto them, Fear not: for, behold, I bring you good tidings of great joy, which shall be to all people. For unto you is born this day in the city of David a Saviour, which is Christ the Lord. Luke 2: 8-11

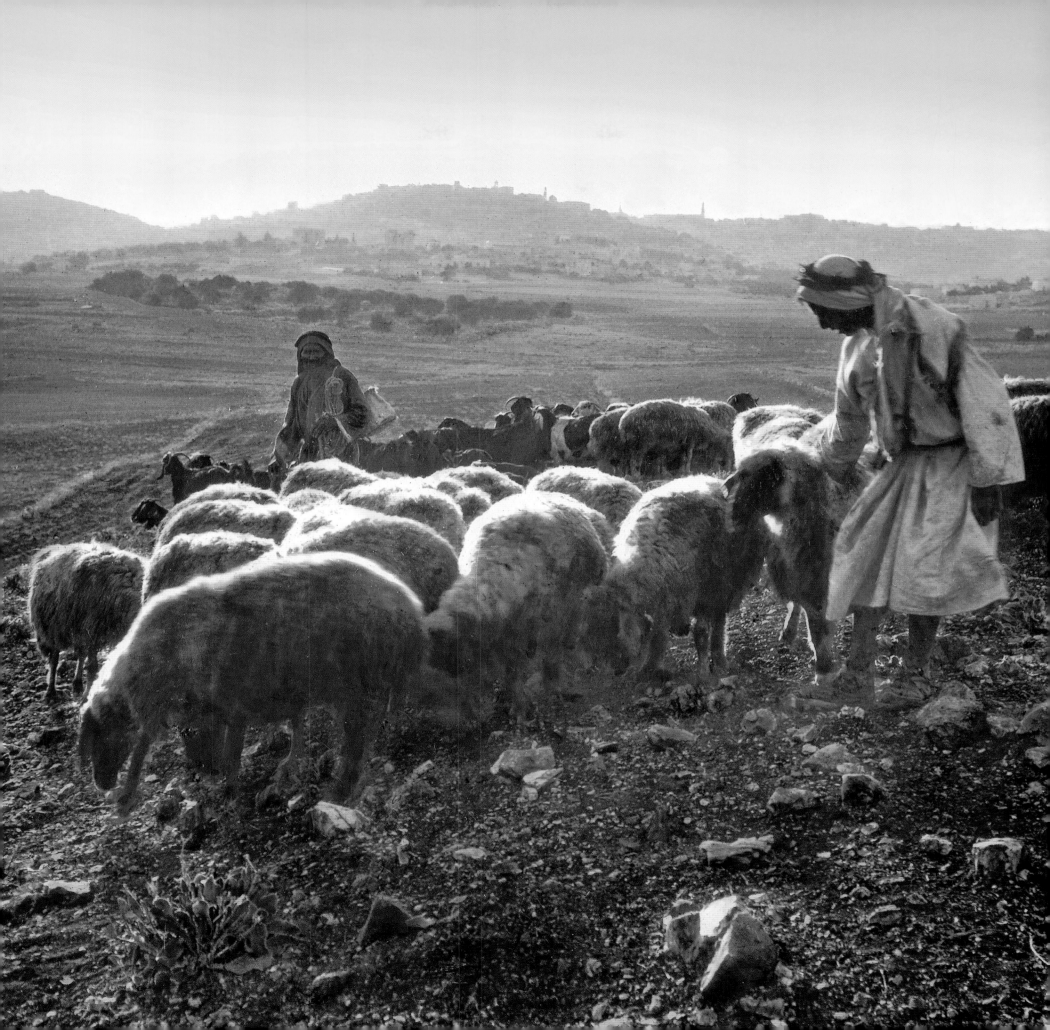

SHEPHERDS WITH SHEEP AT A GROTTO NEAR BETHLEHEM.

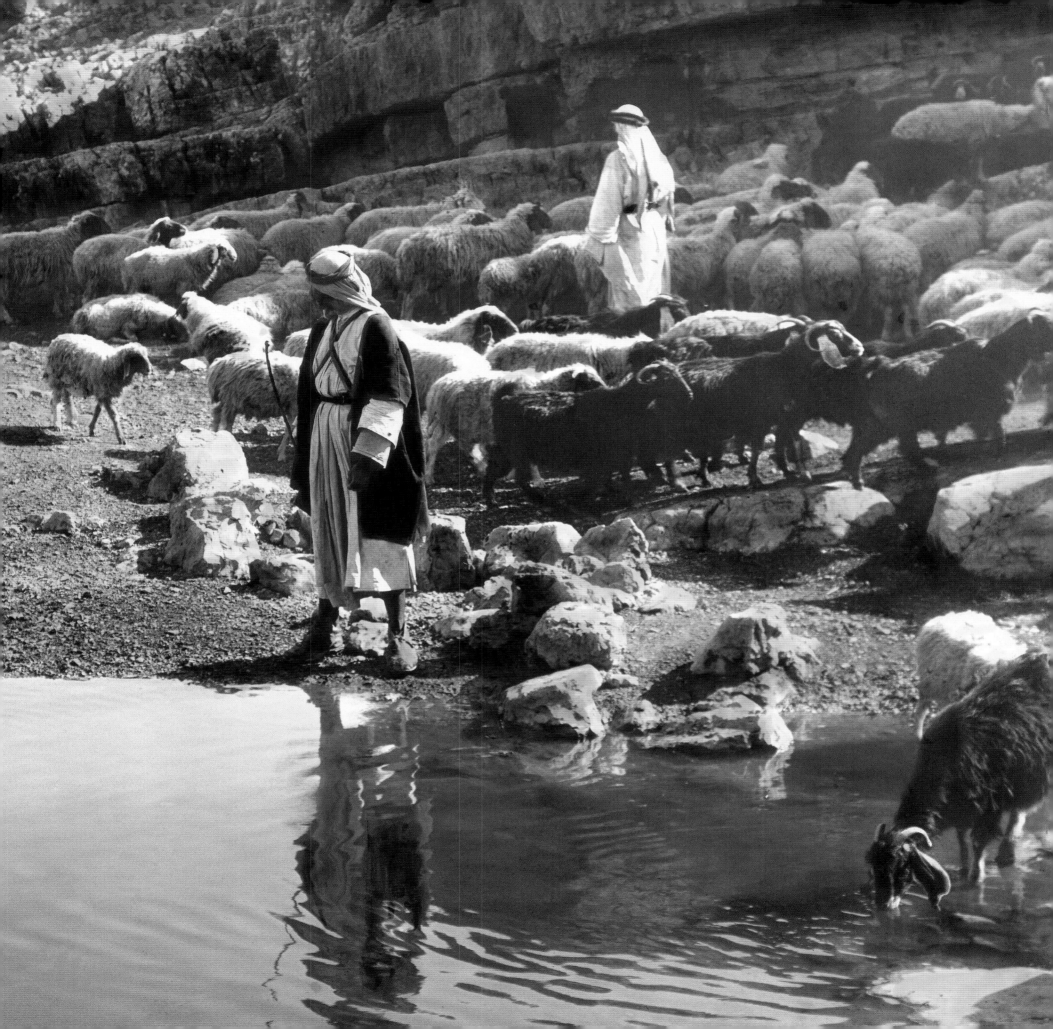

AERIAL VIEW OF HERODIUM.
King Herod built this magnificent fortified palace, on the model he had previously used for Masada, around 24 BC on top of a 400-foot hill 7.5 miles south of Jerusalem and 3 miles southeast of Bethlehem; he also built his tomb at Herodium. Historian Flavius Josephus wrote that Herod was buried "in a bier of solid gold studded with precious stones."

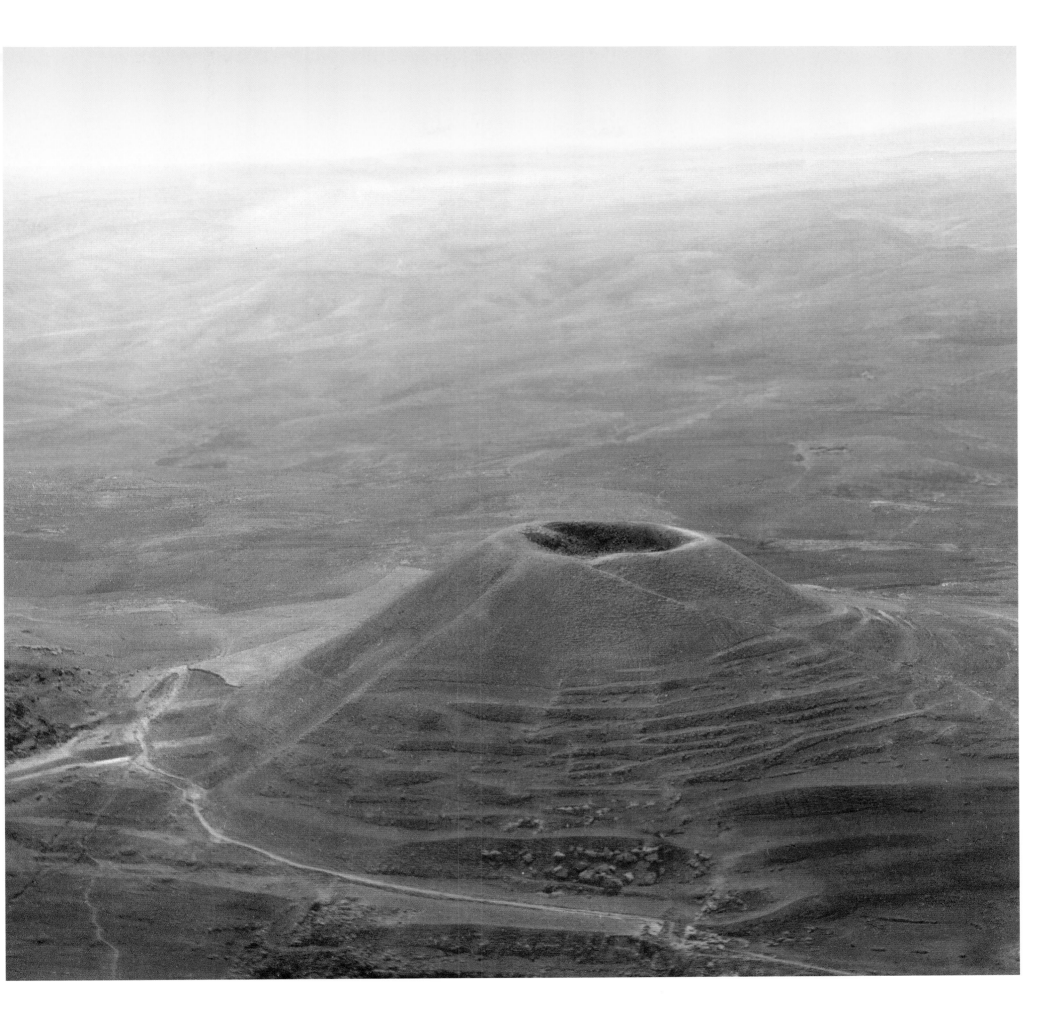

SYNAGOGUE AT HERODIUM.
Jewish rebels used Herodium as a base in both the first Jewish Revolt begun in 66 AD, when they built this synagogue in one of the palace rooms, and during the Bar Kokhba revolt in 132 AD.

BETHLEHEM IN SNOW.

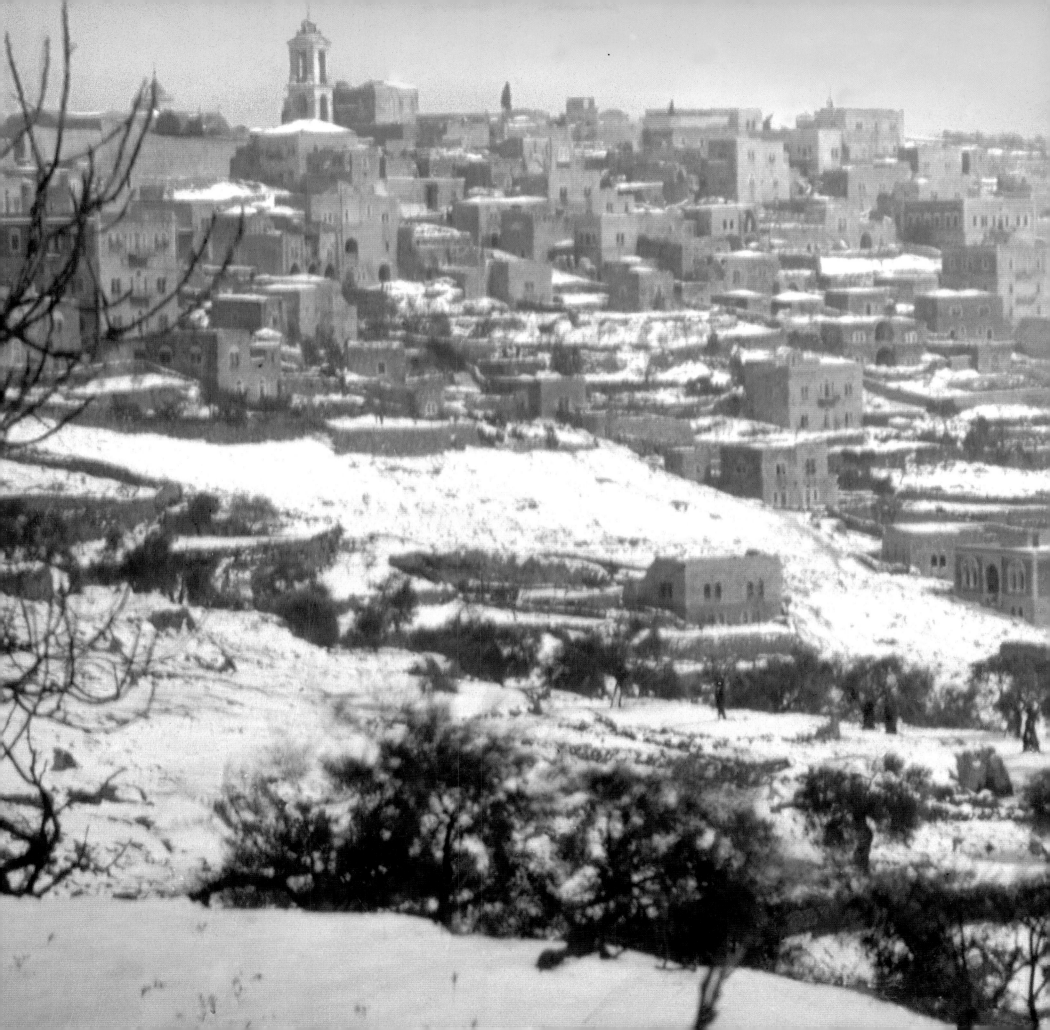

BETHLEHEM FROM THE SOUTHWEST.

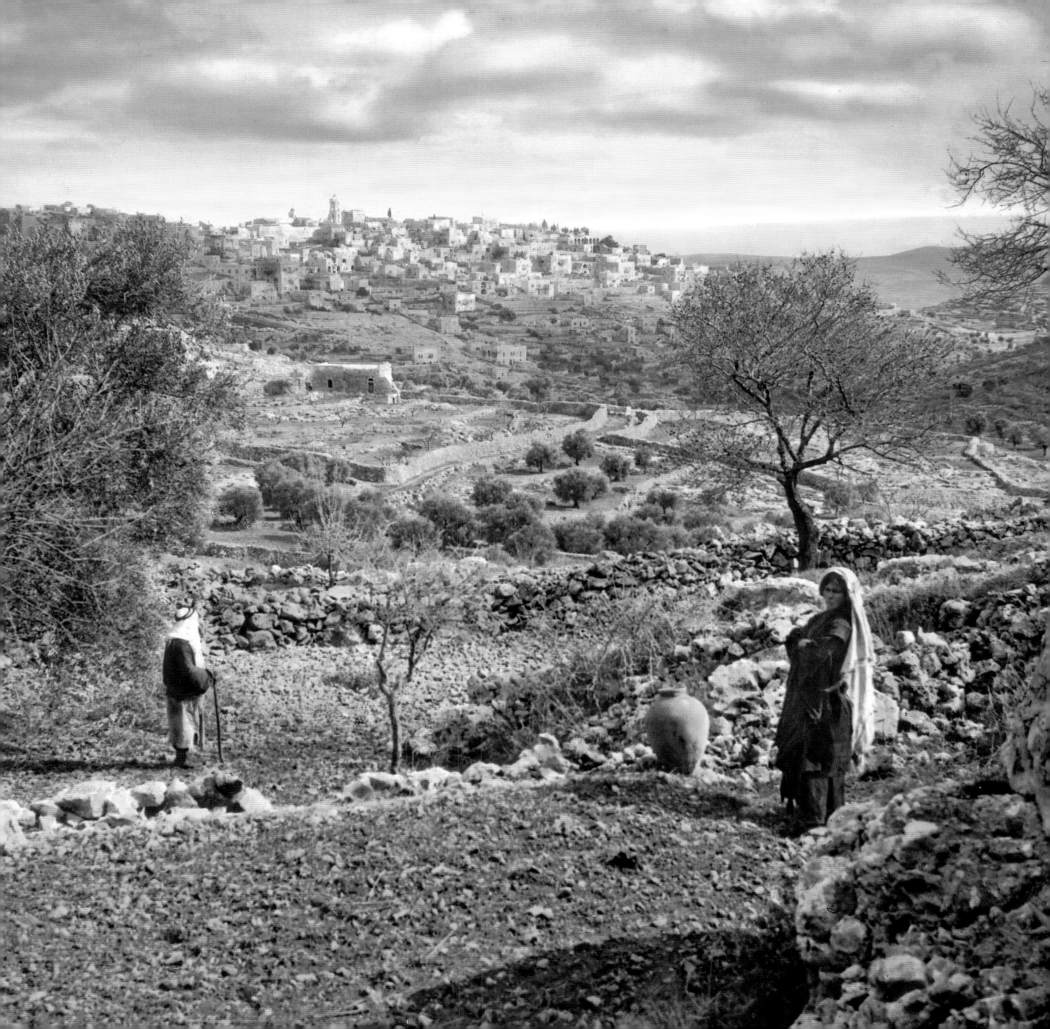

5 THE BEDOUIN

THE BEDOUIN ARE A NOMADIC Arabic-speaking people who live by herding goats, sheep, and camels across a most forbidding and inhospitable desert environment. They are followers of Islam. Tribal loyalty, a strong code of hospitality, and an adherence to traditional nomadic ways, most of which have not changed in centuries, characterize the Bedouin. As no one can survive alone in the desert, Bedouin hospitality dictates they extend to guests 3 days' food and water. They are patrilinear, with clans and tribes headed by Sheiks, literally "elders," and the family bond is sacred to them, illustrated by the traditional Arab proverb, "I against my brothers, I and my brothers against my cousins, and I, my brothers, and cousins against the world." Social classes exist, depending on ancestry and profession; camel herders were traditionally near the top of the social hierarchy. Folk music, dance, storytelling, and poetry feature prominently in their culture. The Bedouins of the Holy Land live largely in the south, in the Negev Desert.

In his memoir *Seven Pillars of Wisdom*, T.E. Lawrence—Lawrence of Arabia—wrote eloquently about his time with the Bedouin:

> This creed of the desert seemed inexpressible in words, and indeed in thought. It was easily felt as an influence, and those who went into the desert long enough to forget its open spaces and its emptiness were inevitably thrust upon God as the only refuge and rhythm of being. The Bedawi might be a nominal Sunni, or a nominal Wahabi, or anything else in the Semitic compass, and he would take it very lightly, a little in the manner of the watchmen at Zion's gate who drank beer and laughed in Zion because they were Zionists. Each individual nomad had his revealed religion, not oral or traditional or expressed, but instinctive in himself; and so we got all the Semitic creeds with (in character and essence) a stress on the emptiness of the world and the fullness of God; and according to the power and opportunity of the believer was the expression of them.

BEDOUIN SHEIK.
Bedouin society is patriarchal and divided into clans, each headed by a Sheik. The Sheikdom is passed down from the father to son, often but not always to the eldest son. The traditional headgear of Bedouin men is the keffiyeh, *held in place by ropes called* 'agal.

224

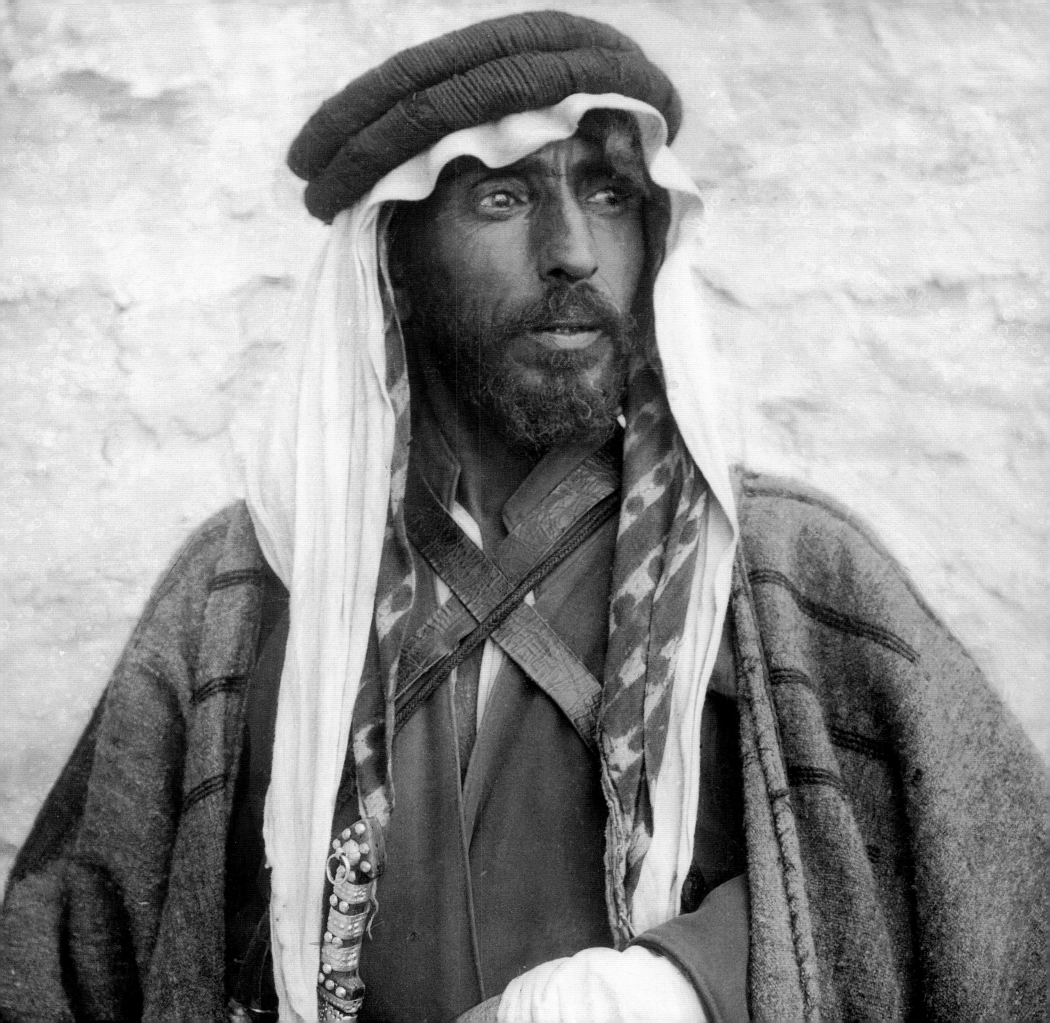

BEDOUIN SHEIK.

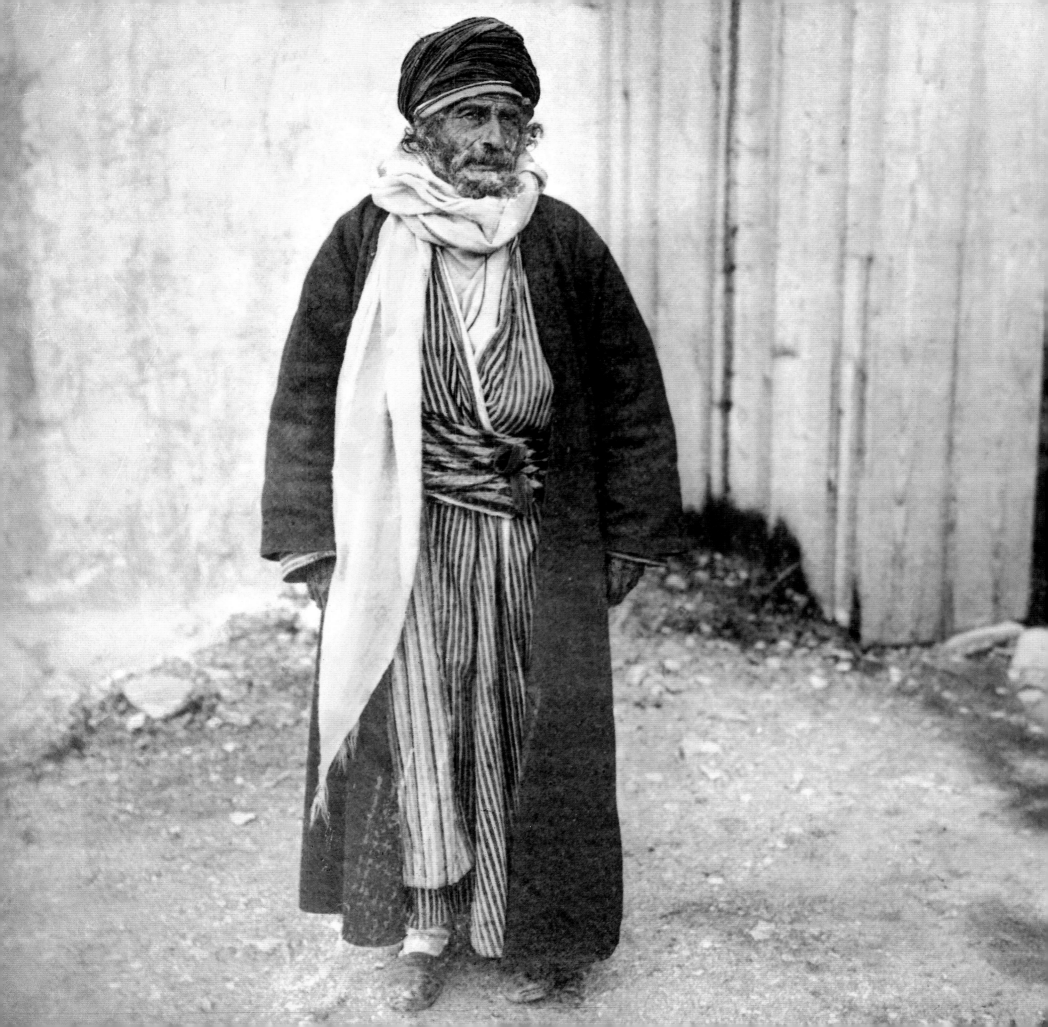

BEDOUIN WEDDING PROCESSION.
The camels would be decorated with beads, shells, and crimson tassels,
with others laden with the wedding gifts—baskets of rice, utensils, reed
mats, trunks, and most important of all, a colorful wooden cradle.

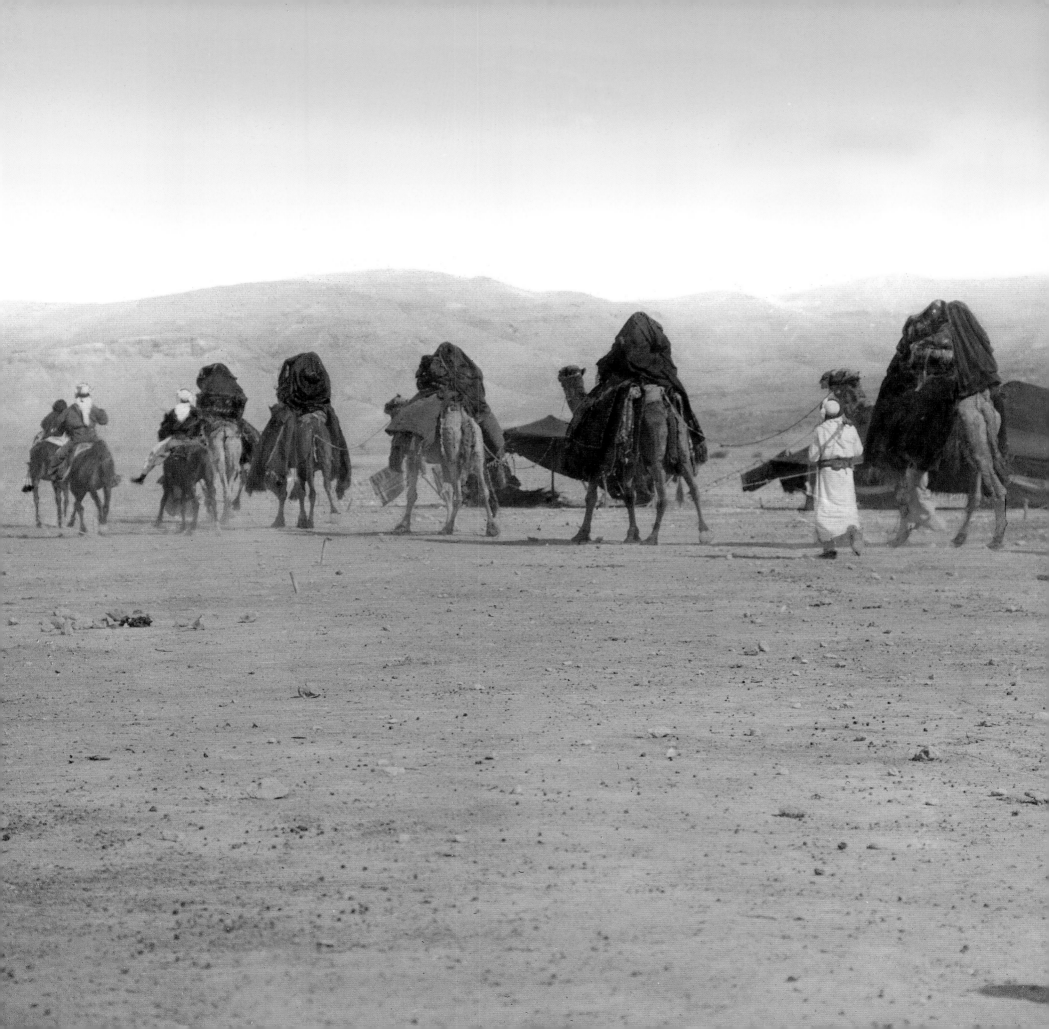

BEDOUIN MAN PREPARING COFFEE.

Serving coffee to guests is part of the ancient Bedouin hospitality code. First, fresh, green coffee beans would be roasted over the fire, the roasted beans then poured into a mortar and ground with an embellished pestle. The ground coffee, together with some crushed cardamom, would be placed in a blackened copper pot with an elegant long handle and brought to boil three times, before the coffee is ready to serve.

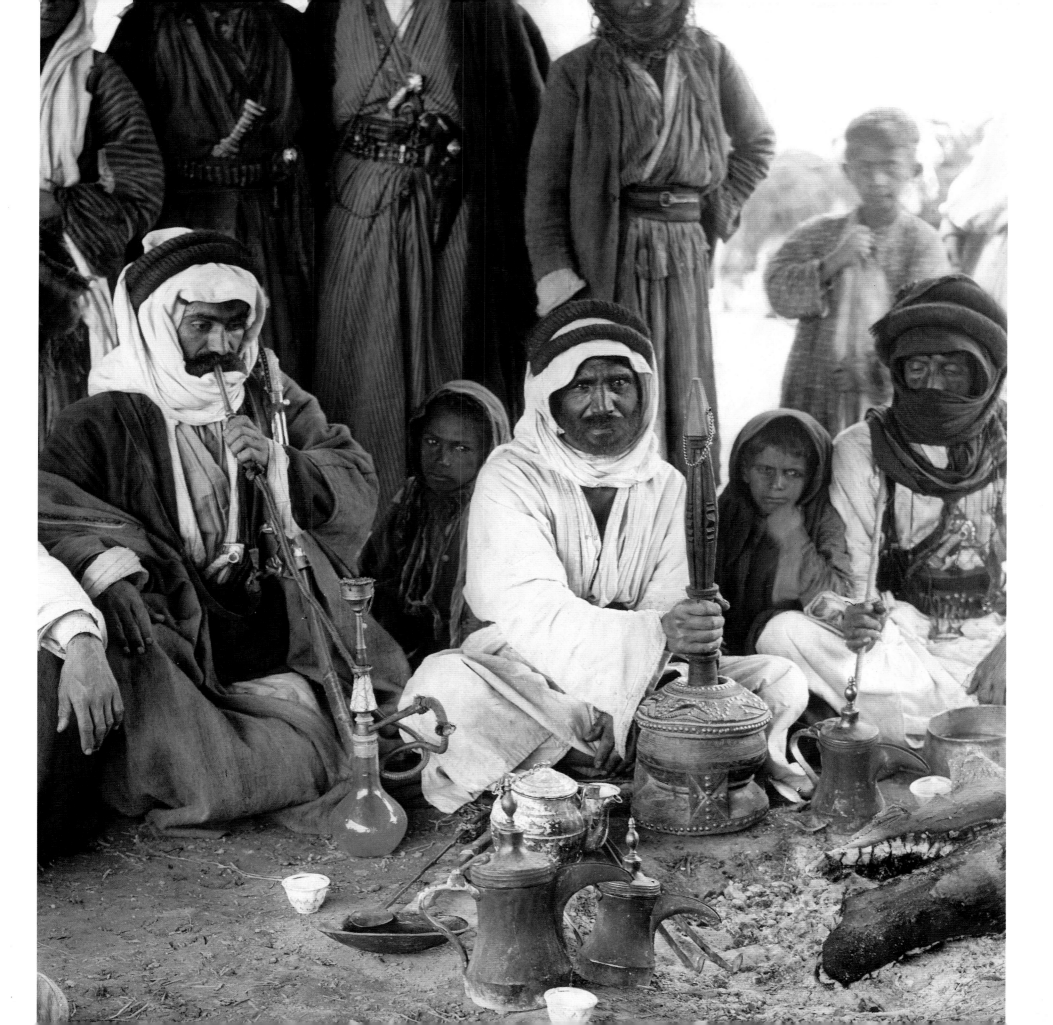

BEDOUINS GATHERED AROUND A BUTTER CHURN.

A goatskin butter churn, hanging from a tripod in the center of the encampment by lengths of twine, would be twisted and then released, and the spinning action would churn the butter.

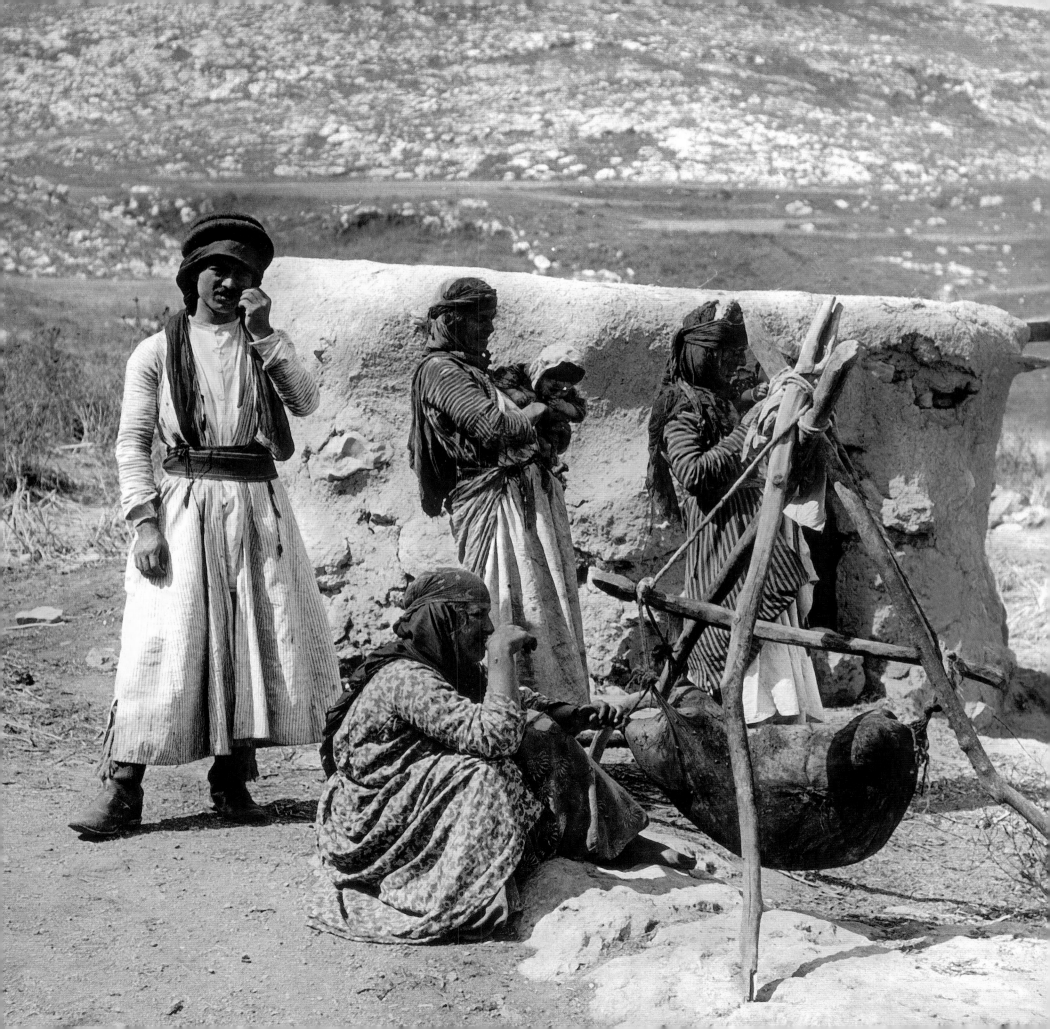

BEDOUIN WOMEN AND CHILDREN SITTING BY A REED ENCLOSURE.

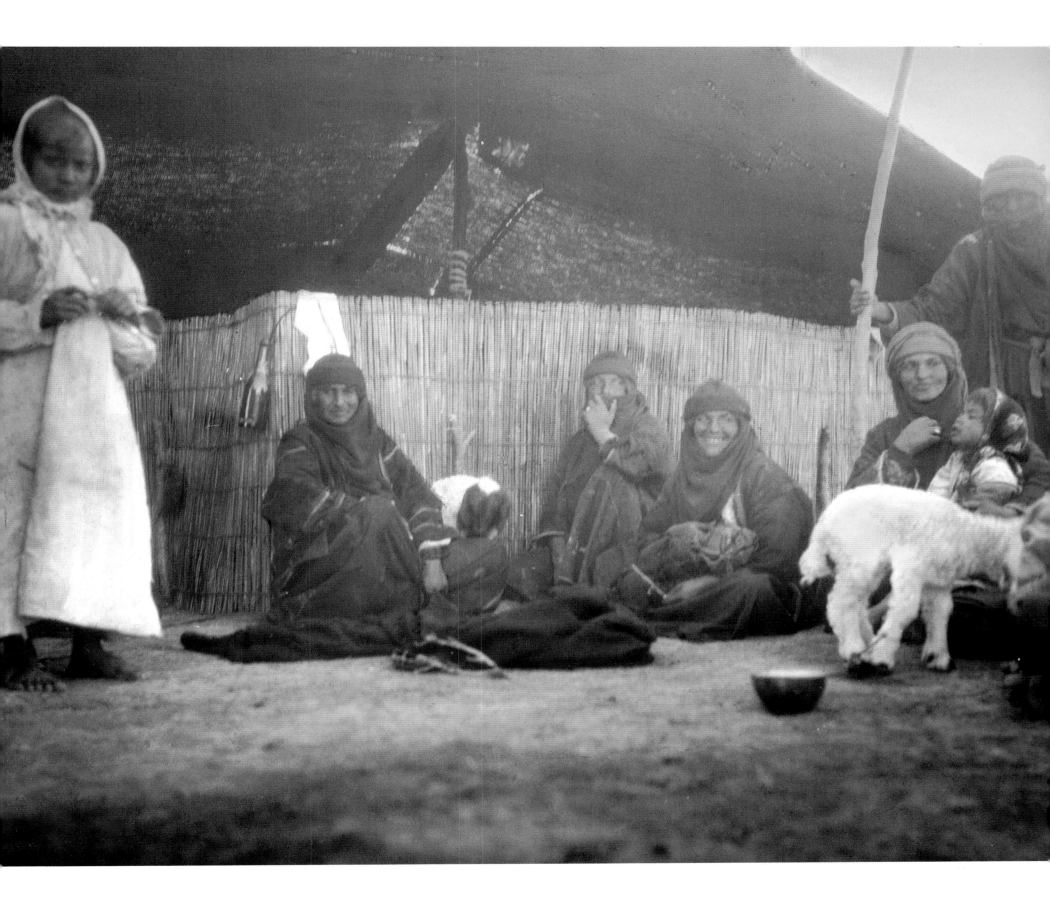

Bedouin Warriors on Horseback.

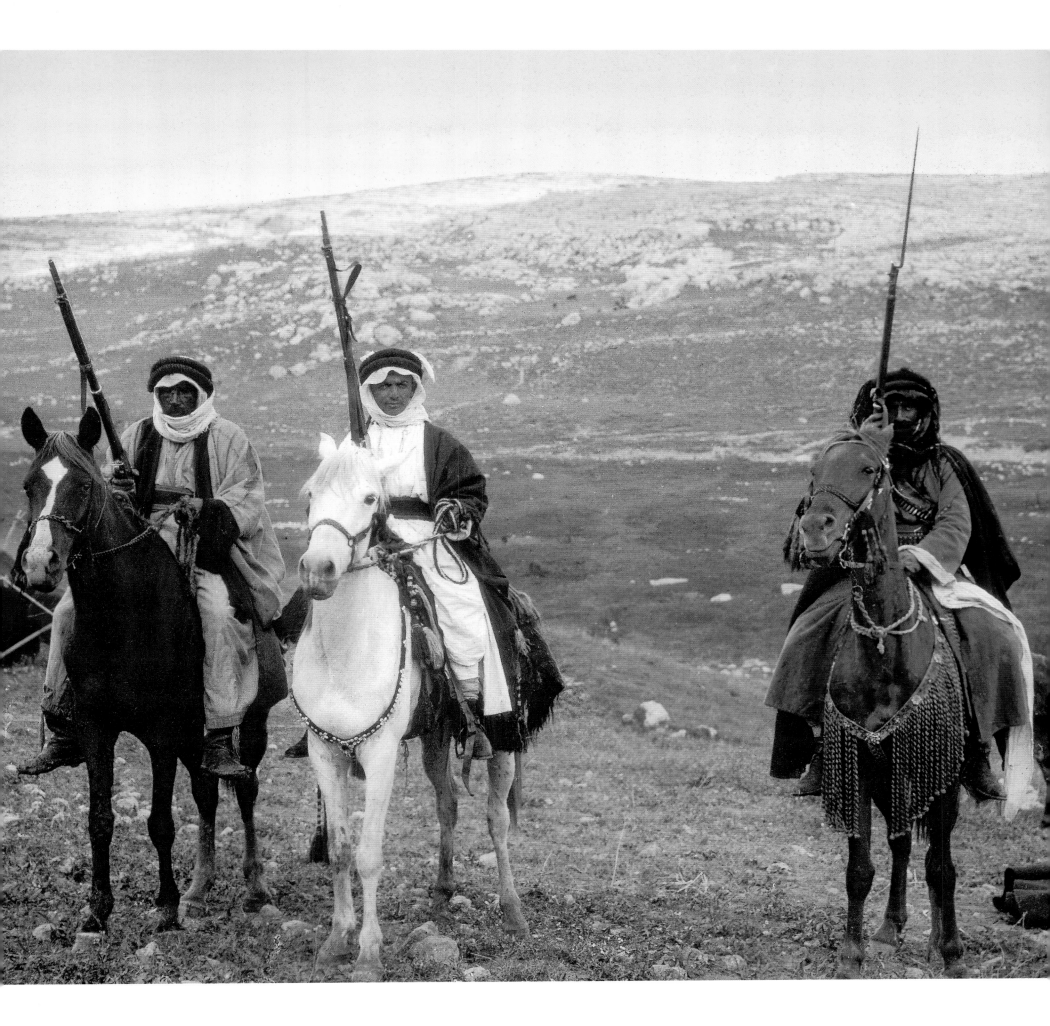

BEDOUINS IN THEIR TENT.

Generally, the larger the family, the larger the tent, and the Sheik, the clan elder, would have the largest tent. Bedouin tents are called "houses of hair" and are usually black and woven from goat's hair or camel's hair. The open side always faces away from the wind and the flattened, elongated shape prevents the tent from being blown away. There are separate sections for the men and women, with the women's section containing the food provisions.

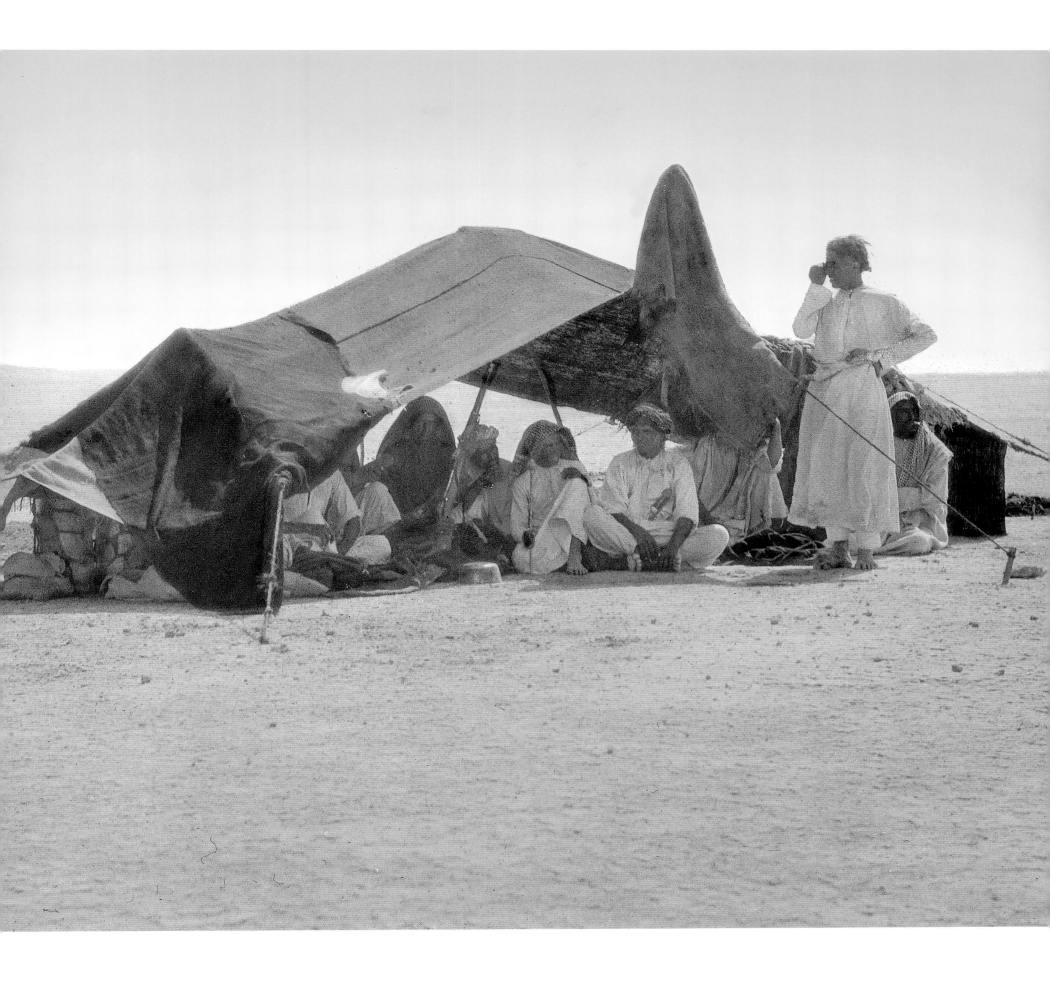

BEDOUIN WOMEN LADEN WITH PAPYRUS.
Collected from a nearby wadi (a dry riverbed in the desert, containing water only after it rains), the papyrus would be woven into matting.

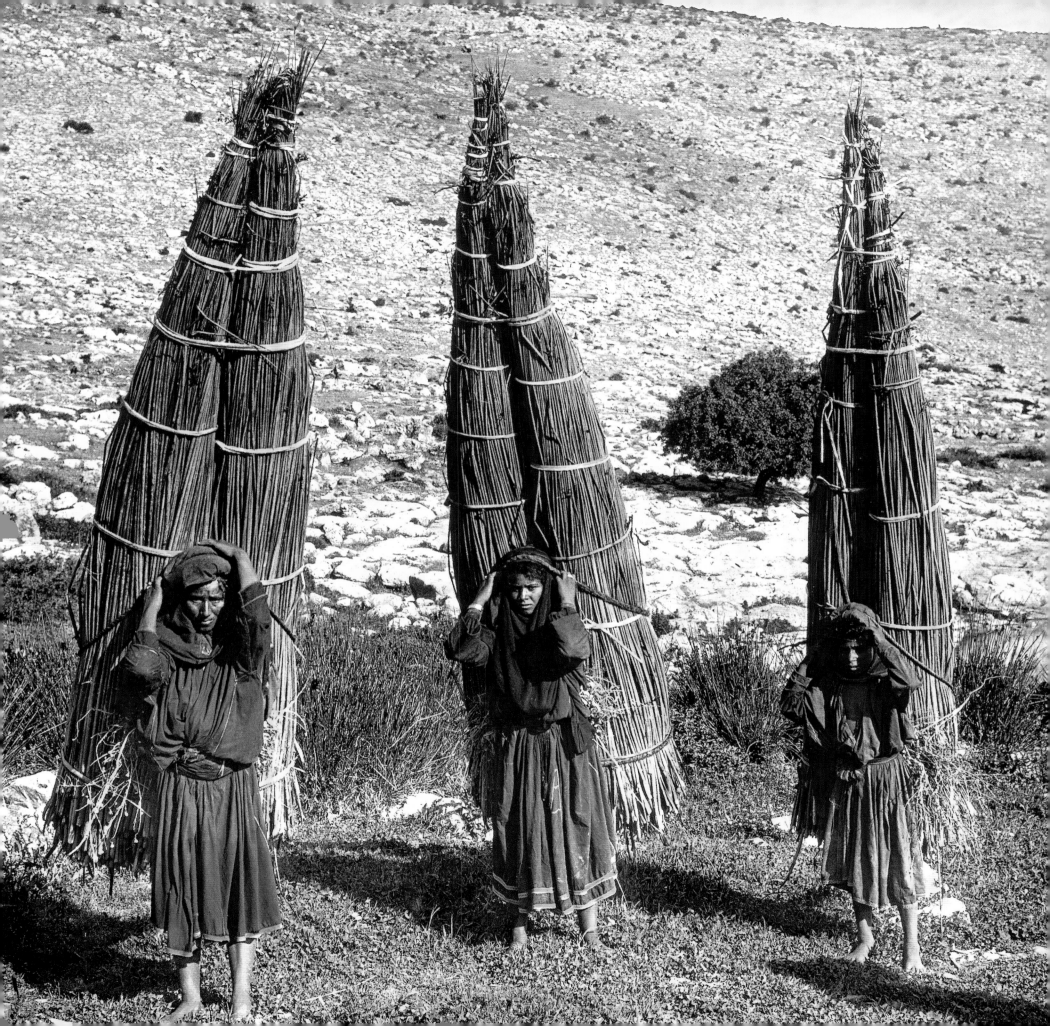

BEDOUIN WOMAN WEAVING PAPYRUS MATS ON A PRIMITIVE LOOM.

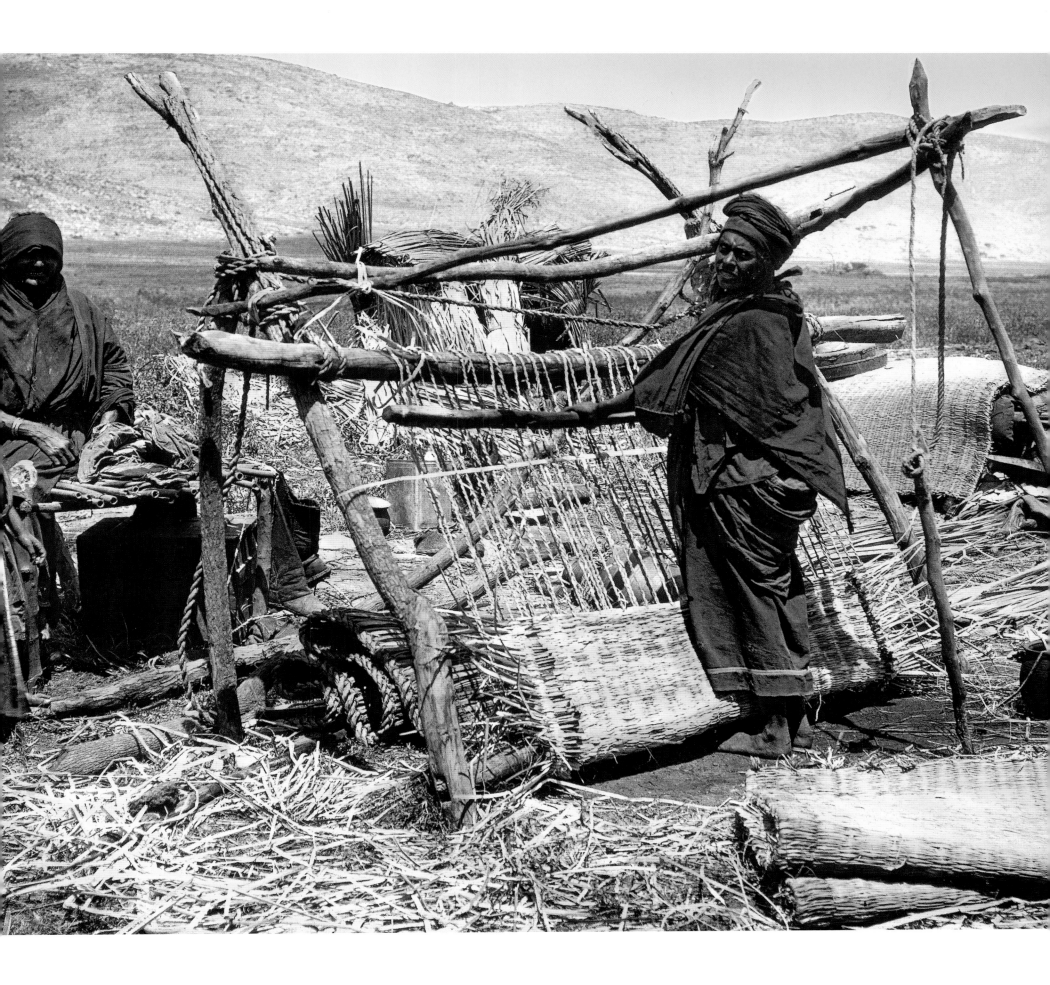

CAMELS AT THEIR WATERING PLACE.
Camels are central to the Bedouin way of life, providing transportation, milk and cheese; their hair is woven to make rugs, clothing, and tents.

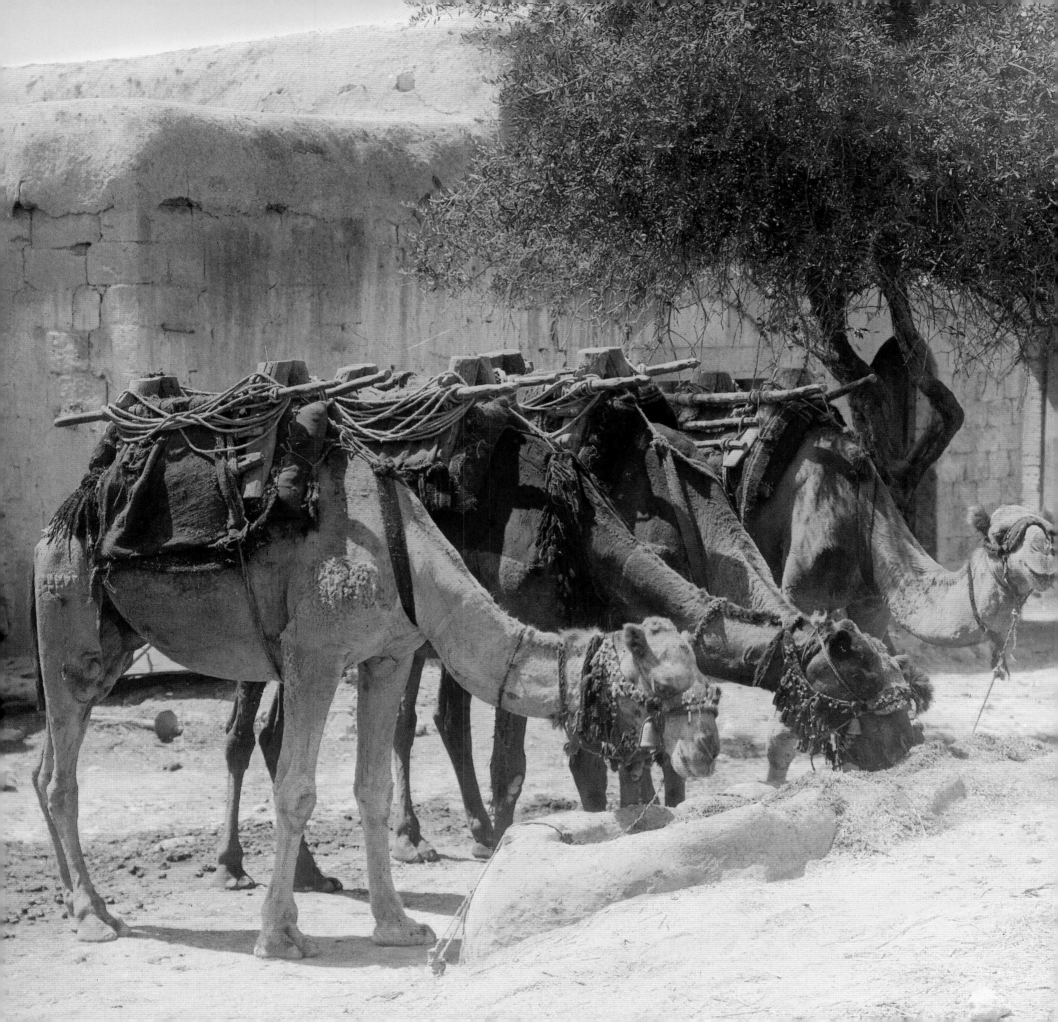

BEDOUIN GIRL.

Bedouin girls and women would wear a loose fitting black or blue garment that fully covered them, protecting them from the harsh desert conditions, whether wind or sand or intense sunlight.

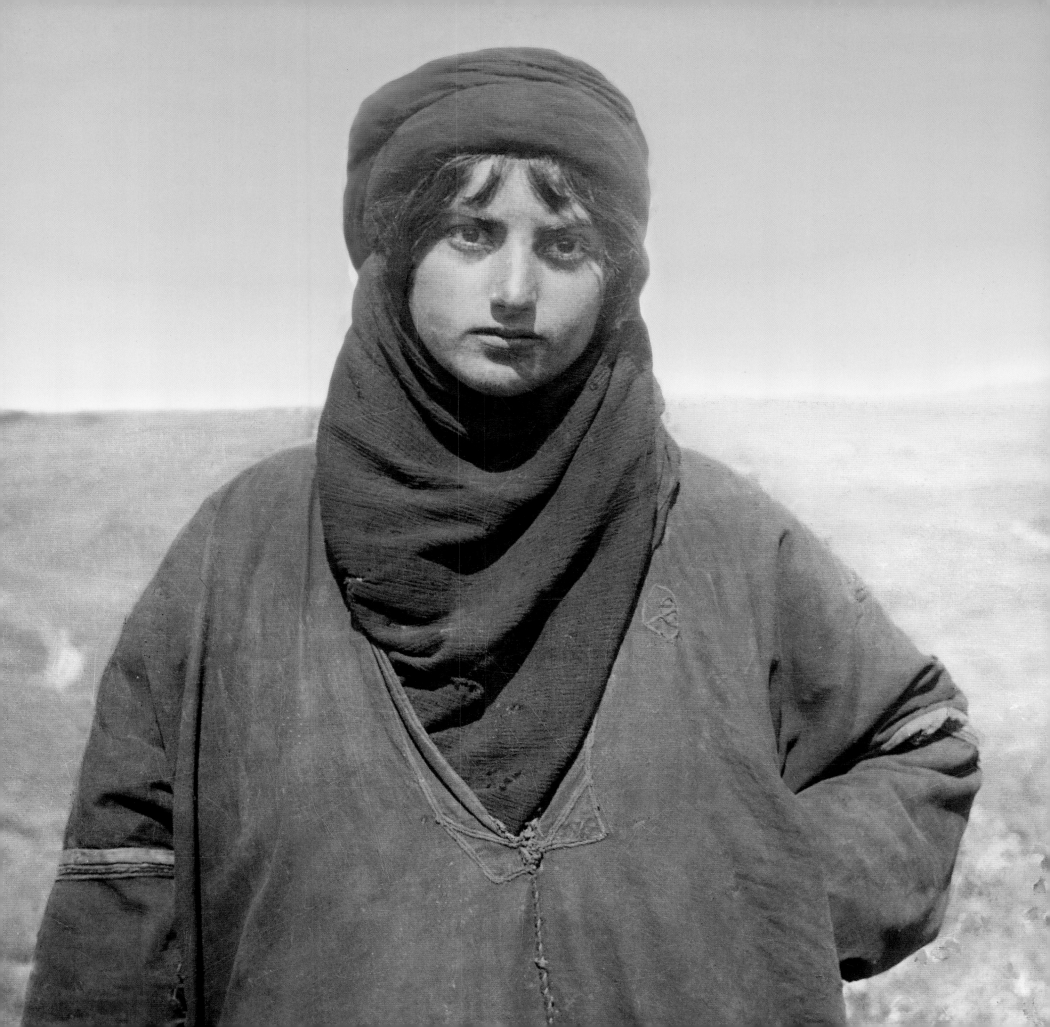

BEDOUIN WOMEN, HEAVILY VEILED.
Bedouin women would cover their faces with masks, often decorated with coins to show the financial status of the family.

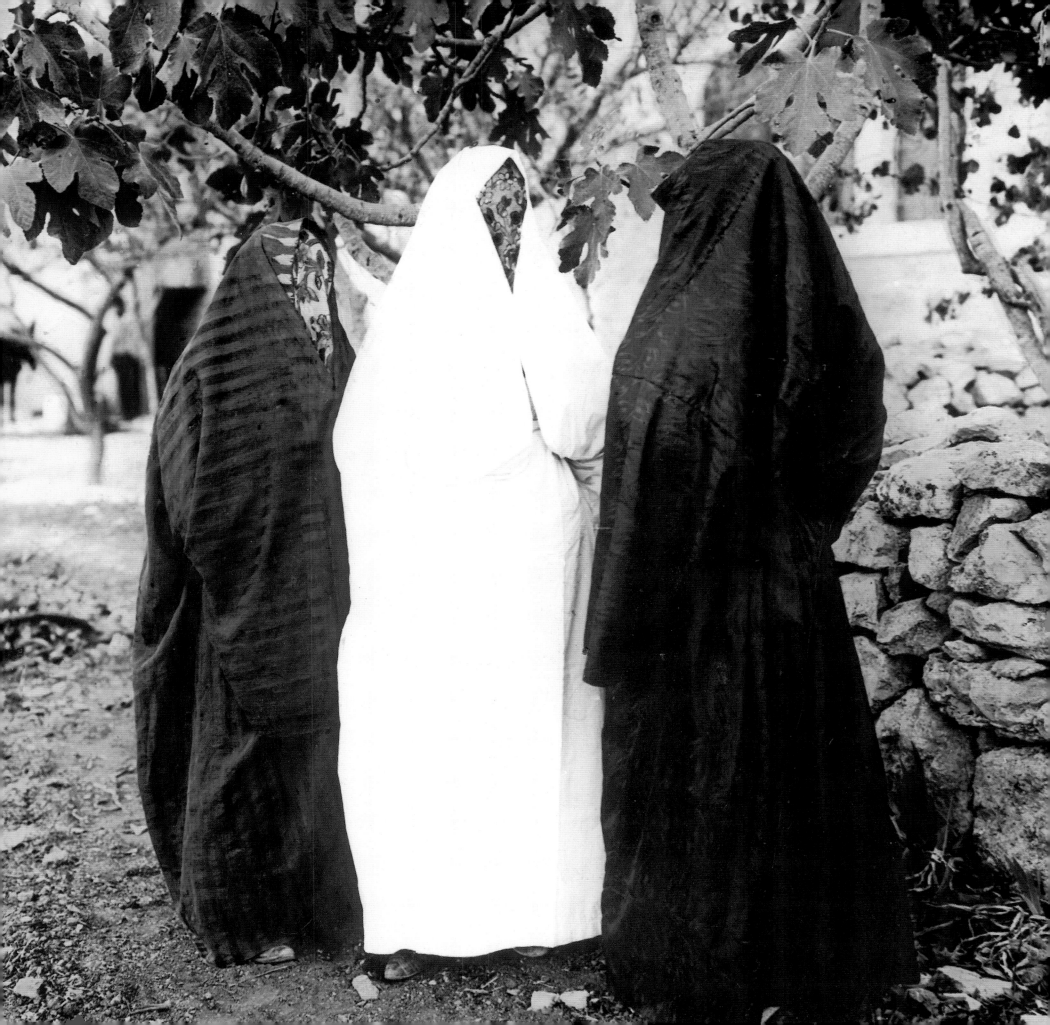

Bedouin Caravan, Crossing the Desert, I.

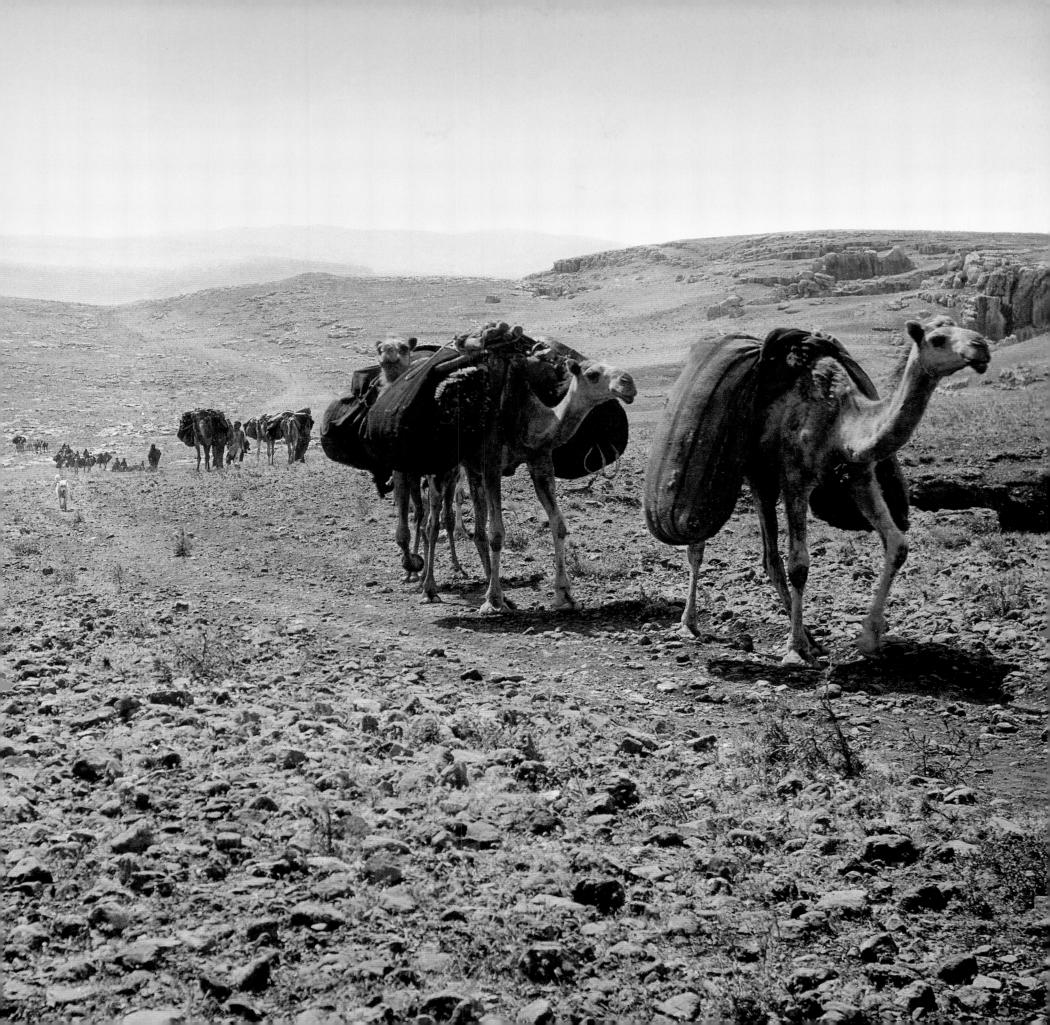

BEDOUIN CARAVAN, CROSSING THE DESERT, II.

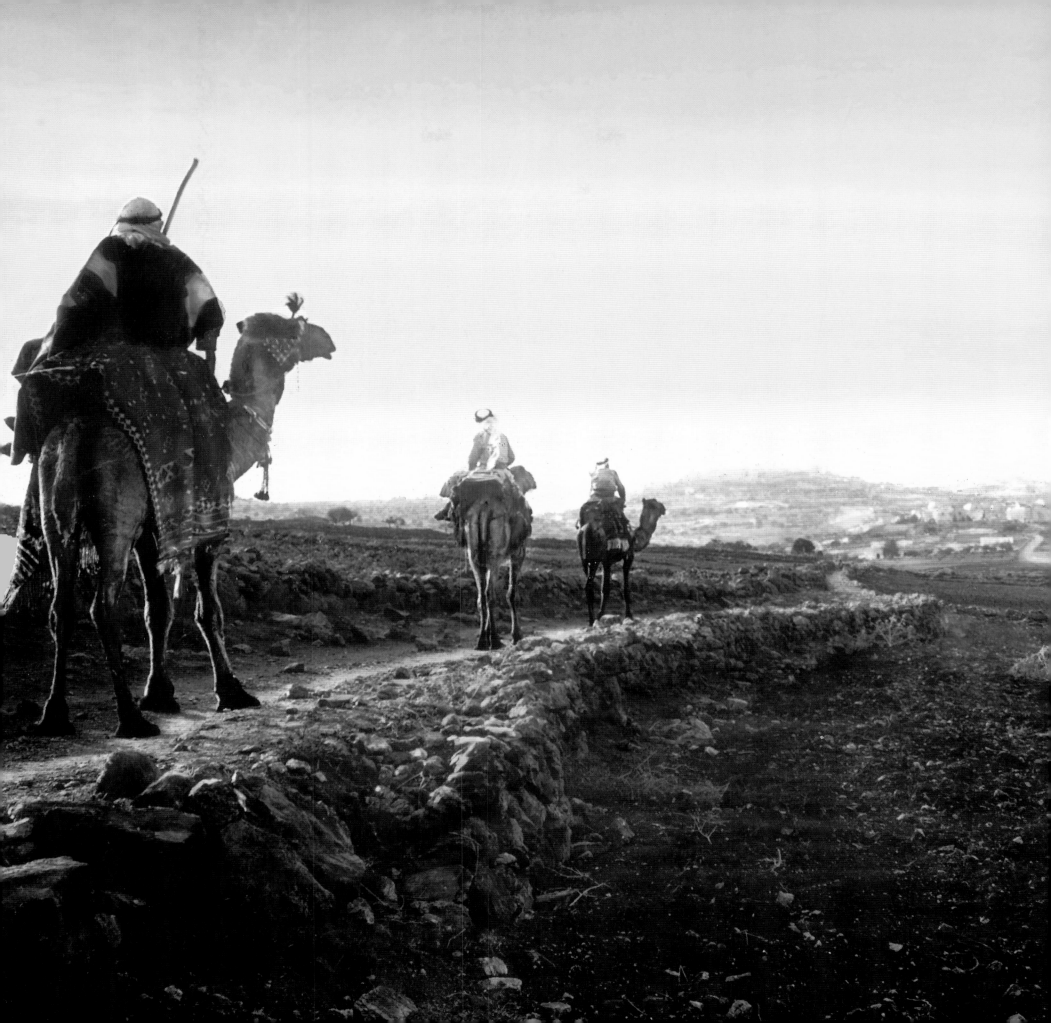

BEDOUIN CARAVAN, CROSSING THE DESERT, III.

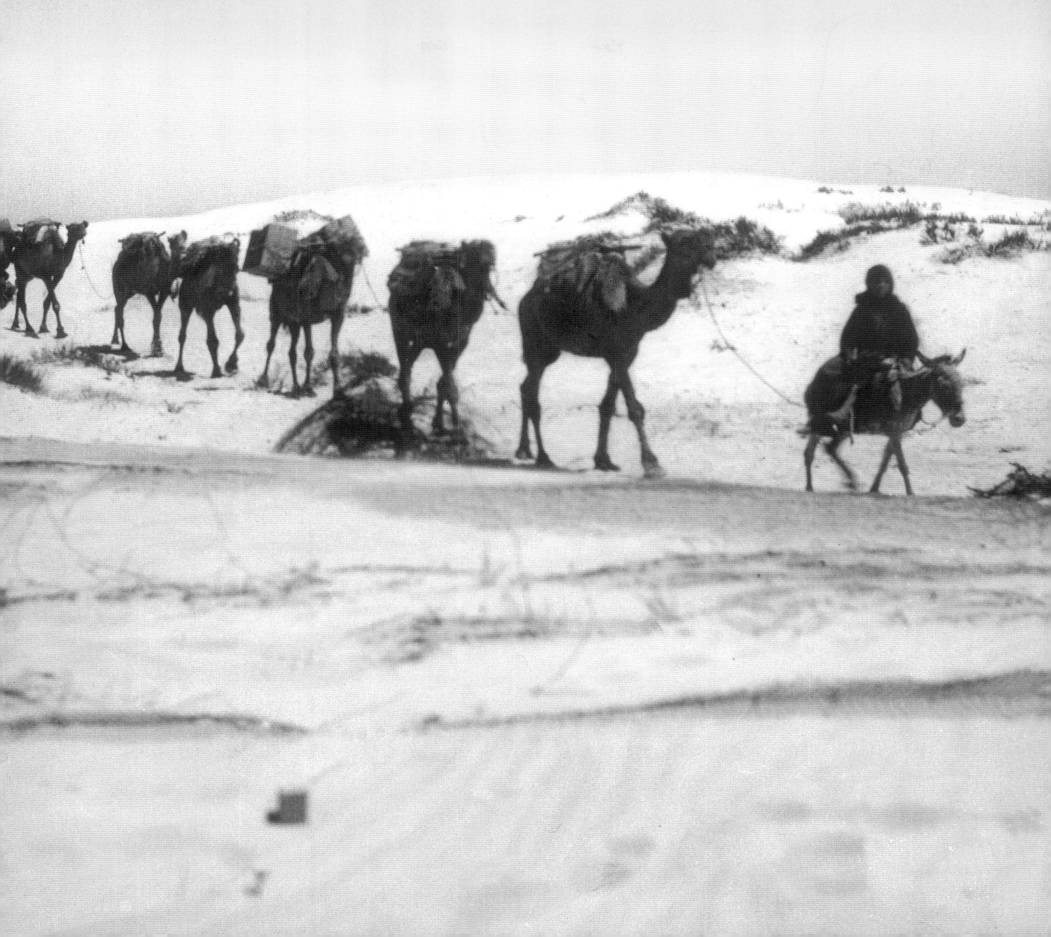

Bedouin Children and Camel.

BEDOUIN AROUND CAMPFIRE AT NIGHT.
In Bedouin camps, evenings would be spent seated around the campfire, where storytelling is a main pastime.

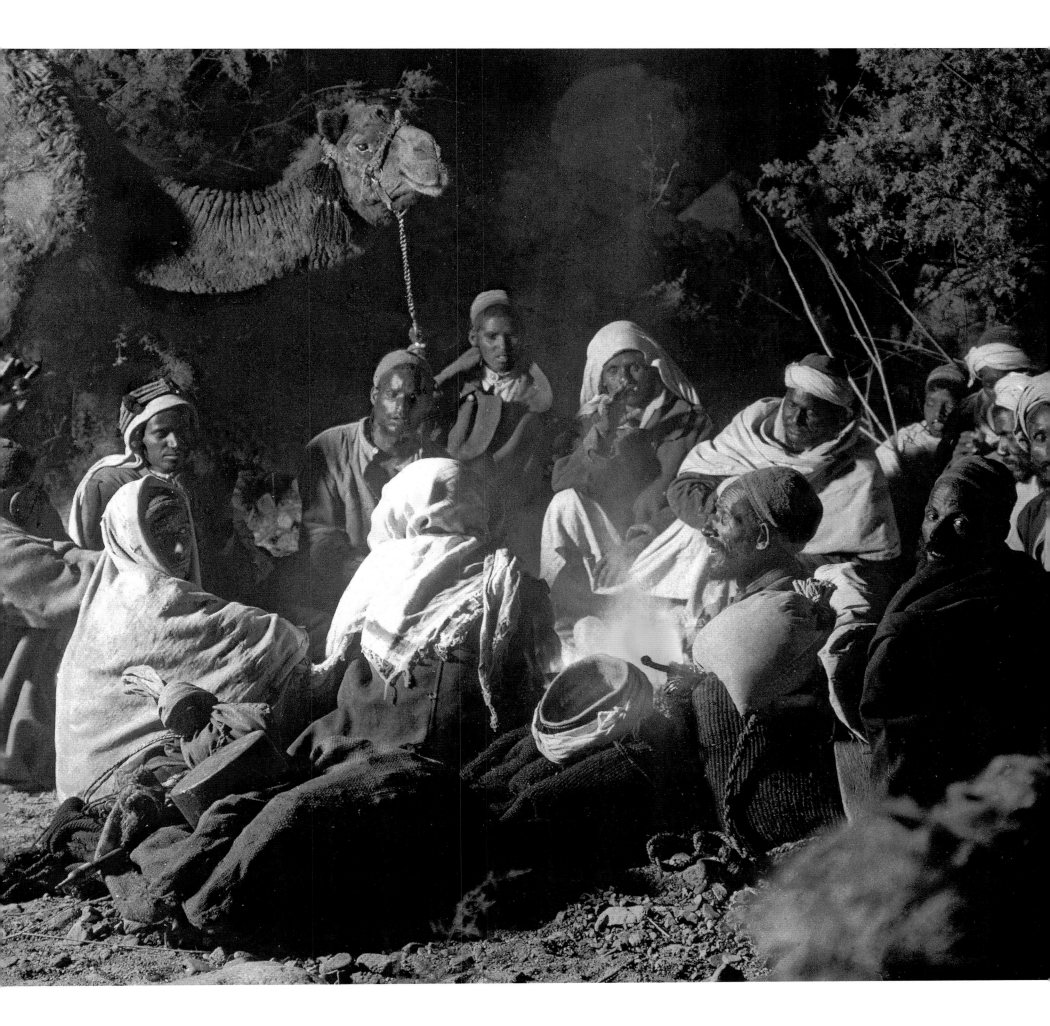

6 THE JORDAN RIVER, THE GHOR, AND THE DEAD SEA

THE JORDAN RIVER, REVERED BY Christians as the place where Jesus was baptized by John the Baptist, originates from several sources, mainly the foothills of Mount Hermon, and flows south through the Sea of Galilee, emptying into the Dead Sea, which, at 1378 feet below sea level, is the lowest point on earth. The Jordan's flow is deep and turbulent during the rainy season and sluggish and shallow during the summer. It is the largest and longest river in Israel. In Old Testament tradition, Joshua, Moses' successor, famously crosses the Jordan, whose waters part as the priests bearing the Ark of the Covenant enter the river. Joshua then leads the Israelites into Jericho, the site of their first major battle of their conquest of the land of Canaan.

The Dead Sea, known in the Bible as the Salt Sea, is nearly nine times as salty as the world's oceans. Ezekiel (47:8-9) prophesied that it would one day contain fresh water and fishermen would spread their nets there. In the Book of Genesis the cities of Sodom and Gomorrah, said to have been destroyed in the time of Abraham, were perhaps on the southeast shore. Herod built several palaces and fortresses on the western bank, the most famous of which is Masada.

The northern part of the Jordan valley, between the Sea of Galilee and the Dead Sea, is called the Ghor. Fertile, several degrees warmer than the area around it, and with good access to water, the Ghor is a key agricultural region of the Holy Land.

AERIAL VIEW OF THE JORDON RIVER.
The waters of the Jordan River are a vitally important resource for this extremely dry region. It flows into both the Sea of Galilee and the Dead Sea, its terminus.

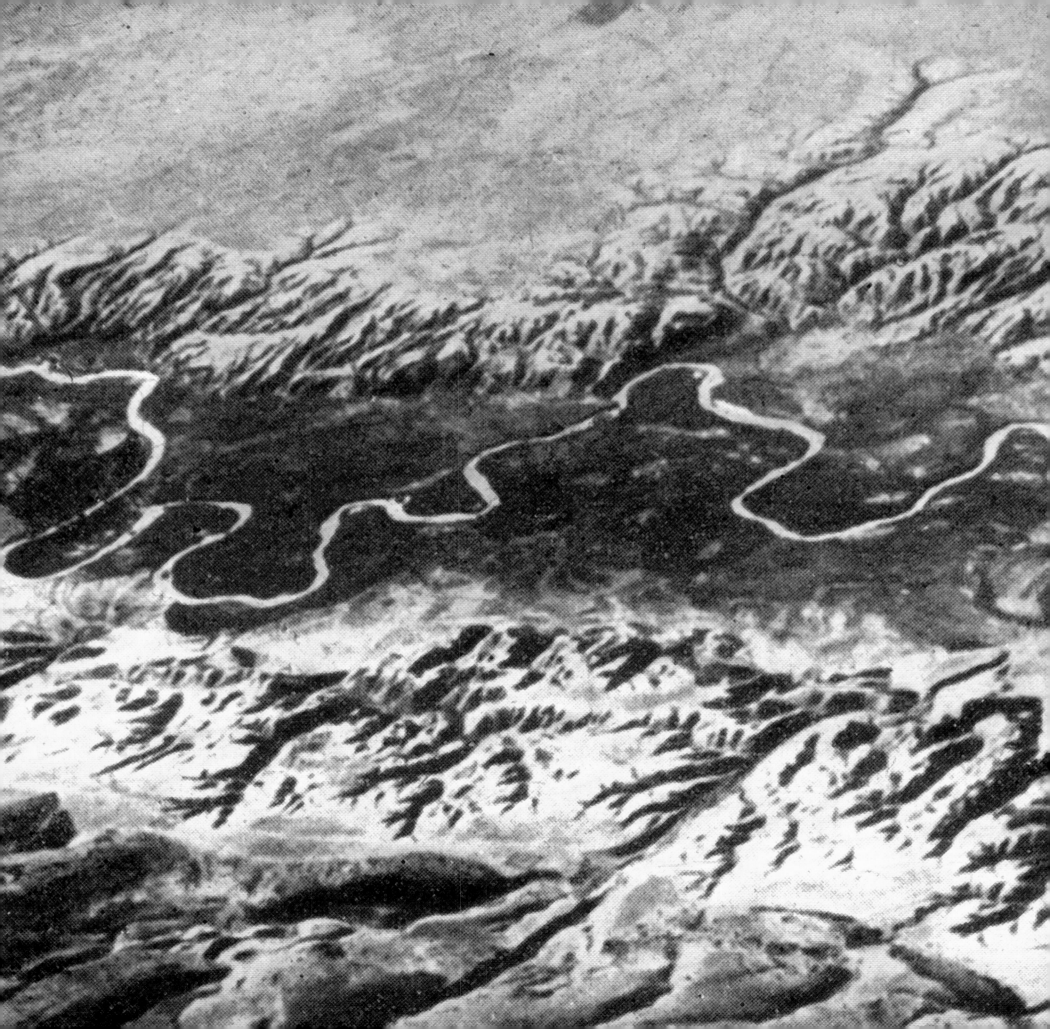

THE JORDAN RIVER, CLOSE UP.

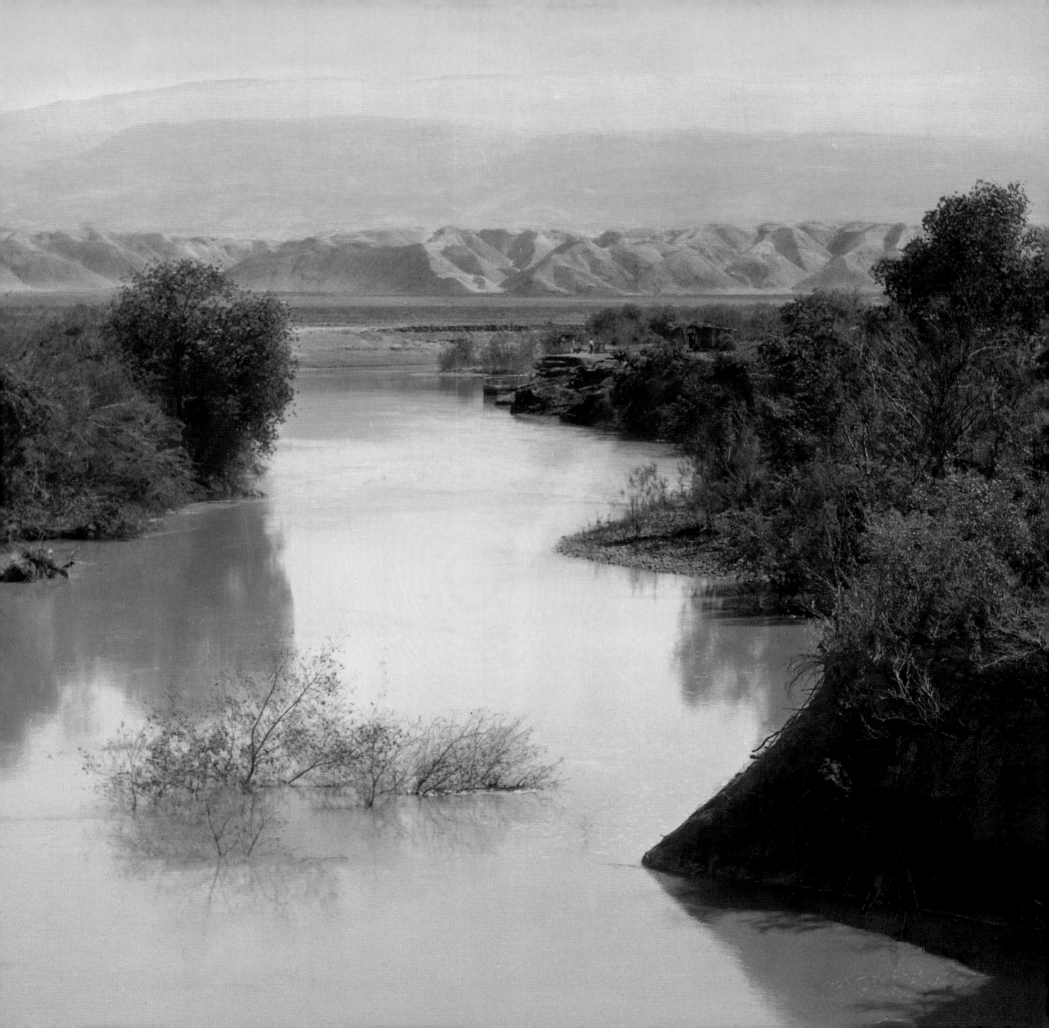

AERIAL VIEW OF THE JUDEAN FOOTHILLS.
Jericho and the Jordan River can be seen in the distance.

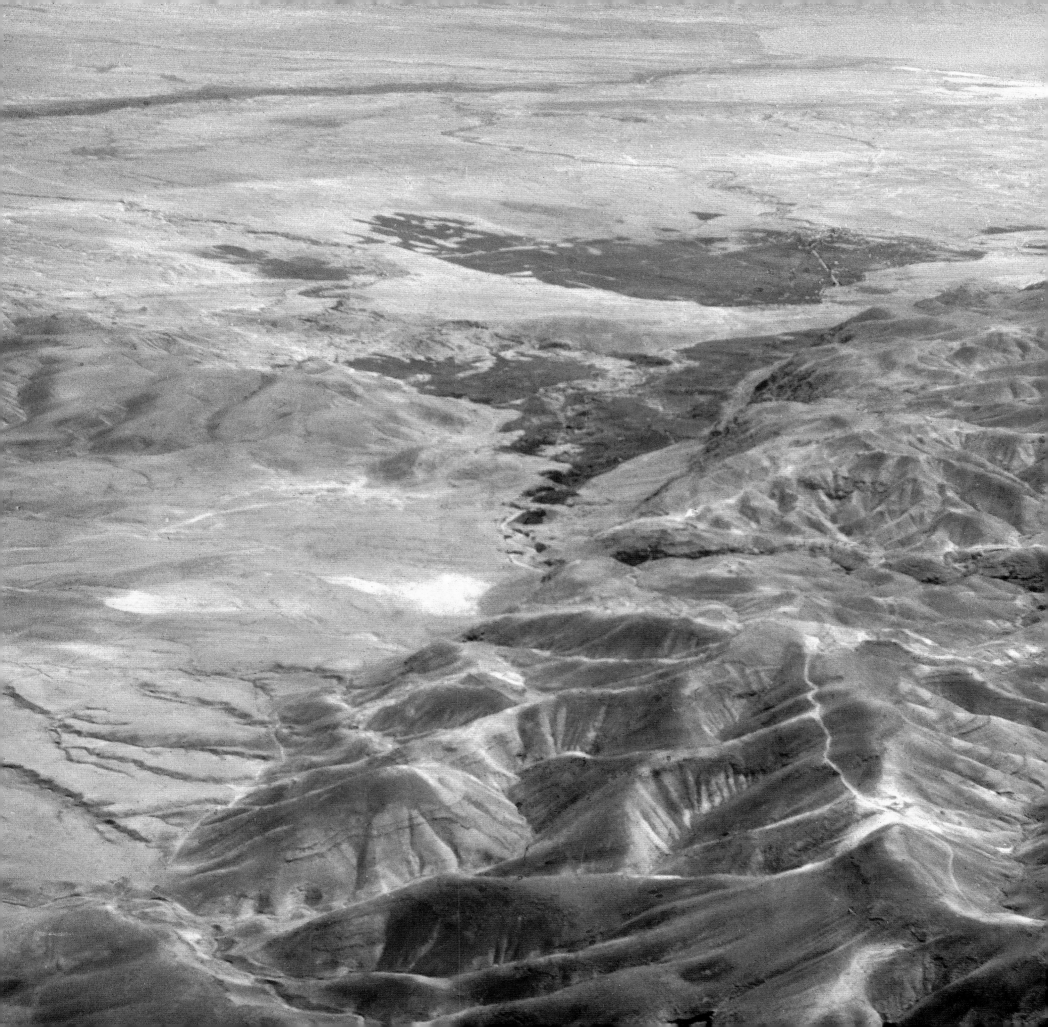

THE JUDEAN WILDERNESS.

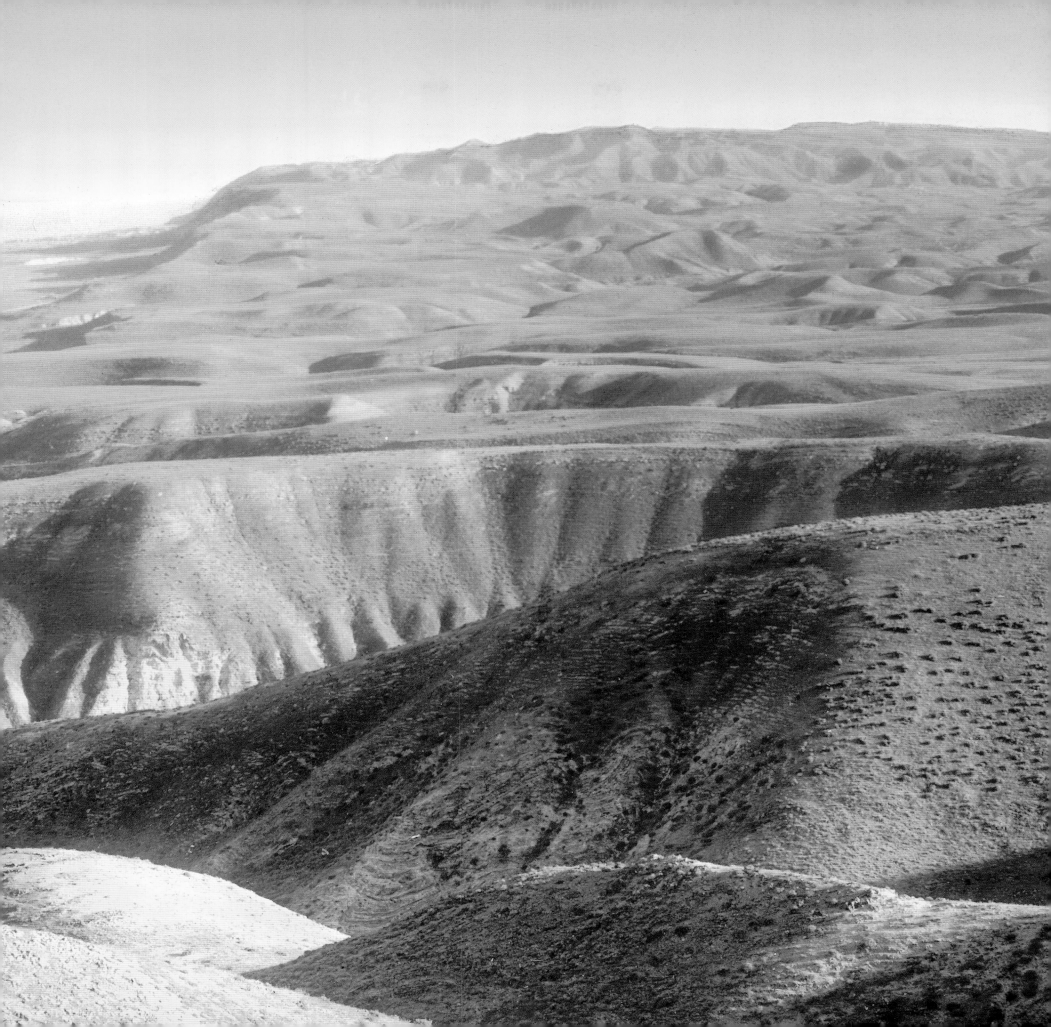

NABI MUSA.

Literally "the Prophet Moses," Nabi Musa is an annual, seven-day long religious festival celebrated by Moslems in the Holy Land. It centers on a pilgrimage from Jerusalem to what is believed by Moslems to be the Tomb of Moses, near Jericho.

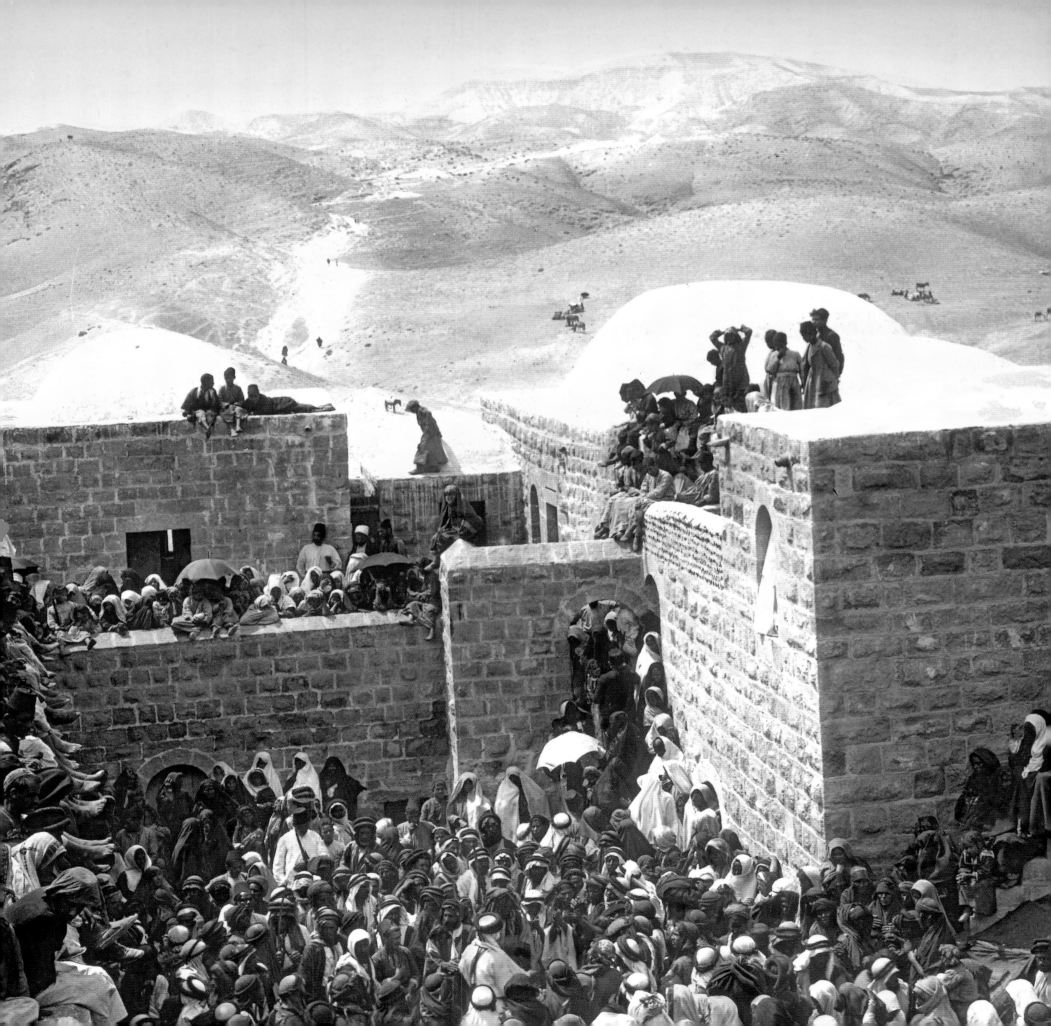

FORMATIONS NEAR THE JORDAN.

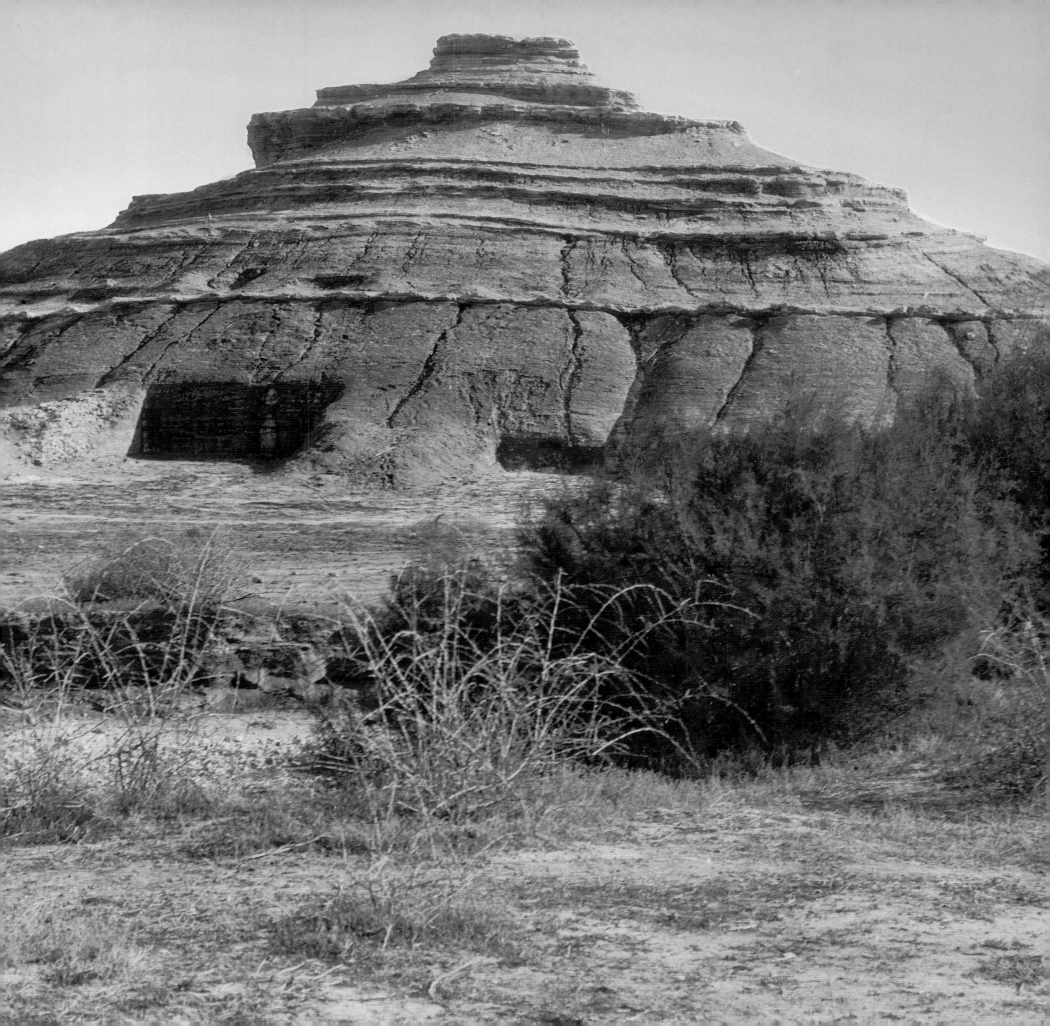

KAFR MALEK.
Kafr Malek is a Judean village situated northeast of Ramallah.

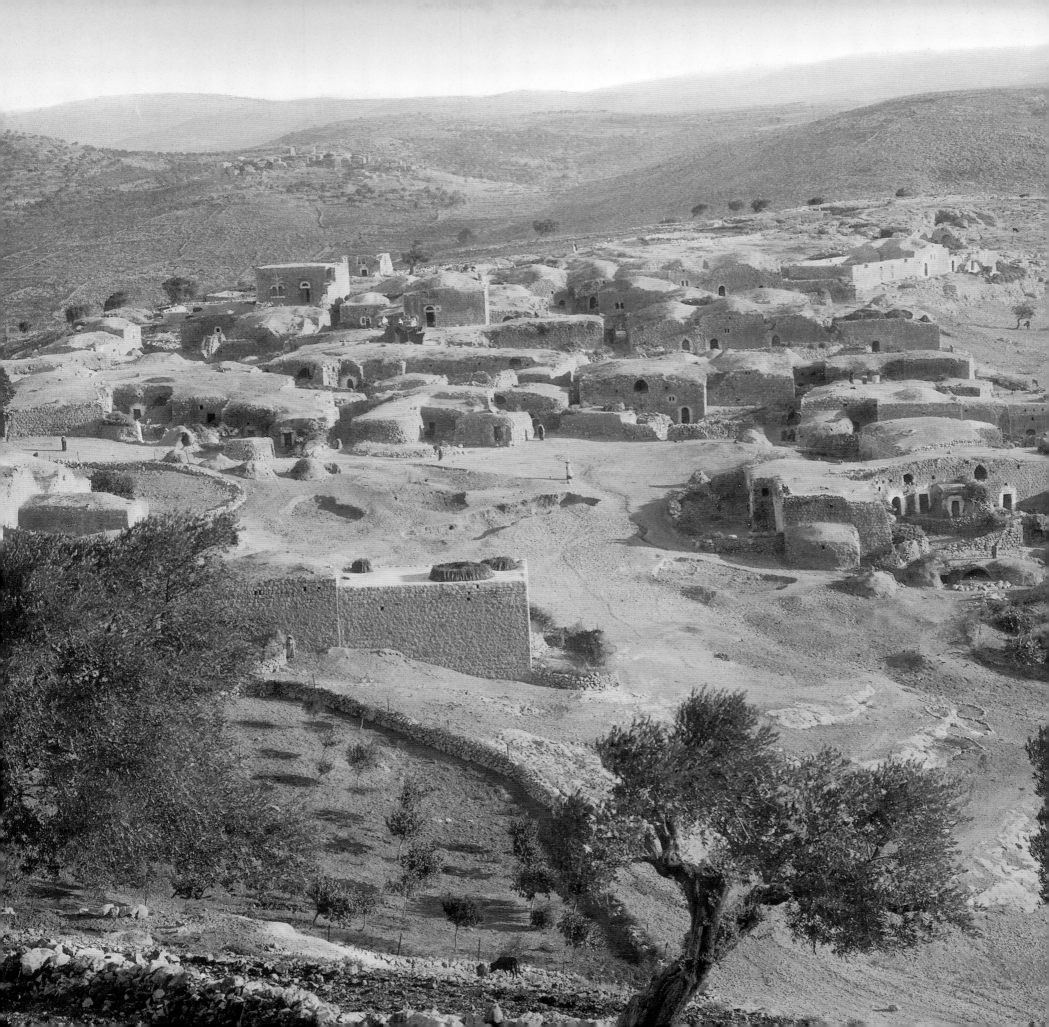

JERICHO HOMELIFE.

There is archeological evidence that there have been settlements in Jericho since 9000 BC. The Biblical account of the Battle of Jericho is found in the Book of Joshua.

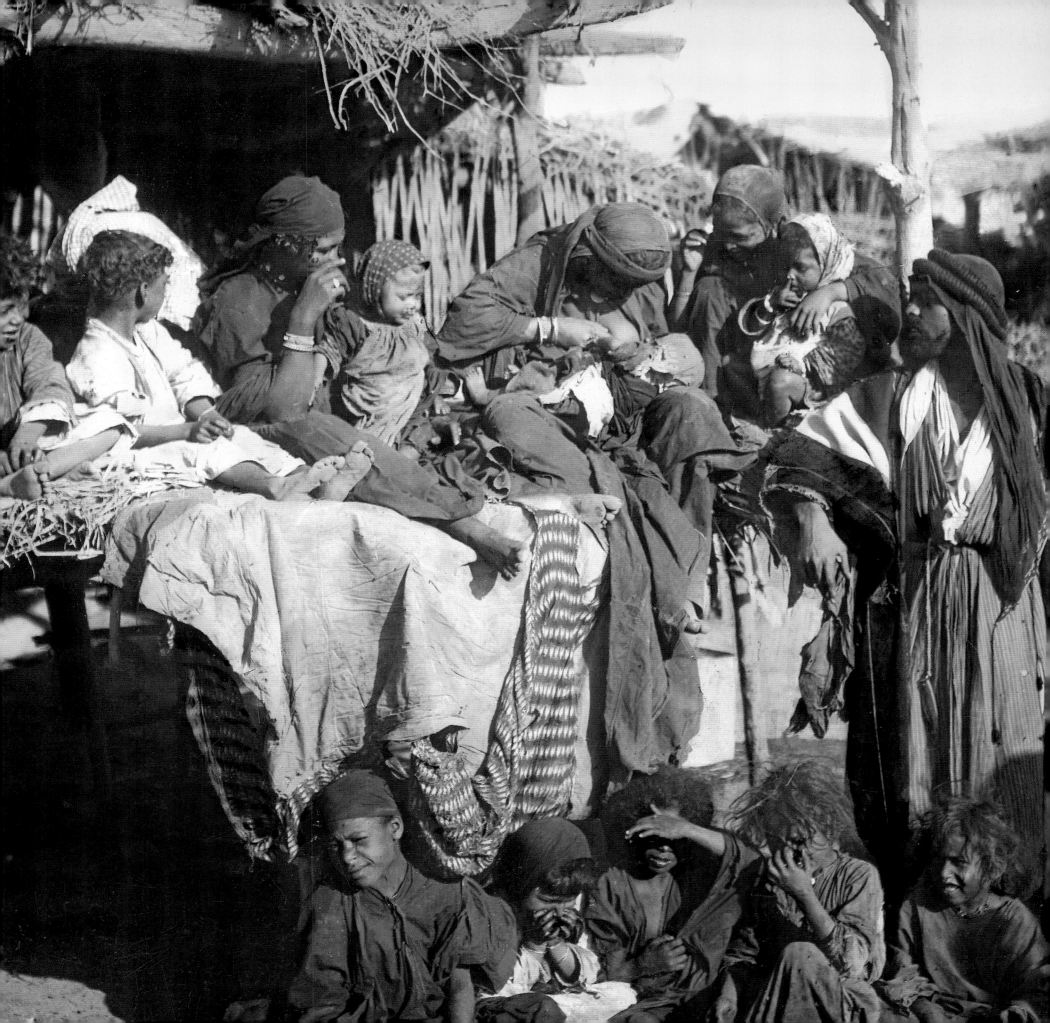

JERICHO NATIVES.

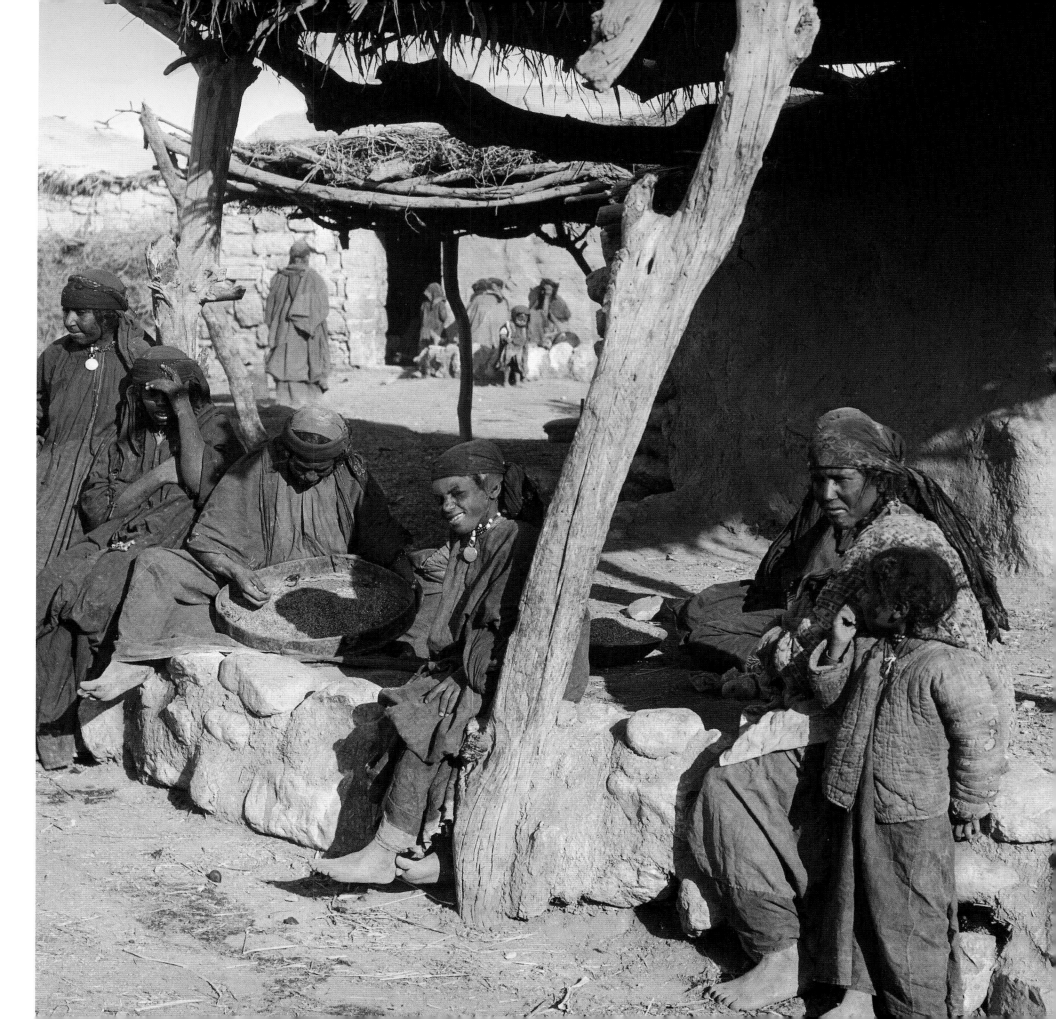

ARNON RIVER GORGE, NEAR THE DEAD SEA.

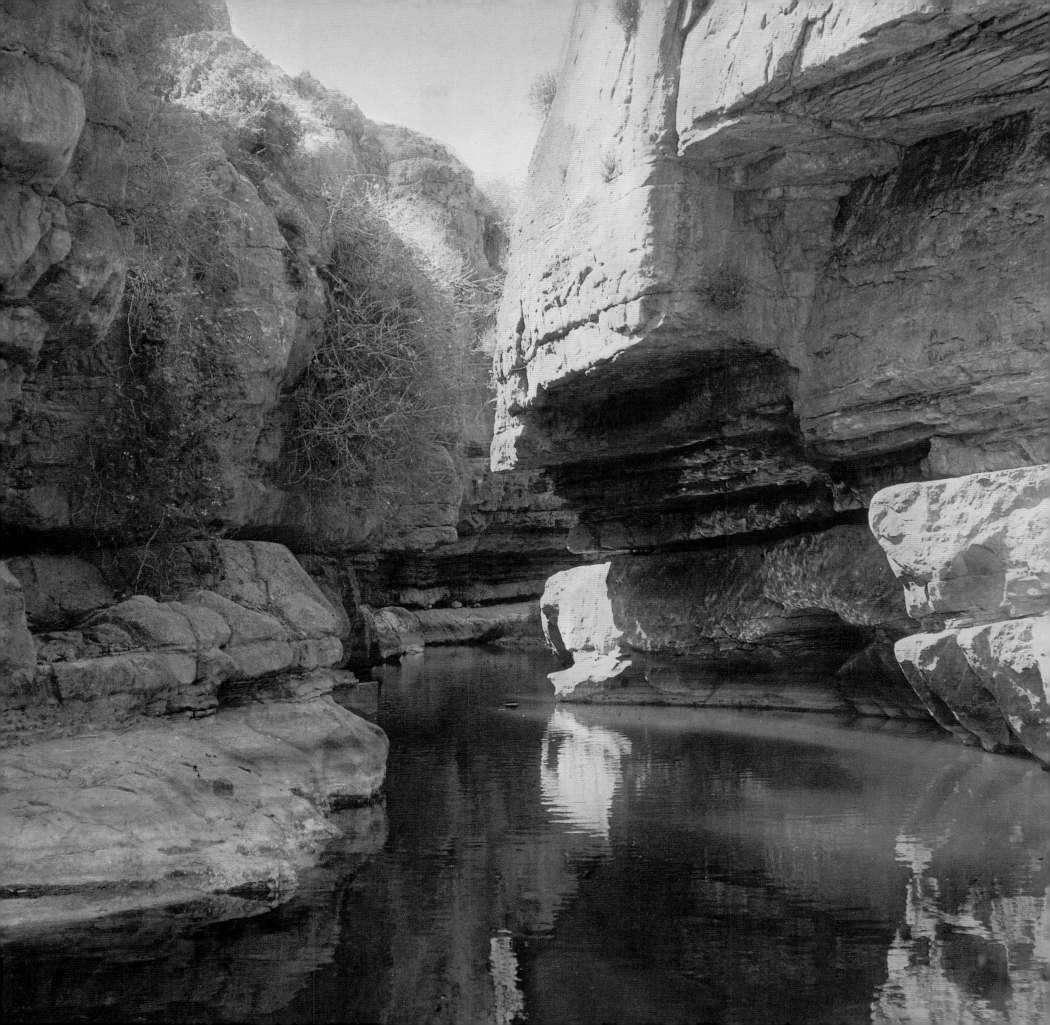

FERRY CROSSING THE JORDAN.
*Square, flat-bottomed ferries drawn by ropes would have conveyed people,
horses and livestock, sacks of grain, wood for fuel, and various household
items across the Jordan.*

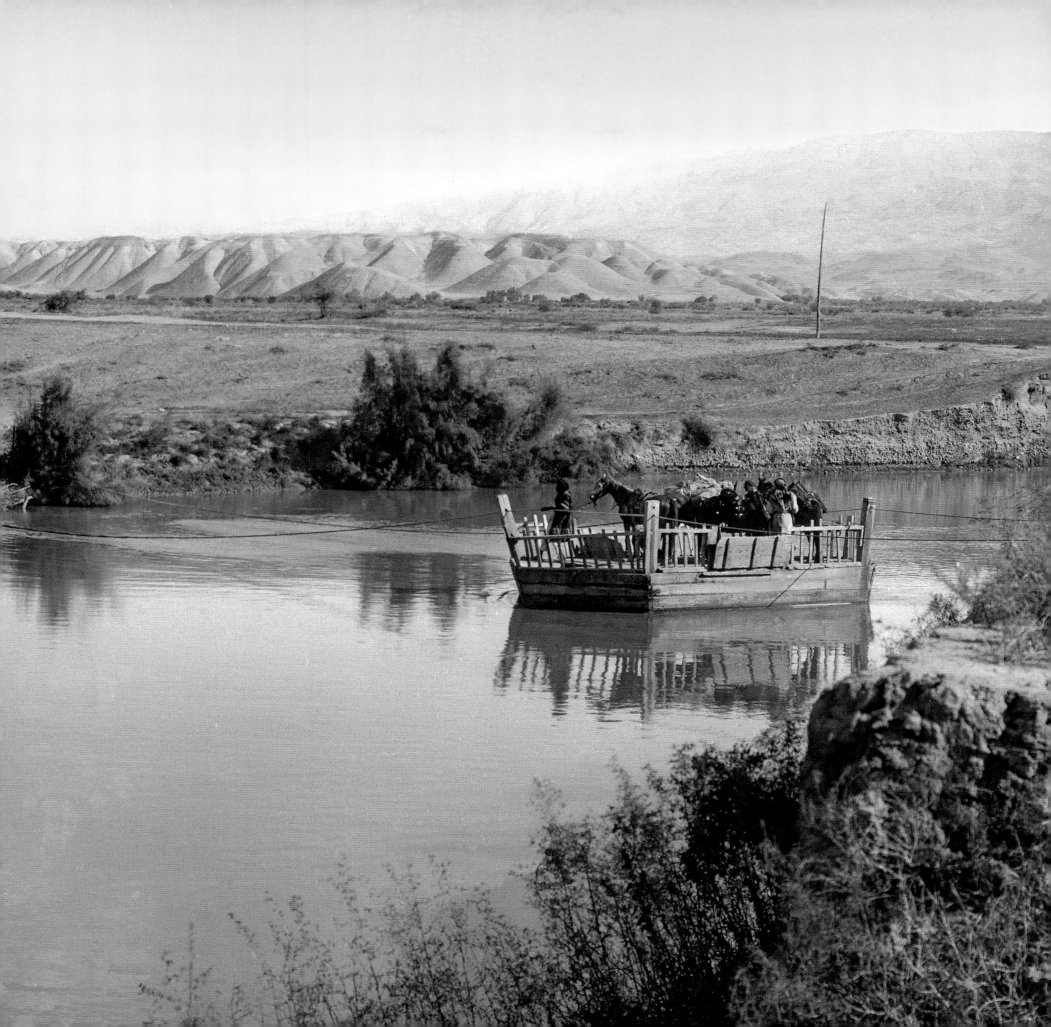

POSSIBLE SITE OF CHRIST'S BAPTISM.

Then cometh Jesus from Galilee to Jordan unto John, to be baptized of him. But John forbad him, saying, I have need to be baptized of thee, and comest thou to me? And Jesus answering said unto him, Suffer it to be so now: for thus it becometh us to fulfil all righteousness. Then he suffered him. And Jesus, when he was baptized, went up straightway out of the water: and, lo, the heavens were opened unto him, and he saw the Spirit of God descending like a dove, and lighting upon him: And lo a voice from heaven, saying, This is my beloved Son, in whom I am well pleased. Matthew 3:13-17

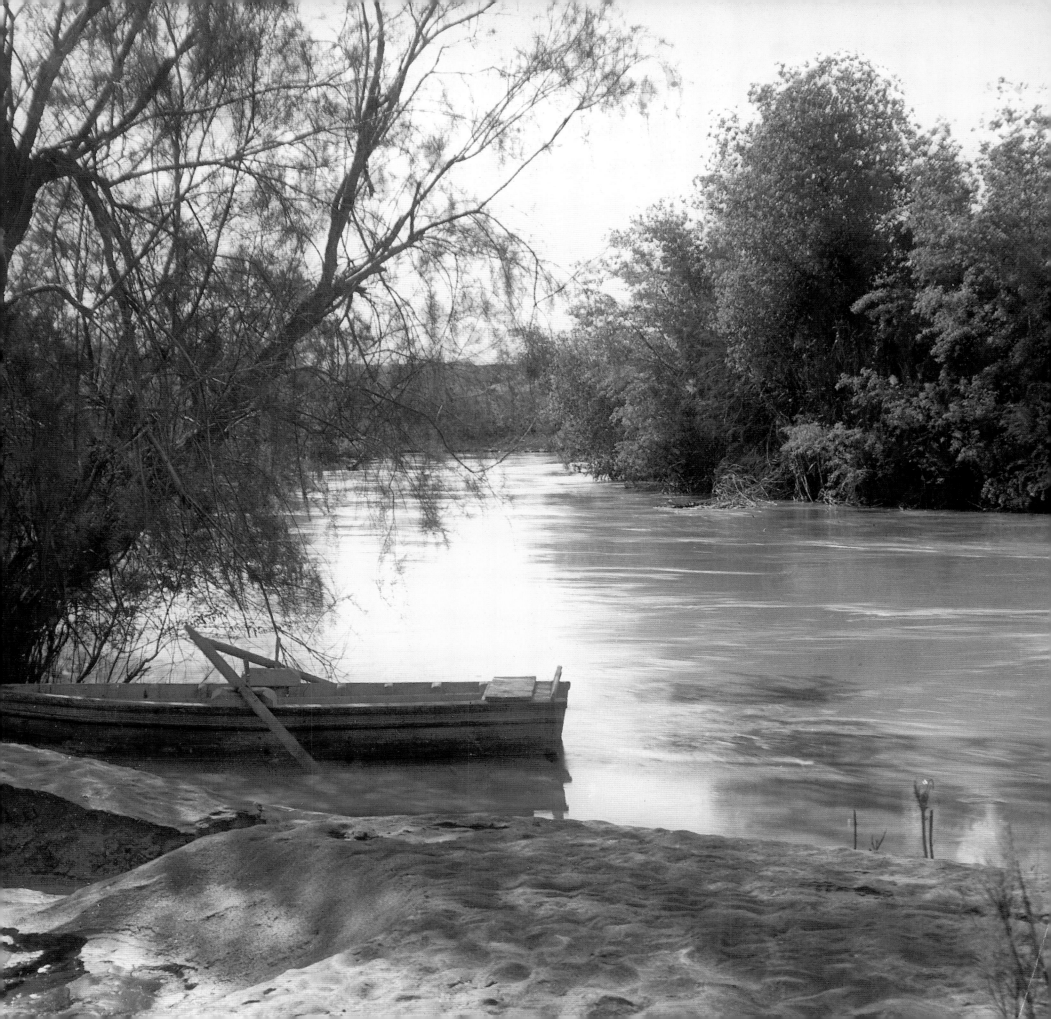

DEAD SEA; THE EASTERN SHORE.

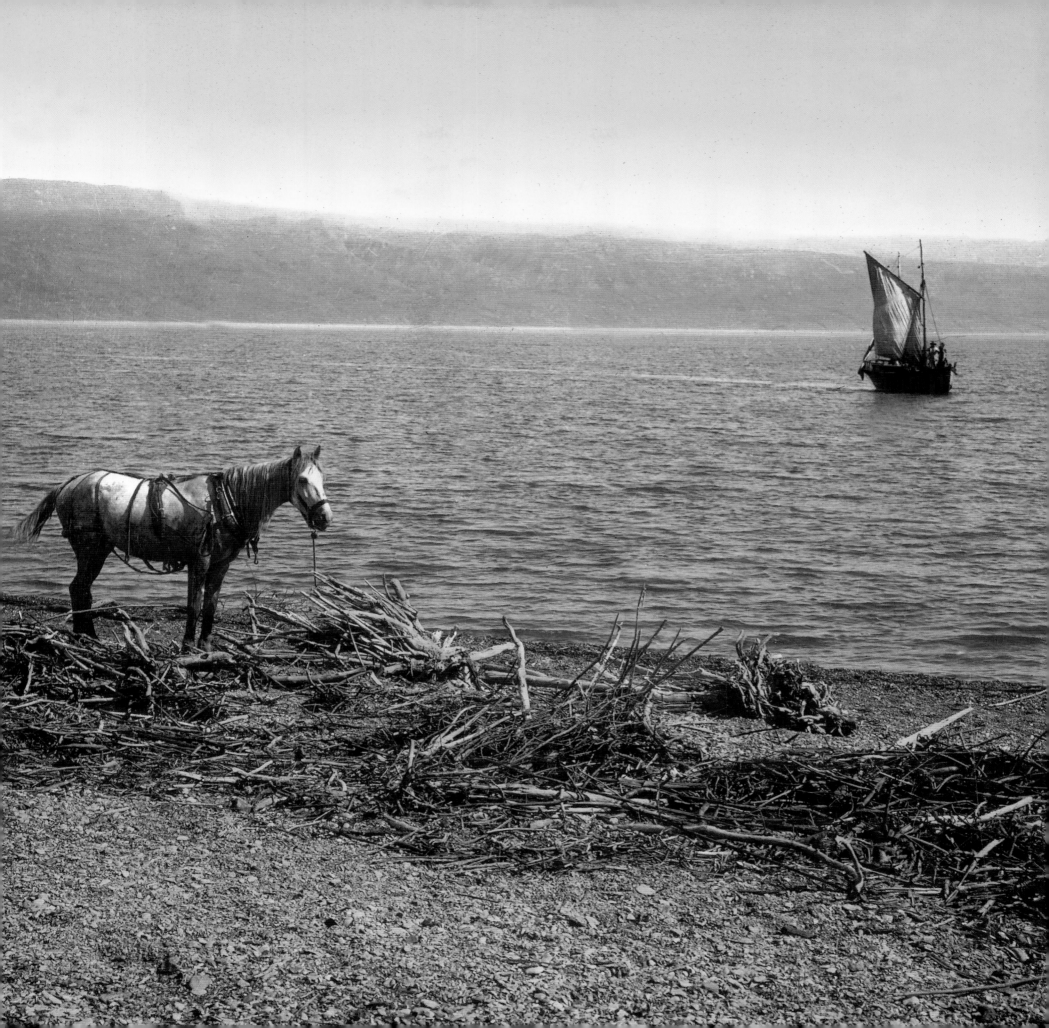

SUNSET FROM A HILL OVER THE DEAD SEA.

FORMATION NEAR THE DEAD SEA.

7 THE NORTH: GALILEE, NAZARETH, SAFED, MT. TABOR, MT. HERMON

THE SEA OF GALILEE, OR LAKE TIBERIAS—in the Bible the Sea of Kinneret (Numbers 34:11; Joshua 13:27)—is Israel's largest freshwater lake. Much of the ministry and many of the miracles of Jesus took place on the shores of the Galilee, the site of Christ's feeding of the multitudes, walking on water, and calming of the storm. The importance of the lake in Christ's life has made it a key destination for Christian pilgrims. It has also been the home of a thriving fishing industry since ancient times. Historian Flavius Josephus noted not only its beauty—"One may call this place the ambition of Nature"— but that 230 boats were regularly working the lake.

One of the villages on its shores, Tiberias, became the center for Jewish culture around 135 AD after the second Jewish revolt against the Romans, Bar Kokhba's revolt, was crushed and Emperor Hadrian expelled all Jews from Jerusalem. It is thought that the Jerusalem Talmud was compiled in this region.

Nazareth, about 16 miles west of the Sea of Galilee, is the home town of Jesus and site of the Annunciation, where Mary was told by the angel Gabriel that she would bear the son of God:

> *And in the sixth month the angel Gabriel was sent from God unto a city of Galilee, named Nazareth, To a virgin espoused to a man whose name was Joseph, of the house of David; and the virgin's name was Mary. And the angel came in unto her, and said, Hail, thou that art highly favoured, the Lord is with thee: blessed art thou among women. And when she saw him, she was troubled at his saying, and cast in her mind what manner of salutation this should be.*
>
> *And the angel said unto her, Fear not, Mary: for thou hast found favour with God.*
>
> *And, behold, thou shalt conceive in thy womb, and bring forth a son, and shalt call his name JESUS. (Luke 1: 26-31)*

Mount Tabor, 6 miles east of Nazareth, is the traditional site of the Transfiguration of Christ (Mark 9: 9-13). The basilica built here to commemorate it is on the site of a twelfth century Muslim fortress.

TIBERIAS HARBOR.
Tiberias is the largest town on the Sea of Galilee. It was built in the Roman style by Herod Antipas around 20 AD and named for his patron, the Emperor Tiberius.

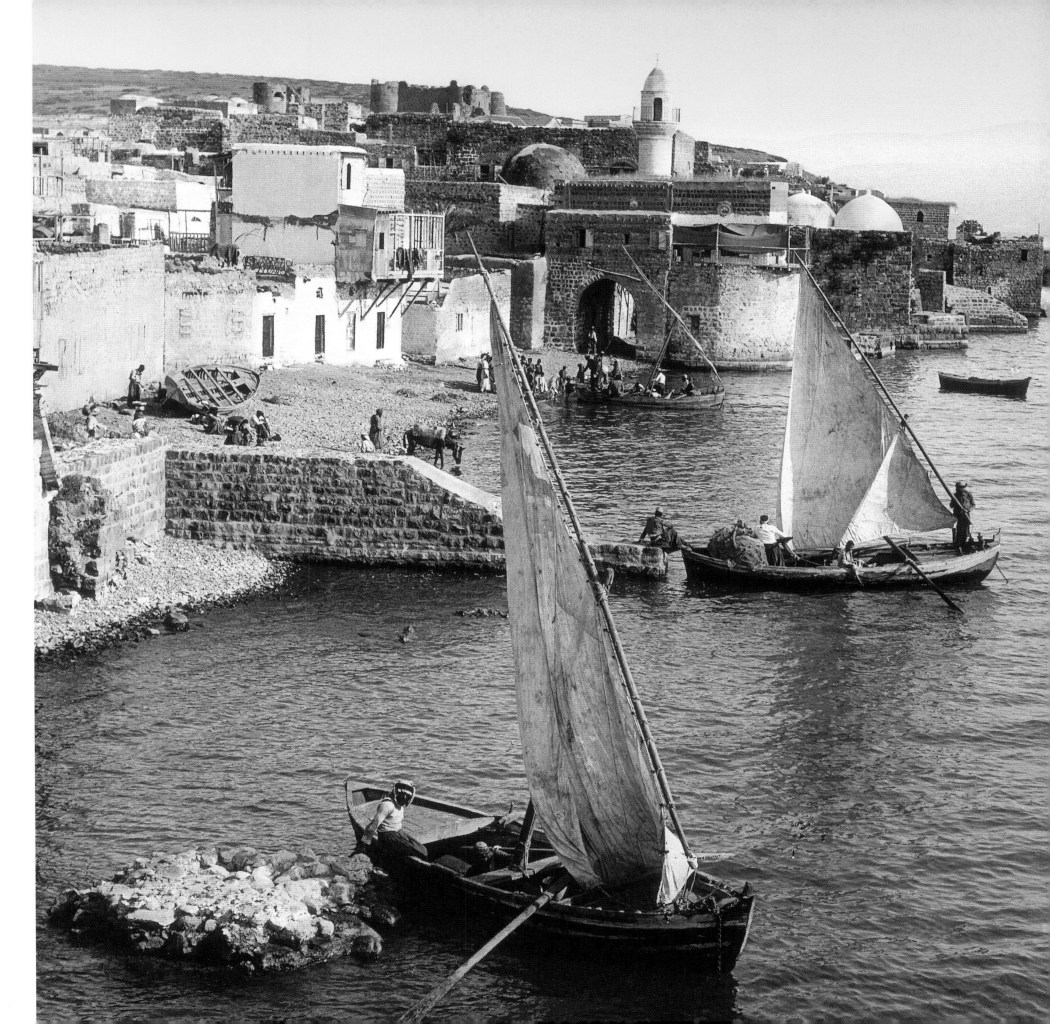

Safed, just north of the Sea of Galilee, is the highest city in Israel. One of the four holy cities of Judaism, along with Jerusalem, Tiberias, and Hebron, it is also a center for Kabbalah, or Jewish mysticism. Situated on a number of small hilltops, Safed is the site of an impressive Crusader citadel.

Mount Hermon, about 20 miles north of the Sea of Galilee, is a major source of the Jordan River. Its spectacular snow-covered peaks are visible throughout the Galilee region and would have been a familiar site to Jesus, living in Nazareth and later Capernaum. In the Bible is it is also called Sion, Senir, and Shenir and is believed by some to be the site—rather than Mount Tabor—of the Transfiguration of Christ.

FISHING BOAT SETTING FORTH.
Fishing is a natural occupation for those living on the Sea of Galilee, with its rich stock of fish undiminished since New Testament times.

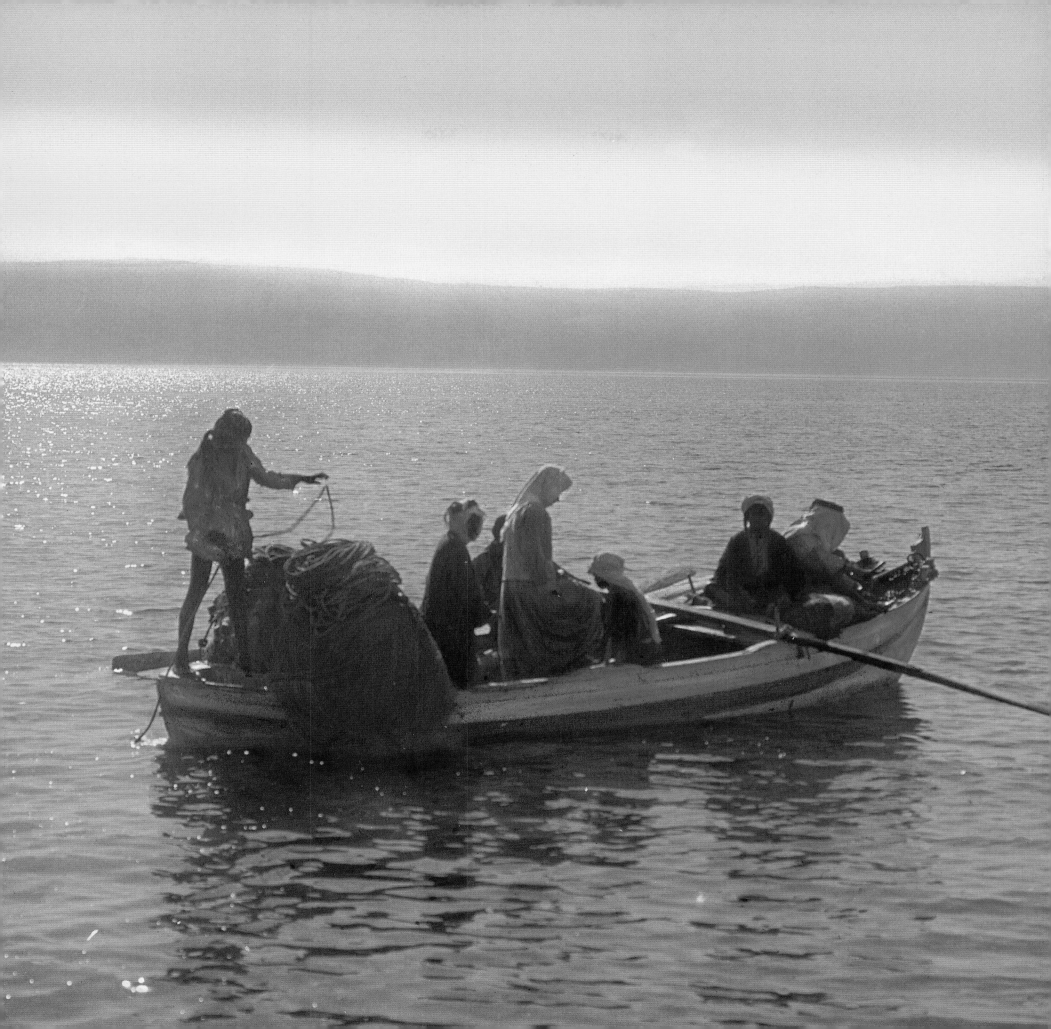

FISHING BOATS AT BETHSAIDA.
Christ's disciples Philip, Andrew, and Peter all lived in Bethsaida of Galilee.

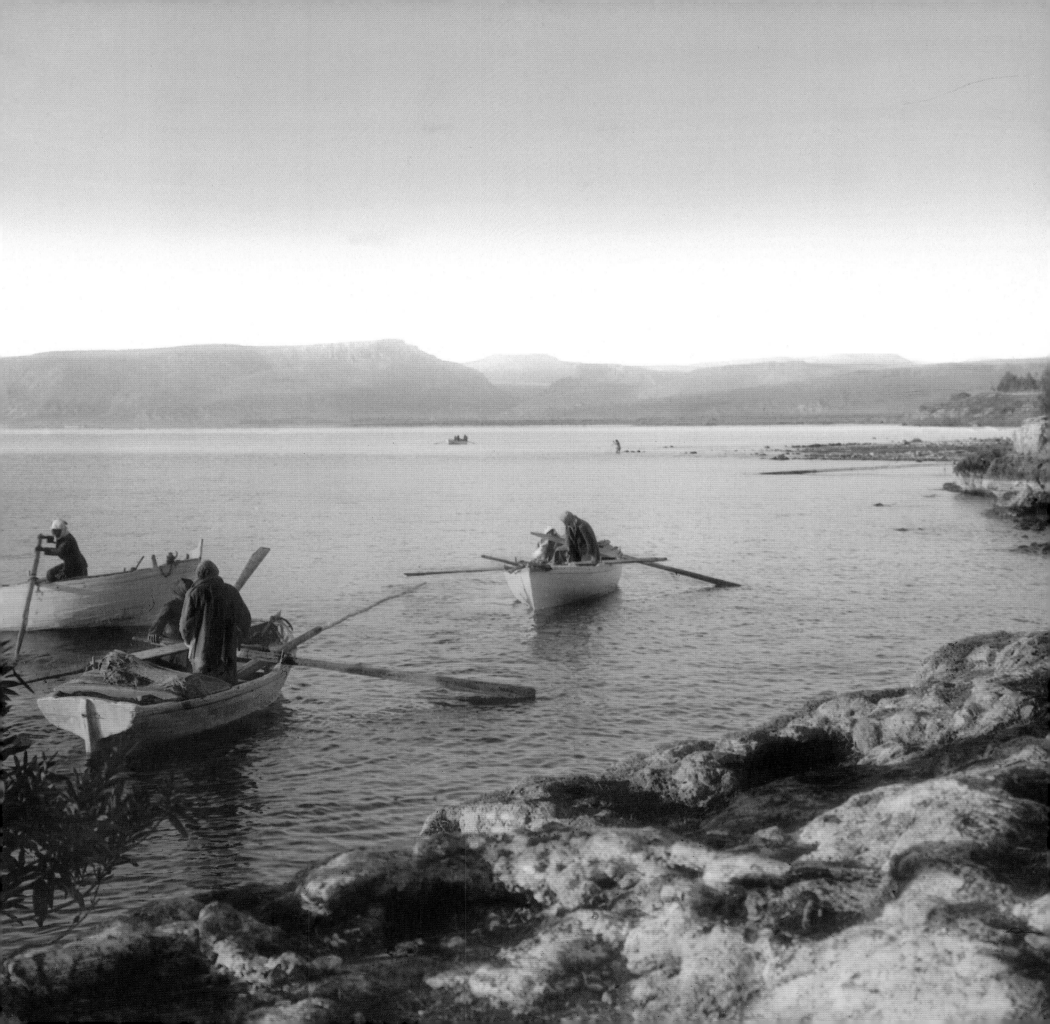

FISHERMEN LETTING DOWN NETS.
The catch would have consisted largely of sardines and tilapia, also known as St. Peter's fish.

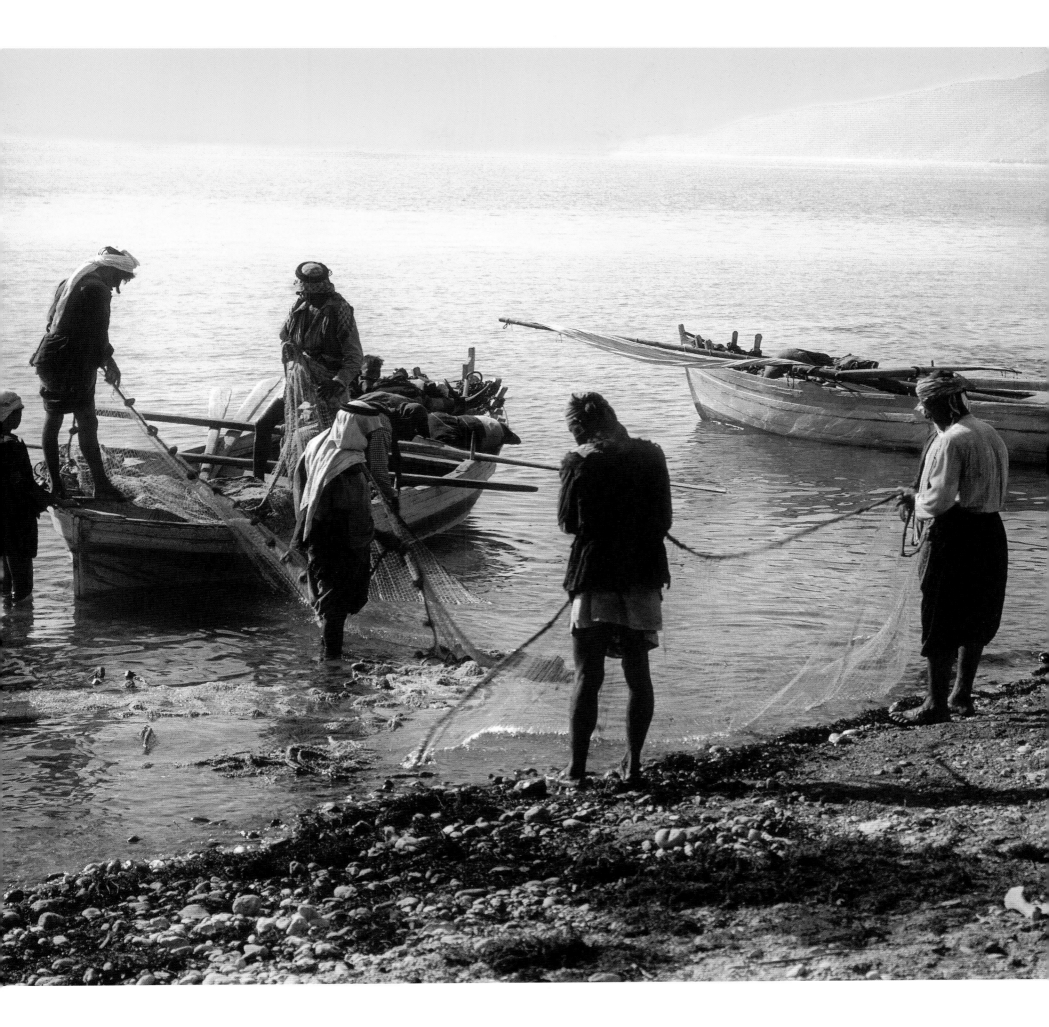

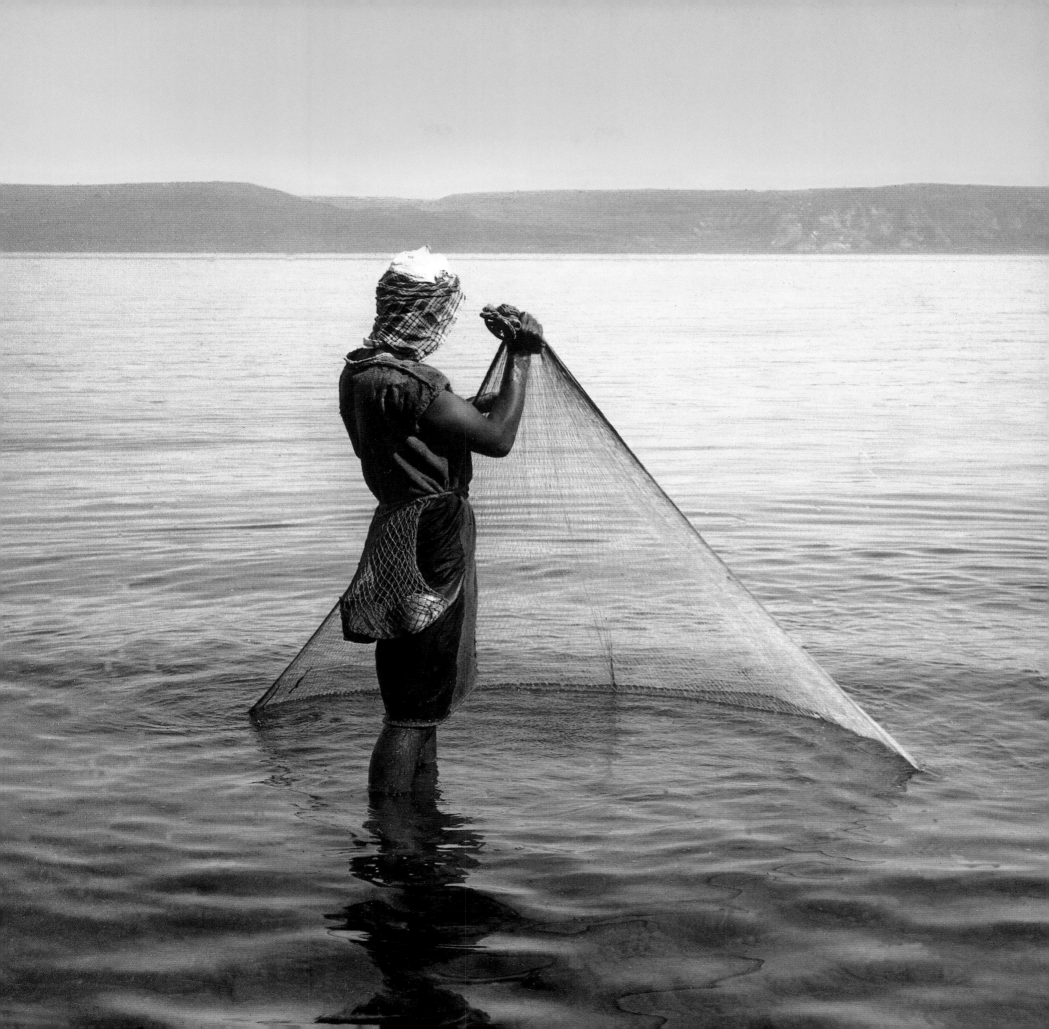

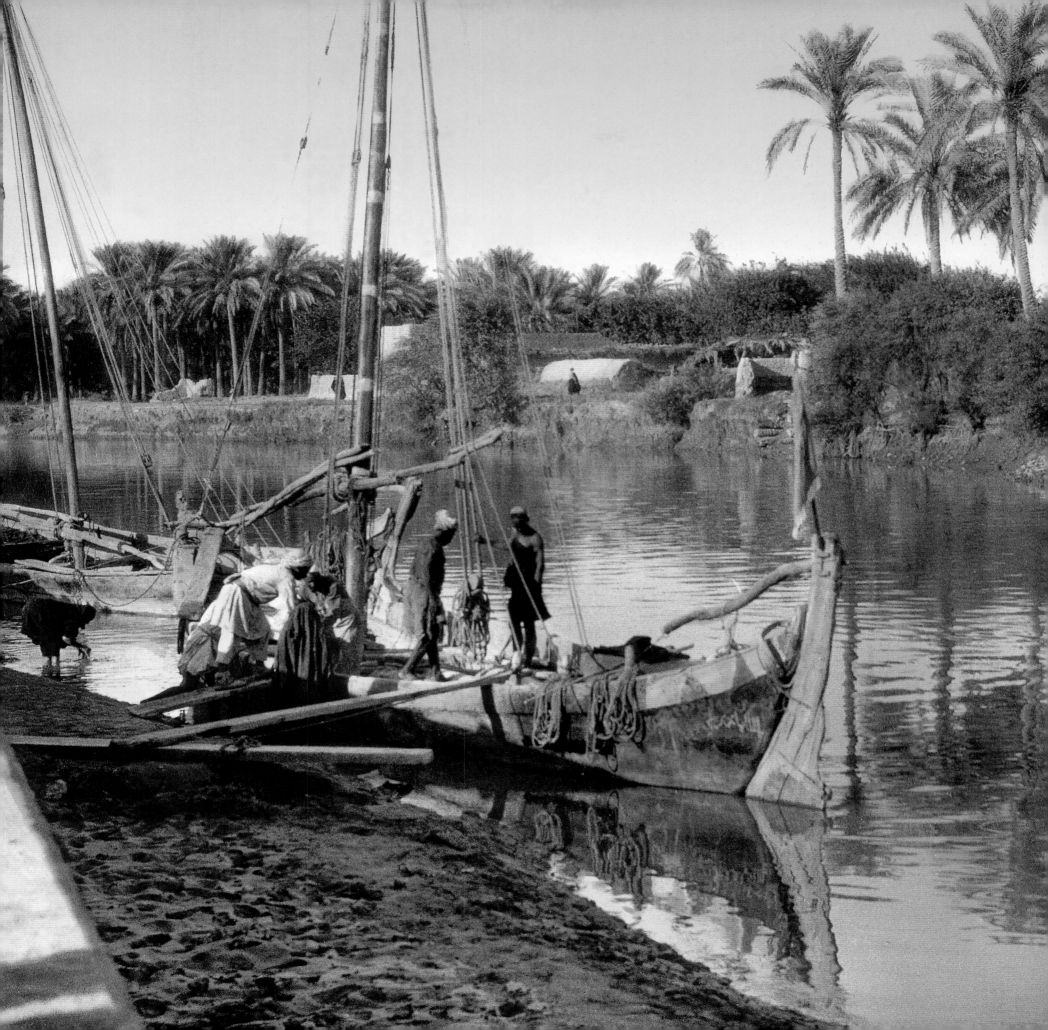

FISHERMEN WITH DRAG NET.

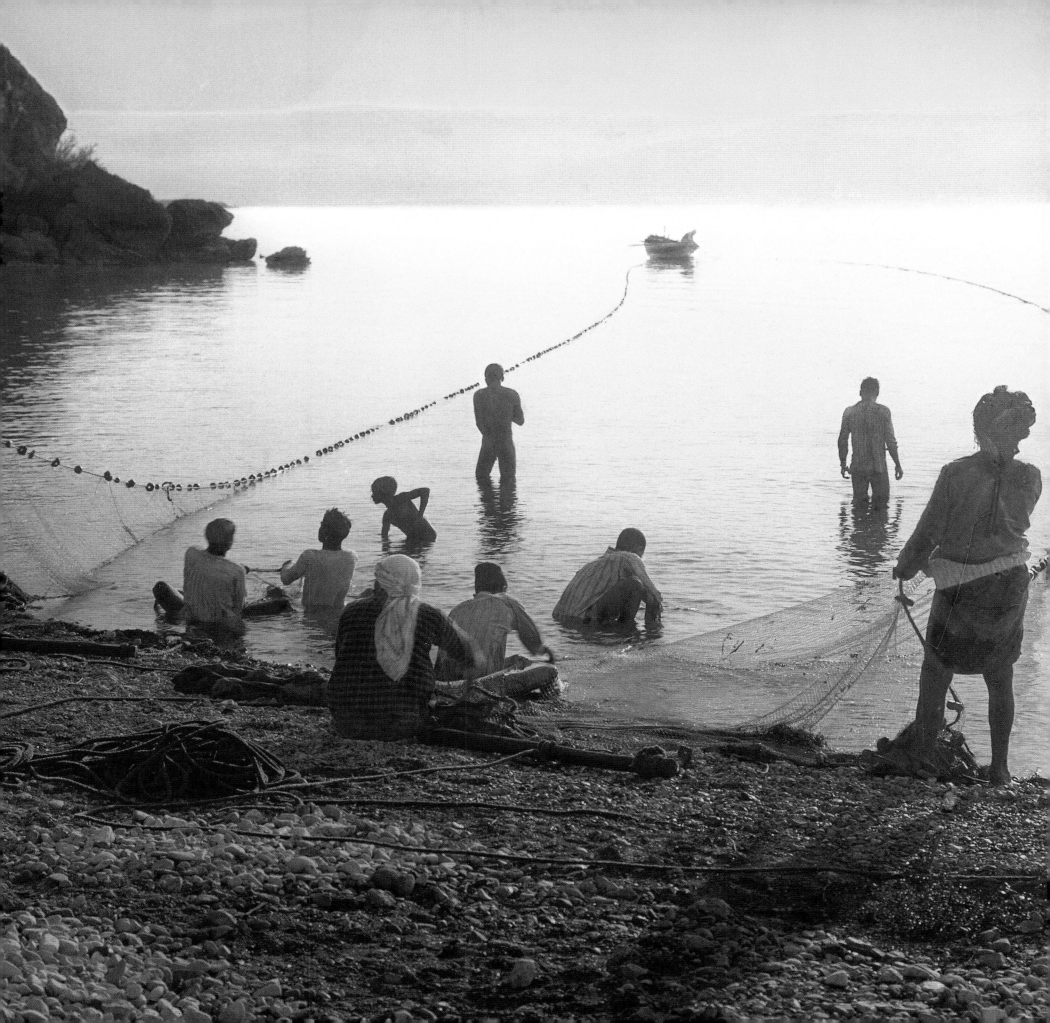

CAPERNAUM FROM THE LAKESHORE.
After leaving Nazareth, according to the Gospel of Matthew, Jesus made Capernaum the center of his ministry, possibly because his first two disciples, his fishers of men Simon (Peter) and Andrew lived there. The miracles of the loaves and fishes and calming the storm on the Sea of Galilee, as well as association of Christ himself with the fish, all show how close Christ was to the fisherman's world of Galilee.

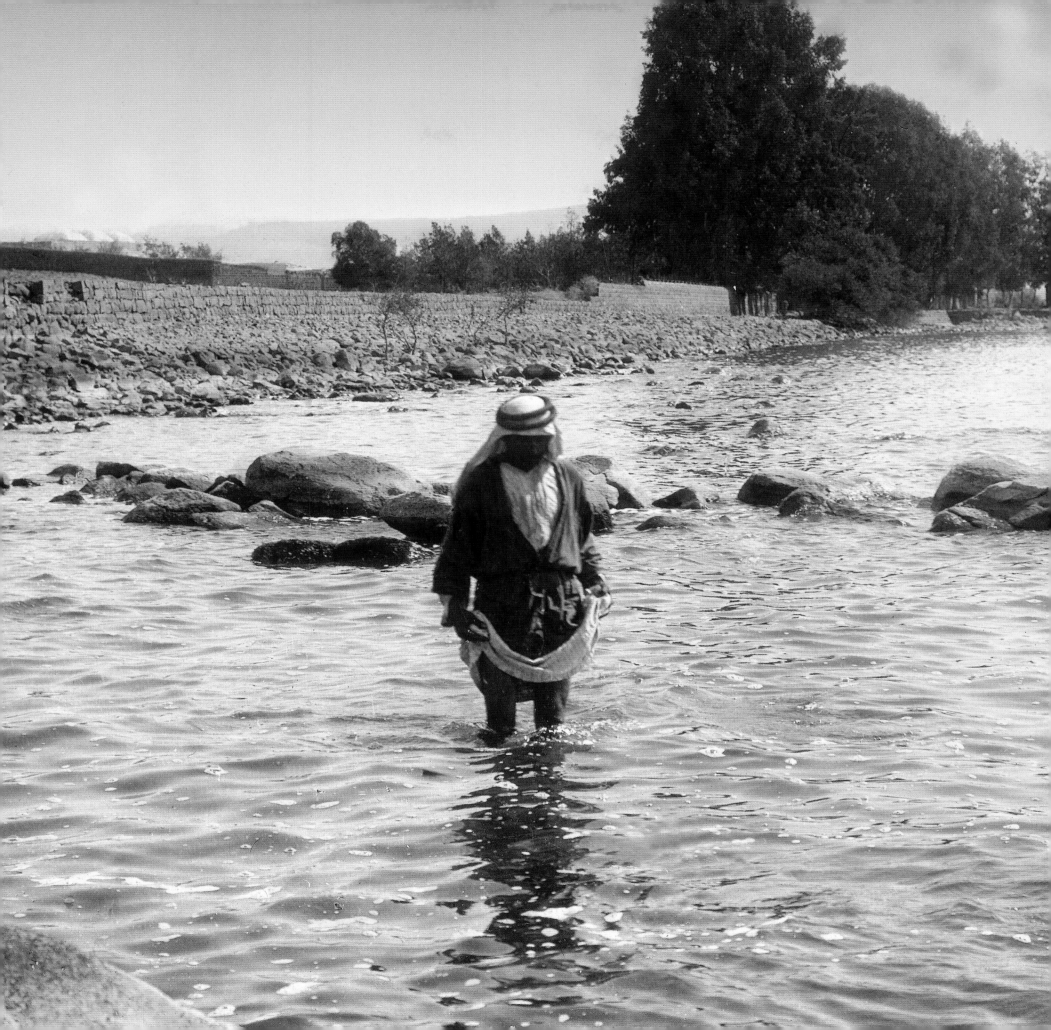

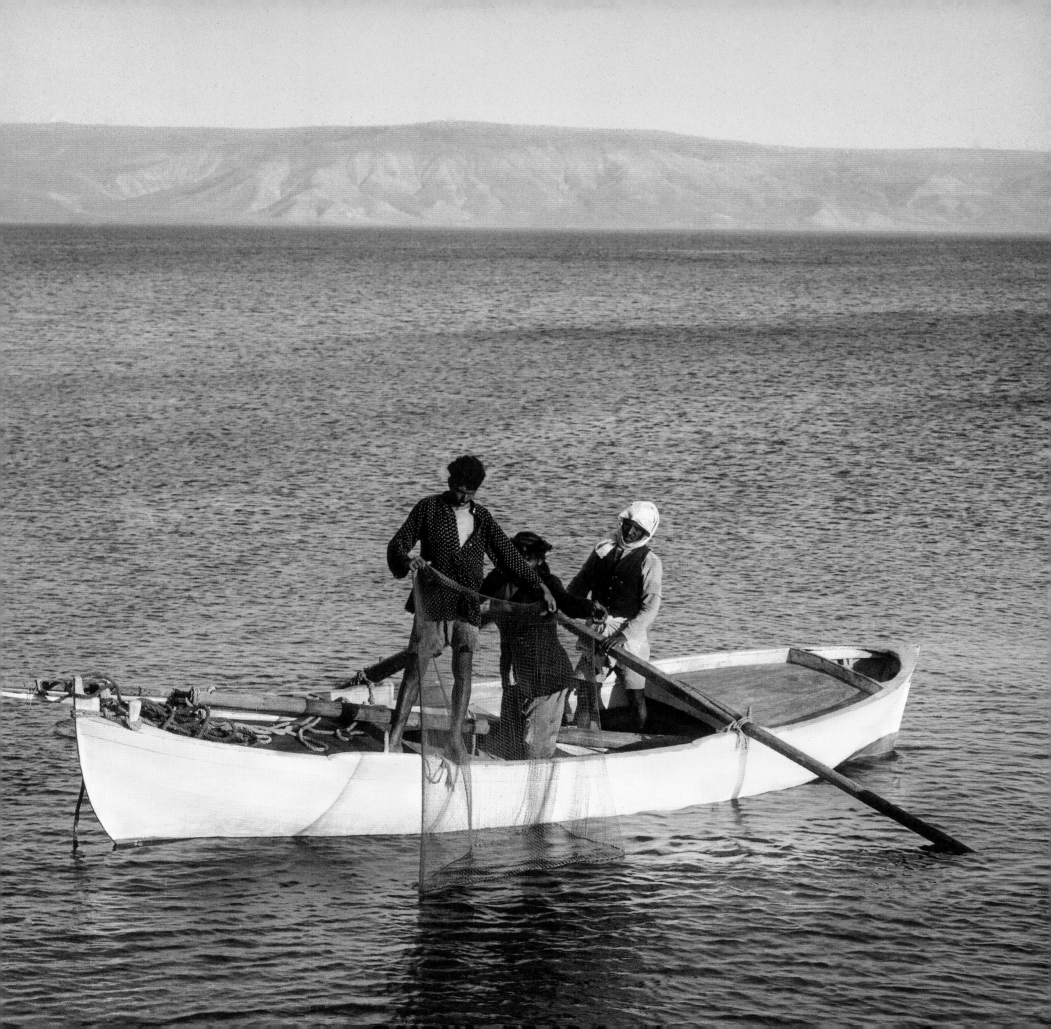

THE CATCH.

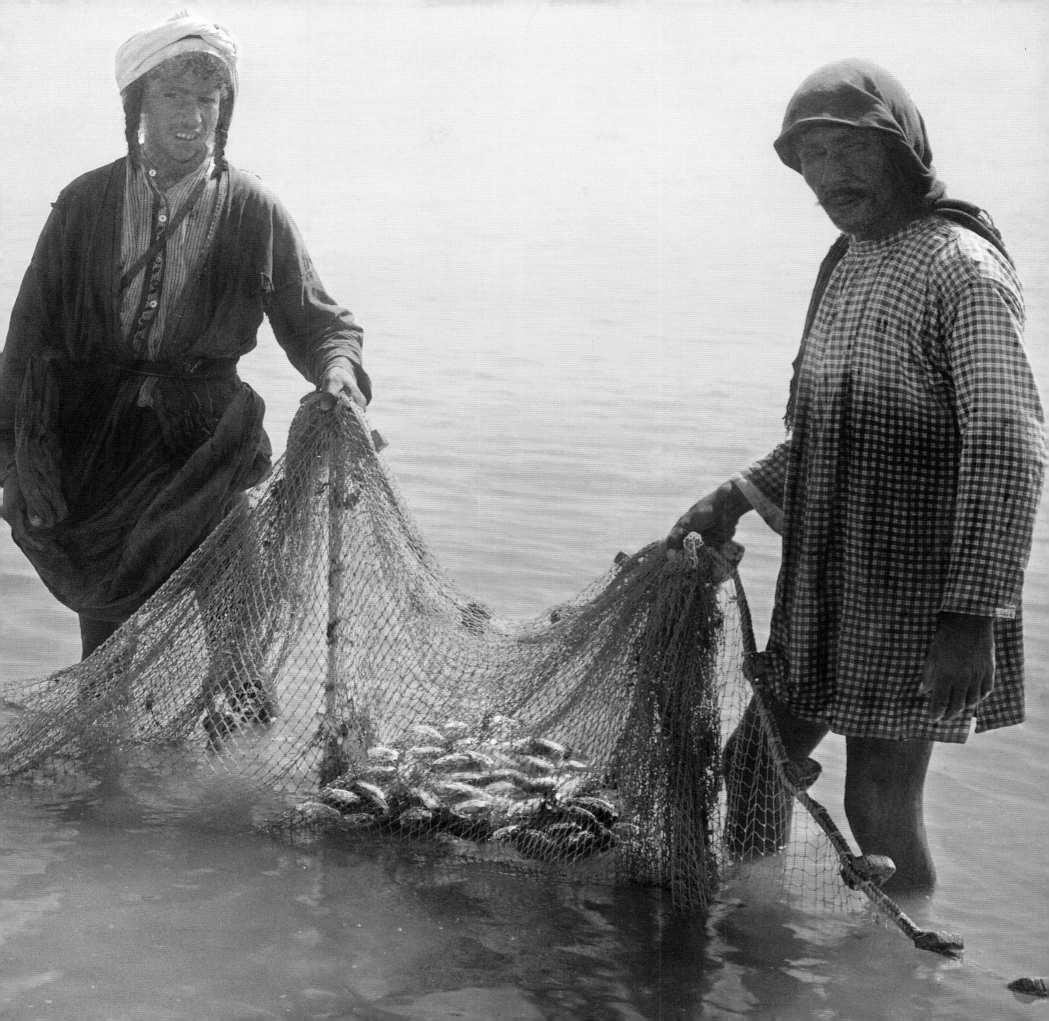

FISHERMEN WEIGHING AND SELLING THEIR CATCH.

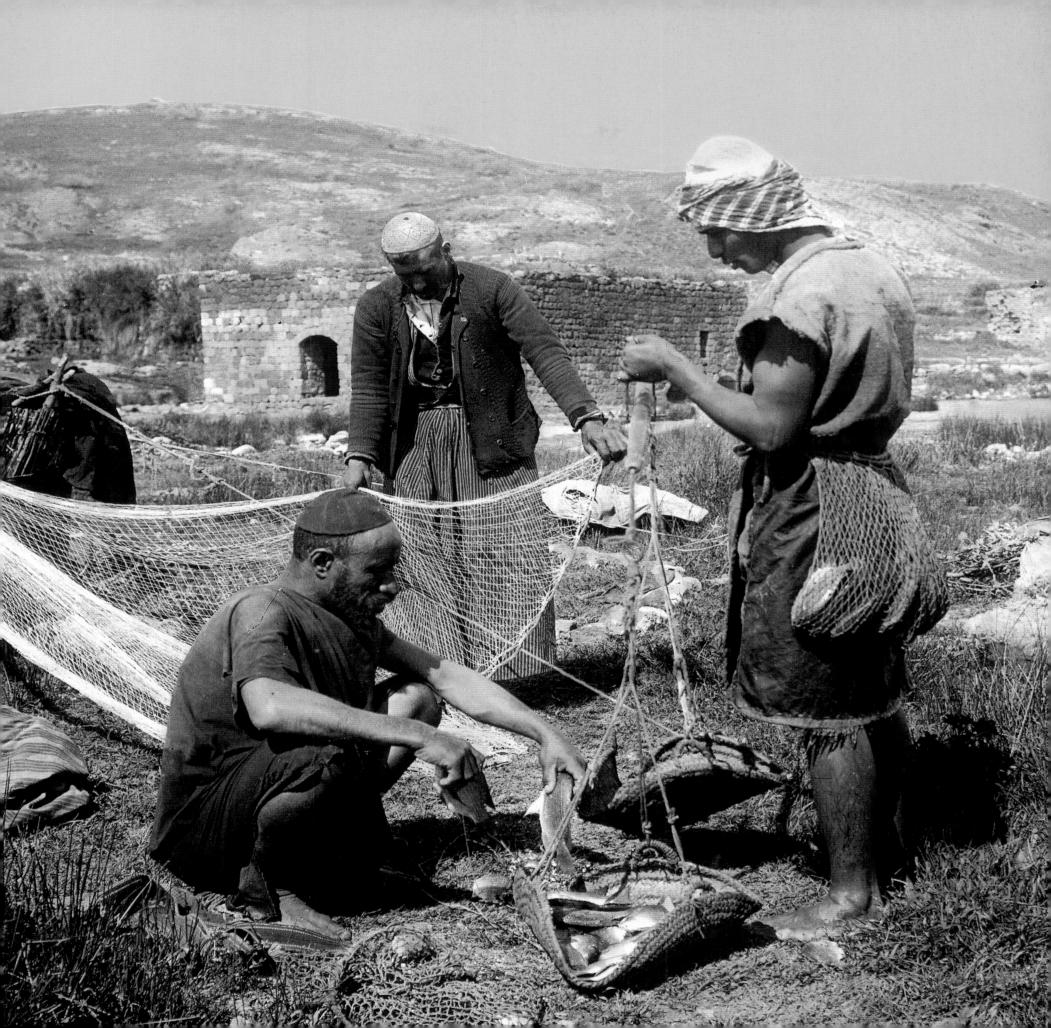

FOUR MEN AROUND A COAL FIRE.

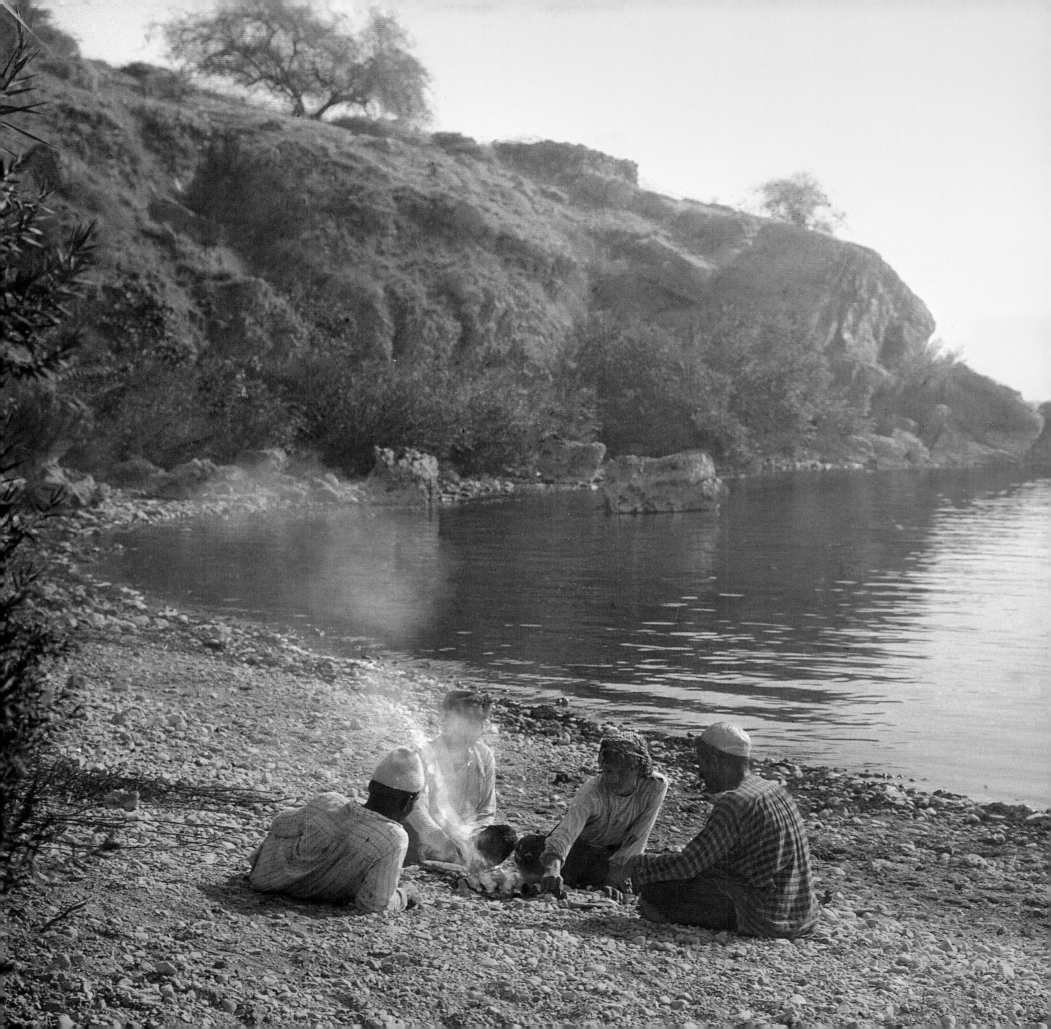

Spring at Cana.

The wedding at Cana is where Jesus turned water into wine. The exact location of the Biblical Cana is not settled; there are four Galilean villages which are candidates.

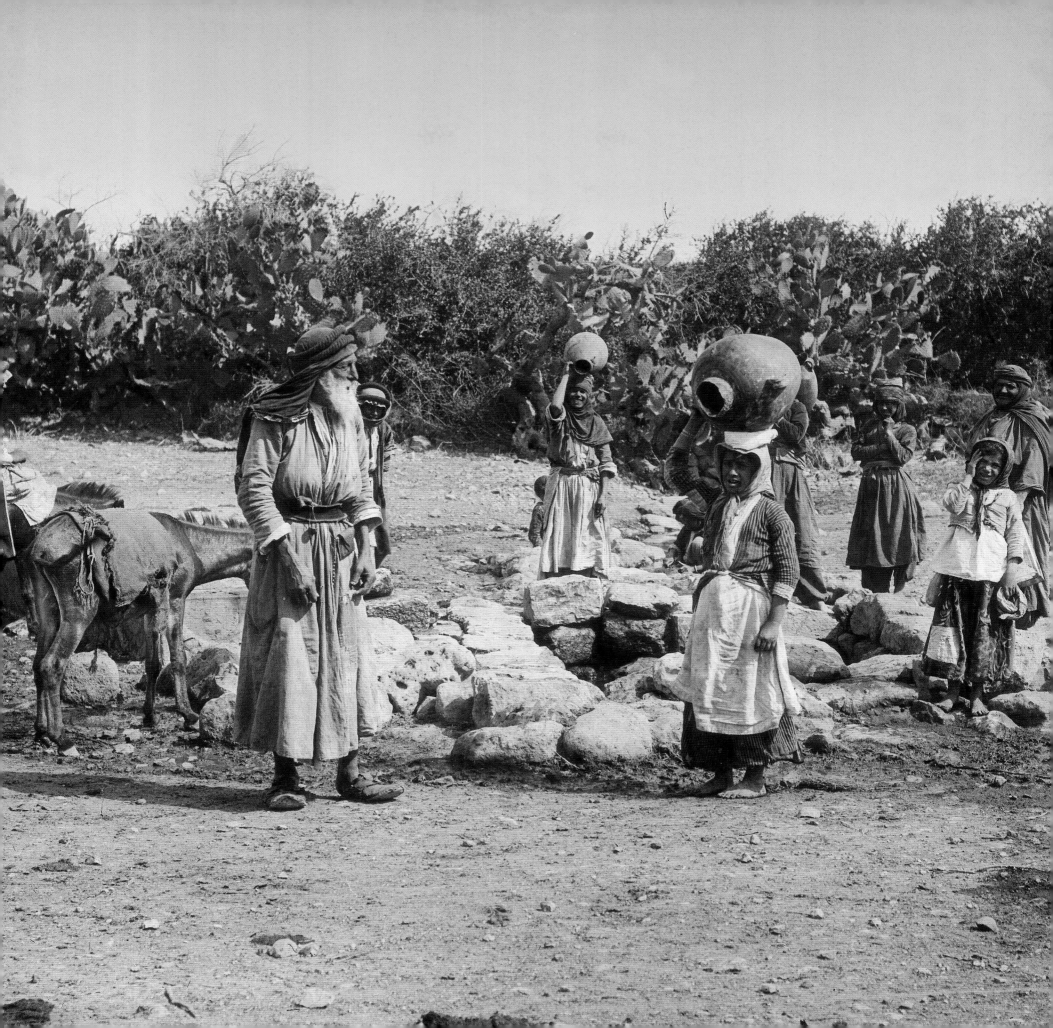

A House in Cana.

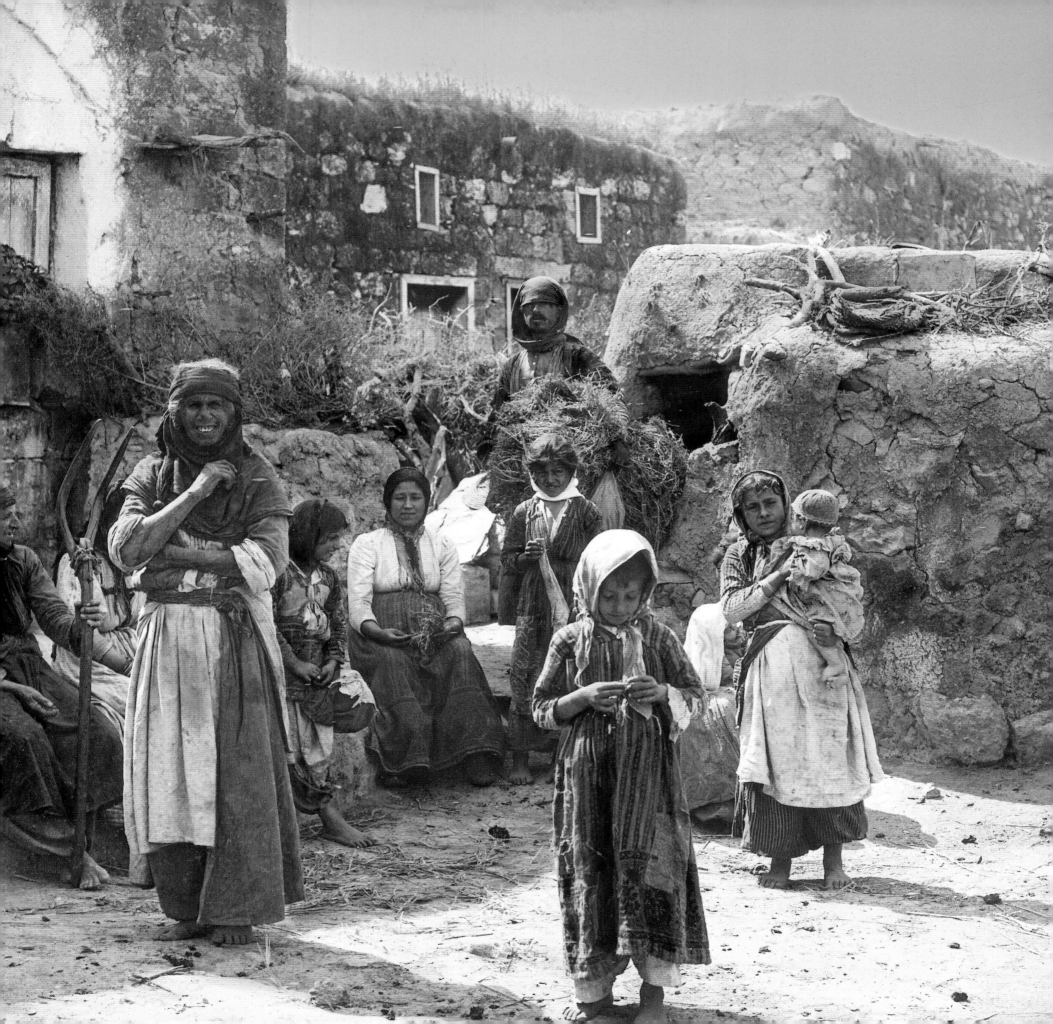

SYNAGOGUE AT CAPERNAUM.
Built around the fourth or fifth century AD, the Synagogue at Capernaum is an impressive white stone structure.

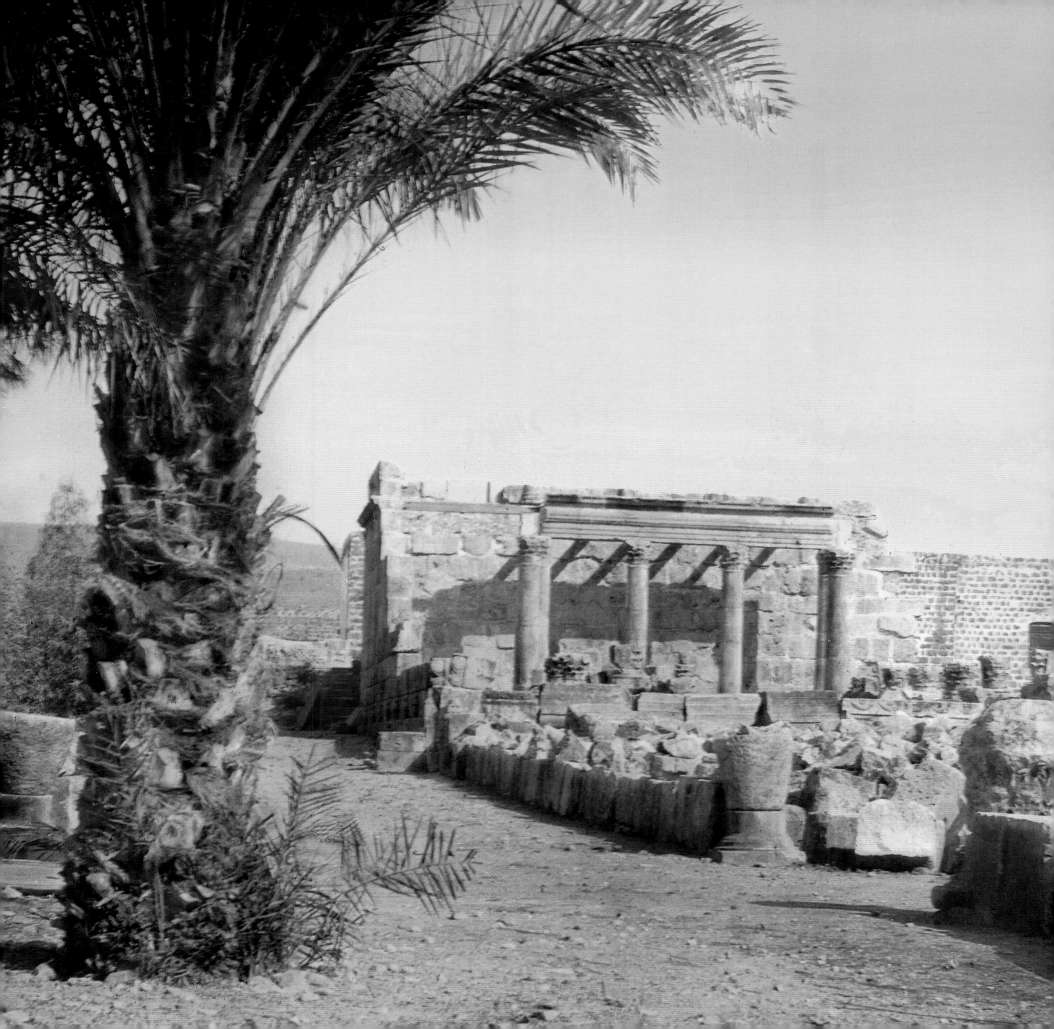

DRUZE SELLING BREAD.
The Druze are a religious community begun as an offshoot of Islam. Secretive about their beliefs, they have official recognition as a distinct religious and ethnic group, with their own religious and court. In the Holy Land the Druze are found in Galilee.

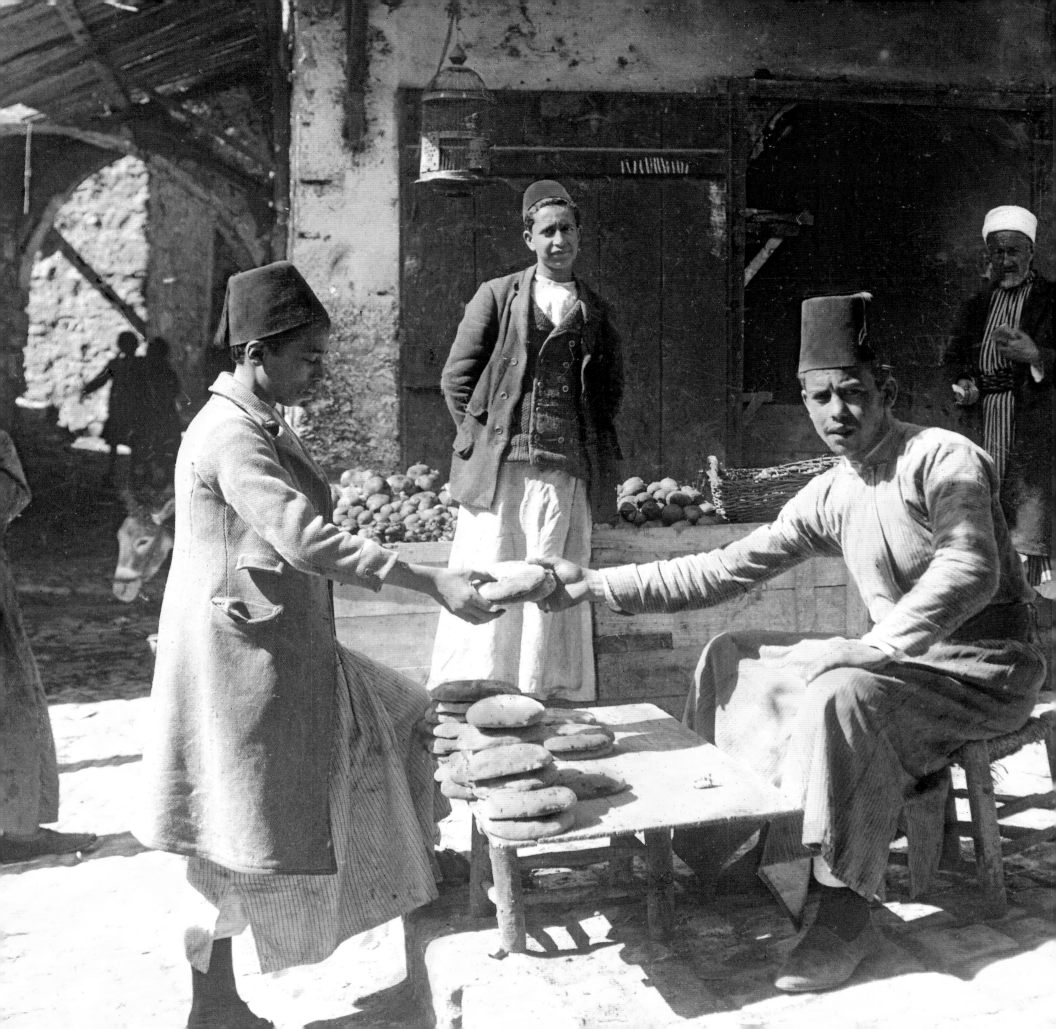

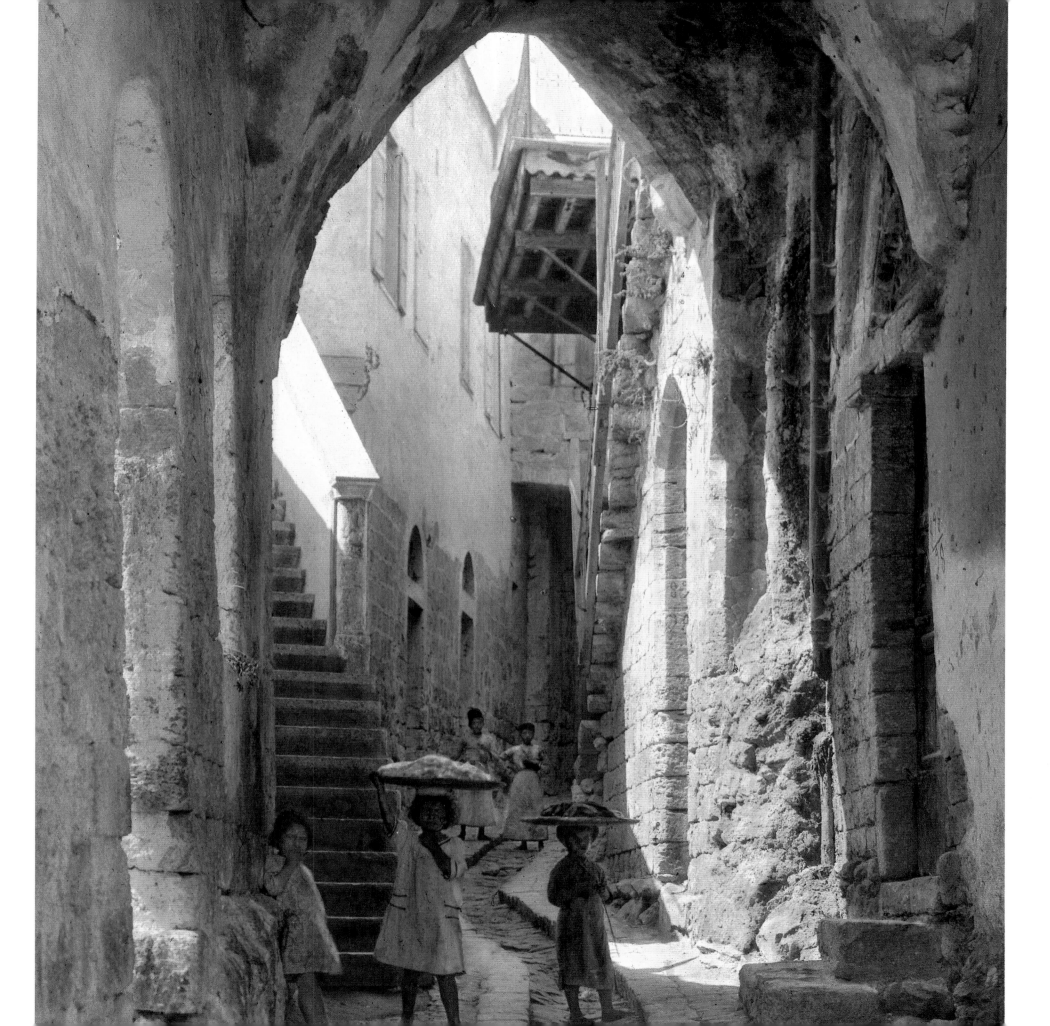

A Galilean Peasant Home.

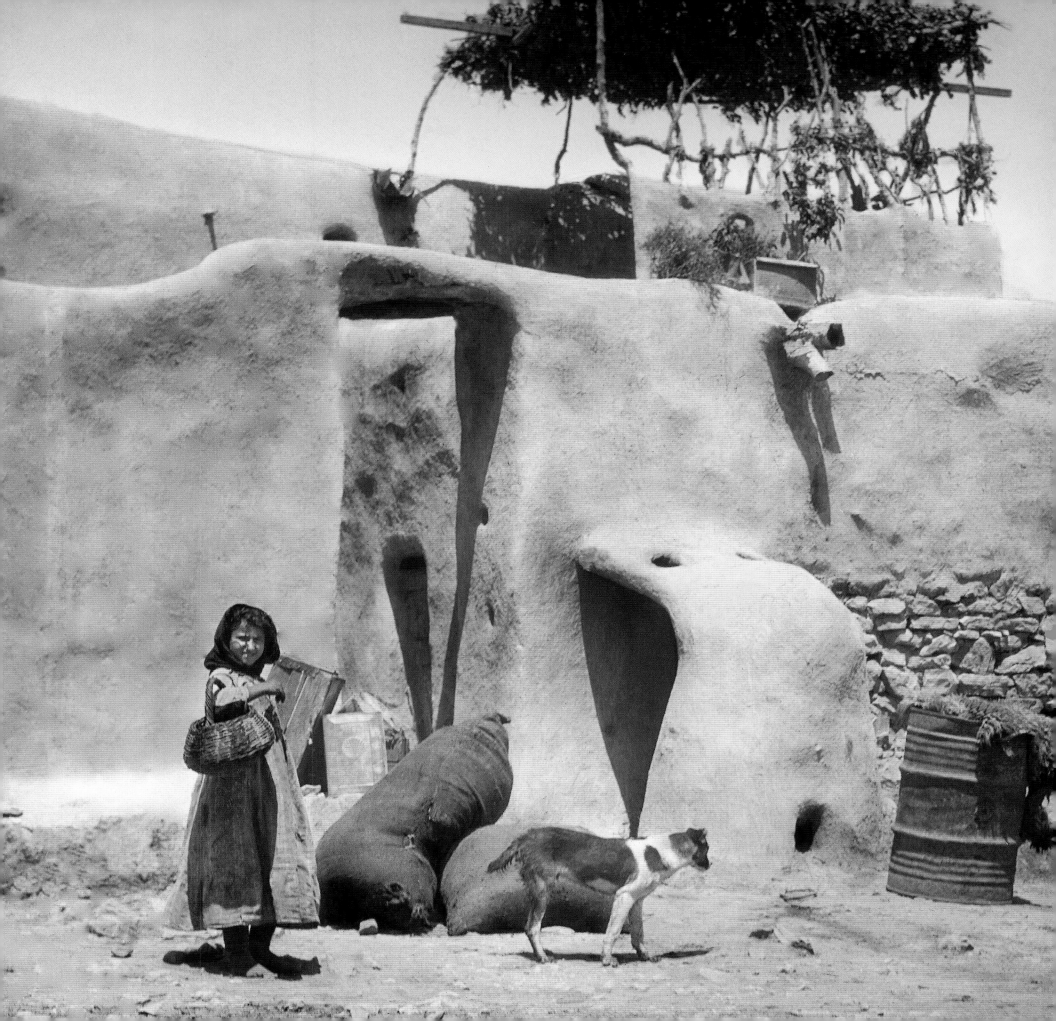

ENDOR VILLAGE.
Children sitting outside the village of Khirbet es-Safsafeh, four miles south of Mt. Tabor, which some believe to be the site of the Biblical Endor, home of the witch of Endor, who predicted Saul's downfall in the first book of Samuel.

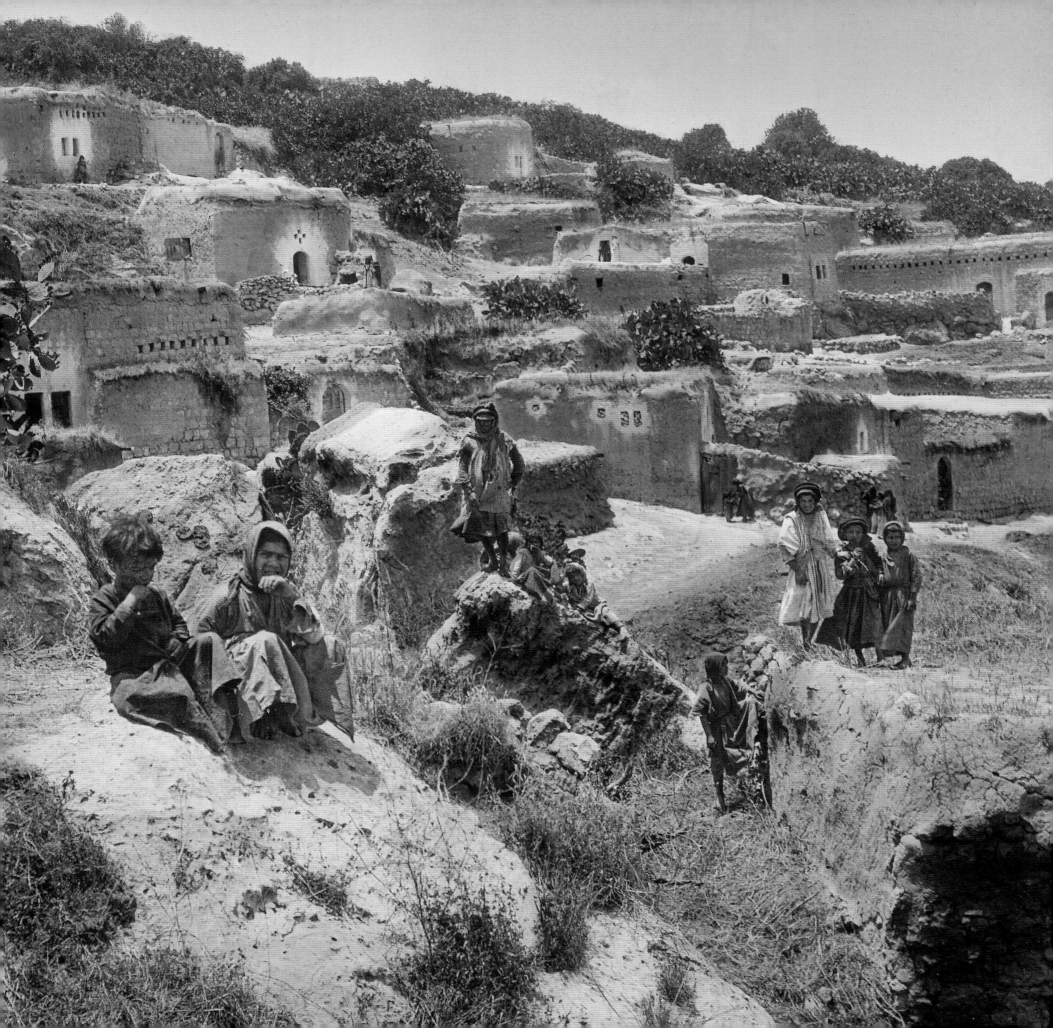

GARDEN IN GALILEE.

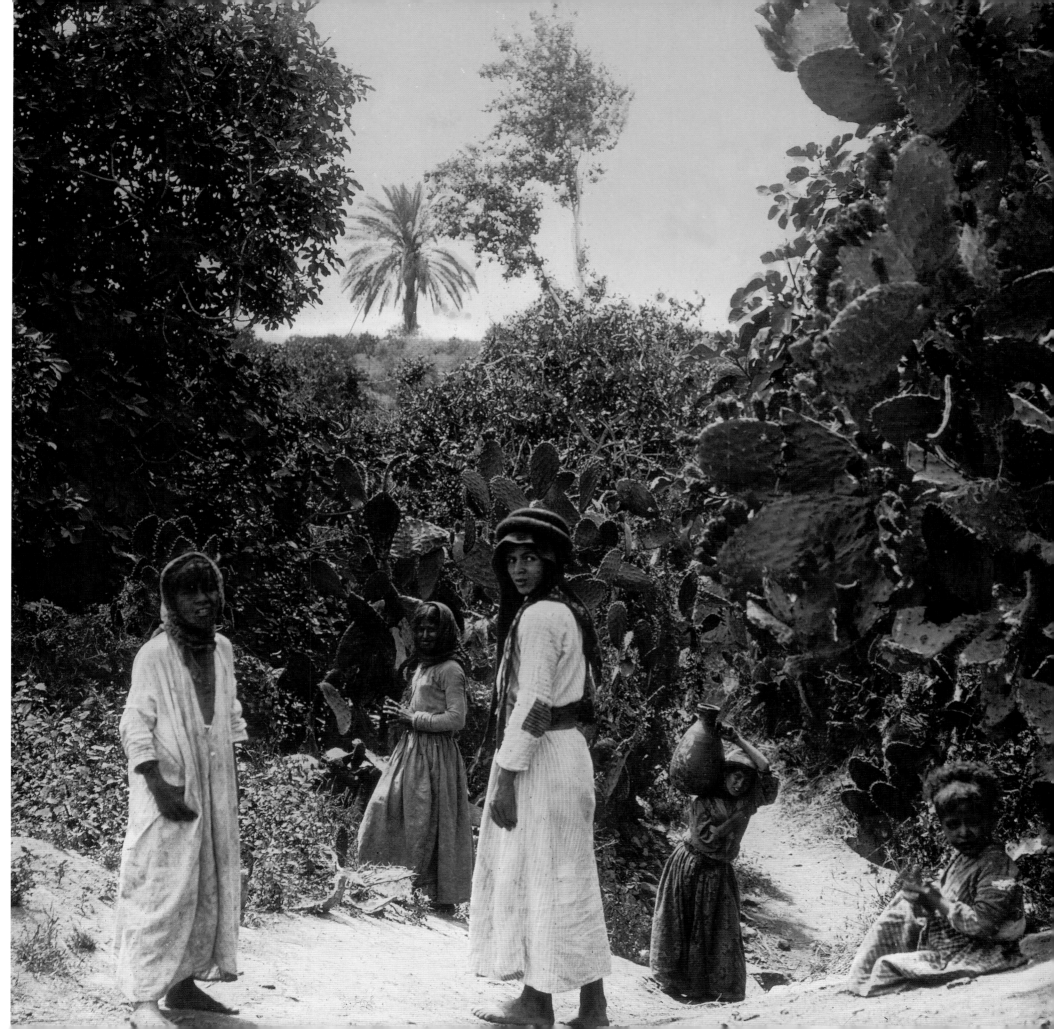

MOUNT TABOR.
Mount Tabor, with its distinctive domed shape, rises majestically over the Jezreel Valley.

The north and the south, you have created them; Tabor and Hermon joyously praise your name. Psalms 89:12

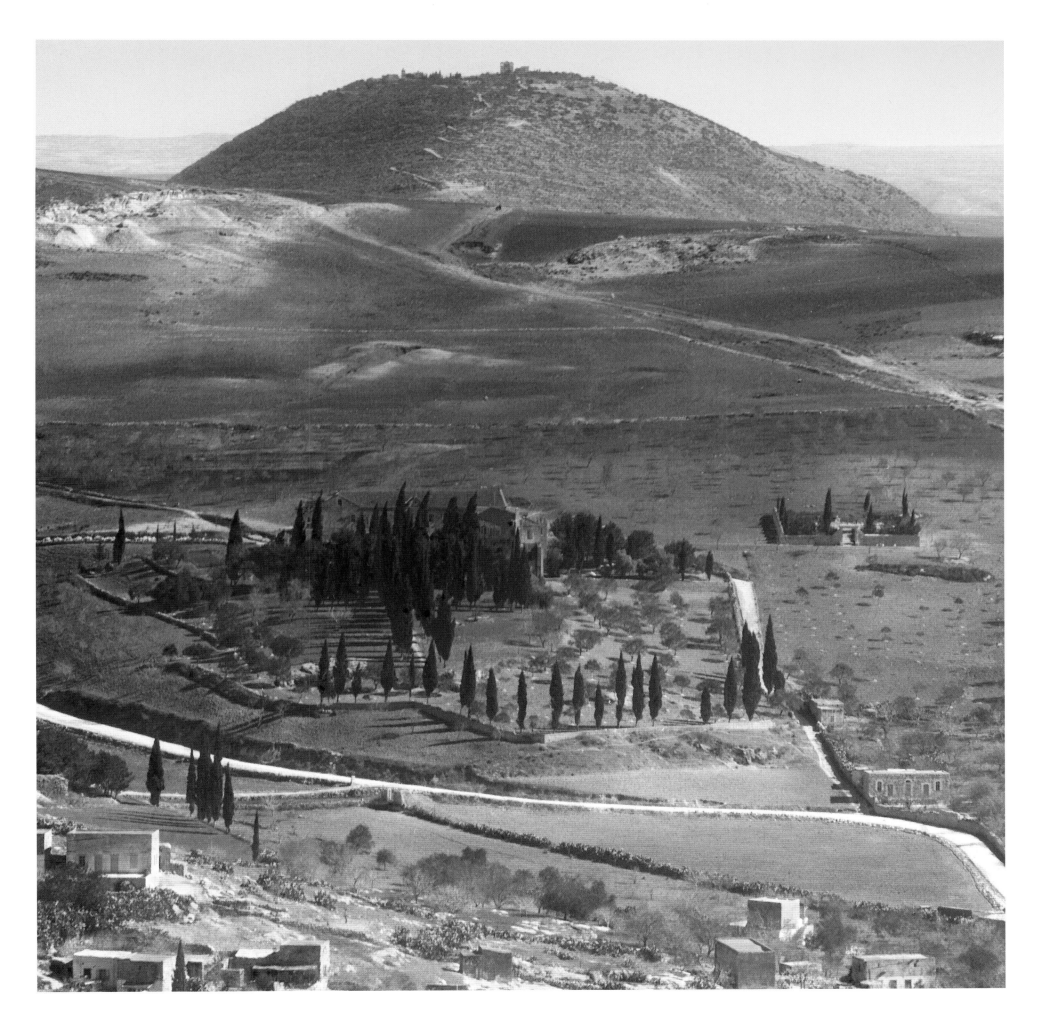

SAFED.

Safed, built on several hills, is the Holy Land's highest city, at an elevation of 2790 feet. Around 1492, after the expulsion of the Jews from Spain, Safed became a center of rabbinical studies, especially of mystical Judaism, known as Kabbalah.

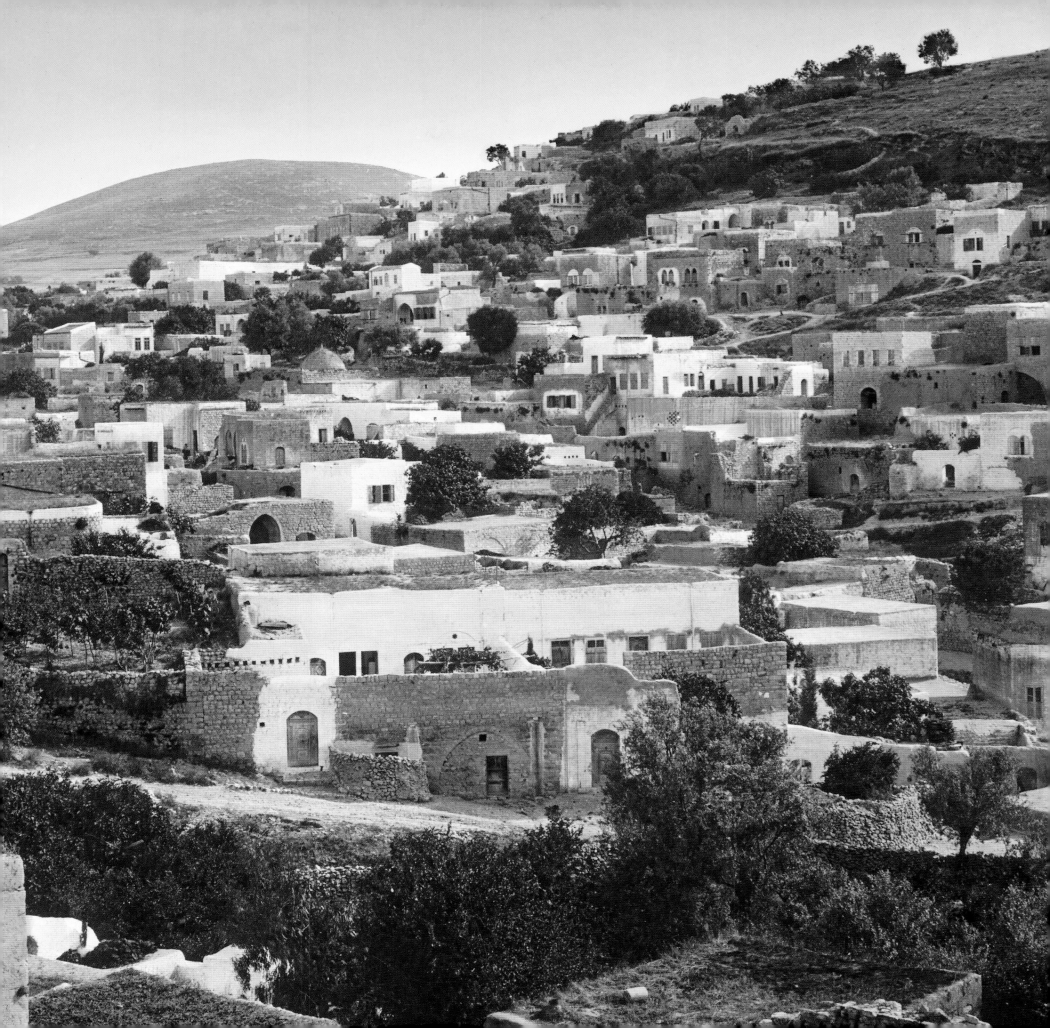

THE ASCENT TO SAFED.

A view of showing the ascent to Safed among olive orchards.

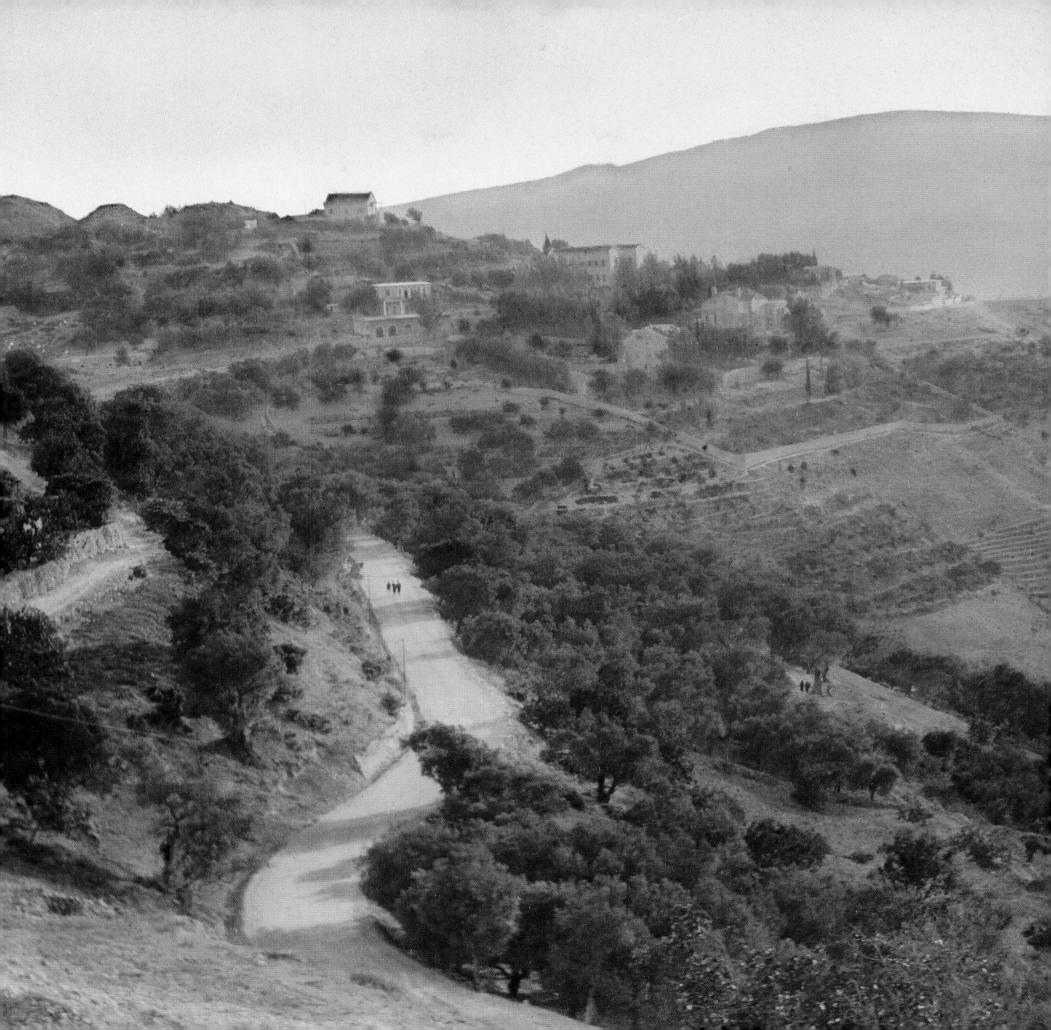

ROMAN BRIDGE OVER HASBANY RIVER.

The Hasbany River, whose source is the snows of Mt. Hermon, is a northern tributary of the Jordan River. This bridge is on the Jerusalem to Damascus highway.

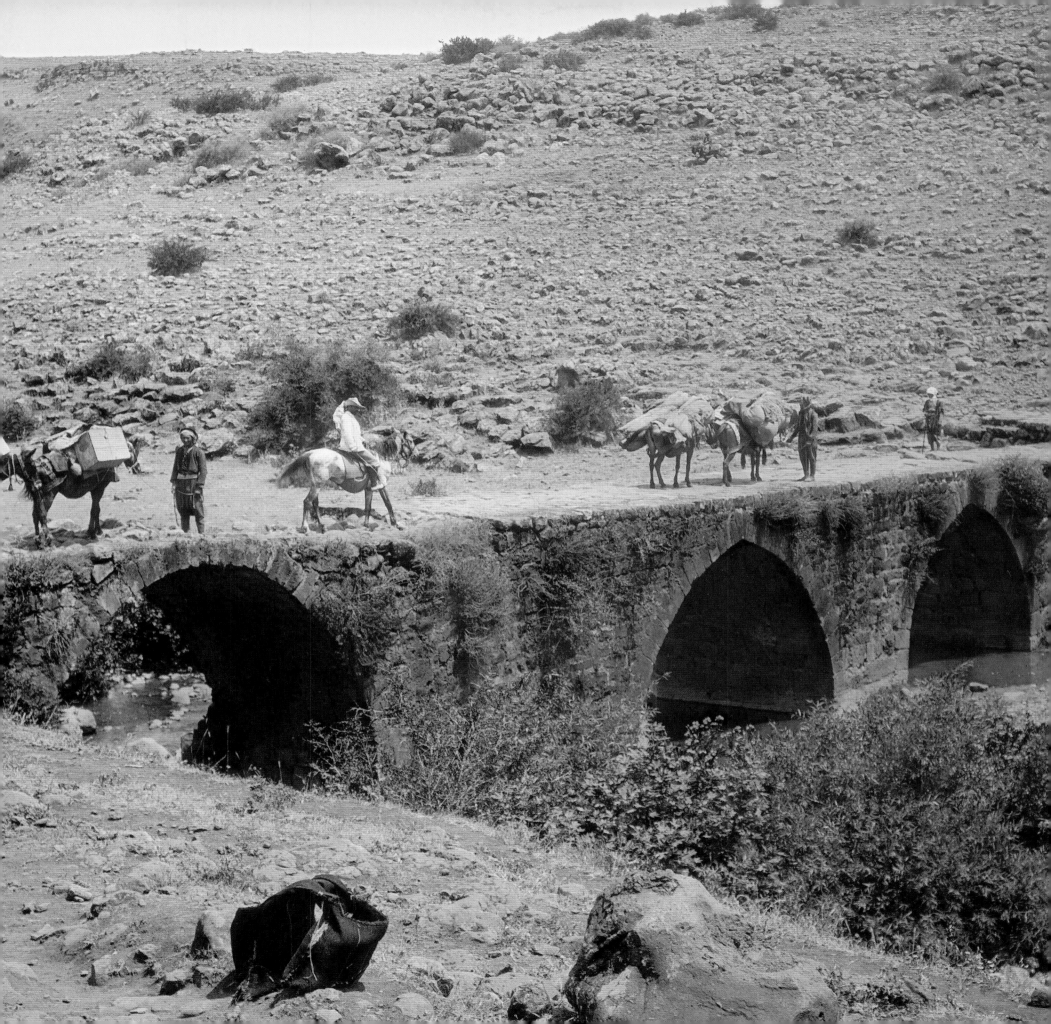

LAKE HULA, WITH DUCKS.
Lake Hula, or Huleh, is called "the waters of Merom" in the Book of Joshua.

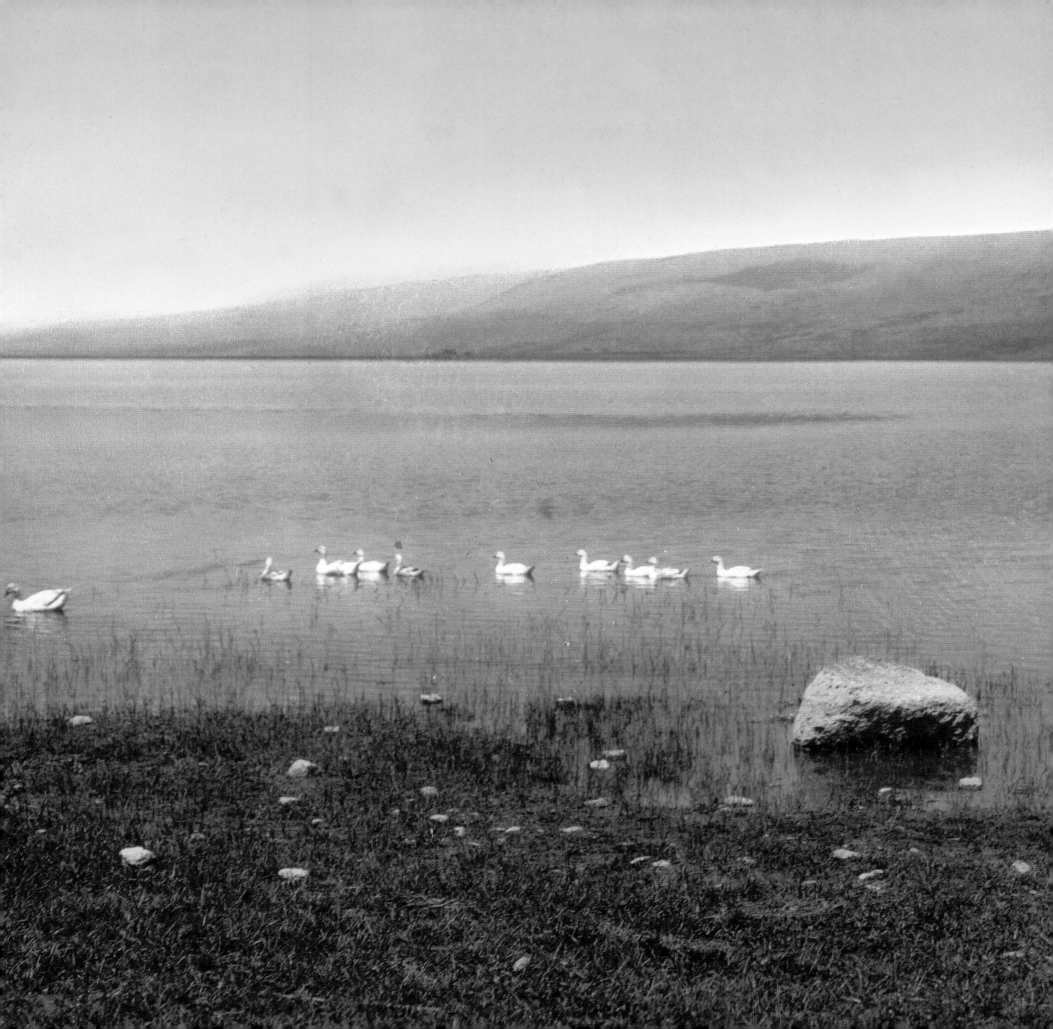

HORSES GRAZING ON LAKE HULA MARSHLAND; MT. HERMON IN BACKGROUND.

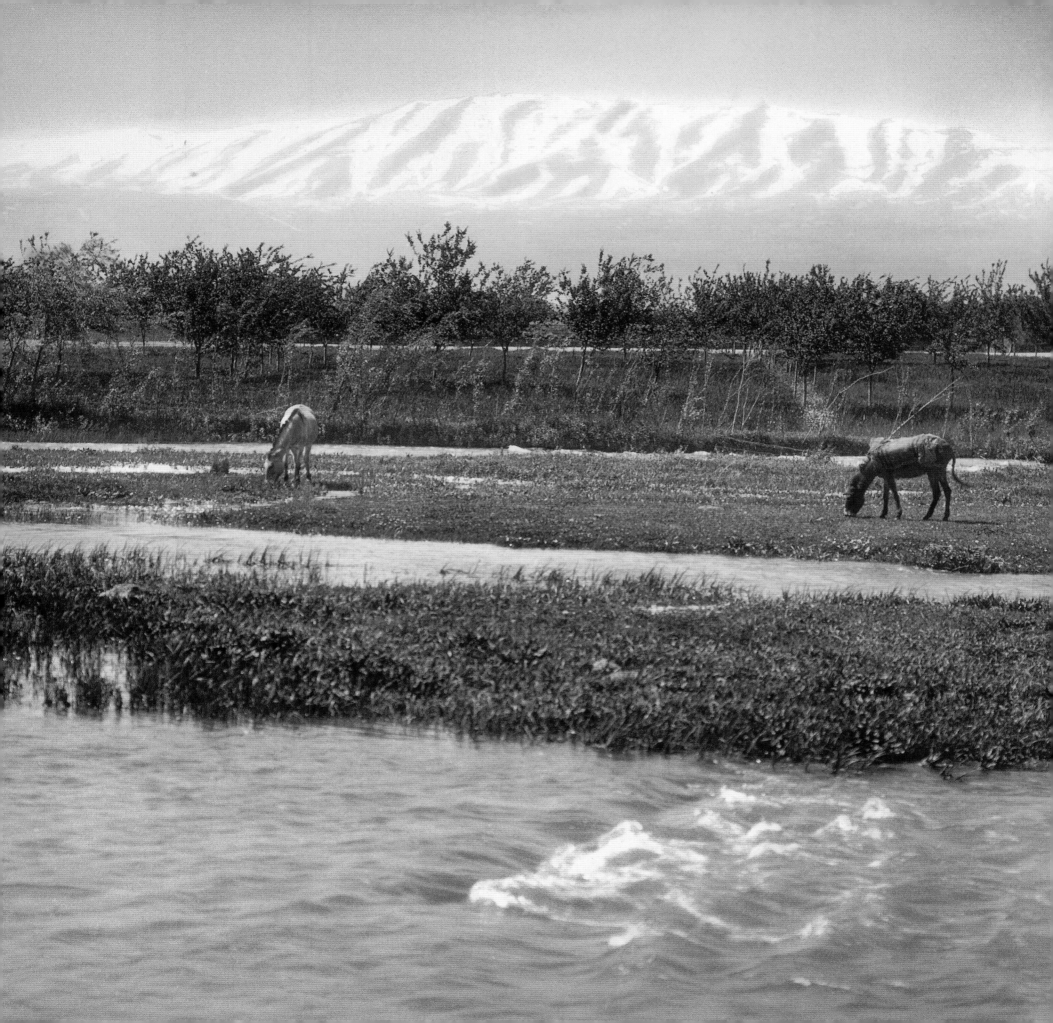

TELEPHOTO VIEW OF MT. HERMON.

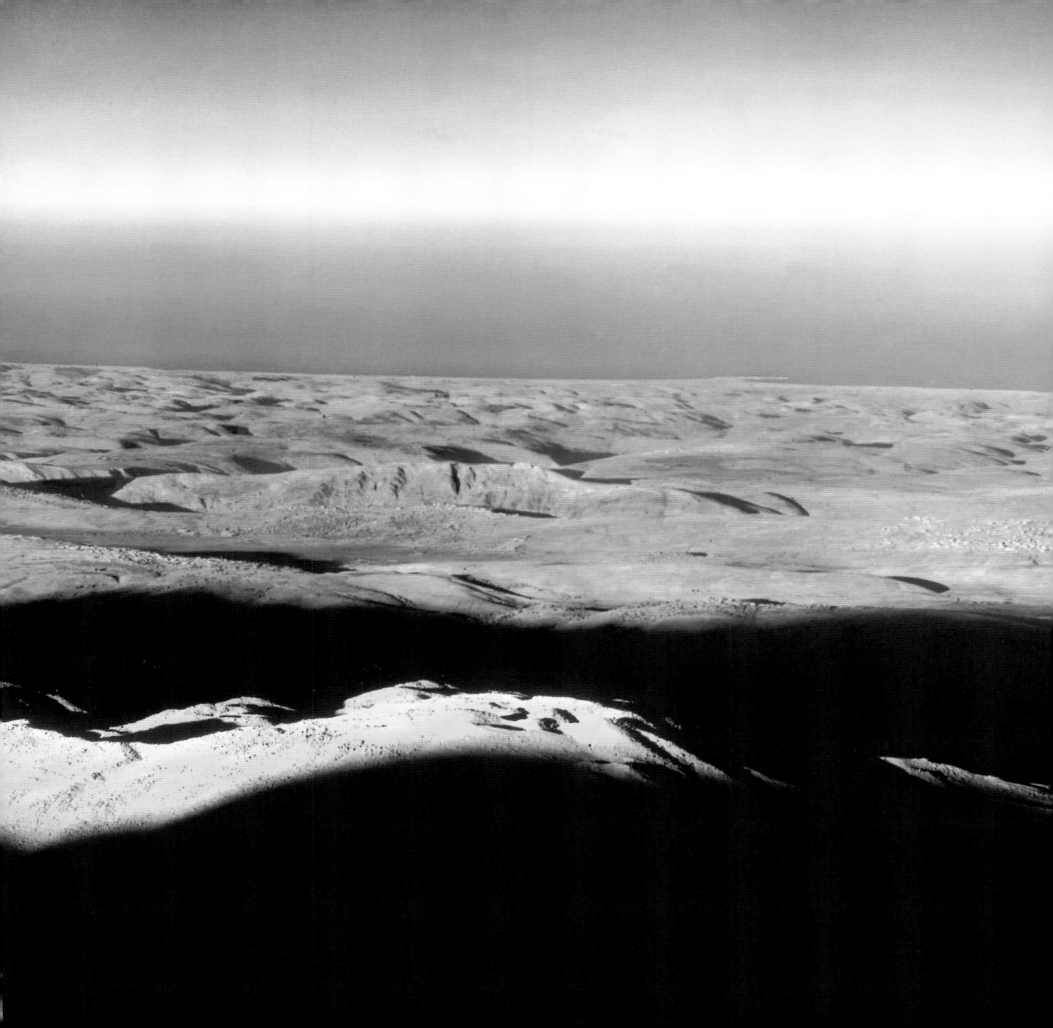

DRAMATIC EROSIONS OF MT. HERMON.

CAMELS GRAZING, WITH SNOW-CAPPED HERMON IN THE DISTANCE.

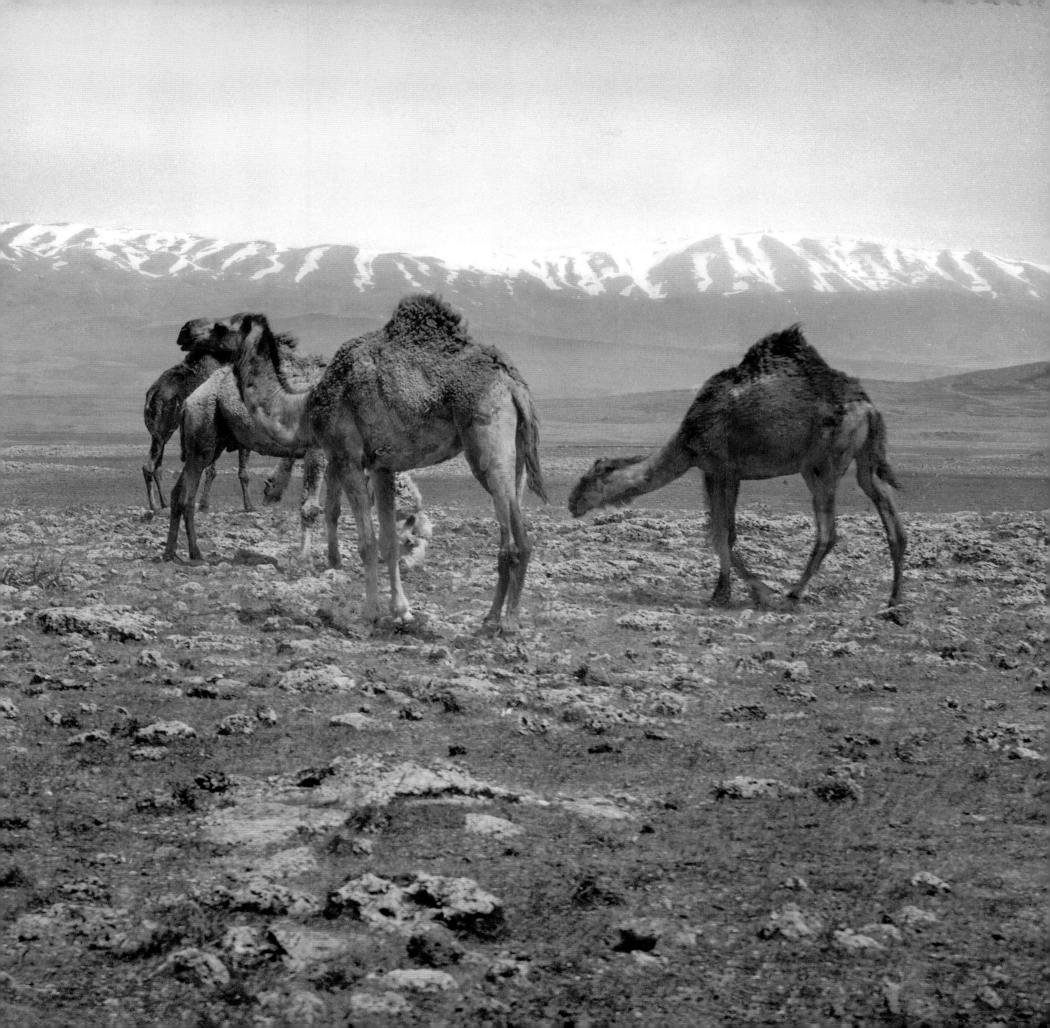

MT. HERMON'S SNOW-COVERED SUMMIT.

8

THE LEBANON

W HILE NOT TODAY GENERALLY considered part of the Holy Land, Lebanon has many Biblical associations, not the least of which are numerous references to its magnificent cedars. The fragrant and sturdy wood of the Cedars of Lebanon, Cedrus Libani, was highly prized throughout the Middle East and down the ages; the tree itself used to indicate qualities such as beauty, strength, dignity, and longevity. In Ezekiel, the cedars are employed as an elaborate metaphor to represent worldly power and ambition:

> Behold, the Assyrian was a cedar in Lebanon with fair branches, and with a shadowing shroud, and of an high stature; and his top was among the thick boughs. The waters made him great, the deep set him up on high with her rivers running round about his plants, and sent her little rivers unto all the trees of the field. Therefore his height was exalted above all the trees of the field, and his boughs were multiplied, and his branches became long because of the multitude of waters, when he shot forth. All the fowls of heaven made their nests in his boughs, and under his branches did all the beasts of the field bring forth their young, and under his shadow dwelt all great nations. Thus was he fair in his greatness, in the length of his branches: for his root was by great waters. (Ezekiel 31:3-7)

The Phoencians, ancient navigators and early inhabitants of the region, used the strong, water- and decay-resistant cedar wood for shipbuilding. King Hiram of Tyre sent Solomon the cedars used in the building of his temple. Ancient Egyptians used the antibacterial resin in mummification.

During the Crusades, twelfth and thirteenth century Christians left their mark on Lebanon in the form of many castles, towers, and churches. The most famous of Lebanon's castles, Beaufort Castle in southern Lebanon, was used as a Crusader fortress after its capture in 1139. Saladin took the castle in 1190 and it changed hands many times after that, its location making it of supreme usefulness in times of war. It stands on a sheer cliff overlooking the Litani River; its unparalleled view takes in, among other sights, Mt. Hermon.

MAN LOOKING UP AT A MASSIVE CEDAR.
A mature Lebanon Cedar can reach a height of 100 feet, with a trunk circumference of over 40 feet. Revered as a symbol of eternity, some of the oldest and largest specimens are believed to be over 2000 years old.

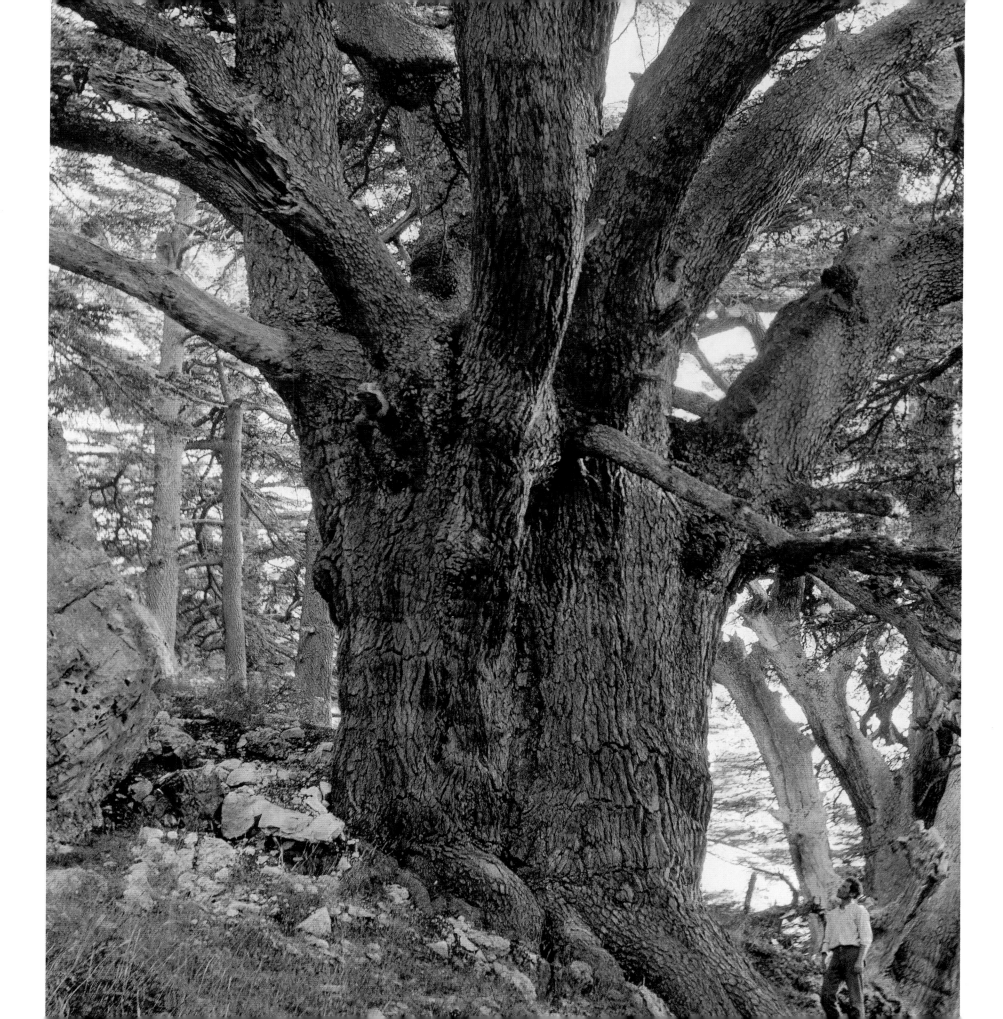

ANCIENT GROVE OF CEDARS.
References to the Cedars of Lebanon go back to the beginnings of epic storytelling; the cedars feature prominently in the Epic of Gilgamesh, dating from the third millennium BC:

> They beheld the cedar mountain, abode of the god,
> Throne-seat of Irnini.
> From the face of the mountain
> The cedars raise aloft their luxuriance.
> Good is their shade, full of delight.

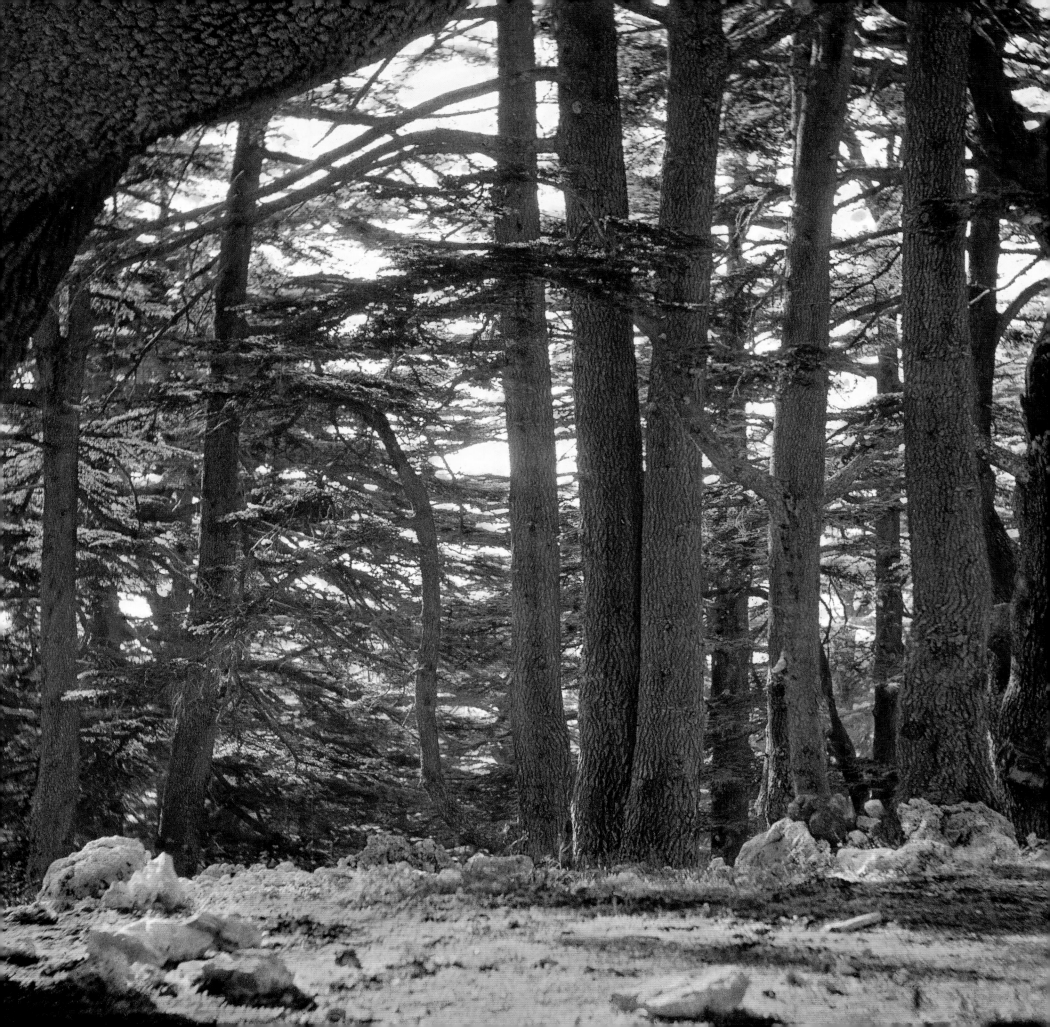

CEDARS.

A striking characteristic of the Cedars of Lebanon is their wide-spreading, horizontal branches.

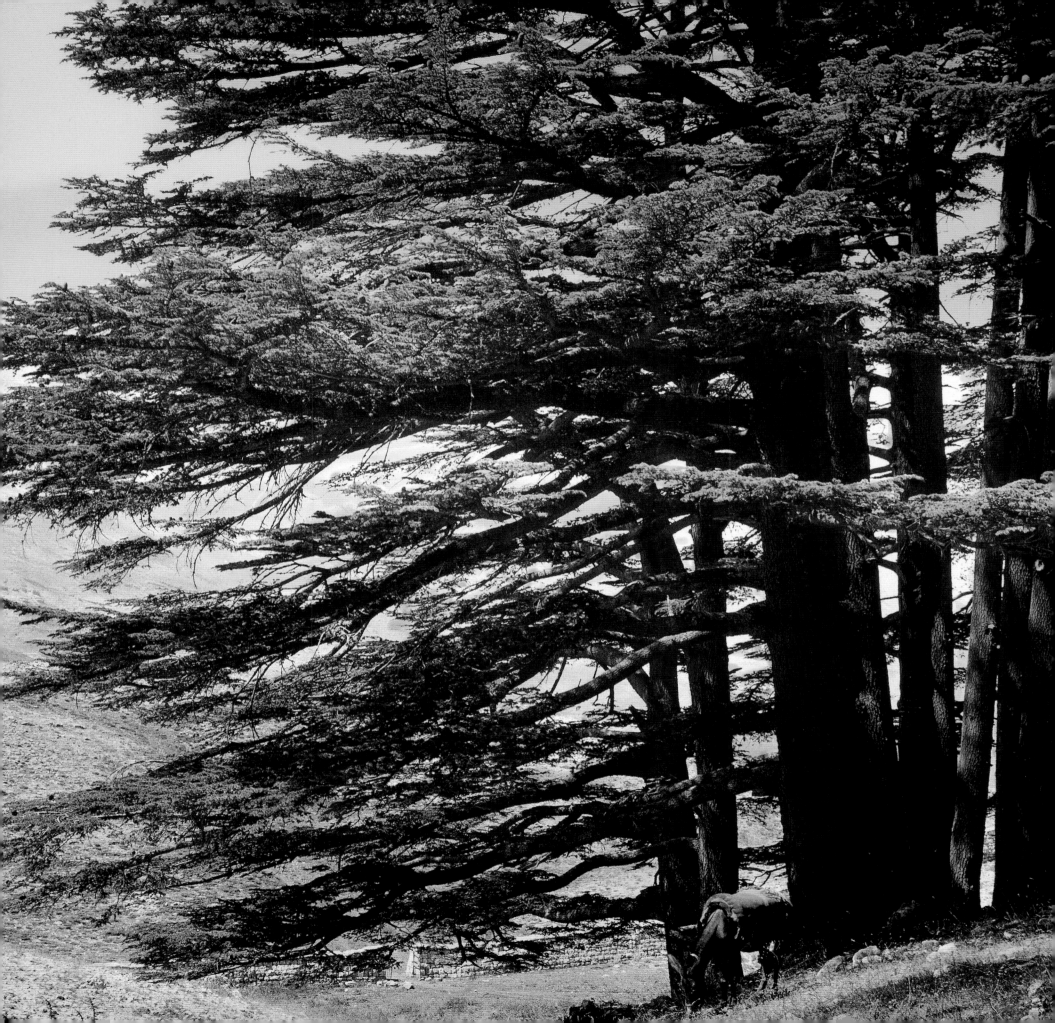

THE FIRE TONGS.
Near Bsharre village, birthplace of Lebanese-American poet and philosopher Kahlil Gibran, this road in the Damour Valley is famous for its treacherous hairpin turns.

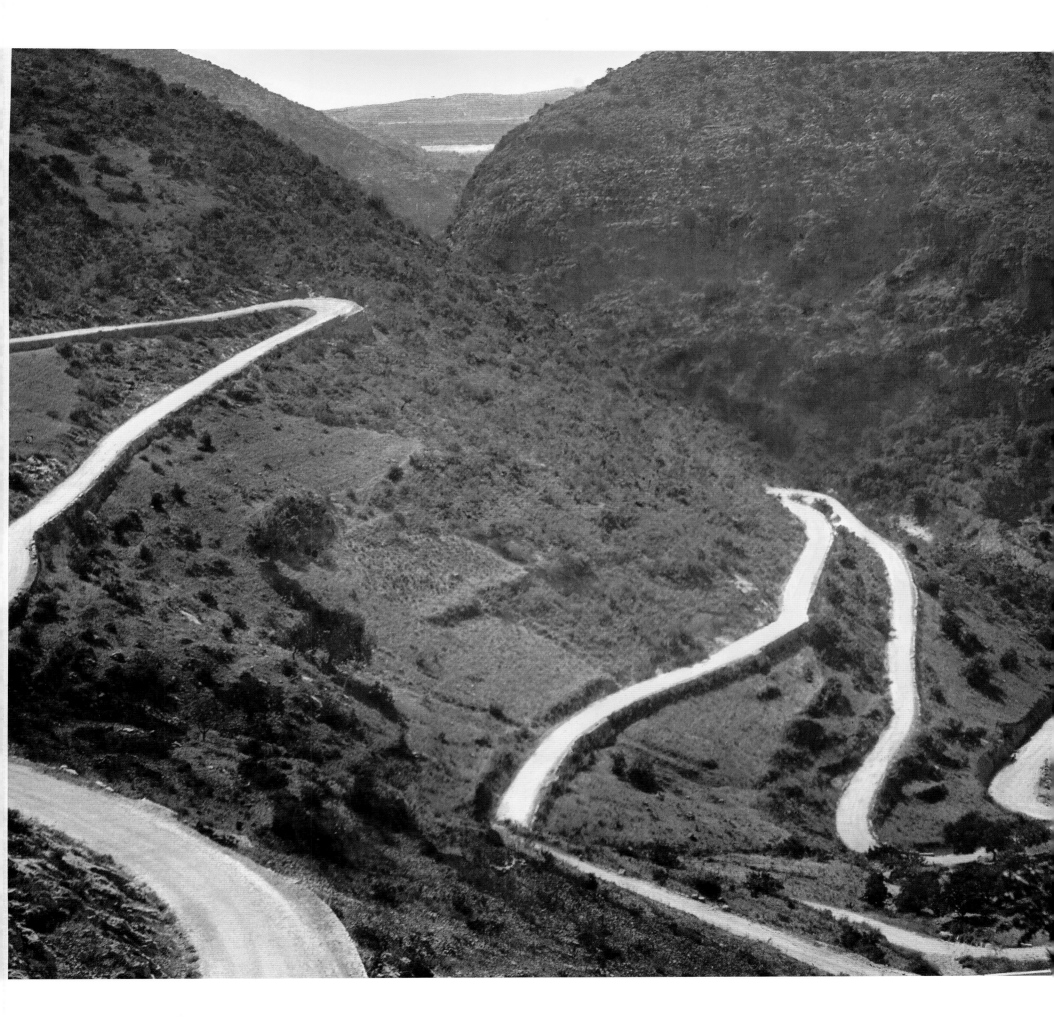

TERRACED WOODED VALLEY FROM BEIT EL DIN.

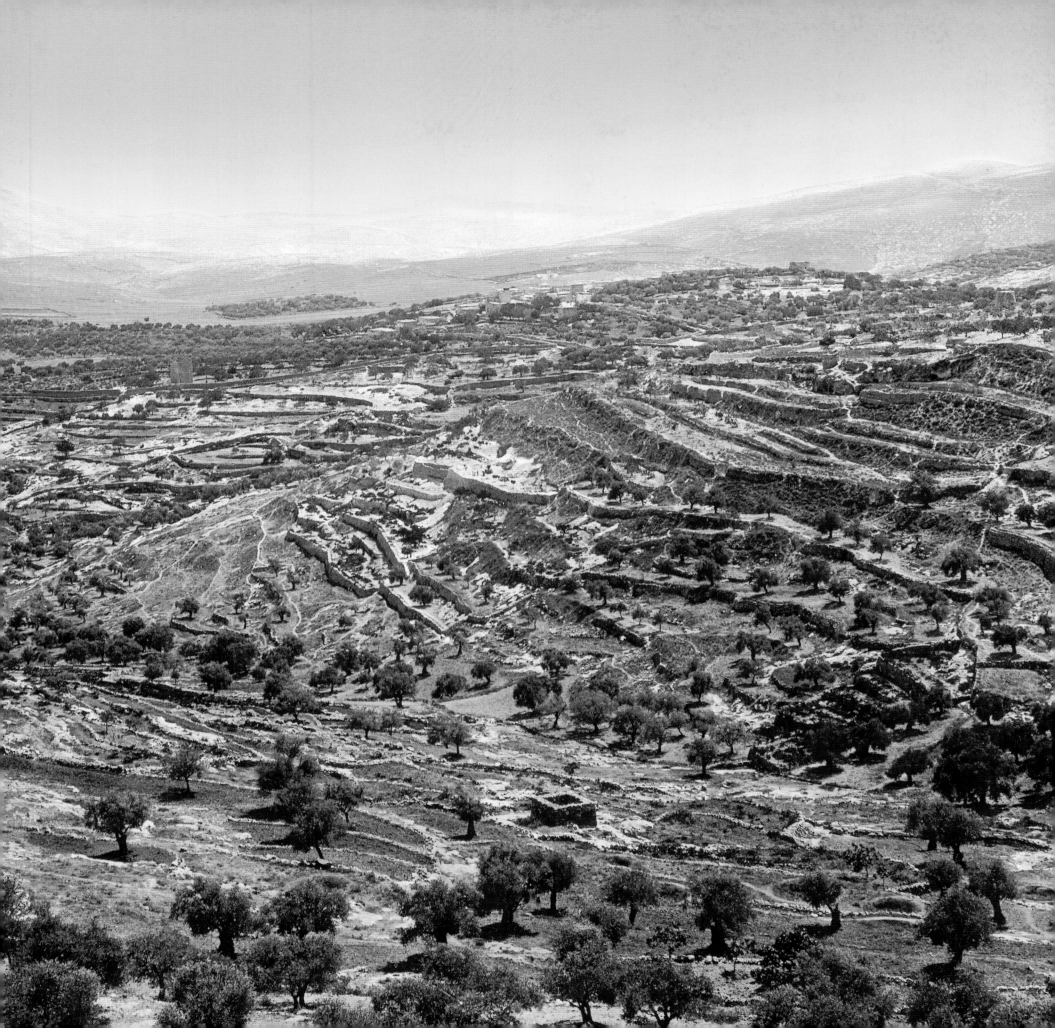

CRUSADER CASTLE AT SIDON.
Sidon's most dramatic sight is the dramatic Sea Castle, a magnificent
Crusader fortress that juts out into the Mediterranean.

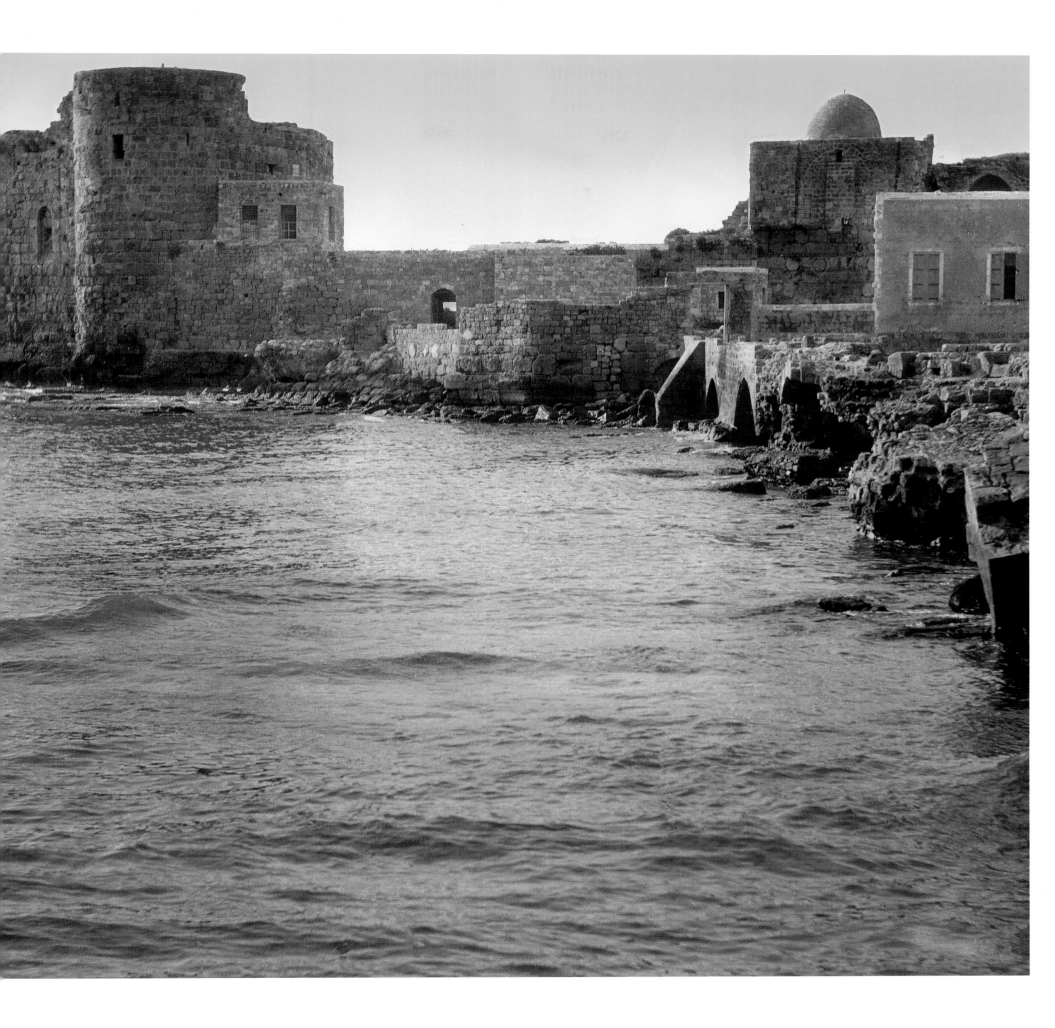

Sidon Castle Wall; Close Up.

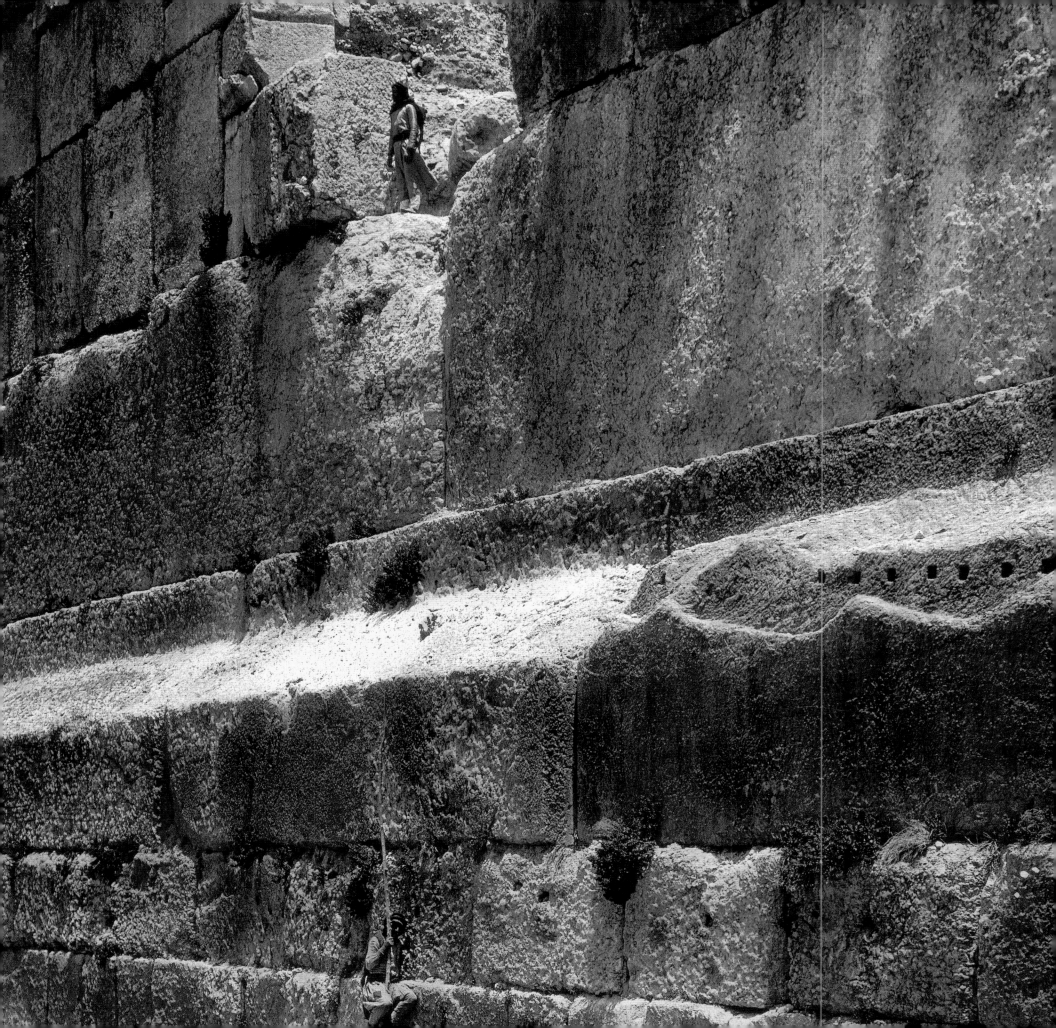

Deep Gorge Near Beaufort Castle.

The breathtaking view from Beaufort Castle, looking down on the Litani River.

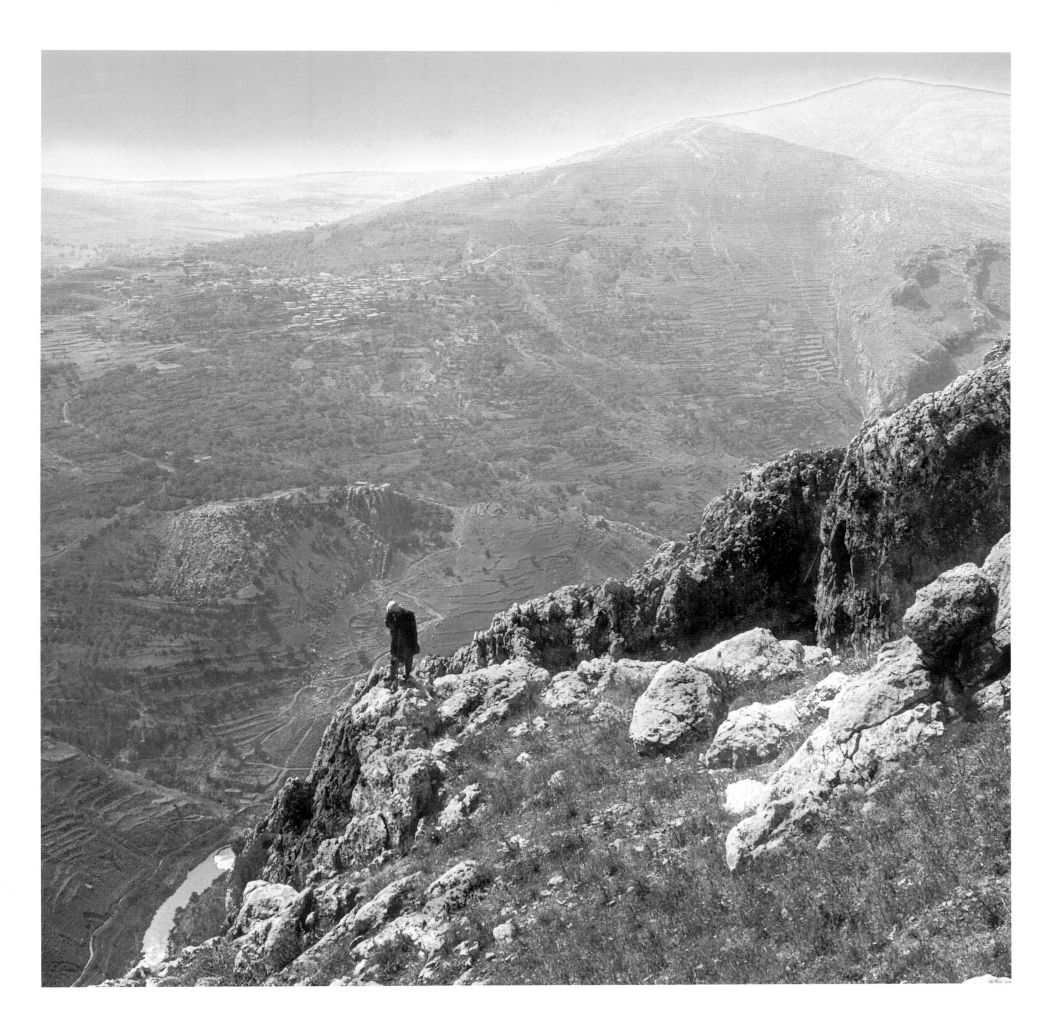